Adventures with Britannia

Adventures

with

Britannia

Personalities, Politics and Culture in Britain

Edited by

WM. ROGER LOUIS

I.B. Tauris Publishers
London

Harry Ransom Humanities Research Center
The University of Texas at Austin

Published in 1995 by

I.B. Tauris & Co Ltd
45 Bloomsbury Square
London WC1A 2HY

&

Harry Ransom Humanities Research Center
The University of Texas at Austin
P. O. Box 7219
Austin, Texas 78713-7219

A full CIP record for this book is available from the British Library.

Library of Congress Catalog Card Number 95-60535

ISBN 1-86064-002-8

Typeset by
Hastings Publishing
Austin, Texas

Printed and bound in Great Britain by
WBC Ltd, Bridgend, Mid Glamorgan

Table of Contents

List of Authors

Lord Blake was Provost of Queen's College, Oxford (1968–1987), and at the time of the lecture was Editor of the *Dictionary of National Biography*. His books include *Disraeli*; *The Unknown Prime Minister: Bonar Law*; *The Conservative Party from Peel to Thatcher*; *A History of Rhodesia*; and *The Decline of British Power*. With Wm. Roger Louis he has edited *Churchill*, published in 1993.

Derek Brewer has been Master of Emmanuel College, Cambridge, from 1977 to 1990. His fields of interest embrace folklore and social anthropology as well as literature and history. His books include *Introduction to Chaucer*; *English Gothic Literature*; and *Arthur's Britain: the Land and its Legend*. His hobby is "publishing other people's books."

Donald Cameron Watt is the former Stevenson Professor of International History at the London School of Economics, having been previously a junior editor of *Documents on German Foreign Policy* in the British Foreign Office. His books include *Personalities and Policies*; *Succeeding John Bull*; and *How War Came*.

Field Marshal Lord Carver joined the British army in 1933 and served in tanks throughout the Second World War, including the campaigns under Wavell's command in the Middle East. He finished his army career as Chief of the British General Staff 1971–1973 and Chief of the Defence Staff 1973–1976. He has written fourteen books, mostly of twentieth-century military history.

M. R. D. Foot was Professor of Modern History at Manchester University, 1967–1973. His books include *SOE in France*; *Resistance*; *Six Faces of Courage*; and *War and Society*. With J.L. Hammond he has written *Gladstone and Liberalism*, and with H.C.G. Matthew he has edited *The Gladstone Diaries*.

Lord Franks was Provost of Queen's College (1946–1948) and Worcester College (1962–1976), Oxford. In the Second World War he served at the Ministry of Supply. His career included the Chairmanship of the Committee on the Official Secrets Act and the Falklands Islands Review Committee. In 1948–1952, as Sir Oliver Franks, he was British Ambassador in Washington.

Sarvepalli Gopal is Emeritus Professor of Contemporary History at the Jawaharlal Nehru University, New Delhi, and Fellow of St. Antony's College, Oxford. He is the author of a three-volume biography of Nehru. His other books include *The Viceroyalty of Lord Irwin*; *British Policy in India*; and *Modern India*. He is a former President of the Indian History Congress.

Joseph Hamburger is Pelatiah Perit Professor of Political and Social Science at Yale University. He has written extensively on nineteenth-century political philosophy and is the author of *James Mill and the Art of Revolution*; *Intellectuals in Politics: John Stuart Mill and the Philosophic Radicals*; *Macaulay and the Whig Tradition*; and, with Lottie Hamburger, *Contemplating Adultery: The Secret Life of a Victorian Woman*.

Albert Hourani (1915–1993) was an Honorary Fellow and former Director of the Middle East Centre at St. Antony's College, Oxford. He was Reader in the Modern History of the Middle East at Oxford until 1979. His books include a recognized classic, *Arabic Thought in the Liberal Age*, and the best-selling *History of the Arab Peoples*.

Sir Michael Howard was Regius Professor of Modern History at Oxford and subsequently Robert A. Lovett Professor of Military and Naval History at Yale University. His book in the official series *British Intelligence in the Second World War: Its Influence on Strategy and Operations*, vol. 5 (1990) has been re-issued in paperback by Pimlico in 1992 as *Strategic Deception in the Second World War*.

Alan Knight is a former Professor of History at the University of Texas at Austin. He is now Professor of the History of Latin America, Oxford, and a Fellow of St. Antony's College. His publications include a two-volume work, *The Mexican Revolution*; and *US-Mexican Relations, 1910–1940*.

Diane B. Kunz is Associate Professor of History at Yale University. A former corporate lawyer, she was educated at Columbia, Oxford, and Yale. She is the author of *The Battle For Britain's Gold Standard in 1931* and *The Economic Diplomacy of the Suez Crisis*.

Jeremy Lewis published the first volume of his autobiography, *Playing for Time*, in 1987, and its sequel, *Kindred Spirits*, will be published in May 1995. A former director of Chatto and Windus, he is currently writing the authorized biography of Cyril Connolly.

Ian MacKillop is a Senior Lecturer in English Literature at the University of Sheffield. He is the author of *The British Ethical Societies*, as well as *F. R. Leavis (1895–1978): A Life of Criticism*; and (with Richard Storer) *F. R. Leavis: Essays and Documents*.

William H. McNeill is Professor of History Emeritus, University of Chicago. He has published more than twenty books, of which the most important, in his own assessment, is *The Rise of the West: A History of the Human Community*. He is a former president of the American Historical Association.

Kenneth O. Morgan is Principal of Aberystwyth College and Vice-Chancellor of the University of Wales. From 1966 to 1989 he was Fellow of Queen's College, Oxford. His books include *Rebirth of a Nation: Wales 1880–1980*; *Labour in Power 1945–1951*; and the *Oxford Illustrated History of Britain*.

R. A. C. Parker is a Fellow of Queen's College, Oxford. Previously, he taught modern history at the University of Manchester. His research has concentrated on British foreign policy before the Second World War and his publications include *Europe, 1919–1945*; *Coke of Norfolk*; and *Struggle for Survival: the History of the Second World War*.

Alan Ryan is Professor of Politics at Princeton University and the author of *Bertrand Russell: A Political Life*. His other books include *The Philosophy of John Stuart Mill*; *J. S. Mill*; *The Philosophy of the Social Sciences*; *Property and Political Theory*; and *Property*.

Lord Skidelsky is Professor of Political Economy at Warwick University. The second volume of his three-volume biography of John Maynard Keynes was published in November, 1992; it received the Wolfson Prize for History. His other books include *Politicians and the Slump*; *English Progressive Schools*; and *Oswald Mosley*.

Hilary Spurling is a British biographer, critic, and former literary editor of the *Spectator*. Her books include a two-volume biography of Ivy Compton-Burnett, and *Paul Scott: A Life*, first published in 1990.

Adolf Wood has been an editor with *The Times Literary Supplement* since 1975. Born in South Africa, he emigrated to Britain, where he worked in book publishing before joining the *TLS*. In 1992 he was a Guest Scholar at the Woodrow Wilson Center in Washington, D.C.

The Editor Wm. Roger Louis is Kerr Professor of English History and Culture at the University of Texas at Austin, and Fellow of St. Antony's College, Oxford. His books include *Imperialism at Bay* and *The British Empire in the Middle East*. He is the Editor-in-Chief of the *Oxford History of the British Empire*.

Introduction

WILLIAM ROGER LOUIS

This book consists of a representative selection of lectures given to the British Studies seminar at the University of Texas at Austin. The seminar has a twenty-year history, but most of the lectures here are clustered in the last decade. Virtually all have appeared individually in the series created about ten years ago called British Studies Distinguished Lectures, which are published by the Harry Ransom Humanities Research Center. Albert Hourani's lecture on T.E. Lawrence is an exception. It was delivered in the fall semester 1977 and is published here posthumously for the first time.

Lectures fall within a slightly different genre from that of essays or scholarly articles. A lecture presumes an audience rather than a reader and usually has a more conversational tone. It allows more freedom in the expression of personal or subjective views. It permits greater candor. It is sometimes informally entertaining as well as anecdotally instructive. In this volume, the lecture often represents intellectual autobiography—the relating of how the lecturer has come to grips with a significant topic in the field of British Studies, which, broadly defined, means things "British" throughout the world as well as things that happen to be English, Irish, Scottish, or Welsh. The scope includes all disciplines in the social sciences and humanities including the history of science. Most of the lectures in this collection fall within the fields of history, politics, and literature, though the dominant theme is historical. The full sweep of the lectures given to the seminar will be apparent from the list at the end of the book.

In the seminar's broader context, the members include lawyers and scientists as well as architects and musicians. The range extends to the larger Austin community to embrace businessmen, doctors, judges, and civil servants. Charles Alan Wright, a UT Professor of Law and a founding member, once remarked that the seminar was the only place he knew of where

people of such diverse backgrounds come week by week and year by year simply for the pure intellectual pleasure of exchanging ideas.

The British Studies seminar at the University of Texas is a remarkable institution and it may be of general interest to record briefly its history. For those in other universities or colleges who feel trapped within the narrow confines of a single field or discipline, it may offer hope. What makes a seminar successful is the willingness of its participants to meet on a regular basis and to discuss work-in-progress, whether their own or that of their visitors. It must be said, however, that the circumstances for the founding of the seminar at the University of Texas were exceptionally favorable because of the Humanities Research Center, now known as the Harry Ransom Humanities Research Center. Harry Ransom was the founder of the HRC, a Professor of English and a former Chancellor of the University, a collector of rare books, and a man of humane vision. Through his administrative and financial genius, the HRC has developed into a great literary archive that holds substantial collections in English literature. Not all faculty members at the time thought that the creation of the HRC was a good idea. They dissented on the erroneous ground that money allocated by the Regents for the HRC might instead be designated for the General Library or perhaps even for faculty salaries. Ransom thought that a weekly seminar might help to win over critics by offering the opportunity to learn of the original research being conducted at the HRC and coincidentally by creating a common bond of intellectual interest in a congenial setting of overstuffed armchairs, Persian carpets, and generous libations of sherry. The HRC would provide the home for the seminar (if not the sherry that has become associated with the Friday-afternoon meetings). This was a shrewd assessment. The seminar was launched in the fall semester 1975 by William S. Livingston (now Vice-President and Dean of Graduate Studies), Warren Roberts (the first Director of the HRC), and me. It had the dual purpose of providing a forum for visiting scholars engaged in research at the HRC and of enabling the members of the seminar to discuss their own work-in-progress.

The seminar's first visitor was Paul Scott, whose *Raj Quartet* had been published to acclaim. His wider fame came later, after his death, with the television series "The Jewel in the Crown." Scott's visit caused a stir, among other reasons because it became known that he had partly modelled the hero in the last volume of the *Quartet,* Guy Perron, on the classicist Peter Green, a founding member of the seminar to whom everyone is indebted for his learning and wit. Green had proposed Scott as a speaker with high expectations, but unfortunately the visit, and the first meeting of the seminar, came close to being a disaster. It never fails to astonish professors that those who work in the real world as novelists, politicians, or journalists sometimes display a nervousness bordering on breakdown when asked to give an academic lecture. Paul Scott met that description. Hilary Spurling writes in

her biography of Scott that he braced himself with alcohol and that the members of the seminar treated him unmercifully. This was Scott's perception, not the reality. He was asked several searching questions about the verisimilitude of some of his characters—could the British Raj actually have produced such a monster as Ronald Merrick?—but in fact the questions were friendly and the atmosphere convivial.

Seminars that sponsor visitors invariably need modest financial support, which in this case the HRC could not offer. The only source at the outset appeared to be the Dean of an ungodly administrative conglomeration called the College of Social and Behavioral Sciences (eventually merged with the Humanities as the College of Liberal Arts). The Dean in 1975 was James McKie, an economist, who came to the second meeting to hear Fritz Fellner of the University of Salzburg speak on Britain and the origins of the First World War. Unfortunately the gathering consisted only of the Dean, the speaker, and myself, plus a departmental secretary whom I dragooned into the room in desperation. Nevertheless the discussion was lively and the session worthwhile. It emerged that, in the measured view of an Austrian historian, the responsibility for the war could ultimately be traced to Germany, not Britain, though this theme has recurred in other sessions and has not persuaded those who read history from an Irish vantage point. There was a practical lesson here. It takes time for attendance of a newly-created seminar to stabilize. The average number of participants is now about thirty, sometimes double that, and seldom less than a dozen. But seminars are sometimes like conversations and can be successful with minimal numbers. I was glad to learn that this was the view of the Dean, who continued to give his support. So also did his successor, Robert D. King, who, during his long tenure as Dean of Liberal Arts for nearly twenty years, helped to raise an independent endowment for the seminar that would ensure its existence regardless of the whims of university administrators. More than to any other single person, the seminar owes its institutional success to Dean King.

To establish a few colorful points in the seminar's history as well as the breadth of topics, I shall dwell briefly on seven prominent members. Two are alive and well, but the others are dead, which permits greater frankness. Two are Englishmen, one a Welshman, another a Scot transmogrified into a UT faculty member, the others American.

The first is C.P. Snow, who paid several long visits to Austin while arranging for his papers to be deposited at the HRC in the late 1970s. Snow was a gregarious intellectual who found himself at home in the free-wheeling and informal debates in the seminar. Heavily jowled and affable, he habitually wore green socks. In his first talk to the seminar he developed the theme of the diverse social origins of Britain's administrative élite and reflected on his own rise from the English working-class to the Peerage. In his most controversial lecture, he reflected on *The Two Cultures and the Scientific*

Revolution, in which he sustained his theme that the ignorance of humanists about science was just as great, and just as "barbaric", as the ignorance of scientists about the arts. This line caused considerable dissent, notably from Elspeth Rostow, who later became Dean of the LBJ School of Public Affairs and then proved her point that there need be no gulf between practitioners of different disciplines, scientific or otherwise. Snow's legacy to the seminar was a sustained interest in scientific topics ranging from the discoveries of Newton to the work of the mathematician Ramanujan.

It is a fallacy to assume that members of a British Studies seminar must be anglophile. Hartley Grattan, a critic and man of letters in the tradition of Edmund Wilson, did not much like the British. But he was an irrepressible participant in the early discussions. Grattan had pursued an independent career as literary critic and journalist, notably as a writer for *Harper's,* before entering the academy, where he never felt entirely comfortable. He once remarked to me that in the UT History Department he felt like a piano player in a whorehouse. His intellectual interests encompassed both history and literature. He had written on Henry and William James, and on an array of literary topics, before turning his attention to the history of Australia. He was a great collector of books. The Grattan Collection on the Southwest Pacific at the HRC is the foremost collection on the region in the United States. During seminar discussions he would, rather ferociously, wave his black pipe for emphasis (before smoking was forbidden at the HRC). He could intimidate as well as persuade, but he was both a respected and beloved figure. When he died in 1980 the Vice-Chancellor of the Australian National University, Sir John Crawford, spoke at one of the seminar sessions *in memoriam.* Australia and New Zealand have ever since been one of the seminar's constant themes.

Morrice St. Brides during his long visits to Texas helped to sustain the interest in Australia, where he had served as High Commissioner, but above all he provided ballast in discussions about British society, the press, Parliament, and the social and economic dilemmas facing the British government. A Welshman of great charm and robust appearance, he had an illustrious diplomatic career behind him and was closely familiar with the inner workings of the Commonwealth. He often sported the navy tie of Balliol or the crimson tie of the Harvard Club of New York City. He will be remembered in the history of the seminar for his pursuit of Indian, Middle Eastern, and African themes—those parts of the world earlier under the sway of the British Empire. St. Brides had served in Pakistan and India and was the only person ever to have been High Commissioner in both countries. He was passionately interested in the history of the British administrations in Palestine, Malaya, Burma, and in outposts such as the Falklands. Since his interests coincided with my own, I welcomed him as a comrade-in-arms in asking, what should they know of England who only England know? He was

excellent on Kipling, as he was on Evelyn Waugh and E.M. Forster. His talk on *A Passage to India* aroused anger, the most striking instance in my memory of scholars coming close to hurling sherry glasses at each other. St. Brides had the audacity to suggest that the David Lean production of the film was better than the novel, which I thought preposterous. It provoked me to re-read the book. After I had done so, I agreed with him.

The seminar was fortunate in its early years to have as one of its members Richard Ellmann, who made several lengthy visits to Austin to continue his work at the HRC on James Joyce and to prepare his biography of Oscar Wilde. During that time he was Goldsmiths' Professor of English Literature at Oxford, but he remained quintessentially American. Among other things he had a distinctively American, as opposed to an English, sense of humor. He liked practical jokes. He had a slightly jaded view of life in Oxford and seemed to welcome the HRC as a respite. In his first talk to the seminar he described the detective work that had gone into his biography of Joyce. He had often found it necessary to balance fragmentary and difficult evidence. He was candid about the difficulties of writing literary biography when members of the family not only still held collections of papers but also did not hesitate to voice opinions. He left the impression that he had pulled some of his punches without compromising his own integrity. He later related his progress with the Wilde biography. Everyone looked forward to it with immense interest, but after its publication he would have been surprised at the critical response by some members of the seminar, notably Peter Green, who believed that Ellmann inflated Wilde's significance as a literary figure. For the seminar, Ellmann helped to set the standard in discussion about poetry and works of fiction. His comments were shrewd, straightforward, easy to follow, and filled with common sense. At one session he expressed surprise when the local Brontë society appeared in strength, all three of them.

Alexander Parker, a Scot, was a Professor of Spanish Literature at UT but previously had pursued a distinguished career in London and Edinburgh. In Austin his wife drove him to and from the University in a rather dilapidated green Cadillac. His most famous book was on the philosophy of love in Spanish literature. He sympathized with what he called the wrong side of the Spanish civil war, the subject of his first talk to the seminar. He had a penetrating and subtle literary mind, and he was a man of kindness and generosity. He brought to English literature the perspective of Spanish and Portuguese literary traditions, but his contribution to the seminar will always be remembered by a confession. It was startling at the time. At a meeting of the seminar at the LBJ Library to discuss recent books about British code-breaking at Bletchley during the war, Alec Parker rose to speak to a large audience of about a hundred. He demonstrated uncharacteristic nervousness, saying that he had always taken the Official Secrets Act seriously. To that very day there were some things he had never mentioned even to his wife. He

stated that, in view of the declassification of secret documents and the books now written about the breaking of the codes of the German High Command through "Ultra", he no longer felt bound by official secrecy. He then told of his experience as one the Bletchley group while his wife Frances sat in open astonishment. He described the Enigma machine as resembling a huge typewriter, a sort of primitive computer. If the ciphers were run through often enough the code eventually would be cracked. No amount of reading of the historical literature on code-breaking can ever replace his vivid description ringing with nervous tension that afternoon.

Robert Blake (alive and well) came to the University of Texas not under the auspices of British Studies but as Visiting Cline Professor. Clarence Cline is a retired Professor and former Chairman of the Department of English who endowed a visiting position attached to the HRC (and was instrumental in the creation of the seminar by suggesting that what we needed were twelve men, or women, tried and true who would each contribute $1000 to an endowment to meet the cost of visitors—he immediately sat down to write out a personal check drawn on the Austin National Bank and thus became the first contributor). Cline was an admirer of Blake's biography of Disraeli, one of the best biographies, he once told me, in the English language. The choice of Robert Blake was felicitous. He and his wife Patricia won the hearts of the UT community. He taught a graduate course on Disraeli's novels, which had the virtue of bringing graduate students in both English and History into the mainstream of the British Studies seminar. He himself first talked to the seminar on the problems of a biographer writing on Disraeli. He later returned to give the lecture on Churchill as historian that appears in this volume. During his tenure here we talked about the prospect of a major reassessment of Churchill by historians who would examine his career from different vantage points. In March 1991 the British Studies seminar, among other sponsors, became the host of a conference that eventually produced a volume called *Churchill,* published in England by the Oxford University Press and in America by the WW Norton and Company. One reviewer remarked that the authors consisted of four Peers, three Knights, one Field Marshal, a Vice-Chancellor, and a gaggle of Professors. It was not our intent to collect dignitaries but to assemble the leading authorities. Somewhat to our surprise, a consensus emerged from the discussion. Churchill could sustain intense historical scrutiny by the best experts we could find. He was a great man after all. The publication of the book was a high point in the history of the seminar.

Alessandra Lippucci (exuberantly alive and well) I mention because of the breadth of her interests and the intellectual vitality she injects into the seminar's discussion. A political philosopher and social theorist by training, she has proved fearless in challenging orthodox views and undaunted in upholding the virtues of deconstruction and multiculturalism in the face of

fierce opposition. Her interest in such diverse fields as social anthropology, Shakespeare, jurisprudence, and opera has stimulated discussion on innumerable occasions. She is willing to take on any topic from astrology to psephology and to examine it with considerable verve from conspiratorial and other angles. Every seminar needs a Sandy Lippucci.

With the mention of Sandy Lippucci, should not her husband David Edwards be used as an example too? It would be invidious not to say that he has made equally incisive contributions over a comparable range. But where should one stop? I trust my colleagues will pardon me for not going into further details about other personalities and I shall conclude with a few words of thanks.

The seminar has been the beneficiary of generous gifts by Baine and Mildred Kerr of Houston, by Edwin and Becky Gale of Beaumont, and by Creekmore and Adele Fath of Austin, as well as by numerous yearly contributions by members of the seminar. We are indebted, above all, to Sam and Sherry Brown, who have established an endowment to further the seminar's purposes. As a result of the Brown Endowment the seminar is now able to sponsor a British Studies Research Fellowship at the HRC, to offer undergraduate and graduate scholarships, and to carry forward our publication program.

We are grateful for the support of Thomas F. Staley, the Director of the Harry Ransom Humanities Research Center. We also wish to thank Harry Middleton, the Director of the LBJ Library. Eugene Jackson has acted as historian of the seminar and has assisted with publications. Miguel Gonzalez-Gerth, Janice Rossen, and Elizabeth Dunn have managed the seminar at various times when I have been on leaves of absence, as has Kurth Sprague. A poet as well as a scholar, Kurth Sprague has served the seminar with unique distinction. To him, among other things, the members owe the choice of Tio Pepe or Dry Sack—to my knowledge the only seminar in the world collectively to be confronted with this exquisitely un-American weekly dilemma.

The sherry symbolizes the attitude. The seminar meets to examine in a civilized way whatever happens to be on the agenda, Scottish or Indian, Canadian or Jamaican, English or Australian. When Oscar Wilde said that England and America were two great countries divided by a common language, he understated the case. The interaction of British and other societies is an endlessly fascinating subject on which points of view do not often converge. The discussion is civil, but diverse preconceptions, which are tempered by different disciplines, help to sustain controversy, not to end it. What makes the ongoing debate in British Studies engaging is the clash of different perspectives as well as the nuance of cultural interpretation.

The chapters are arranged more or less in the order the lectures were given, with some exceptions. There is a standing rule that we do not publish our own lectures. When Alan Knight left the University of Texas to become Professor of Latin American History at Oxford University, the embargo on his lecture was lifted. It thus appears slightly out of sequence. It represents, along with the lectures by Albert Hourani on the Middle East and Sarvepalli Gopal on India, the regional approach of the seminar. The seminar's interest in biography is represented by Hilary Spurling on Paul Scott, Robert Blake on Churchill, Donald Cameron Watt on the personalities of appeasement, and William McNeill on Toynbee. In English literature we have Adolf Wood on the *TLS,* Derek Brewer on fairy tales in relation to English literature and anthropology, Ian MacKillop on F.R. Leavis, and Jeremy Lewis on Cyril Connolly. In political philosophy there are lectures by Alan Ryan on Bertrand Russell and by Joseph Hamburger on John Stuart Mill. On the question of the "Special Relationship," Oliver Franks recalls his time as Ambassador in Washington. Diane Kunz analyses post-war sterling crises while Robert Skidelsky pursues similar economic themes in dealing with Keynes. The origins and course of the Second World War have been a long-standing interest of the seminar and that topic is represented here by R.A.C. Parker on appeasement, M.R.D. Foot on covert operations, Michael Carver on Wavell, and Michael Howard on strategic deception. The last chapter is Kenneth Morgan's lecture, which represents a major strand of the seminar's interest in Wales as well as Ireland, Scotland, and England.

1

The Myth of T. E. Lawrence

ALBERT HOURANI

My interest in Lawrence springs from two different sources, one of which was common in Oxford in the 1930s. There are certain things about Lawrence that one can only understand within the context of a certain inherited, specifically Oxford, culture of his generation. Lawrence was a great figure in our imaginations and in our lives. Second, of purely personal interest, my family came from those villages in the Hawran where Lawrence's campaigns were fought, and I like to think that perhaps my relations or ancestors are from the thirty Christian villages of the Hawran that he mentions in his book. My father knew him a little. My interest was revived at one time by the pure accident of living just over the garden wall from where Lawrence was brought up. In John Mack's book, *A Prince of our Disorder* (1976) there is a photograph taken by the author of the cottage at the bottom of the garden on Polstead Road, where Lawrence lived during his undergraduate days. The trees that appear behind the cottage were the trees at the bottom of my own garden. Every morning when I woke up and looked out the window while shaving, I thought of T.E. Lawrence.

In preparing to talk on the myth of T.E. Lawrence, I did not wish to prejudge the question of what was mythical and what was not. I did what I always do when I work on a new subject. I consulted the *Oxford English Dictionary*, where the word myth is defined as a "purely fictitious narrative involving supernatural persons, actions, or events." I thought that in that sense there certainly was something mythical about T.E. Lawrence. Nobody who ever met him, even those who met him before 1914, ever thought that he was quite like ordinary men, and this is a fact one has to remember about him. Whatever is left of his reputation after inquiry, there still remains something we cannot quite explain—a general consensus that he was larger than life. He impressed people of the most different kinds: soldiers not prone to this kind of adulation, a politician like Churchill who had met all the great men of his time, Bernard Shaw who was sceptical by nature, and,

most surprising of all, Bloomsbury intellectuals such as E.M. Forster and David Garnett, not at all disposed to worship men of action. But I think one should remember from the beginning that his reputation was almost entirely an English reputation. I do not think he ever had such a wide reputation among Arabs.

Successive biographers, including John Mack, have been misled by his reputation and to some extent have given a misleading impression. Of course, those with whom Lawrence had come into immediate contact in Transjordan and western Arabia would remember him because he was involved in the kind of events one remembers all one's life. The former Warden of St Antony's, my college, Sir William Deakin (who was the first British officer to be dropped to Tito's partisans during the Second World War), used to relate how he went back to that part of Yugoslavia when he was writing a book about his experiences. A middle-aged man stopped him in the street and said, "You were the man who came out of the woods." The middle-aged man explained that he had been a boy in Tito's camp and had seen this British officer suddenly emerging from the woods to the encampment. This is a thing one remembers all one's life. When John Mack went to that part of Transjordan while researching his book, he talked to old men who had been in the campaign. They seemed to remember every detail. Had Lawrence come back they would have been glad to see him again. But Mack, in common with other biographers, tended to generalize about this and to talk not merely about this particular group of people who remembered Lawrence with affection, but about all Arabs.

The Arabs in Syria, at least those whom Europeans or Americans tended to meet, did have a certain interest in Lawrence. I remember in the Second World War that there was a retired Syrian officer who had nothing much to do and who used to spend most of his time entertaining British officers to tea and giving them his reminiscences of T.E. Lawrence because he had an audience. Similarly, Lawrence's reputation in France, which is now considerable, came late. He did not like the French, in part because they had a different kind of temperament. We do possess a very interesting description of a meeting between a Frenchman and Lawrence. The accident of the First World War brought together Lawrence with the greatest Islamic scholar of his generation, Louis Massignon, who has written his account of the encounter in an essay in *Opera Minora*, the collection of his shorter works. In 1917 Massignon was appointed French liaison officer attached to Feisal. According to Massignon, Lawrence protested against this because he suspected that Massignon, with his superior knowledge of Arabic and Arab culture, could establish a closer relationship with the Arabs than Lawrence himself. Massignon went on to analyse Lawrence's temperament and character. It is an essay written with a poet's insight. But, alas, Massignon, in addition to possessing a poet's insight, had a poet's power of inventing stories.

His version is as unreliable as Lawrence's. We shall never know what really happened at that interview. The reputation of Lawrence in France came much later in the Second World War, when he became a kind of hero for the French partisans. This reputation was largely created by André Malraux, a man of similar temperament.

Until the 1950s this sense of an unusual man, indeed a unique man, expressed itself in a certain version of Lawrence's life that one might call the vulgate, the accepted version of a remarkable man who had done great things and written about them in a great book. He had called a national movement into existence, led it to victory only to see it snatched from his hands. But he had then won another political victory, and after that he had voluntarily withdrawn. He described and explained all of this in his book, *Seven Pillars of Wisdom*. But before this was published there were the early biographies. The first, *With Lawrence in Arabia* (1924), by an American, Lowell Thomas, was not much read in England. It tended to be dismissed by those who read it as unauthorized, as propagating certain legends about Lawrence, legends that were believed to have been spread against Lawrence's wishes and without his consent. Two more important books were Robert Graves, *Lawrence and the Arabs* (1927) and Basil Liddell Hart, *T.E. Lawrence in Arabia and After* (1934). Lawrence's own *Seven Pillars of Wisdom*, though printed privately in 1922, for subscribers only in 1926, and in an abridged version in 1927, did not appear in its final and complete form till 1935, after Lawrence's death. This was the version accepted by almost everyone in my generation. Later came a substantial volume, *T.E. Lawrence by His Friends* (1937), which contained a number of general essays in praise and admiration, although at least two of those authors almost let certain cats out of the bag.

That generation, and I speak here for myself as well, accepted, almost without question, all of the anecdotes that one finds in these books, even those that are now frankly impossible to believe. I shall mention only two local items. With long knowledge of Oxford, I find them absurd. The first is the story that Lawrence's performance in his final examinations was so brilliant that his tutor gave a party for his examiners. I have been in my time both an examiner and a tutor in Oxford so I know this is impossible. The whole principle of examinations at Oxford is that the examiners should be isolated from every kind of pressure. I would never talk with an examiner even after the examination about what had happened and I would regard the giving of a dinner party by a tutor for an examiner, even after the examination, as coming close to sharp practice. The second is the famous statement that Lawrence in six years read all the books in the Oxford Union Library. There are 50,000 volumes. Robert Graves later said that he did not quite mean this. But clearly he did mean it.

What we accepted almost completely and what now seems absolutely incomprehensible is the verdict that was given on Lawrence. Vyvyan Richards,

who was his undergraduate friend, in his contribution to *T.E. Lawrence by His Friends*, compared Lawrence with St. Francis, Leonardo da Vinci, Odysseus, Shakespeare, and Stonewall Jackson. Liddell Hart added Napoleon to the list. The death of Lawrence was one of the two public deaths I shall remember all of my life, the other being that of President Kennedy. I know exactly where I was when I heard the news, and it was something that became deeply imprinted on my mind.

If one accepts this version of Lawrence's life, there is one real problem. Why after reaching this pinnacle of glory, fame, and power did he give it all up? Until the 1950s various answers had been given. Some said he suffered from fatigue or a sickness of the mind. Others said he was doing penance because his government had deceived the Arabs and he had been a party to the deception. Still others said that he had behaved like a monk who had voluntarily renounced the world. And, of course, some said that he had not really given it up at all, but that he was engaged in secret operations for the British intelligence service. Almost the only hint in the 1930s that challenged Lawrence's part in the Arab revolt was given by George Antonius in his book, *The Arab Awakening* (1938).

There are two essential points that Antonius made in extremely perceptive and judicious passages about Lawrence. First of all, he suggests that Lawrence's role in the Arab revolt was not quite as important as Lawrence himself made out, and that he had not been the leader or the planner of the campaigns. Antonius relied partly on documentary evidence and partly on published, but not easily accessible, Arabic sources. But above all, he depended upon his conversations with the members of the Hashemite family and with the ex-Ottoman officers who had worked in the Arab revolt. Second, Antonius suggests that Lawrence's own version of what had happened in *Seven Pillars of Wisdom* should be seen not as a work of objective history but rather as an imaginative reconstruction.

Antonius put forward his views in a way that was significant. It was in a sort of plaintive, almost apologetic way, as if he was daring to question something sacred. He was not taken seriously at the time and, in fact, was criticized violently by Lawrence's friends. Antonius, himself educated at Cambridge, had been on the fringes of the Bloomsbury group in his youth and was a close friend of E.M. Forster. I have seen correspondence and articles in which the friends of Lawrence attacked Antonius for having presumed to criticize a figure above criticism.

The second phase in the history of the reputation of Lawrence begins quite suddenly in 1955, twenty years after his death, with the publication of Richard Aldington's *Lawrence of Arabia: A Biographical Inquiry*. This book came as a bombshell. It showed, first of all, that numerous statements made by Lawrence were obviously untrue and that various statements made by his biographers were not only untrue but had obviously been made at the

suggestion of Lawrence himself. Aldington showed quite clearly that Lowell Thomas's book, which Lawrence's friends had dismissed as obvious fabrication, had in fact been written with Lawrence's collaboration up to a point. More important than that, Aldington mentioned a certain fact about Lawrence that was widely known at the time (I had heard it about three years earlier) but never published before: the fact that Lawrence was the illegitimate child of a misalliance between a member of one of the Anglo-Irish Protestant landed families and the children's nurse. Aldington calls this the blow of fate in early life that could explain almost everything about Lawrence, including his gift for fabricating stories about himself. This book had a considerable impact at the time, but one which had two limitations. First of all, Aldington's psychological interpretations were rather naive. Second, there was something malicious and mean about the book and about its tone. It is a rather displeasing book. Aldington had had a considerable success with one of his novels inspired by the First World War, *Death of a Hero*, and never achieved much after that. In his later years, he wrote a number of books debunking both people he had known and other contemporaries. He was also an old soldier of the Western Front and, like so many soldiers of the First World War, he suffered from the lifelong trauma of the trenches and had strange, ambivalent feelings towards those of his generation who had not gone through this experience.

Then there came other books that also eroded the established version. A remarkably perceptive book by a member of my college, Elie Kedourie, *England in the Middle East* (1956), suggests that the Arab revolt was not as important as Lawrence had made it out to be, denies strongly that there had ever been any British deceit of the Arabs, and puts forward another view of Lawrence's motives. There is a whole chapter that in some ways is one of the most perceptive pieces ever written about Lawrence. It is a view of Lawrence's motives that at least one has to take into account. He talks of Lawrence as a doctrinaire empty of doctrine and as a partisan without a party, oblivious to the consequences of his actions on others, oblivious to right and wrong, to truth and falsehood. What interested Lawrence were rather his own sensations and the manipulation of events. I do not accept this view of Lawrence as the unmotivated adventurer.

A few years later there came the first serious Arab investigation of Lawrence by Suleiman Mousa, a journalist and government official in Jordan, who had the help of the Jordanian branch of the Hashemite family in writing his book, *T. E. Lawrence: An Arab View*, published in English translation in 1966. It is a sign of how strong the accepted version still was, that the Oxford University Press hesitated a long time before publishing it. The book was finally accepted for publication only on the condition that the Press could ask Lawrence's brother, the guardian of his reputation, to write a postscript that was to refute everything that Mousa had written. Mousa's book was

based upon Arabic sources and upon extensive interviews both in Transjordan and elsewhere. He came up with some startling suggestions. First of all, he said that Lawrence had never held any military command. He had acted as a political liaison officer, who had had money at his disposal, and who had been the channel of communication between the British military authorities and the leaders of the Arab revolt. He therefore played a certain part, but he could not be given the credit that he claimed for himself for such victories as the capture of Akaba or the battle of Tafilah. Most startling of all, Mousa claimed to have discovered certain facts that showed that the most famous of the incidents in *Seven Pillars of Wisdom* could never have happened. This episode was the one in which Lawrence, according to his own account, was captured by the Turks and then imprisoned, tortured, and beaten by soldiers because he would not yield to the advances of the Turkish governor of Deraa. Mousa was the first person who had taken the trouble to identify the governor of Deraa. He was still alive at the time Mousa was writing and he had become a distinguished politician in Turkey. He had been a member of the Turkish House of Representatives. His reputation was well-known. People who had known him during the First World War were still around. Neither his family nor anyone who knew him was prepared to accept Lawrence's statement that he was a well-known pederast. In fact, his impulses went in precisely the opposite direction. It is important to establish the truth because if the incident did take place, as Lawrence suggests, then it must clearly have played some significant part in the development of his personality.

Then later came a book by a team of journalists from the *Sunday Times*, Phillip Knightley and Colin Simpson, *The Secret Lives of Lawrence of Arabia* (1969), which is in my view a rather silly and superficial book. In the process of demolishing some of the myths that Lawrence himself had created, they themselves created new ones: that Lawrence had been recruited into the British Intelligence Service by David Hogarth, who was his patron and who was the Director of the Ashmolean Museum in Oxford before 1914. There is absolutely no evidence of this. The arguments they put forward are tenuous in the extreme. The relationship between scholars and government officials, particularly between Oxford and the Foreign Office at that time, was such that travellers, archaeologists and others who had any views about policy in the Middle East were at liberty to talk to Foreign Office officials who wished to know what they thought and had seen. Everyone at that time in that social milieu was gripped by the Middle Eastern version of the Great Game, by the struggle for independence in the Middle East. And, of course, Hogarth, who travelled all through the Middle East, observed the signs of growing German power and would talk in clubs in London or even, perhaps, at High Table in Magdalen (although my own memories of High Table at Magdalen are that one did not normally talk about anything as serious as that). There was no more in it than that. However, Knightley and Simpson had discovered and

revealed a grave sexual disorder from which Lawrence clearly suffered in his later life, the recurrent desire or need to be beaten by men. This they documented well, and it is clear that his family already knew about it and wished to conceal it. Knightley and Simpson for the first time revealed it.

In the light of all these books, a new series of problems emerges. The problem of T.E. Lawrence must be seen in a new way. One must ask searching questions. First of all, one has to raise the question of truth. Everything that Lawrence said about himself is suspect. It is not all false. I think there is a germ of truth, and indeed an essential truth, in a great deal of what he said. But at every point one has to go over the evidence again and ask, "Is this true?" Clearly, he was one of those people who cannot help inventing stories about themselves. I myself have known people of this kind. I do not regard it as a very grave fault of character. It springs from a combination of motives that are quite simple, that are not necessarily reprehensible, and that in a sense are rather pathetic, rather to be pitied than to be condemned. It is a desire to see how far one can go, a need to soothe some sense of inadequacy, a wish to express indirectly or symbolically something too terrible perhaps to be expressed directly. Lawrence himself was perfectly aware of this.

On the whole one does not go wrong if one follows Lawrence's own analysis of his character. He obviously had great self-knowledge and great self-awareness. In Chapter 103 of *Seven Pillars of Wisdom* there is a long passage of self-analysis that is admirably clear. He writes about his craving for good repute among men, about his sense of always being out of his depth in his dealings with others. He wished to be liked, to be famous. And then he writes about his "treating fellow men as so many targets for intellectual ingenuity: until I could hardly tell my own self where the leg-pulling began and ended." Neither Richard Aldington nor anyone else has written better about Lawrence than that. I do not think all this would matter particularly if he had not played a certain part in history and given his own account of it. So, if we wish to know the truth about his part in history, we have to go beyond his own version and ask, in regard to every detail, whether it is true. Then we must use other sources to question the significance of the Arab revolt and Lawrence's role in it. Further, there is the question of motives that applies not merely to Lawrence's withdrawal from public life in the 1920s but to his whole life from the beginning. This question was put clearly to him by George Bernard Shaw. One day he said to Lawrence, "What is your game really?" That is the question one has to ask: "What was he up to?" And then, two final questions, not about him but about us. Why did we for so long accept him at his own evaluation? Why did this established version become established?

It was to such questions that the latest group of books is directed. As mentioned earlier, one is the carefully researched *A Prince of Our Disorder* by John Mack, a Harvard psychiatrist, one of the best lives of T.E. Lawrence

that has appeared. Another is Desmond Stewart's book, *T.E. Lawrence* (1977). Stewart, a British novelist and journalist who lived for a number of years in the Middle East, had access to Arab sources. Of the two, Mack's is the better book. It is the more compassionate, written with deeper psychological insight. In the light of these two books and recent work on the history of the Middle East of this period, how can we answer the questions that I have posed?

What was the significance of the Arab revolt and of Lawrence's role in it? Here Mack's book is at its weakest. He is not at home in this kind of historical research and political analysis. Although he is quite prepared to question any single statement by Lawrence and to say that this must be ascribed to Lawrence's well-known propensity to exaggerate, he accepts Lawrence's version as a whole and the general thesis almost without question: first, that the Arab revolt was a united and wholehearted uprising by a nation; and second, that Lawrence himself by the sheer force of his personality put himself at the head of it.

A great deal of research has now been done on this period. The essential documents, those in the Public Record Office in London, are now open. They have been read thoroughly by a number of scholars. A different version of the Arab revolt and of Anglo-Arab relations emerges. It becomes clear, first of all, that the Arab revolt was not a revolt of a whole nation. Few revolts are, in fact. Many people are indifferent, many people are opposed. This is so with any revolt or revolution. Life goes on.

Of those who took part in the Arab revolt, it is clear that there were three different groups with distinct interests. First, there was a small group of mainly Syrian, with a few Iraqi, nationalists who were mostly Ottoman army officers or officials. Second, there was the Hashemite family, Sharif Husain of Mecca and his sons. And third, there was the British government. All of these had different interests, all were divided within themselves, and each of them had hesitations and reservations about the revolt. The Syrians and Iraqis hesitated to revolt against their suzerains. It is a very grave matter to throw off a political system that has existed for hundreds of years and that is morally rooted in society. The Syrians also distrusted the British. They did not want the Hashemites to rule them. They would have settled for something less than full independence. And for the most part, while establishing relations with the British, they did not cut off their relations with the Ottomans. That is, in fact, how intelligent people should act in obscure and shifting wartime situations.

The Hashemites were basically out to make themselves paramount rulers of the Arabian peninsula. They did not wish to break irrevocably with the Ottomans. At the same time that they were in alliance with the British, they maintained their links with the Ottoman government. The British were interested both in the Syrians and in the Hashemites, but more in one than in the other at different times.

There were three phases. Desmond Stewart has a certain understanding of this aspect of the Arab revolt that he got largely through his contact with one particular Syrian family, the family of 'Ali Ridha al Riqabi, which had played an important part in the revolt. Riqabi had been a Turkish general and a secret sympathizer with the revolt.

In the first phase of the revolt, the British were more interested in the Syrians than in the Iraqis. That was during the Dardanelles campaign when a landing at Alexandretta might cut off Ottoman Syria from Ottoman Anatolia at a time when most of the Ottoman army in Syria was Arab rather than Turkish. This was an attractive idea for the British and explains those rather obscure negotiations with an Arab-Ottoman officer, Sharif Muhammad Faruki. In the second phase, after the failure of the Dardanelles expedition, the British ceased to be so interested in the Syrians and more interested in the Hashemites because the danger for them at that point was a German thrust southwards into the Hejaz, which could have affected the British position in the Red Sea area, not only in Egypt but in the Sudan. In the third phase, when Allenby's campaign in Palestine got under way and the British moved up into Palestine and into Syria, it was the Syrians who became important once more. These circumstances explain the British statements to Syrian leaders in Damascus. But the British, like the Hashemites and like the Syrians, were interested more for political than military reasons. They were interested only in so far as the Arab movement was weak and relatively controllable. The British also considered at times during the war making a separate accommodation with the Ottomans that would have involved jettisoning their Arab allies.

For all three parties, the revolt was primarily a political act, as is true of most guerrilla warfare. Guerrillas cannot easily defeat an army in the field, but they can affect a political situation. What was important for the two Arab groups was to set in train the minimum military activity that would establish a political claim after the war and that would not incur grave Turkish reprisals. For the British, the Arab campaign was partly a way of keeping the Turkish forces locked up. It was part of the strategy of deception, which was the British strategy of the Palestine campaign of 1917–1918. It was also a way of staking a claim against the French in Syria. Having made the Sykes-Picot agreement, the British government immediately thought better of it. Just as undoubtedly the main British motive in issuing the Balfour Declaration was to provide a political basis for persuading the French to abandon the plan for establishing an international regime in Palestine, so the British support of the Arab revolt was partly a way of going back upon the concessions that they had made to the French in Syria.

What was Lawrence's role in all of this? His military role was considerable but not so great as he himself implies. The Arab forces can be clearly distinguished into two groups. There was a small regular army of prisoners

or deserters from the Ottoman army led by well-trained former Ottoman officers. British officers advised them in the later stages of the war. Lawrence was not even the head of the mission to this army, and played no military role in it. Hubert Young, who wrote *The Independent Arab*, said that Lawrence had had no military training and would have been quite incapable of manoeuvering the smallest regular force. His knowledge of tactics was limited. But he certainly had with him a small group of irregulars, his bodyguard, the people around him of Bedouin origin, with whom he undertook some actions such as blowing up the railway. In this his activities were not different from those of several other British and French officers. I remember a conversation with Colonel S.F. Newcombe, whom I knew well because he retired to Oxford. He had been one of these officers. Although he would never have written about this publicly, Newcombe expressed with a certain bitterness the way in which Lawrence, so he felt, claimed credit for irregular operations that had in fact been carried out by a comparatively large number of British and French officials. Lawrence had not been more successful than the others. But, whatever one thinks of his military role, Lawrence's political role was indeed important.

The documents that have now emerged in the Public Record Office, both for the wartime period and for the post-war period, make Lawrence out to be considerably more important than one had believed. He played a political role and a very individual one. He had a personal policy. He had his own view of what should happen, and he tried to impose this view on all those concerned. He believed that Syria should be ruled by the Hashemites and not by Syrian politicians—indeed, by one particular Hashemite, Faisal, and not by other members of Faisal's family. He had, as he himself said, broader ambitions than this. He had a dream that grew during the war of establishing Faisal in Syria, and then of his absorbing the Hejaz, the Yemen, and finally Iraq.

His ambitions grew in an almost fantastic way in the wartime period. He devoted himself in these years to trying to impose his ideas not only on the Arabs but on his own government with extraordinary force of will. It is a quite remarkable story of the way in which one man with an exceptionally strong will and personality tried to impose a policy not only upon small, irregular Arab forces, but upon one of the greatest governments of the world. He did this not only wholeheartedly, but even to some extent unscrupulously by giving false versions of what had happened, by disobeying the instructions of his government, by misleading the Arabs about British policy, and, it is quite clear, by deceiving the British government itself. He failed, but by sheer force of will he was able to make a partial recovery and to help in the later half-success of the creation of the Hashemite kingdoms of Iraq and Transjordan. There were those who worked with him, however, who felt that he took some of the credit that was due to others. I remember another

conversation that was held with one of his colleagues in the Colonial Office, in which he said rather frankly that Lawrence did tend to claim that the decisions made in the Colonial Office at that time were his decisions.

In light of all this, Lawrence's career has had a certain permanent importance in the Middle East, but it is not exactly that which John Mack claims for him. Mack suggests that the rise and fulfilment of Arab nationalism was largely due to Lawrence. I do not think it was. Arab nationalism developed in ways in which Lawrence was irrelevant. I think I could write a history of the Middle East without mentioning Lawrence's name. But, on the other hand, the overestimation of the Hashemite family in British circles was partly due to Lawrence. This was his continuing legacy for good or for ill in the Middle East.

Let us turn to another set of questions, those about motives. What was his game? And what was his game not only in his later life but in Arabia, or even before Arabia? Once more I think he is his own best interpreter and Mack was right to follow him. Mack's general interpretation of Lawrence's motives is a good one. There were, on the one hand, a number of personal motives: the desire for fame and for something called glory. The First World War in the Middle East could still be thought of in terms of personal fame and personal glory in the sense in which the war in the West could not, at least by 1916. Mixed with this may possibly have been something else. Here I find myself doing what everyone who thinks about T.E. Lawrence does, of speculating or possibly of embracing another myth. I think it might be that one of the personal motives in Lawrence's life was the sense of having been denied his birthright. He belonged to the Anglo-Irish Protestant ascendancy that produced extraordinary talent and a blaze of genius from the eighteenth to the twentieth century. In his later life he emphasized his Irish origins. He became much more insistent that he was Irish and nothing else. The only public honour he accepted in his life was membership of the Irish Academy of Letters which was offered him by the poet W.B. Yeats, the president. He wrote of it with great pride, claiming that he had always been Irish. There may have been in his life a sense that, having been denied his birthright, he was going to win it back by pre-eminent achievement.

Side by side with all these personal motives, whatever they may have been, there was a political motive: the wish to impose his will on a part of the Middle East. I do not believe Elie Kedourie was right in writing about him as a seeker after sensations. There was a genuine conviction that his solution was the right one, an acquired conviction and not one born in his school days. At the end of *Seven Pillars of Wisdom*, he writes that he had the wish to liberate the Arab people even from his school days in the City School in Oxford. There is no real evidence that this was so. Those who knew him at the time detected no signs of it. I think that this was born in the discussions in Cairo in the first two years of the First World War. This helps to explain

his withdrawal after the war. Clearly, there was a grave collapse of his mind and personality which did not take place directly in 1918, but rather in 1921–1922. The real collapse, judging from his letters to his friends, was to come when he left the Colonial Office. There is an element in it of sheer exhaustion, not just of body but of nerves and will. He found strength of purpose twice in his life—once during the First World War and then in the 1930s in the conquest of the air with the technical innovations in airplanes.

In between these two times was a kind of collapse and it is an open question whether, had he not been killed, there would not have been another collapse after he left the air force. One just does not know. With this exhaustion, there was a certain element of despair. He had used his will not only against the Arabs, but against his own government, and had failed. A certain humiliation and self-questioning occurred. Had it been worthwhile? In a sense, he ceased to believe in the cause. This is a kind of weakness in that kind of neurotic will that can fasten itself upon something and then no longer believe in it. There may also have been a certain sense of guilt that, if it existed, was much more personal than he makes out. I am not sure that Mack gets this right.

It was not so much that he felt that the British had cheated the Arabs but that he himself had misled some individual Arabs, particularly Faisal. He had encouraged them to believe that England would back them against the French much more than in fact England was prepared to do. There is an obscure episode in his history in which he gives a slightly misleading account. It concerns the final episode in Damascus in which, as Lawrence says, he asked Allenby for leave, to go away from Damascus, and Allenby pleaded with him to stay. That is his version. The version, quoted by Mack, of the Australian General Chauvel, who was at the meeting on 3 October 1918, is rather different. He claims that Faisal and Allenby had a clash of opinion about whether the Arab government should take over Beirut and the coast. Allenby told Faisal "We told you you couldn't," then turned to Lawrence and said, "But did you not tell him that the French were to have the Protectorate over Syria?" Lawrence denied that he had ever known of the proposed French Protectorates over Syria and Lebanon. After Faisal's departure, Lawrence told Allenby that he would not work with a French liaison officer, and that, as he was due for leave, he had better go. Allenby said, "Yes, I think you had!" It is one of those stories in which one does not know where the truth lies. But at least Lawrence's version must not be accepted without further question.

It is in this period of collapse, whatever the cause, that the grave sexual disorder certainly appears and continues until the end of his life. Mack is right, I think, in saying that it had not been active earlier. Was he right in implying that it was brought to the surface by the Deraa incident? This is one of the crucial episodes of Lawrence's career. Lawrence's report to the Deputy Chief Political Officer with the British forces, on two brothers who were his

political enemies in Damascus, appears to be the first explicit statement by Lawrence of what happened at Deraa. I am entirely sceptical. It seems to me to be a fabrication almost from the beginning. I am inclined to think the episode never happened. Desmond Stewart also believes this. Nevertheless he believes that there was some other incident that happened at the time, not so much of an unwilling but of a willing surrender that released something in Lawrence. One can never decide and I do not think one ought to. But certainly something happened which made him unhappy for the rest of his life. Was he talking about the Deraa incident, was he describing something that had actually happened, or was he talking about another incident, or was he hinting symbolically at something that he knew had gone wrong with himself? Perhaps we should leave those questions. Stewart goes too far in trying to explain everything in terms of Lawrence's sexuality. I would regard it much more myself as a sort of periodical intrusion, what St. Paul calls a thorn in the flesh rather than a constant motive. And here I think there is something important that one must remember about Lawrence's own time and place. The effect of his boyhood and university education was quite different from what it would be today. He lived in a purely masculine world in which boys did have an artificially delayed adolescence and sometimes one which never came at all. Mack says that Lawrence, in a sense, never had an adolescence. Here he is more right than Stewart.

Stewart's book illustrates once more the propensity of those who write about Lawrence to create myths. He has invented two completely new stories that I am sure will now appear in other books. Lawrence was encouraged by his legitimate relations to enlist in the army, in the tanks, and then in the RAF because they were embarrassed by him and wished to get rid of him. Here Stewart is right and had merely mentioned a fact that was perfectly well-known. Before one had seen Lawrence's family tree one would have known that, like other members of that kind of Anglo-Irish family, he was connected with a large number of noble families in England. One of his kinsmen, somebody with whom he kept vaguely in touch, was Robert Vansittart, who played an important part in British foreign policy and who rose to be Permanent Under-Secretary of the Foreign Office. Stewart suggests—the first myth—that it was the Foreign Secretary at the time, Lord Curzon, whom Stewart obviously dislikes as much as Lawrence did, together with Vansittart who encouraged Lawrence to enlist, and who tried to sweep Lawrence under the carpet. He produces no evidence for this whatsoever. He then goes further to suggest that Lawrence's death in 1935 was not an accident but was arranged by the intelligence service. There is not a scrap of evidence for this either, and I do not myself believe it.

Now let me come to the final question. Why did so many people, including myself, accept Lawrence's self-created myth for so long? Once more I think Mack is very good on this. He talks about the need for heroes and for heroes

of different kinds in different ages. Lawrence became a hero in an age of disillusion after the First World War. He met the need for heroism. He was a modern type of hero, one who did great deeds but without really believing in them and who gave them up at the moment of triumph. This is a kind of heroism, Mack suggests, which particularly appealed to the mind of his age. I think there is something in that, but one should bear in mind the kind of people with whom Lawrence associated. He was dealing with a class and generation of Englishmen who almost never told lies, who never boasted about themselves, and who really did not believe that Lawrence was not always telling the truth. I remember the story of a famous Liberal statesman at the time, Lord Crewe, who was so honest that he could not ever bring himself to play a child's card game called Cheating because he believed that gentlemen do not cheat. It was true, by and large, of the English ruling elite at that time that they told the truth and they seldom boasted about themselves. The kind of boastfulness which is at the origin of many of Lawrence's fabrications was so alien to them that they simply did not believe that it was only boasting. And there is something else: Lawrence appealed to the vanity of other people. They derived a special glory from being the friends of this mythical creature. I have known friends of Lawrence for whom the great thing in their lives was that they were friends of Lawrence. They protected his reputation. I am not thinking so much of his brother, because I think his brother was acting in an equitable, fraternal way. I hope very much that my brothers would protect my reputation in this way. I am thinking rather of his friends who protected him, who resented any attack on him, who denigrated those who attacked him, and who even exaggerated his stories and carried them further. I remember a seminar at St. Antony's College when we invited Liddell Hart to speak about Lawrence. This was in the early to mid-1960s, and to my astonishment, Liddell Hart repeated all the old stories about Lawrence, and even, I think, invented new ones. For example, this famous story, which is obviously absurd, that when Faisal appeared at the Peace Conference, he recited passages of the Koran in Arabic and left it to Lawrence to make his speech. Now, when one thinks of it for a moment and asks questions—first of all, was there nobody else there who knew Arabic on the British or French side? Second, was there nobody on the Arab side who knew English? Third, here was the leader, the spokesman of a family and of a national movement on his great day, struggling for his own political life before the world. Is it likely that he would have left the speech to be made by somebody who was not part of his nation, whom he did not much trust, and who, as far as one can discover, he never really liked much? I remember in the course of that seminar that I put various questions to Liddell Hart, who after all was a distinguished military historian, about the military exploits, and pointed out that other versions were possible, that there were people in the small Arab army who were highly trained Ottoman officers who had held important

positions in the Ottoman army. Was it not possible that they had had something to do with the campaign? And I remember Liddell Hart brushing all this aside, saying, "Of course all these people were jealous of Lawrence. Of course they invented these stories because they were jealous of him." I did not mention this at the time but how did Liddell Hart know this? He had never met any of these people. It seems clear that either he had invented these things, or Lawrence himself had told them to him.

Something else again was the intellectual atmosphere in England in the 1930s, at a time when another world war was coming and when the older generation of people who were in control were worried by what they regarded as the dangerously defeatist attitude of the younger generation. The First World War generation looked with some suspicion and distrust upon the younger. For them Lawrence had become a hero and some of them felt that it was important to keep a certain ideal of heroism alive. I remember clearly that this was the reaction to Aldington's book by people of that generation whom I respected. When it was published I had a conversation with one of the men I most admired, the President of Magdalen at that time, Thomas Boase, himself a distinguished medievalist and a specialist on the Middle East, who was a sceptical man by nature and not inclined to hero worship. Yet he was outraged by Aldington's book and used a phrase which I think was significant. "Aldington," he said, "is debasing the national currency. There is Lawrence, Lawrence is a hero, and we must leave him there on his pedestal."

Let me end with one final question. Does it matter any longer? Can we not leave Lawrence to lie in his unquiet grave? I think it does matter because *Seven Pillars* is a remarkable book. True or false, it has made a permanent impression on the imagination of the English reading world and it will always be read. It is a book of a special kind: it is an attempt to write an epic work. But more than that it is an attempt to write an epic work about activities that themselves have been moulded by the person who intended to write about them. Lawrence's ambition to write, his view of epic action based on his reading of ancient epics and of medieval romances, to some extent moulded his actions during the war. He later remoulded the epics in his book. But if it is truly an epic, it is not an epic in the sense that Homer or Virgil have written epics. It is not the kind of book that *The Singer of Tales*, to use a title of a famous work, would have produced. It is more a child of romanticism, of what could be compared with the life and work of a Byron, consciously moulding his life in accordance with a certain norm of what a heroic life should be, or of a Doughty. C.M. Doughty was the great influence upon Lawrence's life. He made his journeys in Arabia because he also wanted to write an epic work in a purified English language and did not think that there were any subjects in late nineteenth-century England that he could write about. It is worth remembering that before 1914 Lawrence's great ambition was to make a similar journey in Arabia and to write about it. He was

modelling himself very closely upon Doughty at that time. That explains some of his pre-1914 activities such as his learning of Arabic, and his interest in the nomads of Arabia with whom he wished to travel. Knightley and Simpson, and then Desmond Stewart, have taken these activities as signs that he was engaged in intelligence operations. I do not think he was. I think he was preparing for a great journey. One should see Lawrence's life from this point of view, as a single process from his school days when he first became aware of the world of epic and romance, through his Arabian days, to the final writing of *Seven Pillars of Wisdom*. And, with that, his life, or that part of his life that concerns us, really came to an end. It is the work of an imagination formed by a dream of epic action and epic poetry. It is an imagination and a mind that is then drawn into a period of intense activity which, after the activity is over, withdraws into itself and records it. But once more then the period of activity is remoulded in the imagination. This provides a further motive both for his Arabian adventures and for his withdrawal because, rightly or wrongly, he believed that just as he had failed in Arabia he had failed in his book. I do not myself believe that he had. I think this is a remarkable book, one that will continue to be read. Somebody could do for Lawrence with profit what Livingston Lowes did for Coleridge in *The Road to Xanadu*—the study of the formation of a creative imagination, something of the interplay between victory, imagination, culture, and action. We have a great deal of material about this. From this point of view, Desmond Stewart's book is suggestive. Stewart, himself a writer and something of a poet, has seen certain things about Lawrence as a literary artist that nobody else has seen. He has rightly tried to situate Lawrence in the inherited culture of England and specifically of Oxford in the 1890s and the early 1900s, in the subculture of classical scholarship and the study of medieval romance and of northern sagas, but refracted through a certain kind of English imagination.

Fall Semester 1977

Paul Scott: Novelist and Historian

HILARY SPURLING

The last story Paul Scott wrote was a version of *Cinderella*, which is also in some sense a parable about history and about himself. "The tale is like a looking glass," he said, "in which you see yourself if you gaze into it long enough." His Cinderella is a working girl, practical, resourceful, unromantic, more than capable when her sisters leave for the ball of finding her own alternative, making pictures and patterns in the flames of the kitchen fire, exploring in imagination "the castle of her history and her future." Her ball takes place in her head. It is her father, the baron, sunk in idleness and self-pity, dogged by failure, loneliness and debt, who consoles himself in the cold castle of the present with dreams of a romantic past that never really existed. The two characters represent, historically speaking, opposite approaches: Cinderella sets to work to make some sort of sense of the past in a present she accepts without repining or illusion, while the baron remains so bemused by false visions of a world he has lost as to be effectively disbarred from playing any active part in the present.

Between them they embody attitudes much on Scott's mind. He himself possessed and cultivated what he called a vigorous sense of history, "vigorous because it pruned ruthlessly that other weakening sense so often found with the first, the sense of nostalgia, the desire to *live* in the past."[1] Scott feared and mistrusted nostalgia. He said the denial of memory was a terrible thing but that its opposite—the tendency to romanticize the past—could be equally destructive; and he resisted it, like his Cinderella, by systematically exploring the castle of our collective history and our future.

By 1976, when he wrote his parable of Cinderella, he had himself spent more than ten years struggling to discern shapes and patterns in the imperial past he saw projected, if not in the kitchen fire, then on the blank wall of his study, the blank sheet of paper in his typewriter, the blank screen of the mind. It took him a decade of concentrated effort, and something like twenty years' preparation before that, to produce the four novels which between them make

up the *Raj Quartet* or, in its television adaptation, *The Jewel in the Crown*. The sequence covers the period between the Quit India riots of 1942 and the massacres which attended Independence and the partition of India from Pakistan in 1947. It starts with the rape of a white woman and ends five years later with the murder of a Muslim—a body falling from a stationary train, which has been intercepted and attacked by a vengeful Hindu crowd and which, after a brief bloody pause, continues its interrupted journey across the subcontinent:

> It was the smooth gliding motion away from a violent situation which one witness never forgot. "Suddenly you had the feeling that the train, the wheels, the lines, weren't made of metal but of something greasy and evasive."[2]

Railway journeys play a vital part in the *Raj Quartet*, as Scott explained in a letter to Rebecca West, another novelist adept at exploiting the technical and metaphorical possibilities of "things that happen on trains." Trains make connections, they move through time and space, they may be used to ferry themes as well as people. They also run, however jerkily, according to official timetables: this particular train is carrying its quota of British passengers, departing imperialists, civil servants, police and army personnel, sahibs and memsahibs, moving in August 1947 rapidly towards Indian Independence and the handover of power, the splendid ceremonial dissolution of the Raj and its terrible consequences for countless unofficial victims.

The observer in the passage quoted above—the witness uneasily aware of the greasiness and evasion inevitably inherent in this process—is the professional historian, Guy Perron, who provides a linking commentary, or consciousness, in the last of Scott's four volumes, *A Division of the Spoils*. Perron is an early and active pioneer of British Studies, having specialized at Cambridge in the late 1930s in nineteenth-century imperial history, and found himself shortly afterwards, midway through the war, posted to India with a job—gathering intelligence as a sergeant in Field Security—that leaves him admirably placed to witness at first hand events leading up to the end of empire. The actual model for Perron was Peter Green, a young British Flight Sergeant in the RAF, also working in Intelligence, also with a scholarly Cambridge background, whom Scott met by chance in Calcutta in wartime (he met him again, incidentally, more than thirty years later, as a distinguished academic at the University of Texas, where Scott himself was the first speaker invited to address the British Studies Seminar in 1976).

But, by Scott's own account, Perron became in the course of the novel a kind of spokesman or stand-in for the author himself. Scott's first contact with India had come when he was drafted into the Indian Army as an officer cadet in 1943. He was twenty-three years old. He had no knowledge of the subcontinent nor any particular desire to go there, and he fell ill with hepatitis

almost as soon as he arrived. He was shocked by the heat, the poverty, the dirt, and he found his liberal, democratic, instinctively anti-authoritarian and anti-imperial attitudes confirmed by what little he saw of the British Raj at work. Young, confident, highly critical, Scott was never in any doubt that India should be handed back to the Indians, and this conviction deepened over the next three years as he became, like Perron, steadily more fascinated by the place, its people and their precarious political position. Like Perron, Scott left India at the end of the war. He sailed for England in May 1946, and by August he was getting worrying letters from friends left behind, both Indian and English, containing news of riots in Calcutta, looting, rape, murder, and even more alarming premonitions of worse to come in case of partition. It would be nearly another twenty years before Scott himself returned to India, and began trying to make some sort of sense in the *Raj Quartet* of a process he had seen, or glimpsed, coming to an end as a young man.

To this extent, Perron, with his writer's notebook, his inquiring and impartial stance, his determination to produce in the future a coherent, orderly account of the chaotic present, is at least a partial portrait of the author when young. One of his pressing problems is the need to distance himself from the distractions of reality, for it is a curious paradox that the closer you get to the situations which interest you, the more distorted your perceptions are likely to become. Perron's dilemma must be familiar to any modern political historian:

> he felt more strongly than ever how perilously close to losing confidence the actual experience of being in India had brought him; and he wanted to go home...so that he could regain lucidity and the calm rhythms of logical thought. These, he knew, depended upon a continuing belief in one's grasp of every issue relevant to one's subject and India seemed to be the last place to be if one wanted to retain a sense of historical proportion about it.[3]

Repatriation in the closing stages of the war restores Perron's sense of proportion. When he returns to India to watch the British leave in 1947, representing in a sense the historian in Scott, it is as an independent observer with no function save to note and record, to ask questions, collect material and interview key witnesses. This is, from the biographer's point of view, a fascinating account of the historical intelligence at work, sifting, collating, comparing, retrieving and assessing evidence. The political momentum of *A Division of Spoils*—India on the verge of partition moving simultaneously towards liberation and disintegration—is mirrored on a domestic scale by tensions threatening the shaky equilibrium of the Layton family, who occupy the novel's forefront (and a large part of Perron's attention in his purely private capacity). But the reader's sense of a historical tide turning in the background

comes from Perron's awareness of its progress, of the ground submerged beneath it, the flotsam thrown up on its surface.

It is Perron who registers and reflects on the political cartoons in a Bombay paper by the popular satirist, Halki (Scott himself entertained some hopes of making his name in these years in London as a satirical cartoonist); the increasingly urgent maneuverings of Indian politicians and British civil servants trying to retain a foothold on the steeply descending gradient of official policy laid down by the new socialist government at Westminster; the expedient nature of these policies, as expounded in theory by Perron's superior officer, the suicidal government economist Captain Purvis, and subsequently put into practice by administrators like his old friend Nigel Rowan; and the violence simmering that summer behind the secession crisis on the streets of Muslim Mirat. Even the collapse of nationalist aspirations, embodied in Captain Sayed Kasim of the Indian National Army, comes into sharper focus in the light of Perron's speculative interest; and so does the stoic resignation of Sayed's father, the increasingly isolated Muslim Congressman, M.A. Kasim (who surely speaks for his creator, at the time of writing the *Raj Quartet*, when he declares himself to be "out of rhythm with my country's temporary emotional feelings").[4]

Perron's professional activities throughout the whole course of this novel provide an object lesson in scholarly gathering techniques, and in the discipline required to sort, process and store each day's harvest of material. He does it by a ritual clearing and cleansing of the mind, the academic equivalent of tooth-brushing, performed each night while sitting half undressed on the edge of a string bed, or lying awake in a room full of sleeping soldiers. It was the army that taught him the protective knack—essential to the private soldier as to any analyst of human affairs—of switching off, blanking out, paying no attention to the droning sound of opinionated or obstructive superiors:

> Perron listened attentively for...ten seconds...and then tried to tune in what he called his other ear: the one that caught the nuances of time and history flowing softly through the room....Glancing at Purvis, he wondered whether that officer also heard the whisper of the perpetually moving stream....[5]

Perhaps Scott himself caught that whisper in India in wartime. Certainly, it was in the army that he, too, perfected the trick of tuning out surface disturbance: in later life he boasted that he could walk through a rainstorm without noticing that he carried a folded umbrella. Indian Army friends envied Lieutenant Scott's ability, in time of boredom or inactivity, to switch off for minutes, hours, sometimes whole days at a time. He said long afterwards that the immensity of India provided him, as a novelist, with a metaphysical as well as physical backdrop for the tiny figures deployed against it: at the core of the *Raj Quartet* is Scott's sense of "the frailty of individual human action

in the face of pressures exerted by a collective conscience—what I call the moral drift of history."[6]

Few, I suppose, would dispute that it is the historian's business to catch that drift. It is what sets him apart from the foreign or political journalist, whose prime concern is with the present. The journalist may well be driven by the historian's need to understand, that devouring curiosity which Scott compared in moments of depression to an insatiable caged beast. But however scrupulous, however knowledgeable, however finely attuned to the reverberations of a particular situation, the journalist cannot afford to listen too intently to the promptings of that historical inner ear. He must train himself to remain mobile, inquisitive, alert above all to surface disturbance in the present: a creature perpetually adrift, in a memorable image from Scott's *The Birds of Paradise*, "hands in overcoat pockets, expressionless, committed to his day, his age, moving across the bottom of its ocean like a blind, tough, enduring fish feeding on the plankton of world affairs." The historian's commitment to his age, no less adamant than the journalist's, must always be, in Scott's view, part of a larger continuum of past, present, and future.

Perron is not, in fact, the only representative of his species in the *Quartet*. There is also a Major Tippit, who turns up briefly quite early in the sequence in *The Day of the Scorpion*, a soldier brought out of retirement to command the fort at Premanagar (on which he is writing a monograph). Tippit is greasy and evasive, like the railway lines carrying the train smoothly away from a violent situation in the fourth and final volume. History is his excuse for turning his back on the convulsive upheavals tearing modern India apart. Required to take custody of M.A. Kasim, imprisoned as a Congress leader in 1942, he blocks complaints and queries with "mindless, vegetable implacability." He wants no part in the present and accepts no responsibility for it: "I'm a historian really. The present does not interest me. The future even less."[7] Tippit personifies the defeatism and insularity Scott diagnosed among the root causes of what came to seem to him the irresponsible and ultimately disastrous haste with which the British left India in 1947.

One of the dangers of Tippit's defeatist view of history is that it plays into the hands of unscrupulous politicians only too anxious to encourage and exploit in their electorate what Scott called the spirit of withdrawal: "a readiness to withdraw from the problems of the modern world,"[8] which was in his view the defensive reaction of ignorance, prejudice and fear. Hence his distrust of any attempt to take refuge in the past, and the importance he attached to an active, vigorous, ruthlessly anti-nostalgic sense of history. These attitudes were fundamental to his practice as a novelist, for Scott saw no contradiction between two activities—writing history and writing fiction—which have often seemed to others diametrically opposed. For him, the present was not autonomous, which is why he so emphatically denied being an

historical novelist. When he argued the point with an American scholar interpreting the *Quartet*, their difference boiled down to one of generation: she was twenty years his junior so that, from her point of view, the events leading up to the British leaving India belonged to history, whereas for Scott, who lived through them, that departure and its repercussions remained unfinished business: a major item in what he called his personal luggage.

He was thinking of a character called Barbie Batchelor, a retired elderly missionary in the third volume of the *Quartet*, who turns up in the hill station of Pankot, bringing with her a large, battered tin trunk from which she cannot be parted. As Barbie herself is shunted around Pankot, moving from house to house and from one family to the next, the trunk becomes a fearful nuisance, continually having to be sent for, stowed away, brought out again and sorted through, ending up capsized in transit with its contents spilt out over the road. "I see now," Scott wrote, looking back after he had finished the *Quartet*,

> that her trunk of missionary relics, which gives her so much trouble throughout the book...is really a symbol for the luggage I am conscious of carrying with me every day of my life—the luggage of my past, of my personal history and of the world's history....One is not ruled by the past, one does not rule or reorder it, one simply *is* it, in the same way that one is as well the present and part of the future.[9]

At the end of his life, after he had finished the *Raj Quartet,* Scott attempted to define his achievement for the class of postgraduate students taking his fiction course at the University of Tulsa, Oklahoma, in 1976. He drew up a chart on the blackboard, beginning at the start of the century with Britain in possession of an empire covering a quarter of the globe, and ending after the Second World War with the election of Attlee's Labour government, the abandonment of empire abroad, and the creation at home of the welfare state. He saw the changes signalled by these two achievements—each billed at the time as a glorious liberation, each producing over the next twenty years and more increasingly sour and disruptive consequences—reflected willy-nilly in the novels of the days. Scott described post-war British fiction— the novels written by himself and his contemporaries in the 1950s, 60s and early 70s—as "the end of the party and the beginning of the washing up."[10]

This may seem something of an old-world metaphor in America today. But in England in an age without servants before the arrival of the dishwasher the end of the party would have meant, in a household like the Scotts', stacking the dirty dishes, rounding up the empties, finishing off the whisky bottle, holding some sort of inquest probably over broken glasses, ash spilt on the carpet, holes burned in the furniture, going over any row that might have blown up, working out who came and who had left with whom, who was on speaking terms and who wasn't. It is an accurate, if not a glamorous,

description of what Scott was doing in the *Raj Quartet*. It is what he meant when he drew his chart on the blackboard at Tulsa, and said to his students: "You write for an age; and this is my age."[11]

It is, of course, Cinderella who does the washing up and gets neither perks nor status for it, any more than Scott did in his lifetime for the *Raj Quartet*. The last volume was published in 1974 and, although it may seem hard to credit in the light of what happened later, none of the four had much popular success in Britain at the time, nor were they received with any great enthusiasm by the critical or literary establishment. It was not simply that the views Scott put forward were intellectually disreputable: India itself was still in some sense taboo: a subject regarded as intrinsically frivolous or boring, admissible at best as the setting for adventure stories or the kind of period romance that made Scott fight shy of the term historical novelist. He himself cited Hermione Gingold in a 1950s London cabaret, taking off a lady lecturer who had only to hitch up her shoulder strap and announce her subject—*India*—for the whole audience to be convulsed with laughter.[12]

The British public did not want to know about India and, even if it had, finding out would not have been easy. "Imagination is not enough," Scott said once to a group of fellow writers: "Knowledge is necessary."[13] But his own researches were constantly obstructed. He corresponded in the late 1960s with Sir Conrad Corfield, who had been head of the Political Department in India, retiring after the transfer of power to the home counties to write his memoirs. Corfield's book, *The Princely India I Knew*, had been rejected by every British publisher he approached on the grounds that there was no interest in the subject. It was eventually brought out by a historical society in Madras, a specialist press so small, unworldly, and obscure that the author himself had the greatest difficulty in extracting a review copy for Scott, who was apparently the only person prepared to acknowledge the book's existence in the London press.

Things were if anything trickier on the official front. While working on *The Jewel in the Crown*, Scott needed access to the emergency regulations which would have enabled the authorities to arrest his hero, Hari Kumar, when rioting broke out in 1942. There was no question of the India Office in London disgorging classified information, however trivial, so Scott applied to an Indian friend in Bombay, who consulted a number of distinguished lawyers, one of whom laboriously copied down the relevant section of the operative code in longhand on half a dozen foolscap pages, which were duly smuggled out to Scott in London. Towards the end of the sequence, as he approached the infinitely more sensitive subject of the Indian National Army, Scott found doors closed on all sides. People in India were reluctant to discuss the INA, even unofficially, and the records remained closed. "My not very thrusting attempts in Delhi to be shown pertinent archives were not successful," Scott wrote in 1975. "I didn't persist, because as a novelist and

not a journalist, the reluctance interested me almost as much, if not more, than the archives would have done."[14]

This is one of those points at which the novelist parts company not only with the journalist but also with the historian, who is bound either to persist or to retreat, if only temporarily, until he is in full possession of the facts. But the novelist in Scott had come up against yet another aspect of his subject itself: that widespread and deep-rooted amnesia which made writing the *Raj Quartet* so difficult, and its initial reception so comparatively muted. The end of the Raj had been an abrupt and humiliating withdrawal for the British, who reacted by turning away from what was generally felt to be a closed chapter, and vehemently resisting any attempt to reopen it. When *The Jewel in the Crown* was published in 1966, Scott had a letter from an old friend, the novelist Gerald Hanley, who vividly remembered the poisonous atmosphere in Delhi in the last months before Independence, the sense of helplessness he shared with Indian friends, their agonized discussions about the future. Hanley recognized the book at once as a work of power and durability, but he also understood the mixed reception it received in Britain. "I'll be interested in seeing how the *Jewel* goes in America," he wrote to Scott that summer: "I guess they'll read it straight, not bent, as the British are bound to do even now with their blockage about India—though the *Jewel* is the kind of writing which will help to dissolve that strange blockage."[15]

Time has proved Hanley's point. But Scott was accused in 1966—as he still is to this day by those who make no distinction between nostalgia and the historical sense which Scott saw as its opposite—of glamorizing the colonial past, of a sneaking desire to return to the bad old days of British supremacy. He was also attacked, simultaneously but from the opposite direction, by supporters of the Raj who resented what they saw as his determination to rock the boat, to disturb any form of complacency, to rake over old bitterness and failure. Scott's answer to both attitudes was a stern one: "To forget strikes me as the quickest way of making the same mistake again," he wrote. "I'm not sure that there is genuinely any such thing as forgetting, but there are tender conspiracies of silence—and these may engender ignorance, always a dangerous thing."[16]

Here the novelist finds himself again at one with the historian, and it is surely no accident that the first sign of serious intellectual recognition for Scott in his own country should have come, ten years after publication of the *Jewel*, from the historian, Professor Max Beloff, reviewing the entire *Quartet* on its completion with *A Division of the Spoils* in *Encounter* in 1976. Beloff conceded with grace and generosity that Scott had got there first, that the novelist had penetrated areas not yet available for historical exploration:

> the subject is one to which the historian's techniques, however refined, may not be able to do full justice....History is still being written by a generation

that voted Attlee, Cripps and Bevin into power in 1945. Things will change as time reveals more of their handiwork. But the novelist need [not] wait.[17]

Beloff quotes Sergeant Perron's superior, Captain Purvis, expounding the political economist's line on India:

It's taken me no more than three months to write it off as a wasted asset, a place irrevocably ruined by the interaction of a conservative and tradition-bound population and an indolent, bone-headed and utterly uneducated administration, an élitist bureaucracy so out of touch with the social and economic thinking of even just the past hundred years that you honestly wonder where they've come from....The most sensible thing for us to do is to get rid of it fast to the first bidder before it becomes an intolerable burden.[18]

This was, roughly speaking, official British government policy immediately after the war, and so in a sense was the forgetfulness that interested Scott so much. It was in nobody's interest to ask awkward questions. As a young officer in his twenties, Scott had himself shared Purvis's exasperated view of the authorities in India, but as he grew older he found those early confident certainties harder to maintain. He came ultimately to feel respect and sympathy for the British in India at a time when it was deeply unfashionable to do so. One unexpected, and in some quarters, unwelcome aspect of the *Quartet* at the time of publication was its refusal to dismiss out of hand the bone-headed bureaucrats, the reactionary colonels, the traditionalists who, in Beloff's words, "take refuge in nostalgia, the cultivation of the tradition of the regiment, the lore of the station, memories of what were thought of as simpler and happier times."

The voices of people like this were for a time virtually suppressed in Britain. Even highly sophisticated men, who had, like Conrad Corfield, wielded considerable power, found their views mocked or ignored. Scott did not condone the Raj. He looked long and hard at its many failures, its inhumanity, complacency, self-righteousness and rigidity. One of the things that surprised him most was the reaction to his books of people who, he felt, would have had every right to be indignant. Admittedly, some were. But he received considerable support from others, especially from "old ICS wallahs" who had left India for good on the transfer of power, and whose messages or letters were not simply appreciative but full of something very like relief.[19] They seem to have felt that here at last was someone interested in comprehension rather than condescension, someone prepared to take them and their historical predicament seriously, not treat them as intrinsically ridiculous or, worse still, a write-off.

Scott received similar responses from Indians, including what seemed at the time a decidedly worrying telephone call in New York from the son-in-law of General Mohan Singh of the INA. Scott had had difficulty in

discovering anything about Singh, who seemed to have disappeared or died after the abortive show trials held in the Red Fort in Delhi at the end of the war. He had figured prominently in an episode over which his countrymen preferred to draw a veil and Scott, having removed the veil and painted a far from flattering picture of the INA's activities, was naturally alarmed to learn that Singh had not only read his book but proposed sending him a parcel. Scott spent an uneasy half hour waiting for the son-in-law to deliver this parcel, which turned out, when unwrapped, to contain nothing more explosive than a copy of Singh's memoirs.[20] Singh, too, had found himself for years officially relegated to limbo; like Corfield, he had spent part of his retirement justifying his past on paper; and, like Corfield, he felt that he had found in Scott the reader he had been writing for, someone who understood at last the cause for which the INA had fought.

But, for Scott, it was more than a matter of setting the record straight: he felt strongly that he was dealing with unfinished business, unfinished not only for men who had been on the spot like Corfield and Singh. He insisted that the empire which had supplied Britain's nineteenth-century industrial base could not simply be discarded when it had ceased to be profitable, or not at any rate without acknowledging the consequences. His reaction to the growing racial tensions of contemporary Britain, and his correspondence with friends in India when war broke out with Pakistan in 1965, both make clear how intimately he connected the present with the past: "what is so interesting (historically) is that, although there is an obvious and increasing feeling of responsibility, no one has yet traced the responsibility back to the failure of the British government to consolidate and unify," he wrote to a friend in Bombay in the closing stages of the war, adding sadly: "All this is in my book, you know."[21]

Scott struggled long and hard against a kind of collective inertia cloaking what he saw as the dogged British determination to disclaim responsibility for the empire, its precipitate collapse and problematic aftermath: the greasy and evasive, perennial human instinct to glide smoothly away from violent disturbance. He confronted unpopular issues in the *Quartet*, and reached unpalatable conclusions. His view of history may be said to be in this sense heroic: for Scott, it was a principle of energy and vigilance. His historian wields, if not exactly a drawn sword, a ruthless and intrepid pen, with which he must be prepared to do battle on all fronts against the pervasive, obstinate and pusillanimous spirit of withdrawal from the problems of the modern world.

Scott got small thanks for his pains, comparatively grudging critical esteem, and virtually no public recognition until in 1977, just before he died, he won the Booker prize for *Staying On* (which is a kind of afterthought or pendant to the four preceding novels). It is an irony that would not have been lost on him that the *Quartet*, so underrated in his lifetime, should have been

translated after his death into a TV series which precipitated in Britain in the early 1980s an overwhelming nostalgia for the Raj, and which was duly followed by a wave of fashionable Raj restaurants and pubs, serving Raj drinks against Raj decor—potted palms, basket furniture, brass hall stands—to customers wearing Raj clothes in white or biscuit-coloured linen. Stranger still is the fact that the romantic interest—the undisputed popular heart-throb of that series—turned out to be none other than the historian, Sergeant Perron, the scholarly seeker after truth, the specialist in British Studies, the personification of "lucidity and the clear rhythms of logical thought."

This was something no one, certainly not Scott himself (nor apparently Charles Dance, who played the part), could have foreseen. The explanation lies partly no doubt with the nature of television itself, which meant that—faithful though the series was to the original text—it could not attempt to grasp, still less present, the full weight and detail of Scott's historical conclusions. It lost in lucidity, or at least in logical thought, what it gained in the immediacy of actual experience. But I like to think that the popular, romantic perception of Perron was also due, at least in part, to Scott's own charismatic view of the historian, and the importance he attached to history as an active force for understanding, tolerance and freedom in the present.

But fiction makes its impact by emotional, metaphorical and imaginative as much as rational means: Scott's business as a novelist was with the texture of life itself, not simply its lucid and logical components. If Perron represents the historian in his noblest and most alluring aspect, then the emotional heart of the *Quartet* lies in quite another direction, with his opposite number, the least theoretical and most practical of men, a character whom he initially distrusts, subsequently despises, and eventually detests with wholehearted and uncharacteristic venom. This is that formidable officer, briefly Perron's own CO, Major Merrick, whose career progresses steadily through the four volumes, shifting him from one rung to the next up the official ladder of command and trust, until he reaches his high point (and his dreadful end) in *A Division of the Spoils*. In so far as the *Quartet* may be said to have a villain, it is Ronald Merrick.

Merrick believes implicitly in the Raj and its panoply of racial privilege and power. He regards sceptics like Perron as traitors to their class and country: "He believes we've abandoned the principles we used to live by," Perron explains,

> what he would call the English upper-and-ruling class principle of knowing oneself superior to all other races, especially black, and having a duty to guide and correct them. He's been sucked in by all that Kiplingesque double talk that transformed India from a place where plain ordinary greedy Englishmen carved something out for themselves...into one where they appeared to go voluntarily into exile for the good of their souls and the uplift of the

native...most of us are as bad as black to him. There aren't many real white men left.[22]

Merrick is a man of the past as well as a man of action. His insistence on the virtues of a world that no longer exists, perhaps never existed, makes him dangerously attractive in time of trouble and unrest, when his methods come as a relief even to people who mistrust them. What inspires confidence is "his absolutely inflexible and unshakeable sense of his own authority." He is the kind of man invariably welcome in a tight spot, but he also comes increasingly to seem (as someone said of a similar character in one of Scott's earlier novels) *the man who brings the tight spot with him.* He embodies rigid authoritarian principles of repression and manipulation. For all his public reputation, he is in private a sadistic bully and blackmailer. He specializes in winning the confidence of the victims whom he drives to despair and, in at least one case, to suicide. He is an ingenious and imaginative torturer, both physical and mental. He lacks entirely, in Perron's words, "that liberal instinct which is so dear to historians that they lay it out like a guideline through the unmapped forests of prejudice and self-interest as though this line, and not the forest, is our history."[23]

Scott attempts to penetrate that dark, unvisited forest principally through Merrick: through glimpses of his background and upbringing, his social and emotional deprivations, his private obsessions, the sources of his indomitable will and his undoubted power to charm. For, if a bald summary of Merrick's activities makes him sound absurdly melodramatic, it should perhaps be emphasized that this is by no means an unsympathetic portrait. On the contrary, it is one of Scott's singular achievements in the *Quartet* that he somehow makes the reader look through Merrick's eyes and, seeing the world in the same light as Merrick sees it, understand how his conduct might have appeared to him to be a series of sound, bold, eminently justifiable moves in pursuit of honorable ends. Merrick's baleful influence is generally apparent only in his absence through the ruined lives of his prisoners—Hari Kumar, Corporal Pinker, Havildar Khan ("the poor, weary, shagged-out, shamed and insulted havildar,"[24] who hangs himself in *The Division of the Spoils* in the course of interrogation at Merrick's hands). Each represents, so to speak, a landmark in Scott's efforts to map the dark irrational impulses which operate in regions far from the historian's searchlight of conscious understanding.

He said that the original seeds of *The Jewel in the Crown* were planted in his mind by the affair of the Jallianwallah Barg, nearly a quarter of a century before his story opens, when British troops fired on a trapped and helpless crowd of Indian civilians in 1919. The two related incidents which set the sequence in motion—the attacks on Daphne Manners and Edwina Crane, each of whom eventually dies in consequence—had a historical precedent

from the same period. For Scott the roots of brutality, vengeance and repression, running invisibly underground through time and space, proved accessible only through a work of fiction in which the figures operating at the center of the stage in fact—Wavell, Nehru, Jinnah, Mountbatten—would be dimly visible, if at all.

The effect is perhaps furthest from any formal historical process in the third of the four novels, *The Towers of Silence*, which is the quietest, most domesticated, least eventful, and most elegiac of them all. It serves as a kind of bridge passage or recapitulation between the excitements of volume two and the gathering climax, violence and resolutions of volume four. It takes place largely in 1943–44 among the isolated, Anglo-Indian community of Pankot: mostly spinsters, widows, wives with sons or husbands away at the front. It is set against the background of distant European war, Japanese invasion of the subcontinent, defeat and dispersal on all sides; and it charts the gradual, reluctant acceptance by one small section of the British civilian population in India that their time is up. "This sense of danger, of the sea-level rising, swamping the plains, threatening the hills, this sense of imminent inundation, was one to which people were now not unaccustomed...."[25]

It was Professor Beloff who first pointed out that Scott spoke for the other half, the wives and daughters, the memsahibs of British India without whom the empire could not have functioned. *The Towers of Silence* shows the rising tide of history as it appears—not to an active, analytical observer like Perron—but to the passive watchers in Pankot; people who play no part in the decision-making process, who remain for the most part barely conscious of its existence, let alone its ramifications behind the scenes, and who yet must gather their energies to receive and absorb its impact.

The whole novel is focused through the eyes of the missionary Barbie Batchelor, the elderly, insignificant owner of the battered tin trunk, who finds herself professionally redundant at the beginning of the book, and who spirals slowly downwards in the course of it through successive circles of loneliness, rejection, homelessness and humiliation to madness and death. Barbie ends up a speechless outcast with no recollection of the past, forcibly parted from her trunk, physically restrained by cold water and winding sheets behind bars in the Samaritan Hospital at Ranpur. It is a grim and graphic image of the denial or suppression of memory. Barbie's fate is parallelled by the experience of Susan Layton, the younger and prettier of the two Layton sisters, who starts the book a radiant bride, and who also finishes by succumbing, if only temporarily, to insanity and incarceration. Susan's dog, which has pined in its mistress's absence, causes perturbation when glimpsed by a guest at a garden party given to mark the first of many unwilling British departures from Pankot:

> She...was staring horrified, at a patch of petal-strewn grass, a corridor between long rectangular beds of rose trees, bush and standard, vagrant-looking, with green reversionary shoots pale and erectile, already sucking the life out of the roots. Along this path the creature crawled, slunk, towards them; a black spectre of famine worn to its hooped rib cage and the arched column of its backbone. A thin dribble of saliva hung from its open mouth....The others stayed where they were, watching the apparition approach the verandah steps slowly, dragging one leg, pausing every few paces to rest, droop-headed, before struggling on, its eyes upturned...showing blood-shot whites.[26]

Images like this horrifying hound help bear the historical weight of a novel which comes down in the end not with Viceroys and Congress leaders, not with generals, kings, or king-makers, but with an almost Shakespearian sense of ordinary people: people who have no individual existence for the historian: shallow, cowardly, small-minded, opportunist people activated by thoroughly Shakespearian principles of prejudice and self-interest: the sort of people who provide the casualties and mop up the damage when greater men, like Caesar, cry havoc and let slip the dogs of war.

Barbie Batchelor said once that the only figure missing from the historical pageant in her Victorian print called "The Jewel in the Crown" was the unknown Indian. Scott (who had read Nirad Chaudhuri) put the unknown Anglo-Indian firmly at the center of his own canvas. He stayed several times, immediately before and during the writing of the *Raj Quartet*, in a flat with a balcony overlooking the nineteenth-century law courts on the Oval maidan in Bombay. If there is one place in particular where Perron stands for his creator, it is in the passage where he, too, looks across from a Bombay balcony at the dark bulk of the law courts:

> For a moment—perhaps under the influence of that symbol of the one thing the British could point to if asked in what way and by what means they had unified the country, the single rule of law—he felt a pressure, as soft and close to his cheek as a sigh: the combined sigh of countless unknown Indians and of past and present members of the glittering insufferable *raj*.[27]

This was what Scott tried to do: to speak for (or catch the sigh of) countless, unknown, unrepresented, insignificant members of the Raj: to preserve them from the dangers of misrepresentation, the denial of memory, the distortions of nostalgia: to insist that their history was neither disposable nor detachable from the present and the future. Or, as he said himself on his last visit to India in 1972: "I should like to think that, here and there, in the books I write are things which, at home, reduce the weight of ignorance, and consequently of prejudice."[28]

NOTES

1. Paul Scott, *A Division of the Spoils* (Panther Granada: London, 1977), p. 333.

2. Ibid., p. 141.

3. Ibid., p. 22.

4. Ibid., p. 535.

5. Ibid., p. 23.

6. *My Appointment with the Muse, Essays and Lectures by Paul Scott*, ed. Shelley C. Reece (London 1986), p. 68.

7. Paul Scott, *The Day of the Scorpion* (Heineman: London, 1968), p. 28.

8. *My Appointment with the Muse*, p. 95.

9. Ibid., pp. 118-19.

10. Ibid., p. 30.

11. Hilary Spurling, *Paul Scott* (New York, 1991), p. 396.

12. *My Appointment with the Muse*, p. 91.

13. Ibid., p. 19.

14. To J.A.E. Heard, 8 October 1975, Scott Papers, McFarlin Library, University of Tulsa.

15. Gerald Hanley to Scott, n.d. (August 1965), Scott Papers.

16. *My Appointment with the Muse*, p. 119.

17. Max Beloff, 'The End of the Raj: Paul Scott's Novels as History,' *Encounter* (May 1976), pp. 65 and 70.

18. Ibid., p. 68.

19. Correspondence with Sir Herbert Thompson and others, Scott Papers.

20. Mohan Singh, *Soldiers' Contribution to Indian Independence: The Epic of the Indian National Army* (New Delhi, 1974).

21. Scott to Dorothy Ganapathy, September 1965, Scott Papers.

22. *A Division of the Spoils*, p. 259.

23. Ibid., p. 369.

24. Ibid., p. 260.

25. *The Towers of Silence* (Heineman: London, 1971), p. 25.

26. Ibid., p. 316.

27. *A Division of the Spoils*, p. 48.

28. *My Appointment with the Muse*, p. 121.

Winston Churchill as Historian

ROBERT BLAKE

Many aspects of Churchill's life have been discussed here in the past. I thought it might be a good idea to deal with one that has not been. This is the question of Churchill as an historian. I will straightaway acknowledge my debt to Maurice Ashley's book with that very title, published in 1968.[1] One need not agree with all his judgments to appreciate his pioneer work in this, till then neglected, field. Ashley as a young man worked in the muniment room at Blenheim and also at Chartwell, helping Winston in his great biography of Marlborough. So his testimony about the way Churchill worked, his outlook on history, and what it was like to be one of his assistants is both authentic and valuable.

Churchill's role as historian is of course only a secondary part in his astounding career. He was the greatest war leader in the whole history of what he called "the English-speaking peoples." But his four-volume history of them does not make him one of their greatest historians. He is not on the level of his hero, Edward Gibbon, or his *bête noire*, Thomas Macaulay. As Ashley puts it, "He preferred to make history than to write it." The only other English Prime Minister to have made writing an important part of his life was Disraeli who, like Churchill, wrote before he entered politics and, also like Churchill, did so to make money. He wrote novels with one excursion into history, his biography of Lord George Bentinck. Churchill wrote history with one excursion into novel-writing, *Savrola*. It is a remarkably Disraeli-like romance, just as Churchill's life of his father has many echoes of Disraeli's *Lord George Bentinck*. Disraeli does not stand or fall by his reputation as a novelist. He was never on the level of Dickens, Thackeray, Trollope, or George Eliot. His best are acute, perceptive, witty, dramatic and occasionally moving. They are never profound. They are two- rather than three-dimensional. The same might be said of Churchill's works of history. He could paint a vivid scene. He did not always or often inquire into why the scene was there to be

painted. For both prime ministers writing was ancillary to their careers. They would go down in history if they had never published a word.

Much of Churchill's historical writing was autobiographical—another parallel with Disraeli's novels. His account in five volumes of the First World War and its aftermath is one example; likewise his story in six volumes of the Second World War. It is worth remembering that in neither of these cases did he claim that he was writing a detached history of the two great conflicts that have shaped the pattern of the world ever since. Sir William Deakin, who was Maurice Ashley's successor as principal research assistant to Churchill, made the point clear in discussion with Churchill's biographer. He told Martin Gilbert: "Winston's attitude to the war memoirs was 'this is not history, this is my case.' He made it absolutely clear that it was *his* case he was making. It was an anthology [based on] his papers, not a history."[2] Churchill himself said of his account of the First World War: "It is not for me with my record and special point of view to pronounce a final conclusion. That must be left to others and at other times....I present it as a contribution to history."[3]

In both wars he had a case to make. In the 1914–18 war it was largely though not exclusively a defense of the Dardanelles expedition. He was never easy about this unhappy episode. He took full responsibility for it—ironically fuller than he need have. Kitchener and Asquith were at least as much to blame as he was, if "blame" is the right word. The affair has always been one of intense controversy, especially in Australia and New Zealand. The ANZAC forces suffered grievously and there was much criticism. Churchill in his day visited almost every major country of the old British Empire. He never went to Australia or New Zealand though he was often invited.

He had a case to make in the 1939–45 war also—the case basically for his own leadership and decisions. Like the memoirs of the First World War those of the Second are marvellously readable. They carry one on in vivid, if rather rhetorical, prose from episode to episode, drama to drama. And drama is no exaggeration. The history of the Second World War, like that of the First, is highly dramatic, full of extraordinary twists and turns of fortune. It is superbly told in splendid language. But the author never claims to be definitive. In 1927 a critical but generous analysis of Sir Winston's memoirs of the 1914–18 war was published by Sir Charles Oman, a distinguished military historian. No one has attempted a similar *critique* of the six volumes on the Second World War. It would be well worth doing one day.

There is, apart from anything else, a missing clue in Churchill's account, as in every other book written before 1974. For security reasons it could not be mentioned in Sir Winston's lifetime. The embargo was only lifted nine years after his death. I refer of course to the cracking of Germany's most secret cyphers—on the Enigma machine. The operation was code-named "Ultra." No doubt its effect can be exaggerated—and has been—but it was enormous. To take just two examples, the defeat of the Atlantic U-Boat

campaign and the success of the deception plan for D-Day, 1944, were largely due to this remarkable breakthrough. It was one of the best-guarded secrets of the war. As a junior officer in 1944–46 in one of the intelligence services, I knew about it myself at the time. I was one of a quite large number to be "in the know." It is very remarkable that the secret was kept from the public for thirty years. But we belonged to a generation which was less leaky, and—dare I say it—more *patriotic* than is always the case today. We believed in our "national cause." We obeyed orders. We signed the Official Secrets Act, and we did not go back on our promises or break oaths because we regarded our pensions as inadequate.

Churchill's memoirs of 1939–45 have other defects. No one could regard his account of the Dieppe Raid in August, 1942, as a full and frank description of a disaster that was a tragedy for the Canadian Army. Even before Churchill wrote, there was a very fair account published in the Canadian Official History. But it did not go into detailed planning responsibility. In fact, this was assumed by Lord Mountbatten and admitted fully in a speech in Canada after the war. The operation had been decided upon, then dropped, and then revived. But apparently it was "the only occasion in the whole war," according to Lord Ismay, "when nothing was put in writing by the Chiefs of Staff about a final operational decision." Four months after the raid, Churchill wrote a minute in December, 1942, with a series of questions, by implication very critical of the whole plan. He had himself been consulted if at all only in the most general terms and had no recollection of details. The minute was disinterred in 1950, and after some delay Churchill consulted Mountbatten who replied that Churchill was "as ever the moving spirit behind the operation." Churchill decided not to publish the critical minute.[4] His account in the third volume of *The Second World War* is bland and unrevealing, though correct as far as it goes.

I have mentioned this episode, not to condemn Churchill as an historian, but to illustrate the real problems that beset a statesman writing his historical memoirs of events so recent. The Dieppe Raid had occurred only eight years before Churchill drafted his account. Montgomery, also involved in the early planning, was still alive. So was Mountbatten. So was Alanbrooke. So were a host of others both British and Canadian. It was a controversial issue, and it was stirred up from time to time by the Beaverbrook press in pursuit of its owner's vendetta against Lord Mountbatten. Churchill, himself a past and prospective future Prime Minister, had to be careful what he said. He would have to deal with Canadian leaders, American presidents, and generals—a host of people whom he did not wish to offend in the interests of the present, whatever the truth about his and their pasts.

Churchill's memoirs of both world wars are very far from being his only contributions to history. By the time he had written the first series he had already produced three important historical works. *The Story of the Malakand*

Field Force came out in 1898 when he was only 23; *The River War* a year later; and his major biography of his father in 1906 just before he took office in the new Liberal Government under Campbell-Bannerman. He had also written a bad novel, and two other books which were collections of dispatches written as war correspondent in the Boer War for the *Morning Post*.

What started him in this important sideline to his main career? It is not true, as often has been said, that his interest stemmed from the chance reading of Gibbon's *Decline and Fall* during the long siestas imposed by the climate when he was a cavalry subaltern in India. His enthusiasm dated earlier— back to his days as a boy at Harrow. He exaggerated in retrospect, as some great men like to do, the poorness of his school performances. At fourteen he received a prize for history and excellent school reports on the subject. At Sandhurst his interest was enhanced by a schoolmaster to whom he was always grateful. Before then, though he failed the entrance twice, he got excellent marks in English History on each occasion, finally obtaining the top result in the subject. He did undoubtedly read Gibbon and was much impressed. But his previous interest in history was what stirred him to read Gibbon. It was not Gibbon who first stirred him to read about history.

His motives for putting pen to paper were by no means those of the academic Ph.D. devoted to pure, learned—and unremunerative—research. In 1897 Churchill quoted with approval Dr Johnson's celebrated dictum: "No man but a blockhead ever wrote a book except for money."[5] And money was undoubtedly a prime motive in all his writings. He probably made more in real terms than any non-fiction author in the twentieth century. Money was important to him. He was for some years separated by only a heart beat from the dukedom of Marlborough, but under the English system of primogeniture, younger sons got very little and sons of younger sons even less. Lord Randolph Churchill left nothing but debts. Lady Randolph had barely enough for herself. A subaltern's pay presupposed a private income. And politics, the goal of Winston's ambition, was entirely unpaid, except for office-holders whose incomes were by the nature of things precarious. It was not till 1919 that he inherited a substantial sum, and even then he was by no means rich enough to sustain a style of life that had become ever more opulent.

Churchill had discovered at an early stage the gift of writing in a manner that captured his reader and compelled him to go on reading. There is much to be said for an historian, indeed other literary men, to have had some experience of journalism. I mean of course reputable journalism. It forces one to be clear, lively and entertaining. And the discipline of the deadline concentrates the mind wonderfully. Churchill wrote against deadlines all his life, and all his life he was conscious of the need to hold his readership and hence his fees and royalties.

The Story of the Malakand Field Force (1898) is, on a minor scale, like his volumes on the two world wars, a mixture of history and personal experience.

He took part in this campaign of 1897 on the Indian northwest frontier, combining the duties of a cavalry officer with that of a war correspondent—an arrangement eccentric even then and inconceivable today. He repeated the performance in 1898, participating in Kitchener's campaign to avenge the death of General Gordon. The result was *The River War*, published in 1899. The early chapters—indeed the whole first volume—are genuine history, covering years in which Churchill had no personal involvement. The second volume deals with Churchill's own experiences in that war—or perhaps one should say it is a history of the war illuminated by his personal experiences.

It cannot be expected of two books written at breakneck speed so soon after the events that they will be the last word. In particular is this true of volume I of *The River War*. A great deal has been written since then about Gordon and Khartoum and indeed about Kitchener. Some of it came out in Churchill's lifetime. He did not try to revise or correct his work. Both books must be regarded as "a good read" but essentially as provisional accounts of picturesque episodes in imperial history. The first (*The Malakand Field Force*) sold 8,500 copies—a lot for those days. Its success induced publishers to suggest that he should write the life of his father and of his great ancestor, the Duke of Marlborough. He wrote both in the end, though neither immediately. He began to assemble material for a life of Lord Randolph in the summer of 1902. Since 1900 he had been a Conservative MP, but as time passed his doubts about his chosen party increased. The task of writing his father's life hastened the process. Lord Randolph, after his famous resignation in December 1886 from the Chancellorship of the Exchequer, became ever more disenchanted with the Conservative "establishment." He thought he had been unfairly treated. Few historians would agree nowadays. Most would sympathize with Lord Salisbury for accepting the resignation with alacrity. When someone urged him to readmit Lord Randolph, he said, "Did you ever know a man who had a boil on his neck who wanted it back?" A loyal son would hardly see matters like that. Winston was neglected by his father and mother, but he remained devoted to them nonetheless. He belonged to the Victorian Era. Children were guarded by nannies and servants. When they grew up they did not psychoanalyze either themselves or their parents of whom they knew so little.

Churchill's life of Lord Randolph came out in 1906. By then he had crossed the floor of the House and was a junior minister in the Liberal Government which had just won a huge electoral victory. So he was writing the book in a politically transitional period of his own life about a father who was disillusioned with the Conservatives, though he never contemplated the move made by his son. In any judgment of the biography this background has to be considered. Yet the book remains an essential source. It is the best life ever written by a son of his father. Churchill's capacity to hold the reader's attention has seldom been better shown. Nothing could be a potentially drier

subject than the government finances of yesteryear. Lord Randolph was only Chancellor for six months, and resigned before he brought in a budget. Yet his son's account of the details, the arguments, the drama which lay behind an abortive measure swept away by the tide of events makes compulsive reading. Subsequent lives by Robert Rhodes James and R.E. Foster have to be read too, but their fully acknowledged debt to this first biography remains immense.

Winston's life of his father is the only one of his historical works that does not have war as an important theme. Churchill was fascinated by war. Asked in the 1950s what year of his life he would like to relive he replied: "1940, every time, every time." But his sense of achievement and satisfaction in the conduct of war does not mean that he glorified it. His enemies have accused him of welcoming war. A disgraceful first volume of a new biography by David Irving has reiterated the charge. The title *Churchill's War* strikes the keynote of a scandalous attack. Churchill, like the Duke of Wellington or the Duke of Marlborough, may have been at his most brilliant and best in war. This does not imply failure to see the tragedy, misery, torment and waste. In his very first book, writing of the pursuit of the Pathans, he said:

> The spectator who may gaze unmoved on the bloodshed of the battle must avert his eyes from the horrors of the pursuit unless indeed, joining in it himself, he flings all scruples to the winds and indulges to the full those deep-seated instincts of savagery over which civilization has but cast a veil of doubtful thickness.

One is reminded of the Duke of Wellington's dispatch from the field of Waterloo: "Nothing except a battle lost can be half as melancholy as a battle won."

Of Churchill's purely historical works, the best is his four-volume biography of John Duke of Marlborough, his ancestor through the female line, arguably the greatest military commander in English history. Churchill began this work in 1929 when the unexpected defeat of Baldwin's government gave him an unexpected period of leisure. That leisure was to be prolonged, though the Conservatives were soon back. Churchill resigned from the shadow cabinet in 1930 and he was not again in office till war broke out in 1939. In the course of ten years he not only produced *Marlborough* but also *The Aftermath* (an epilogue to the *World Crisis*), *My Early Life* (a most entertaining autobiography), *The Eastern Front* (an account of the Russian campaigns in the First World War) and *Great Contemporaries* (a book of vivid pen portraits). As if that were not enough, he wrote some half a million words of his *History of the English-Speaking Peoples*, though he laid it aside and did not complete the work till 1956. The sheer energy is astounding—the more

so when one remembers that most of his time was devoted to a highly active and controversial role in politics.

Of course he was surrounded with secretaries and research assistants; and, by dictating straight into galley proof, he adopted one of the most timesaving methods of production—and also one of the most expensive. But he could afford it. The advances for book and serial rights were very large by the standard of the day. "I am going to spend money with some freedom on expert advice," he wrote to his wife in August 1929.[6]

He was writing from aboard ship. He had decided before starting work to make a tour of Canada and America with his brother and son. Among many other places he visited Edmonton, Calgary, and Vancouver. The Calgary oil boom was in full swing. Young Randolph deplored the oil magnates who ruined beautiful valleys to make money that they were too uncultured to know how to spend properly. "Instantly Papa flared up," wrote Randolph in his diary. "'Cultured people,' he said, 'are merely the glittering scum which floats upon the deep river of production.'"[7]

However, we must return from North America to Blenheim Palace. The archives, scarcely seen by anyone since they were written, formed the material on which the biography was based. Churchill left the task of extraction and selection to his young researchers, but what finally appeared was very much his own. Those who helped him have rightly resented the description of "ghost writers." They were nothing of the sort. Every word was Churchill's.

As in other instances, Churchill avowedly had a case to make. He wished to defend his ancestor against the charges of treachery to both James II and William III, dictated by unscrupulous ambition, avarice, greed, and meanness. These charges were memorably articulated in prose just as eloquent as Churchill's by Lord Macaulay. Most historians agree that Macaulay overstated his argument for the prosecution and used dubious sources, but they also agree that there were some questionable passages in John Churchill's early career. Winston Churchill's efforts to whitewash these are not wholly convincing and do not seem to have wholly convinced the author himself.

After the first volume came out, Churchill consulted various academics about a second edition. Among them was Lewis (later Sir Lewis) Namier— a Polish Jew who had emigrated from Poland to Britain and was in the process of making himself one of the greatest experts on British eighteenth-century history. Namier replied praising the book but suggesting that too much space was occupied in refuting Macaulay. He also criticized Churchill's habit of talking about what individuals *may* have felt or—worse still—*must* have felt.

> Such imaginary accounts always throw me into opposition. Our conjectures must be rational, whereas neither men nor events are rational, and there is seldom a correlation between a so-called historical moment and what people feel or do on the occasion.

He went on to urge Churchill to make more use of his own experience in politics, government and war.

> Please do not try to write history as other historians do, but do it in your own way. Tell us more how various transactions strike you, and what associations they evoke in your mind.[8]

In reply Churchill was not prepared to give up on Macaulay. He was too deeply committed for that. But he accepted the second point. "I agree with you about imaginary conversations. I felt at the time that they were a weak indulgence on my part....I hope to avoid them altogether in Volume II." And on the third point he fully agreed. "I certainly propose to apply my experience in military and political affairs to the episodes."[9]

The History of the English-Speaking Peoples, published in 1956–58, has had a less enthusiastic welcome than *Marlborough* from the academic world though it had a very wide sale to the general public. It is a curious mixture. Churchill had little knowledge of the Middle Ages or the period of the Tudors and Stuarts. He had to rely on his expert advisers. In conversation Churchill could be reckless. When he was pressed in 1940 to reduce the meat ration with the consolatory observation that less meat might be good for people, he exploded. "Almost all food faddists I have ever known, nut eaters and the like, have died young after a long period of senile decay."[10] It would be interesting to be told how many he had known and what was his evidence.

In print he was more cautious. His advisers stopped him arguing, on the strength of an historical novel he had recently read, that Richard III was not guilty of the murder of the little Princes in the Tower.[11] But they could not prevail over the tale of Alfred and the cakes, although he qualified it as "one of those gleaming toys of history fashioned for children of every age." Nor could they veto the legend of Henry II, Queen Eleanor and her supplanter, "the Fair Rosamund," given the choice by the Queen between the dagger and the poisoned cup. Churchill defiantly wrote: "Tiresome investigators have undermined this excellent tale but it should certainly find its place in any history worthy of the name." I agree with Maurice Ashley that there is a somewhat contrived impression about the first two volumes. Churchill was not at ease in this field and had to depend too much on expert advice.

He is on surer ground in Volume III, *The Age of Revolution,* and Volume IV, *The Great Democracies.* He clearly feels his own analogy with the elder Pitt who "called into life and action the depressed and languid spirit of England." He gives a vivid account of the American War of Independence in Volume III, and of the Civil War in Volume IV. Indeed it is probably the best short account ever written on a subject that has inspired so many millions of words.

His history is very much an affair of war and politics. Not for him the problems of society and the economy. Of course he was aware that they existed. But they were not his main interest. That is fair enough. No one can comprehend even in a major work every aspect of history. Despite the stuffy academic critics who write learned articles for each other and for promotion, there is a case for popular history. Sir Arthur Bryant in England and Barbara Tuchman in America may not have met the requirements of a doctoral thesis, but they brought history home to a wide public. So did Winston Churchill. He was not perhaps a "great" historian but he was certainly a great communicator of the sort of history in which he believed.

With that fourth volume in 1958, Churchill's career as an historian comes to an end, and so also must this lecture.

Churchill often found writing history tedious and he did not always enjoy the hard labor involved. Had he been born a millionaire he might not have been a historian at all. In that case the world would have been poorer. But he would always have been personally fascinated by history for its own sake and the lessons to be drawn from it.

I will conclude with a quotation. It is from Martin Gilbert's final volume of his vast biography. Churchill is writing to his grandson, little Winston, then aged eight:

> Learn all you can about the history of the past, for how else can one ever make a guess at what is going to happen in the future.[12]

He could not have stated more clearly the main reason for the spell which the reading of history had cast over him throughout the whole of his long life.

Spring Semester 1989

NOTES

1. Maurice Ashley, *Churchill as Historian* (London, 1968).
2. Martin Gilbert, *Winston Churchill*, vol. VIII (London, 1988), p. 315.
3. Quoted in Ashley, *Churchill as Historian*, p. 70.
4. See Gilbert, *Winston Churchill*, VIII, pp. 550-52.
5. Ashley, *Churchill as Historian*, p. 16.
6. Gilbert, *Winston Churchill*, V, p. 339.
7. Ibid., p. 343.
8. Ibid., p. 501.
9. Ibid., p. 502.
10. Sir John Colville, *The Fringes of Power* (London, 1985), p. 196.
11. Ashley, *Churchill as Historian*, pp. 27 and 237.
12. Gilbert, *Winston Churchill*, VIII, p. 459.

The "Special Relationship" 1947–1952

OLIVER FRANKS

I have been asked to speak on Anglo-American relations during the period in which I was involved, 1947–1952, and to assess the so-called "Special Relationship" between the United States and Britain in this period.

As victory in the 1939–45 war came near and was achieved, the United States had a vision for the future. It included a world in which men lived freely together in democratic societies, with freedom to vote and freedom of the press, free in Cordell Hull's words from "spheres of influence, alliances, the balance of power or any other of the special arrangements through which in the unhappy past, the nations strove to safeguard their security or promote their interests." It also included a world in which the peoples traded freely together, restrictions on the movement of money and goods having been swept away. And this new world was not to be left to chance: it was to be watched over by a great new institution, the United Nations, which through the presence of the Great Powers on the Security Council, the "Four Policemen," would preserve law and order in international society.

Before I appeared on the scene, things had changed. It rapidly became clear that there were two visions of the shape of things, not one, a Russian as well as the American. The Russians were preoccupied by security, and in order to achieve it they would have nothing to do with free democratic societies or the free movement of money and goods in the large part of the world where they lived and in those countries west of the Soviet Union which their conquering armies had occupied. They set about securing governments friendly to Communism and, sooner rather than later, Communist governments in Poland, Czechoslovakia, Hungary, Rumania and Bulgaria.

So what might have been one world system became two world systems. In the United Nations the effective veto of each of the Great Powers in the Security Council destroyed the UN's capacity to serve as the policeman of the world as President Roosevelt had hoped.

Then in late 1945 and 1946 came a new set of problems, further dimming the original vision. The Soviet Union exhibited expansionist tendencies to the south, in Iran and Turkey, territories it had not occupied in the course of the war. There has been dissension and controversy about what Russian moves in Azerbaijan or the Dardanelles really portended for Russian policy. My view is in agreement with that of Professor Ulam who remarks that "the simplest and most banal explanation is not necessarily wrong. The Soviet Union was bent on expanding her sphere of power and influence but without incurring the risk of war." To which the British historian, Alan Bullock, adds "in what earlier century would anyone have thought of looking for any explanation other than this?"

The United States was alarmed at what it saw to be the thrust of Russian policy: it resisted, strong messages were sent, and warships moved into the Eastern Mediterranean. The Russians discontinued their moves and withdrew. It was at this time that President Truman said "I'm tired of babying the Soviets."

So not merely was the world divided but the two superpowers, the United States and the Soviet Union, saw their respective policies as hostile, each to the other. It was this change which provoked George Kennan's famous long telegram in February 1946, with its advocacy of a policy of containment. It also produced the Truman Doctrine about Greece and Turkey with its statement that "it must be the policy of the United States to support free peoples who are resisting attempted subjugation by armed minorities or outside pressures."

At the same time difficulties progressively increased over the greatest single problem in the western world, the future of Germany. Slowly but inexorably the different views held by the Russians on the one hand and by the Americans, British and French on the other became unbridgeable. At the end of April 1947, General George Marshall, the American Secretary of State, recognized that he could not do business with the Russians about Germany. The Western powers must get on with the job before them in West Germany and prevent the chaos and dissolution of society threatened by the incursion of millions of Germans from East Germany, homeless, without food, and without work.

For all these reasons the vision of the United States came to be focused on two interrelated aims, the containment of the Soviet Union and the succor of Western Europe, including Germany. The motive was not only to relieve human suffering but still more to prevent the 250 million people in Western Europe—intelligent, hard-working, and skilful—from falling victims to the advance of Communism. This threat arose not so much from a fear of invasion but from a concern that serious economic and political disorder might throw countries such as Italy and France into Communist arms. These issues were made worse by the dreadful winter of 1946–47 in Western Europe; crop yields were heavily down, far below pre-war; the hesitant recovery after the war

had halted; there were thousands of bridges still down in France alone. Food, steel, machine tools were all short. It may be, as has been argued, that Western Europe at a cost could have survived and recovered by itself, if the analysis is purely economic. I doubt that, for the essential problem was not only the political economies but the moral, political and social structures of Western Europe. Could these withstand the pressures and the shortages? General Marshall and his advisers thought not. One of them, William Clayton, wrote in a memorandum in May 1947, that Europe was steadily deteriorating.

> The political position reflects the economic. Millions of people in the cities are slowly starving. More consumer goods and restored confidence in the local currency are absolutely essential if the peasant is again to supply food in normal quantities to the cities. The modern system of division of labor has almost broken down in Europe.

The Americans believed that a prosperous, democratic Western Europe, including Western Germany, was a vital strategic interest of the United States. Hence in his Harvard speech on 5 June 1947, General Marshall offered aid and support from the United States if the countries of Western Europe would produce a joint program for recovery.

This was the point in time when I became a participant in Anglo-American relations. In early July 1947, I was Provost of Queen's College, Oxford, having returned a year before, after nearly seven years of wartime service. I and my family were looking forward to our first real vacation, when I was suddenly asked to see the British Foreign Secretary, Ernest Bevin. When I met him, he told me that a sixteen-nation conference was being arranged in Paris to draw up a European Recovery program in response to General Marshall's speech. He wanted me to be the leader of the British delegation which he expected would carry with it the Chairmanship of the conference, the Committee of European Economic Cooperation. The work would last for two months, all within the long vacation. I agreed and set off for Paris with Ernest Bevin. After a day of Ministers' meetings at which the Committee was formally constituted, I was left to carry on. For the next eight weeks I worked harder than I have ever worked in my life, from 9 a.m. to 2 or 3 a.m, seven days a week for all the eight weeks. The job was not easy for many reasons, but there were two main ones. The first was that the sixteen European nations were being asked to do something unprecedented. They were confronted with something that was not part of their previous experience. They had to create a map and use it simultaneously. The second reason was that General Marshall, after saying that a Recovery Program was the business of Europeans and that the initiative must come from Europe, had offered friendly aid in the drafting of the program as well as American support for it so far as might be practical. We received this friendly aid as we worked. It consisted in part

of visits from officers of the American State Department, George Kennan, Paul Nitze, Harry Labouisse, and in part from a triumvirate of Lewis Douglas, American Ambassador in London, Jefferson Caffery, American Ambassador in Paris, and Will Clayton, Assistant Secretary of State for Economic Affairs, at the time based in Geneva negotiating the General Agreement on Tariffs and Trade.

This friendly aid had two characteristics. One was that on a purely personal basis it was easy, open, and friendly. The conversations, the arguments, were between people sharing common objectives and trying to sort out the best ways of achieving them. The other was that the stance of the European countries, particularly that of Britain and therefore of myself, was different from that of the Americans. Here I quote from a passage in Isaiah Berlin's essay on Mr Churchill in 1940. He says:

> the American view is larger and more generous: its thought transcends the barriers of nationality and race and differences of outlook in a big sweeping single view. It notices things rather than persons, and sees the world in terms of a rich, infinitely mouldable raw material, waiting to be constructed and planned in order to satisfy a world-wide human craving for happiness or goodness or wisdom. And therefore to it the differences and conflicts which divide Europeans in so violent a fashion must seem petty, irrational, sordid, not worthy of self-respecting, morally conscious individuals and nations; ready, in fact, to be swept away in favour of a simpler and grander view of the powers and tasks of modern man. To Europeans this American attitude, the larger vista only possible for those who live on mountain heights or vast and level plains affording an unbroken view, seems curiously flat, without sublety or colour, at times appearing to lack the entire dimension of depth, certainly without that immediate reaction to fine distinctions with which perhaps only those who live in valleys are endowed, and so America, which knows so much, to them seems to understand too little, to miss the central point.

The Americans who offered us friendly aid had a large vision. Of course they were concerned that the European response should be such that it would win the approval of the Congress when it came to the authorization and appropriation of aid, but chiefly they were anxious to urge the Committee of European Economic Cooperation that the Recovery Program should give effect to the idea of unity in Europe. They wanted a *European* program for recovery, not a series of shopping lists from the several countries. They wanted the working out of the program institutionalized so that to an extent the views of the participating countries would be merged through some institution that gave reality to the integration of Western Europe. Their motives were mixed as all human motivation tends to be: they wanted a more integrated Western European community of prosperous democratic countries to contain the Soviet expansionist threat; they were moved by the humanitarian impulse to help Europe in its plight; they had in mind the example of the United

States where the States of the Union under a Federal Government had created one vast market for the free movement of goods and money. They remembered the reflections of George Kennan in the paper which he and his Policy Planning Staff wrote for General Marshall before the Harvard speech: the insistence on a joint program initiated by Europeans so that they began to think like Europeans and move towards a larger, less fragmented market.

The immediate preoccupations of the Committee of European Economic Cooperation were different. They were attempting something novel, on a scale and within narrow time limits which created a sense of urgency. Principles, methods, ways of gathering and standardizing statistics, had to be worked out and applied almost simultaneously. The quality and quantity of official information in Southeastern Europe was not the same as in Northwestern Europe. The position of the three neutral countries had to be watched. The Irish Republic was delighted to take part in the European Recovery Program but was anxious not to be too close to the United Kingdom. Switzerland was intent on preserving its seamless robe of neutrality in all directions. Sweden was concerned that its participation should not be on lines that could incur the hostility of her neighbor to the east. Even history could cause division. On the early stages of the work of the Committee I found the French at odds with the Dutch, the Belgians and the Luxemburgers. The French wanted the Recovery Program to be for four years: the Benelux countries thought two would do—enough time, they argued, to repair the damages of war. Neither side would budge. I could not understand why the parties were so unyielding. So one night I had the Dutch and Belgian leaders to dinner and we talked till late into the night, until finally the root of the difference was exposed. With the power vacuum that had been Germany now ruled by the Generals commanding in the four Zones, the only country in a position of power was France. If the Recovery Program lasted for four years and led to full reconstruction, the fear was that France might use its power and attempt to do what Louis XIV had done, namely dominate the Low Countries. Memories of 250 years ago were alive, but as is often the case, once the ghost had been exhumed and seen for what it was, the affair was over and we all settled for four years.

Most of the arguments with the Americans were conducted by the British. It was not that the British Foreign Secretary disagreed with the objectives of the Recovery Program, i.e., the containment of the Soviet Union and the restoration of Western Europe as strong, prosperous and democratic. It was Ernest Bevin who had sprung into action on hearing General Marshall's speech, who made immediate contact with Bidault, the French Foreign Minister, and who organized the different preliminaries to setting up the Committee, including the talks with Molotov who finally withdrew from participation. At that time Britain was the leader in Europe and the only possible leader. Therefore the Americans relied on the British and were

disconcerted to find that their ideas on how to reach the agreed objectives were different. The weight of the arguments fell on Ernest Bevin in London and on me in Paris, as leader of the British delegation and Chairman of the Committee.

What were the differences? They arose because the stance of the British was not the same as that of the Americans. In April 1948, my wife and I were asked to lunch by Mr and Mrs Churchill at Hyde Park Gate. As an aside I might report that as we were shown in, we discovered Mr Churchill seated in an armchair with a kitten on his lap. The kitten was purring loudly. Very agreeable, said Mr Churchill, just like the sound of distant machine-gun fire. After lunch he suddenly took his napkin and with a pencil drew on it three interconnecting circles. "Young man," he said, looking sternly at me, "never let Britain get out of any one of these circles." They represented the three dimensions of British foreign policy, the American dimension, the Commonwealth dimension and the European dimension. In those years after the war the Prime Minister Attlee, and Ernest Bevin, on the one hand, and Mr Churchill and Anthony Eden, on the other, all accepted this view. They were at one in seeing it as the foundation of Britain's power and influence in the world. They all knew that our economy was weak, that much of the national capital had been consumed in the war, that export markets had been lost and that our reserves of gold and dollars were perilously low. But they believed that if Britain stayed firmly within the three circles of her destiny, she would recover and continue as a Great Power and go on being entitled to a seat at the top table where world decisions were taken. Of course they also knew that the nineteenth century had gone. The age of superpowers had come. Britain could no longer decide its foreign policy alone. It could do so only in association with one of the superpowers and that meant with the United States.

But this position carried consequences with it. It was right to press on with great energy in the Committee of European Economic Cooperation to secure European recovery, but not to lose ourselves in Europe, in effect leave the other circles of our life and power. It was important to stay within the circle of the Commonwealth—nearly all of it, with other countries as well, belonging to the sterling area which underpinned British trade and its revival. And most important of all, it was essential not to step outside the circle of the United States.

This stance was the main cause of the arguments between the Americans and the British. The triumvirate, Douglas, Caffery and Clayton, wanted me to agree to integrate the United Kingdom more fully into Western Europe and further to agree to the creation of a powerful international institution that would help towards an integrated Western Europe. I resisted. In the end we compromised. The Recovery Program, in deference to the American belief that it did not go far enough, was called provisional and the Committee

agreed to set up a continuing organization after the Report had been sent to General Marshall. The Committee of European Economic Cooperation therefore met again and finally in March 1948, to set up this organization. There was a major debate about its form. The Americans and the French wanted a strong central organization, with a high political figure at its head, able to take initiatives in policy. The participating governments would only convene from time to time and between these meetings the work of the organization would be carried on under central direction. The British did not agree and argued for a standing conference of all the participating countries in perpetual session with a secretariat designed to serve it and carry out what the standing conference decided, without itself having any powers to initiate policy. In the end the British view prevailed. The Organization for European Economic Cooperation, now the OECD, continues to operate to this day on the model proposed by the British. The event illustrates the reluctance of the British to integrate their political economy so closely into Europe as would, in their judgment, curtail or endanger their freedom of maneuver in the other two dimensions of their policy.

The nature of Anglo-American relations did not basically change during the period of nearly five years when I was British Ambassador in Washington from middle May 1948 to the end of 1952. For the last four years Dean Acheson was Secretary of State. It remained true that the large objectives of foreign policy were shared by the United States and the United Kingdom. I remember Dean Acheson explaining to me at dinner in March 1950, that to perform its global responsibilities, the United States required the support of the other power with global responsibilities, Britain. The situation required "a partnership with Britain."

But it was still the case that the stances of the two countries were different and it therefore required a continuous process of discussion, argument and compromise to find the path for common action in foreign policy. Of course this process took place in the first instance through the close relations of Dean Acheson and Ernest Bevin. But it also took place in Washington through the way in which Dean Acheson and I worked together. You will remember the passage in *Present at the Creation* in which he describes our relations:

> Not long after becoming Secretary of State, I made an unorthodox proposal. On an experimental basis I suggested that we talk regularly and in complete personal confidence, about any international problems we saw arising. Neither would report or quote the other, unless, thinking that it would be useful in promoting action, he got the other's consent and agreement on the terms of a reporting memorandum or cable. The dangers and difficulties of such a relationship were obvious, but its usefulness proved so great that we continued it for four years. We met alone, usually at his residence or mine, at the end of the day before or after dinner. No one was informed even of the fact of the

meeting. We discussed situations already emerging or likely to do so, the attitudes that various people in both countries would be likely to take, what courses of action were possible and their merits, the chief problems that could arise. If either thought his department should be alerted to the other's apprehension and thoughts, we would work out an acceptable text setting out the problem and suggested approaches. Later, comparing the relations between our governments during our time with those under our successors we concluded that whereas we had thought of those relations and their management as a part of domestic affairs, they had regarded them as foreign affairs. The heart of the difference lay in the intimacy, the secrecy and the complete confidence of Sir Oliver's and my relationship during the consultation period.

This relationship was buttressed and enhanced by contact between the members of the British Embassy staff and officers of the American administration. The staff of the Embassy was large: it contained experts by geographical region or by subject matter on nearly everything. Its members were in constant contact with their opposite numbers in the State Department, the Treasury, the Departments of Defense and Commerce. These continuous exchanges gave body and detail to the working out of agreed policies. Anglo-American cooperation on foreign policy was the fruit of a large and continuous range of discussion at all levels.

Nonetheless, there were continually obstacles to agreement that had to be overcome or in some way resolved. I give one or two examples. When the negotiations for the North Atlantic Treaty were near their final stages, there was a sudden difficulty on the American side about the crucial Article 5, which refers to armed assistance being given by other members of the Treaty to any member attacked. This Article ran into difficulty in the course of a debate in the Senate. The State Department was alarmed and wondered whether to omit any mention of military action. At this point Dean Acheson asked my advice on the effect this would have on the other parties to the Treaty. After discussion we decided to go for phrases which in the end were embodied in the Treaty to the effect that each Party to the Treaty would assist the Party attacked by taking forthwith, individually and in concert with the other Parties, such action as it deemed necessary, including the use of armed force, to restore and maintain the security of the North Atlantic area. The Senators were persuaded and the British Cabinet approved the form of words.

The Korean War broke out on 25 June 1950. The British Government at once announced that British naval forces in the Far East would be put at the disposal of the Americans. But what concerned Prime Minister Attlee was the extent to which the Korean campaign might involve large forces and what effect that might have elsewhere. On 6 July he wrote to President Truman asking that the United States and Britain should "look ahead as far as we

can and reach some agreement as to our common policy in these areas in the event of further outbreaks." Political as well as strategic implications should be considered. "My colleagues and I," he said, "attach very great importance to reaching the closest possible understanding with the United States Government so that we can both plan in full confidence that we understand each other's approach to these weighty problems." Almost immediately talks began. They were conducted in great secrecy in the Pentagon. The Marshal of the Royal Air Force, Lord Tedder, who was Chairman of the British Joint Services in Washington, and I represented Britain; the American representatives were Philip Jessup of the State Department and Omar Bradley, Chairman of the American Joint Chiefs. We reviewed the possibilities and likelihood of other attacks being launched in the world across the Pacific and considered what responses might be made. It seemed natural that we should talk in this way at a moment of crisis. Agreed general objectives in the world led to close cooperation on what could or should be done in the light of them.

Then at the beginning of December in the same year the Prime Minister visited Washington. There had been a press conference given by President Truman at which the impression had mistakenly been given that there were circumstances in which the use of the atomic bomb might be considered. The talks were far-ranging: the possible extension of the war in the Far East, the issue of raw material supplies, and Western European defense. Nearly at the end of the conference when the communiqué was being drafted, the President and the Prime Minister went off together and alone to talk in another room. When they returned the President said in effect that in the course of discussing atomic warfare they had agreed that neither of them would use these weapons without prior consultation with the other. At this point Bob Lovett said to Dean Acheson that he foresaw great trouble: he had in mind particularly the attitude of the Congress. In a trice the President, the Prime Minister, Dean Acheson, Bob Lovett and I moved into another room, the President's office. There Dean Acheson proceeded in his words "to unachieve" the agreement just announced. He spoke briefly, with conviction and total mastery of the subject. He explained that there could be no commitment on the part of the President to limit his power to authorize the use of the atomic weapon. The President had himself indicated that he would not change that position, and further Congress would not allow a change.

The argument succeeded and I had to begin drafting a suitable paragraph to insert in the communiqué. The President pulled out a sliding panel in his desk and I had to kneel to write. The President at once observed that he thought it the first time a British Ambassador had knelt before a President of the United States. But once again it was these two powers which conferred on a matter of great importance and in their fashion arrived at an answer.

The Prime Minister heard what the President had said and the communiqué provided an acceptable public answer: "The President stated his hope that world conditions would never call for the use of the atomic bomb. The President told the Prime Minister that it was also his desire to keep the Prime Minister at all times informed of developments which might bring about a change in the situation."

A classic case in which the United States and Britain found means to overcome their separate stances in pursuit of agreed objectives occurred between July 1949 and May 1950. After the North Atlantic Treaty was signed Dean Acheson took up again the twin issues of the original Marshall Plan, the revival of Germany in a European context and the integration of the Western European economies. He made progress on the first of these issues at the Conference of Foreign Ministers in Washington in the spring of 1949. A whole new set of arrangements was made about West Germany, which together started the process by which West Germany was involved "within the framework of a European association," to quote the words of the communiqué. The other issue was to harmonize the Western European economies by a European Payments Union. Here, there were difficulties with the British. In the summer of 1949 Britain was gripped in an economic crisis. The stability of the pound was under threat and the drain on the gold and dollar reserves steadily increased. In July the American Secretary of the Treasury, John Snyder, met with the Canadians and the British in London. At that stage the British refused to devalue the pound, something which the Americans thought necessary. Instead the British asked for various forms of assistance. They made it plain that, unless so helped, they would have to look after their reserves and the trade of the sterling area by taking restrictive action which would drive the western world into separate dollar and sterling areas.

The British attitude caused major concern and dismay among the Americans. If Britain persisted, the liberalization of trade within Europe would become almost impossible, with grave consequences for European integration and the full entry of West Germany into Western European trade. Dean Acheson was determined that this should not happen. He was prepared to take account of Britain's commitments and therefore to think afresh about American policy towards Western Europe. On his instructions, George Perkins, an Assistant Secretary of State, met with the American Ambassadors in Europe and explained that it was vital both to maintain progress on the liberalization of trade and to gain British support for the effort. British support must not require Britain to weaken its ties with the United States or its commitments in other parts of the world. Dean Acheson's thinking on Britain went beyond purely European considerations: it extended to Britain's world position and, according to the briefing paper, to "the deep conviction" shown

by officials in the Pentagon "that the United States needed Britain above everything else."

Dean Acheson therefore worked out a series of measures that would give relief to the British. When these were communicated, the British responded with a substantial devaluation of sterling, in American eyes a necessary first step towards the integration of intra-European trade and the promotion of a general multilateral system of world trade.

When I had dinner with Dean Acheson on 6 March 1950, he talked about the need for new initiatives to strengthen Western Europe and Southeast Asia in the light of the collapse of Nationalist China and the demonstration that the Soviet Union had the bomb. This involved partnership with Britain. He realized that this turned on financial considerations since the British tested American intentions against their effect on sterling, the state of the reserves, and the future of sterling as an international currency. These ideas bore fruit in May 1950. The British brought the sterling area into the European Payments Union: the Americans for their part agreed that payments in gold by Britain to the Payments Union should have a limit and that beyond that they could rely on special assistance from the United States. In addition there was an escape clause to allow the British to reimpose quantitative restrictions on imports if the reserves came under too great a strain. These arrangements were then approved by the Organization for European Economic Cooperation.

The two stances had been reconciled. The Americans had gained their large objective. The European Payments Union came into being as a major contribution to a multilateral trade and payments system in Western Europe which included West Germany. The British had stubbornly argued their case but in the end had been ready, with American help, to compromise. Their position as the upholder of the sterling area had been rendered compatible with entry into the Payments Union.

Before these meetings in London in May 1950, a draft paper had been prepared by American and British officials setting out the general heads of agreement finally reached about Britain and the European Payments Union. In the course of the paper reference was made to the "special relationship" between the United States and Britain. When Dean Acheson read this, he was extremely displeased. He had all the copies of the paper he could lay hands on destroyed. It was not that he doubted the existence of the special relationship. He simply thought it was folly to talk about it, which could only raise international suspicion. It was not the content of the paper that annoyed him: it was the import of the phrase.

Was there a special relationship between the United States and Britain during my period in foreign affairs? The first thing to say is that to the best of my recollection neither Dean Acheson nor I ever used the words, either in public or in conversation with each other. It was not part of our language.

Yet here it was, bobbing up in a joint paper in London, its appearance in print denounced by Acheson at the same moment as he affirmed that it did indeed exist.

In the two-volume edition of the Oxford English Dictionary, "special" is defined as "of such a kind as to exceed or excel in some way that which is usual or common: exceptional in character, quality or degree." That seems to me an objective definition to describe a factual situation. Now the debate over the special relationship has focused upon two alternative interpretations. One is that it is subjective, essentially portraying and evincing a sentiment. The great author of this view was Mr Churchill. He clothed it in his own splendid language, speaking of our common heritage and the unity of the English-speaking peoples and suggesting an immemorial affinity between the United States and Britain. No doubt this holds for the war years, but the question is whether it holds for my period in foreign affairs. Should the special relationship be conceived in terms of sentiment or is its foundation essentially to be looked for in the manner in which the two countries actually conducted their affairs together?

In my period I do not think the special relationship was really an affair of sentiment. I do not believe that its roots were subjective and symbolic. They were rather to be found in two interconnected facts.

The first is the general identity of interest which linked the two countries. Dean Acheson viewed our relations as those of partners. I would add, of unequal partners. At that time the United States claimed the Pacific for itself. It also considered its relations with Latin America its own affair. Anglo-American relations in foreign policy covered the Atlantic and the whole Old World up to China. Then, and a more important limitation, there was the inequality of power between the two partners. The United States stood pre-eminent in military power and in the vast productive strength of her manufacturing and agricultural enterprises. The United States was a superpower with global responsibilities; it accepted these responsibilities and was prepared to lead. By contrast, Britain had been gravely weakened by the Second World War. And yet in this period Britain still had global responsibilities: Britain was a member of the Security Council of the United Nations; it had considerable military strength and was making the atomic bomb; it stood at the center of the Commonwealth and the Sterling Area; it was a leader in Europe. Britain was not just another power. The difference was that the United States could pursue an independent foreign policy. Britain could not; it could act only in concert with a friendly superpower. In 1947 to 1952 that superpower was without question the United States. Britain could undertake major initiatives in foreign policy as Ernest Bevin did with the North Atlantic Treaty, but in the last resort the decision to begin serious negotiation rested with General Marshall. Britain needed her association with the United States, but on the other hand the United States needed Britain

if its policies were to be effective. That is why Dean Acheson placed emphasis on the fact that British and American interests were either the same or very close in all parts of the world and held that therefore the policies of these two countries should be aligned as closely as possible. They should be working partners.

The second fact is that to translate common aims into agreed action required constant and close consultation and cooperation. All the more because of the different initial stances of the United States and Britain, the different perspectives, the different background of their histories. Translation into action was hard work, and involved a real opening of minds. This working relationship became so close that Dean Acheson could say, as I have already quoted, that he and I came to think of relations between our governments and their management as a part of domestic affairs. This is why Dean Acheson consulted so frequently with Ernest Bevin. It explains why Dean Acheson and I, as he states, met regularly, frequently and alone. And in somewhat the same way, open and regular discussion took place between the officials of the British Embassy and those of the State Department, to an extent that placed them on a different level from the normal cordiality of allies. That is what made possible the resolution of most difficulties that arose from our different stances, or, if at the time they could not be resolved, the handling of them in a way that prevented any breakdown of relations. A case in point is Ernest Bevin's decision to give *de facto* recognition to Communist China, telling Dean Acheson that there were some factors that affected Britain specially. The Secretary of State replied that "the views of states differ and each has to act from its own immediate and long-term interest."

What then is to be said about the "special relationship"? In my time Dean Acheson accepted that it existed. I agree with him. Of what did it consist? In the first place of a broad identity of views on the main issues of foreign policy, the containment of the expansionist tendencies of the Soviet Union, and the recovery of a strong, prosperous and defensible Western Europe. Richard Ullman is right when he observes that "without the spectre of Soviet expansionism seemingly ever present, the Anglo-American relationship might have taken a quite different course." Everyone knows the positions Dean Acheson held. But Ernest Bevin did not differ. He presented a paper to the British Cabinet in January 1948, in which he said:

> The Soviet Government has formed a solid political and economic bloc. There is no prospect in the immediate future that we shall be able to re-establish and maintain normal relations with European countries behind their line. Indeed we shall be hard put to it to stem the further encroachment of the Soviet tide. This in my mind can only be done by creating some form of union in Western Europe, whether of a formal or informal character.

In the second place, this basic agreement, as I have explained, led to close cooperation at all levels on the problems of foreign policy as they arose. These habits of working together engendered and were in turn enhanced by a feeling of mutual trust and confidence. The special relationship was not a mystique of the shared inheritance of the English-speaking peoples. It arose out of common aims and mutual need of each other; it was rooted in strong habits of working together on which there supervened the sentiments of mutual trust. Those sentiments were important because they facilitated agreement and the resolution of problems. But the special relationship consisted not of sentiment but of the exceptional and unique degree of collaboration between the two powers.

Fall Semester 1989

Open and Secret War 1938–1945

M. R. D. FOOT

T his lecture will seek to map in outline part of what David Dilks and Christopher Andrew have called the "missing dimension" in twentieth-century historical studies: the work of the secret services and the influence they exert on policy.[1] It will include some reflections on how British strategy was formed, and indicate one or two paths down which research might well go next.

The government of England has been conducted, in accordance with ancient tradition, by divers groups of people whose spheres of authority overlap: noblemen, lawyers, clergy, orators, entrepreneurs and so on. Overlapping circles of influence were drawn by Anthony Sampson in the original edition of his *Anatomy of Britain* to illustrate the world of the nineteen-sixties; they can be projected forwards as confidently as backwards. The innermost of these governing circles, one of the smallest yet by no means the least powerful, contains the monarch and the Secret Services.[2]

By the late nineteen-thirties, everybody who cared to look could see war with Hitler's Germany on the political horizon, though it was excessively inconvenient to admit the fact. At this time there were three secret services: the security service, generally called MI5; the secret intelligence service, conveniently known as MI6; and a small decipher staff, concealed behind the cover of the Government Code and Cypher School [GC and CS]. Originating in the Admiralty during the Great War of 1914–18, the Cypher School had been amalgamated with the Army's deciphering teams early in the twenty years' truce. By the 1930s it came under the nominal direction of the Foreign Office. A few survivors of the greatest days of Room 40, Admiralty O[ld] B[uilding], where they broke the cyphers of the High Seas Fleet, were still with it; how efficient it was remains a secret.

That anything from so long ago can remain a secret will puzzle an American audience, but in England there is no right to know; no Freedom of Information Act, and a strong tradition in favor of what old dons call

confidentiality. Abrasive investigative journalists, of newspaper or television, seem to think no secret worth keeping for fifty minutes, let alone fifty years; the innermost English do not think so. Apart from anything else, it would be thought the depth of bad manners to reveal to any foreign country that its diplomatic codes had been broken.

Such break-ins were not then uncommon. Mussolini had been able, all through the Ethiopian crisis of 1935, to read all the telegrams the British Foreign Office sent to Rome, not because his staffs could decipher them, but because they were stolen for him in clear by the major-domo at the Embassy, an official so competent that the new British Ambassador there in 1946 was only with difficulty dissuaded from re-employing him. But this was plain espionage, not decipher. Hitler was better served than Mussolini in the thirties: all through the Czechoslovak crisis of 1938, which culminated in the Munich agreement at the end of September, he read the whole of the British, French and Czech diplomatic cable traffic, which his *Forschungsamt* was able to unravel quite as fast as the official cipher clerks on the other side. Historians working over the crisis have been aware of this for some time, but it has hardly penetrated into public consciousness at all: a sign perhaps of how hard it is for historians to dislodge a myth once one has been firmly implanted by journalists.

Controversy goes on whether the Munich agreement was an ignoble or a necessary surrender; it may have been both. One further factor needs to be adduced in this debate: a matter not of Secret Service, but of secret equipment.

The public followed Baldwin, Prime Minister until 1937, and the novelist H. G. Wells in the belief that the bomber would always get through. The air staff began to develop private doubts based on an invention made by the now half-forgotten Watson Watt in 1935: then known as radio direction finding, RDF, now familiar as radar.

Even within the Air Ministry, few knew about RDF in the early stages; and though those in the know included the Chief of the Air Staff, it was some time before he bothered his colleagues on the Chiefs of Staff Committee on so technical a point. By September 1938 there were just two radar sets that worked in England: one at Edith Cavell's birthplace at Bawdsey on the Suffolk coast where the first tests had been made, one at Dungeness. Their arcs of observation did not quite overlap; the cover they provided was minimal, wholly inadequate against Goering's Luftwaffe. By September 1939 there was a whole chain of interlocking RDF stations which reached from Hull to Portsmouth; and by July 1940, when the nation's safety hinged on it, the chain reached from Edinburgh to Land's End, with an outlier at Scapa Flow: enough, but barely enough, coverage.

It may be that I lean too much on the importance of RDF; if so, it is due to ocular evidence. All through August 1940 I was an eyewitness, at RAF station Hornchurch in the Thames estuary, of how critical its help was.

Hornchurch, now covered by a housing estate, lies on the Essex flats east of London right in the throat of the main German daylight assaults on the capital. With RDF's help, the three fighter squadrons at Hornchurch could be flown off at judicious intervals to intercept each attack, instead of wasting time, fuel, and energy on patrols. Air Marshal Dowding, alone in Fighter Command, was eventually privy to Ultra Secret signal intelligence about the enemy's intentions, and made invaluable use of it; down at station level no one even dreamed of its existence, RDF was miracle enough.

Moreover, about ten minutes before each major raid set out from the airfields behind Calais, a plot would start to appear on the Hornchurch operations room plotting table, one presumed by most of us to be RDF detection of the bombers as they circled round to gain height. We now know from Aileen Clayton that these plots came from the "Y" service, which listened to the German pilots' chatter as they tested their radio-telephone sets before they took off.[3]

About the Y service, with the single exception of Aileen Clayton's book, hardly anything is known, except that it went back to the previous world war, when it was useful against the Bolsheviks around the Caspian as well as on the western front. Inquiries about it tend to meet a blank wall of feigned incomprehension: a suitable line to take about a weapon certain to be of future use, against any enemy who has not got the sophisticated R/T that enabled senior officers in the Falkland Islands to talk securely to senior and remote personages in England during the campaign in 1982. Our lack of knowledge of the Y service may be another instance of patchy cover that will eventually give way to full disclosure when technology has marched a long way forward. Meanwhile I owe it to Ronald Lewin's ghost to remark that he was endeavouring to open this subject up himself just before cancer carried him off in 1984.

The eagerly awaited second volume of David Dilks's life of Neville Chamberlain may fill in a little of the missing dimension; it will be interesting to see what explanation Dilks gives of government's understanding of the nature of the threat from Nazi Germany as war became imminent.[4] There may yet be secrets to be prized out of the MI6 papers, supposing any can be found, to indicate what warnings the British got that the storm was about to break.

Once it did so, Secret Services began to multiply. All told, so far as I know, they ran to eight before the war was over; there may have been more. MI5, MI6 and GC and CS continued in being; all three expanded very considerably in size. In close conjunction with MI5, and later with MI6, there developed a Radio Security Service (RSS), which maintained a permanent watch on every wireless wavelength, and took steps to account for every transmission from British-occupied soil. In close conjunction with MI6, a new service called MI9 was begun in late December 1939 to handle escapes,

evasions, and the forwarding of intelligence by British prisoners of war out of enemy prisoner-of-war camps. MI9 broke MI6's monopoly of secret activity outside the bounds of the British Empire; MI6 believed it to be under its wing.

The same could certainly not be said of the Special Operations Executive (SOE), formed in a great hurry in July 1940 to undertake subversion and sabotage in enemy-occupied territory. SOE's founding charter was written for it by Neville Chamberlain as the last important political act he ever performed; its real creator was Winston Churchill, the new Prime Minister, who set it on course with the by-now almost hackneyed phrase, "And now, set Europe ablaze." SOE was made up from three pre-existing tiny bodies which had been studying aspects of the problem for several months past: MIR, a research branch of the War Office; section D (presumably for Destruction) of MI6; and EH, a semi-secret propaganda branch of the Foreign Office.

C, as the head of MI6 is known in Whitehall—the first holder of the post (Sir) Mansfield Cumming used to sign his minutes by the first letter of his surname as an elementary security precaution—was angry that SOE had been set up at all to break his quasi-monopoly; he was angrier still when he discovered that no one remembered for five weeks to tell him that his section D had been struck off his strength and removed from his command. In that furiously hectic summer of 1940, the few people in the know had been too busy to remember to inform him. For the rest of the war there seemed to be a brisk rivalry between MI6 and SOE, which is continued to the present day by a few disgruntled gossipers and veterans of both camps.

There was one sound professional reason for the rivalry between these two services, much more important than the trivial discords of gossip and innuendo. SOE was frankly out to raise hell: to create conditions of unrest, mayhem even, in every area in which it operated. When it was doing most good, it was bound to attract Nazi police attention. This was precisely the opposite of what SIS's agents required: they needed minimum police presence, nothing beyond a few somnolent and if need be bribable local constables. Tiresome though the rivalry sometimes was, at least it was not as bitter as the rivalry between the *Abwehr* and the *Sicherheitsdienst* in Germany, which ended for the head of the *Abwehr* on the execution ground at Flossenbürg.

The summer of 1940 saw at once the foundation of SOE, and a triumph as well as a disaster for MI6. MI6's triumph was secured for it by GC and CS; but by a particularly deft stroke in secret service politics, the new C (there had been a change, brought on by the death of the previous head of the service, in November 1939) managed to take political responsibility for the discoveries made by GC and CS. It was he (Sir) Stewart Menzies who laid them—as often as not, in person—before Churchill, and on him that the kudos came to rest.

Thanks to indispensable Polish and French help, and to some indiscretions by Luftwaffe signals operators, Ultra came on stream in serious quantity in mid-May 1940, thus producing a neat paradox in military history. The French and British armies in France were provided with exceptionally complete intelligence about the order of battle of their opponents, always the apple of any intelligence officer's eye; thus equipped, they underwent an ignominious defeat. Thenceforward GC and CS produced, through MI6, marvellously valuable news about what the enemy was saying to himself and some absolutely priceless indications of his intentions, both short term and long.

Yet it is important to recall two limitations on Ultra intelligence. It was not complete; and it had to remain deadly secret. At the back of each of his scholarly volumes of assessment of the strategic contribution of British intelligence to the winning of the war, F.H. Hinsley prints lists of which Enigma ciphers GC and CS did, and which it did not, break—with dates: an invaluable corrective to the idea that All Was Known.[5]

The extreme secrecy of Ultra needs to be stressed. Commentators are now fond of saying "but the Allies knew" of this point or that; how many of them? In Downing Street itself, the secret was kept so close that one of the private secretaries, who was not in the know, supposed that another, who was, was a sort of supernumerary courtier, hanging about waiting for odd jobs.[6] Group-Captain Frederick Winterbotham, who first broke the subject to English readers—it had come out eighteen months before in French, and seven years before in Polish—suggests that it was he himself who handled the flow of information from Bletchley Park, where GC and CS had its main station, to 10 Downing Street, the office of the Prime Minister. In fact if anything of real importance cropped up, C brought it around himself; and when he appeared, by a strict rule, he saw Churchill alone. The innermost secretaries, the most confidential typists, Privy Councillors, members of the War Cabinet, Admirals of the Fleet, Mrs Churchill herself, were all turned out of the room: C and Churchill met alone. What they then talked about we are unlikely ever to know. At any rate the papers so far released from Bletchley are crammed full of military detail, usually minor, but say hardly anything about politics.[7]

MI6's disaster is much less well known than its triumph, but deserves a word. By old custom, C ran most of his agents in northwest Europe through an office in The Hague. A junior officer there in the middle nineteen-thirties had gotten into money troubles and was recruited by the Gestapo. The British soon found this out and dismissed him; but they did not take in that he had revealed to the Germans not only where the front office was, but where the real work was done. Opposite the latter building, a villa on a canal bank, the Germans moored a houseboat in 1935 and photographed for five years all comings and goings.

When the Germans captured The Hague in May 1940, they raided the villa. All the birds had flown; but they found an overlooked scrap of paper with all the staff's addresses on it, and at one of those addresses they found an account book, with every detail of payments for five years past. They thus had identities for all their photographs, and during the next two months they cleaned up all C's left-behind agents in Denmark, Holland, Belgium, and France. A deafening silence resulted in Whitehall. Luckily for C, he could partly fill it in with Ultra reports, for which the original cover was that they came from an exceptionally well-placed agent in Berlin, code-named "Boniface".

With the help—indeed through the agency—of Polish, Norwegian, Danish, Dutch, Belgian and French patriots in exile, and with a great deal of dangerous and highly motivated help from citizens on the occupied ground, C was able to get a flow of secret information from the continent restarted. The thought cannot help darting—were all these intelligence circuits, raised and maintained at such risk, nothing but a gigantic insurance policy in case the Germans changed their cipher system to one Bletchley could not read? The Germans after all had invented the one-time pad system, wholly impenetrable (in those days at least); might they not, one day, revert to it?

They did not; their Enigma machines were so much more convenient than one-time pads, and seemed—so they often reassured themselves—almost certainly secure. The gigantic apparent mathematical odds against breaking any given Enigma message blinded them to the fact that there are only twenty-six letters in their alphabet. It would be madness for a non-mathematician to try to probe the intricacies of decipher, which Hinsley's team in the official history leaves severely alone.

In fact, the data brought in from decipher, from air photography and from the new intelligence circuits complemented each other: they could be interlocked by a few well-placed analysts such as R.V. Jones, to provide (as it proved) a complete and accurate picture of enemy strength and dispositions.[8]

One of these senior analysts, Leo Long in MI14—not itself a secret service, the army intelligence branch that dealt with the German army—was a Comintern agent, recruited by Anthony Blunt in MI5 who was also privy to Ultra; so the Soviet government must have been aware of GC and CS's successes, even if it knew nothing of GC and CS's methods. How much Ultra material was in fact officially passed by the United Kingdom to the USSR, and by what channels it travelled, are interesting but as yet unanswered questions. If the current new mood in Moscow lasts, there may be important discoveries to be made there. It is known that the work of Alan Turing and his fellow geniuses at Bletchley was being matched by the work of William Friedmann and his fellow geniuses in the United States who unravelled the Japanese "Purple" code; one day historians may be allowed to know whether the Russians were then playing in the same league.

The roll call of Secret Services on which this lecture embarked earlier is still not complete; only six of the eight have been covered. The two so far left out were the Political Warfare Executive (PWE) and the Deception Service, known as the London Controlling Service (LCS).

SOE as it was originally founded, in a tearing hurry, in July 1940 was to have covered political warfare as well as sabotage and preparations for insurrection. Given the structure of Whitehall at the time, and the proud and petulant personalities of some of the principal ministers involved, this did not turn out to be a practicable system. Thirteen months' bitter internecine interdepartmental warfare, involving the Foreign Office, the Ministry of Economic Warfare, the Ministry of Information and the BBC as its main contenders, with occasional interventions from the three service departments, the Colonial Office, the Dominions Office, the India Office and the Home Office, resulted in August 1941 in a treaty between the Foreign Office and the Ministry of Economic Warfare, under which SOE surrendered its political warfare branch (called SO 1), which turned into a quasi-independent PWE: mainly under Foreign Office control, though MEW (and SOE acting through MEW) could have a voice in what it decided. There is a subject here for a riveting thesis on bureaucratic warfare at a moment of national danger, if only someone can be found with access to such documents as survive and understanding of political character to complete it.

David Garnett, who was in it, wrote a good short history of PWE; it has never been released for publication. Similarly, W.J.M. Mackenzie—later Professor of Government at Glasgow—in the late nineteen-forties wrote an excellent history of SOE, which has been read by many official historians and from which extensive quotations have been made by the late Elisabeth Barker; that too is still at present under wraps.[9] However, as part of the "Waldegrave initiative" for more open government, authority has now (1994) agreed in principle to release the surviving archives of SOE—after laundry— to the Public Record Office. Seven-eighths of SOE's original archive have already vanished down the gulf of time: more probably to save space on archive shelves than to cover up past enormities.

SOE, controversial from start to finish, continues to arouse enmities and enthusiasms. Brisk debate goes on at the moment about the reasons why SOE switched support from Mihailovic to Tito in Yugoslavia; presumably this will be settled when the impending official history of SOE in Yugoslavia by Mark Wheeler of Colorado, an American historian with full access to the surviving British secret papers, finally appears. To the inexpert, it looks as if the switch was made for the simple reason that Tito was killing Germans, while Mihailovic was biding his time; those who love conspiracy theories of history are sure that it was all due to machinations in Cairo by former Cambridge Communist Party secretary James Klugmann. Klugmann lived

to be ordered by his party to write a book denouncing Tito for having betrayed the Communist cause; a neat little example of history standing on its head.

Not quite all of SOE's activities are fit for the light of day, even now. For example, it has now emerged that Admiral Darlan, who was killed in Algiers on Christmas Eve 1942, was shot by an officer who belonged not only to a group of fanatical French royalists but to the local training section of SOE. That he was acting on any sort of orders from his superiors in SOE has been officially denied, probably quite rightly. There are a few sensitive points into which even Clio had better not probe yet, if at all.

Ronald Lewin once remarked that, in the light afforded by the Ultra telegrams, it would be worth having another look at the East African campaign of the winter of 1940–41, in which the Italians were driven out of Somaliland and Ethiopia. SOE also played a small part here, sending a camel-borne expedition into western Ethiopia from the Sudan which was accompanied by Emperor Haile Selassie. A ludicrous side issue of this campaign may help to account for the disdain that the high command often showed for SOE, which seemed to be carrying rather far Churchill's instruction that it was to be the department of ungentlemanly warfare.

A junior officer on this western expedition, on detached duty, sent a ciphered message (he did his own ciphering) to a friend who was in charge of the expedition's main base at Khartoum. He was surrounded, he said, by hordes of delectable young women, all anxious to share his bed; so far as he could judge, they were all riddled with syphilis; please, *please* could his next supply drop contain some protective equipment? He did not know, though his friend did, that all the telegrams exchanged by this expedition were read by Generals Wavell, Platt and Cunningham, who formed their own sharp opinion about the morals and discipline of SOE's officer corps.

There were points to be argued in favor of SOE, as well as points against it. Of its enormous importance in helping to restore a sense of national self-respect to countries that had lost it when overwhelmed in the military catastrophies of 1940–41, a little has been written and much remains to be conjectured.[10] This was probably among SOE's most important achievements. So was something it did before its political wing had been shorn off it in the winter of 1940–41. Under the guidance of (Sir) William Stephenson, who died recently, it helped to persuade the bulk of United States newspaper owners and broadcasters that to be anti-Nazi rather than to be isolationist was a more constitutional attitude for the United States to adopt. This was a world-shaking shift in opinion, for which SOE must not dream of claiming the full responsibility but for which it deserves to receive a share of the praise.

Moreover, and unusual, for a fighting service, SOE ended up with its accounts in the black. Its rear party, winding it up in the spring of 1946—it had been disbanded on 15 January of that year—received a form letter from the Treasury in mid-March, reminding them that they were to return anything

they had in their kitty to the Treasury on 3 April 1946, the last day of the financial year. SOE returned twenty-three million pounds, most of it in United States dollars.

Secret Service finance is now an aspect of secret service from which historians in the United Kingdom are permanently barred—perhaps rightly; but a guess can be ventured about where most of this money came from. One of SOE's more wayward agents was Walter Fletcher, born Fleischl, a rubber merchant who weighed over 250 pounds (airlines always counted him for two) and was a highly persuasive talker. He coaxed £100,000 out of SOE (he had asked for half a million) in order to extract rubber from the occupied Dutch East Indies, now Indonesia. When over a year had passed, and not a pound of rubber had appeared, Fletcher was told to shut up shop. He proposed instead to go to China. SOE, he was warned, was not allowed to operate in China, which lay within the American sphere of clandestine influence. He was unworried, he was not going to operate, he was going to win friends and influence people. He made so many friends among Chinese tycoons that he secured £77m in hard cash, most of it US dollars, partly on the currency black market, partly in return for fine watches obtained in Switzerland and smuggled out by SOE's F section agents, who thought they were smuggling gun sights for the RAF.

A prevalent American belief seems to be that clandestine services are a mistake—that, if they exist at all, they ought only to operate under close control of Congress and of the news media. This belief does not seem valid to the present writer; the history of SOE, for all its waywardnesses, does seem to indicate the contrary. A secret service, under proper secret control, provided that the control is exercised by an elected personage—and the obvious personage in the United States is the President as Commander-in-Chief—can be an enormous influence for good.

There is a short proof of this in the work in the war against Hitler of the LCS, the deception service. With the help of section B1a of MI5, the security service, and of GC and CS, the decipher teams at Bletchley—observe how closely components of an efficient secret world interlock—the LCS was able to mount operation "Fortitude" in the spring and summer of 1944. "Fortitude" convinced Hitler that, despite his own judgment to the contrary, the main allied effort for the invasion of Europe would come just where his own general staff had told him it would have to come, to the east of Normandy on the steep-to-sandy beaches south of Boulogne. The invasion of Normandy was therefore a feint, intended to draw his forces westward while the army that he knew from his agents had been assembled in Kent and Essex under General George S. Patton was waiting its moment to strike eastward at Germany's heart. Hitler hardly moved a man west of the Seine in June 1944, thus enabling the Allies to secure a firm base in Normandy from which, at the end of July, Eisenhower could release Patton—the locations of whose

vast army had been notional, created by the LCS's wireless operators—in a great right hook that all but encircled the German army. It was a triumph of maneuver on the ground; it owed much of its success, and the saving of thousands of lives, to a few devoted staff officers working underground at the south end of Whitehall.

Spring Semester 1989

NOTES

1. Christopher Andrew and David Dilks (eds.), *The Missing Dimension: Governments and Intelligence Communities in the Twentieth Century* (London, 1984).

2. Anthony Sampson, *Anatomy of Britain* (London, 1982).

3. Aileen Clayton, *The Enemy is Listening* (New York, 1982 edition).

4. D.N. Dilks, *Neville Chamberlain*, vol. I (Cambridge, 1989).

5. F.H. Hinsley and others, *British Strategic Intelligence in the Second World War*, 3 vols. (London, 1978–88).

6. Sir John Colville, *Fringes of Power* (London, 1985), pp. 59–60.

7. Public Record Office, Kew, DEFE/3.

8. See R.V. Jones, *Most Secret War* (London, 1978).

9. Elisabeth Barker, *British Policy in South-East Europe* (London, 1976).

10. M.R.D. Foot, *Resistance* (London 1976, New York 1977). The rest of this lecture is based on extensive readings, not all of them admissible, in British open and secret archives.

6

Personalities and Appeasement

DONALD CAMERON WATT

Central to the examination of British policies during the era of appeasement is the personality of Neville Chamberlain, Chancellor of the Exchequer from 1931–1937, Prime Minister from 1937–1940.[1] In these years he had two predecessors as Prime Minister, Ramsay MacDonald, who with three or four other leading Labour party figures had set up the National Government in 1931, to see themselves disowned by their party, and Stanley Baldwin. Both had had their main energies absorbed in keeping the variegated coalition of National Labour (so-called), National Liberal and Conservative parties together. Baldwin had had in addition to cope with taking the issue of British rearmament to the country in the 1935 General Election and with Edward VIII and the abdication crisis. Neville Chamberlain played a major part in the debate over rearmament, and tried and failed to persuade the Cabinet into a rapprochement with Japan in 1934[2] and again in 1936. Long before Baldwin finally resigned after the coronation of George VI in May 1937 and retired to the House of Lords, Chamberlain was widely recognized as the dominant figure inside the Conservative party, and as Baldwin's natural successor to the premiership.

The key to Neville Chamberlain is his parentage and his age. In domestic affairs he was the social reformer, radical, statist up to a point, concerned with the alleviation of poverty.[3] In international affairs he was a liberal imperialist concerned with maintaining Britain's wealth, strength and leadership, as the center of the emerging Commonwealth and the financial center of the world outside the dollar area. He was a managerial social imperialist concerned with the modern and the up-to-date, with efficient administration, free of rhetoric and emotion. He also shared many of the prejudices of bourgeois radicalism in matters international. He distrusted the French, but distrusted the professional diplomatist more. He disliked alliances, which, he felt, bred war rather than prevented it. He loathed war itself as wasteful of life and treasure and destructive of the international polity

on which Britain depended. He distrusted rhetoric and he distrusted public opinion, prone as it was, as he saw it, to great waves of irrationality, ranging from panicking pacifism to unreasoning jingoism. Most of all he distrusted the two future superpowers, the United States not only for its apparent belief in rhetoric and gesture, but also for the exceptionally hard bargains it could be expected to drive if real help was on offer. He also distrusted the Soviet Union because British intelligence depicted the Soviet leadership as constantly engaged not only in subversion within Britain and the Empire, but also in a policy designed to embroil Britain and France in a European war.[4] So far as was possible he wished to see European problems solved by the European great powers of which Britain was, by virtue of her Empire and Commonwealth, both the dominant power and the least directly involved.

In terms of guidance on all matters save in diplomacy, Chamberlain trusted his expert advisers. While at the Exchequer these were primarily two in number, Sir Warren Fisher, head of the Treasury since 1919, and Sir Maurice Hankey, Secretary to the Cabinet and to the Committee of Imperial Defence, which had existed since 1905 to coordinate British defense and foreign policy and to ready British government for total war. Fisher, virulently anti-German, disliked and distrusted the United States, and regarded the various Chiefs of Staff who served alongside him, with one or two exceptions, as strategic incompetents incapable of rising beyond the needs of their own particular service.[5] He was obsessed with Britain's vulnerability to air attack. Hankey, a former colonel in the Royal Marines, resented Fisher's interference in matters military, while sharing his distrust of the United States.[6] Hankey had less time than Fisher for Europe and much more for the emergent Commonwealth. For him isolation from European squabbles and the containment of Japan were the priorities. Both he and Fisher regarded the alienation of Italy over Ethiopia and the Spanish Civil War as an idiocy and a luxury Britain could not afford.

When Chamberlain became Premier, however, he built up a new staff at No. 10 Downing Street.[7] Three figures were central: Sir Horace Wilson, who held the rank of Chief Industrial Advisor to the Cabinet and succeeded Fisher in 1938 as Permanent Under-Secretary to the Treasury; George Steward, the press secretary inherited from his predecessors; and Sir Joseph Ball, head of the Conservative Party research department, a former operative in MI5, the British security service, and No. 10's liaison with MI5, MI6 and with the embryo clandestine propaganda machinery established in 1936 at Electra House.[8] Ball had links with the right-wing weekly, *Truth*, which he used as a propaganda vehicle against the Conservative opposition, especially Churchill.[9] From MI5 Chamberlain knew of the less diplomatic aspects of the Czech and Soviet embassies in London, of the money they used to back his Conservative and Labour critics and organizations and of the information and misinformation supplied by those embassies to those critics.[10] Sir Reginald

Kell, head of MI5, regarded it as his duty to keep an eye on all this and to inform No. 10 about it. Evenhanded in everything, Kell also felt it his duty to inform the Permanent Under-Secretary in the Foreign Office of No. 10's incursions into diplomacy.[11]

The two most frequent offenders here were Steward, who went out of his way not only to cultivate his opposite numbers at the German embassy but to depict the Prime Minister as more sympathetic to German aspirations than the Foreign Office,[12] and Sir Joseph Ball. Ball it was who from 1937 onwards managed the "secret channel", which led from No. 10 via the legal adviser to the Italian embassy in London, Adrian Dingli, to the ambassador, Count Grandi, and his number two.[13] Steward briefed the lobby correspondents of the British press.[14] Ball made sure the newsreel companies reported all British government moves, and Mr Chamberlain's in particular, in suitably "gung-ho" terms.[15]

Chamberlain's dominance over his own party was ensured by the Chief Whip, Captain Margesson. It was his task to keep the Conservative dissidents isolated, to put them under constant pressure from the party organizations in their constituencies, to divert patronage away from them, and to make sure their ostracism by the bulk of the party was as complete and permanent as he could make it. His problem, given the pluralist nature of English society, was that there were networks and social linkages he could not penetrate, areas of British society open to a relative of the Duke of Marlborough who regarded him and the Prime Minister as social *arrivistes*, clubs which were not prepared to exclude members on a nod or a wink from the Whip's Office. What he could do, however, he did most efficiently.

Chamberlain was further served by a group of ambassadors abroad, most notably Lord Perth, the ambassador at Rome until May 1939,[16] Sir Eric Phipps, ambassador at Berlin from 1934–1937, and at Paris from 1937–40, and his successor at Berlin, Sir Nevile Henderson.[17] Their official reports went to the Foreign Office; their private correspondence, as often as not, went also to the Prime Minister and, at least where Phipps was concerned, to Sir Horace Wilson.[18] Other loyal Chamberlainites were the junior ministers in the Foreign Office, R.A. Butler, and Lord Dunglass who, in his later reincarnation as Sir Alec Douglas Home, was to be Macmillan's Foreign Secretary and successor as Prime Minister, and Foreign Secretary to Edward Heath. Sir Henry "Chips" Channon, a wealthy American who anglicized himself, married into the Guinness fortune and idolized Chamberlain, was another junior minister.

Chamberlain dominated his Cabinet; but he cannot be said either to have liked them individually or to have had any very close allies, save for the two former, perhaps failed, Foreign Secretaries, Sir John Simon and Sir Samuel Hoare. As a National Liberal Simon presented no challenge to Chamberlain's leadership. He was a highly accomplished professional politician whose service

in the House of Commons almost rivalled Churchill's. But he had resigned from the Liberal Cabinet over the issue of conscription in 1915. It had taken him sixteen years to find his way back into office. He was not going to resign again. Hoare was gutsy, intelligent, but accident-prone. Of all Chamberlain's Cabinet he was the one that Churchill, on becoming Prime Minister, exiled the soonest, sending him as ambassador to Spain. He was close friends with the Astor family and with Lord Lothian, had a background in British intelligence in the First World War which covered both Italy and Russia, had been a very popular Air Minister in the 1920s when he had built up Britain's imperial air routes, and had piloted the Government of India bill through parliament in a two years' epic fight against the Tory imperialist right. In 1939 he was to emerge as one of the strongest advocates of an alliance with the Soviet Union.[19]

Of the others, Hore-Belisha in the War Office, Jewish and a great publicist, was fighting a desperate battle to modernize the administration of the War Office. In 1938 he had sacked the entire Army council. His reward was the hatred and detestation of all the leading figures in the military hierarchy, and the blackballing of those original maverick minds he picked out to improve matters. Had he had the judgment to pick military winners this would not have mattered. He did not, however. He used Captain Liddell Hart as his adviser until he recognized Hart as the isolationist he was. But the successful generals and Field Marshals of the Second World War all advanced while he was War Minister. He gave them the framework for a modern mass conscript army. He was no appeaser for the sake of appeasement.

The Admiralty was not so fortunate. Its First Lords under Chamberlain were Duff Cooper, a man of honor, whose political clout was weakened by his well-deserved reputation for indolence and good living, and Lord Stanhope, generally regarded as an ageing drunk, whose main use to Chamberlain was as a representative Tory peer and landowner. The Air Ministry was led by Sir Kingsley Wood, a shrewd city lawyer, with excellent political instincts and the ability to listen to his advisers without being dominated by them. For the remainder of his Cabinet—National Labour such as de la Warr and Malcolm MacDonald in the Colonial Office, the Scots Tories Walter Elliot, Euan Wallace and Jock Colville, the English landowners Oliver Stanley and Thomas Dugdale, the businessmen such as Morison or Leslie Burgin—Chamberlain had only contempt. Stanley, with the Derby family and their dominance of the Lancashire constituencies, was the strongest. After Munich he warned Chamberlain that he would resign rather than accept another such act of appeasement. Chamberlain regarded this as mere wind.[20]

In the whole Cabinet Chamberlain had one friend and ally, Edward Wood, Lord Halifax. As a peer he represented no threat to Chamberlain's premiership; which was just as well because in 1940 the Labour Party were,

for a moment, prepared to serve under him as Chamberlain's successor. In the Baldwin Cabinet Halifax held a watching brief over Foreign Affairs. In March 1936 he accompanied Eden to Paris to ensure that Eden was not carried away by those Frenchmen who wished to meet Hitler's remilitarization of his western frontier with France by force. In November 1937 he had gone on a special mission to Germany to meet Hitler. When Eden resigned as Foreign Secretary in February 1938, Halifax, despite his membership of the House of Lords, was his natural successor. A former Viceroy of India, a formidable scholar at Oxford who held a Fellowship at All Souls College, a devout Christian, he towered physically as well as mentally over his Cabinet colleagues. His reputation for detachment, integrity and lack of political ambition was, deservedly, unshakeable. He had, however, two faults. His ability to recognize the complexities in any situation made him slow to make up his mind; and while in such a state he could be panicked into a hasty decision. As a Christian he hated and detested Hitler. From the middle of September 1938, if not earlier, he is on record as regarding Hitler as an implacable enemy both of peace and of his country. As a Christian, however, he was reconciled to living in an imperfect world and dealing with evil men—for some tastes, too much so.

As a Christian he was also too merciful an employer. After Munich his advisers wished to recall and replace Sir Nevile Henderson and Sir Eric Phipps.[21] Had he chosen to make an issue of it, that would have been that. Both were, however, protected by their friends and allies. Both were still in position when war broke out, even though Phipps was well over the age of retirement.

Halifax inherited a Foreign Office which was divided and unhappy. Since 1931 its professional head had been Sir Robert Vansittart, who was as brilliant a judge of policy as he was erratic as a judge of men and as an administrator.[22] Perth in Rome, Nevile Henderson in Berlin were both basically his appointments. His alienation from Sir Eric Phipps, who had married his wife's sister, dated from his insistence that Phipps go to Berlin rather than Paris in 1934. Despairing of MI6, he had set up his own private intelligence service in Europe in the early 1930s. Vansittart was exceptionally well-informed, and the gloomiest of his prophecies had a habit of coming true. He was wealthy, much wealthier than the ministers he served, gutsy (in his youth he had been a formidable amateur boxer), regarded himself as a man of culture (he had written plays which had been performed on the professional stage in Paris) and, on paper, intolerably prolix and verbose. In the early 1930s he had bombarded the Cabinet with lengthy memoranda long beyond the point where their length and frequency had destroyed their effectiveness. His closest friend and ally was Stanley Baldwin. Eden found him intolerable. It is hardly surprising, therefore, that once Baldwin retired, having failed to persuade him to take an Embassy, Eden replaced him as Permanent Under-Secretary

with Alexander Cadogan,[23] promoting him to the newly invented position of Chief Diplomatic Adviser to the Cabinet. This position has been wrongly represented as one of honorific desuetude. Since he retained his unique sources of information and played an important part in the crises of 1938 and 1939, this is not true. But he had no role in the daily transactions, the drafting of dispatches, the interviewing of foreign diplomats in London, and the writing of memoranda on those interviews. He had complete and total access to the dispatches and telegrams, incoming and outgoing; but only after they had been acted upon.

This left Halifax with Cadogan, who was to serve as Permanent Under-Secretary from 1937 to 1945.[24] Cadogan, scion of the Anglo-Irish nobility, had previously spent the bulk of his career away from Central Europe. He was as small as Halifax was lofty, and he remained unflappable through the worst of crises, venting his occasional anger and frustration, and his professional contempt for many of those with whom he worked, in the pages of a most candid diary. He was an efficient organizer and manager, which Vansittart was not, a shrewd judge of persons, and determined to stand no nonsense from No. 10. When Sir Reginald Kell, the head of MI5, Britain's Security Service, enlightened him as to George Steward's activities he read the riot act to Sir Horace Wilson.[25] His main impact on the Foreign Office was less immediate. He could not move either Henderson or Phipps. Perth, whose replacement was delayed until after Chamberlain and Halifax's visit to Rome in January 1939, he replaced with Sir Percy Loraine from Ankara who, within three months, had moved from being Mussolini's *bête noir* to that of Ciano's trusted confidant, without ever giving away any inch of British interests.[26] He was replaced at Ankara by Sir Hugh Knatchbull-Hugessen, whom Cadogan undervalued, but who proved an effective ambassador with the Turks.

Cadogan's other major ambassadors, Sir Ronald Lindsay in Washington, Sir Robert Craigie in Tokyo, Sir Howard Kennard in Warsaw, and Sir Maurice Peterson in Madrid, were largely inherited from his predecessors. Lindsay, a shrewd enough judge of the general American scene, was handicapped by his American wife's rock-ribbed Republican connections. He was replaced in the normal course of events by Philip Kerr, Lord Lothian, a political appointment, at the end of August 1939. Craigie was and remained a good friend of the Chamberlain family.[27] Churchill had a feud with him which went back to Churchill's anti-American phase in 1927–29.[28] He was, perhaps, the senior official at the Foreign Office most identified with appeasement, as the British acceptance of Hitler's offer of a naval agreement was mainly his responsibility. As a negotiator he was without a rival. The avoidance of an Anglo-Japanese conflict over Tientsin in June–July 1939, and Japan's consequent neutrality when war broke out, was entirely his responsibility, as his promotion to the top of the hit-list maintained by the right-wing secret

societies in Japan well illustrates. He too had an American wife, a formidable Virginian to whom he was so devoted that he had few, if any, interests or friends outside his marriage. As the leading Foreign Office expert on disarmament from 1927–1937, he knew better than most the financial constraints on British rearmament.

The British ambassadors in Moscow before 1939 present a considerable contrast. Lord Chilston, who retired in December 1938, was a diplomatist of the old school and as such out of place in Moscow. Most of the work in his embassy—and its reports are perceptive and have been little vitiated by the passage of time—was that of his juniors[29] and reflects the generally high quality of recruitment to the Foreign Office in the 1920s and 1930s. His successor, Sir William Seeds, another giant of a man, was a simple Russophile whose excellent Russian had been learned as a student in St Petersburg before the First World War.[30] He could, on occasion, make Molotov laugh. But his enthusiasm made him an unperceptive negotiator, and the strain of negotiation affected his health. The failure of the 1939 negotiations for an Anglo-Soviet alliance cannot be laid at his door since they were controlled and orchestrated between London and Paris, and every new proposal was known to Moscow from its agent in the Foreign Office Communications Department before it reached Seeds himself.[31] Nor, in the end, can one see any way Britain could have outbid Germany, given Stalin's conviction that the Soviet Union itself was in danger only if an Anglo-German deal were to be struck at his expense, the manner in which a series of more than adequately publicized would-be mediators between Britain and Germany fed these anxieties, and the prior commitment Britain and France had made to Poland and Romania. For Hitler, determined to strike down Poland and certain, so low was his estimate of Soviet military capabilities, that anything conceded could be easily recovered later, reaching agreement with the Soviet Union presented no such problems.

Within the Foreign Office there is a striking difference between generations. For Cadogan, Orme Sargent, his deputy, even Lawrence Collier, head of the Northern Department, British interests were conceived in the same mixture of the material strength and the balance of power as they had been by Eyre Crowe, Hardinge, Nicolson, or Salisbury or Palmerston. Collier, ultimately responsible for the Foreign Office's dismissal of the various secret warnings of Nazi-Soviet contacts which reached London,[32] was a reserved and isolated man. The younger generation, led by William Strang,[33] were much more inclined to identify Britain's interests with the survival in other countries of democratically elected governments responsible to their own public opinion and had little confidence in totalitarian or autocratic states and systems whether of right or left. Strang himself, who headed the central department and went to Moscow as back-up to Seeds in 1939,[34] was a scholarship boy from a lower-middle class background, who had run the British embassy in

Moscow during the Anglo-Soviet crisis of 1933–34. He had no upper-class guilt complexes and no illusions about either the German or the Soviet systems, save that in common with 95 per cent of his colleagues he could not recognize Stalinist myopia.

Within the Foreign Office, Vansittart's main support lay with Rex Leeper, head of the press department,[35] and Ralph Wigram, Strang's predecessor at the Central Department who died of cancer in 1937.[36] Neither Vansittart nor Leeper had any hesitation in leaking evidence, destructive of the terms in which No. 10 Downing Street was apt to defend and justify British policy, to the journalists of the newsletters[37] which flourished where the Prime Minister's minions had nobbled or converted the orthodox press. One may take leave to doubt whether Vansittart ever fed anything to the best known of the newsletters, *The Week,* as its editor Claud Cockburn was to claim after Vansittart's death, not only because Vansittart, to whom Cockburn's alias as Frank Pitcairn, deputy editor of the Communist *Daily Worker,* was well known, loathed Communism, but also because *The Week* was so consistently badly informed.[38] But *The Arrow* and the *Whitehall Letter,* which was put out by the diplomatic correspondent of the conservative *Daily Telegraph,* Victor Gordon-Lennox, were another matter. MI5 kept a watch on the latter on No. 10's orders.[39] It is a pity they did not achieve the international circulation of *The Week* on which both President Roosevelt and Senator Borah relied for their inside information.[40]

An exception to the general role played by Vansittart's protégés was Frank Ashton-Gwatkin, head of the Economic Section of the Foreign Office. After 1945 Ashton-Gwatkin was to represent himself as one of the internal critics of appeasement within the Foreign Office.[41] This was far from being the case. He began in 1930 by drafting on Vansittart's instructions a lengthy memorandum on the need for an economic appeasement, which would avoid a collapse of the European economy out of which a second world war might develop.[42] In February 1939, with Chamberlain's support, he was still reporting from a visit to Berlin on the prospects of economic appeasement in the most sanguine of terms.[43] His failure to achieve any major embassy and his early retirement may be explained by this. Lord Halifax had dismissed the desirability of seeking an agreement with Germany in November 1938,[44] and the Foreign Office was inundated with reports of where Hitler's next aggression was most likely to occur.

In 1939 Chamberlain was to find himself increasingly marginalized within the Cabinet on questions of foreign policy by Lord Halifax and the Cabinet's younger members. Hore-Belisha won a point in January 1939 when, as a result of a war scare, largely engineered by an odd conjunction of the French general staff and the German intelligence service, the *Abwehr,* and its anti-Nazi German conservative go-betweens, the Cabinet committed Britain to a guarantee of France, Belgium and the Netherlands and thus to a continental

strategy. The size of the Territorial Army was doubled in March 1939 and conscription introduced a month later. This decision was probably eased by a Cabinet crisis which broke just before Christmas when a group of junior Tory ministers led by Robert Hudson, the Parliamentary Under-Secretary for the Department of Overseas Trade, attacked both Hore-Belisha and the Minister for the Coordination of Defence, Thomas Inskip.[45] Inskip's post, a substitute for the single Minister of Defence urged on Baldwin in 1936 by the Tory right, involved the coordination of the rearmament programs of the three services so that they conformed to the single strategy laid down by the Cabinet on Treasury advice.[46] It was a thankless task, as Inskip had no authority over the three service ministers who remained his Cabinet colleagues.[47] But it made him a member of the Foreign Policy Committee of the Cabinet, set up in 1938 to control Eden, and continued as a kind of inner Cabinet for foreign affairs. Hoare, Halifax and Simon were the other members besides Chamberlain. Of these Inskip was the most vulnerable. To his fury and resentment Chamberlain switched him to the Dominions Office while Hore-Belisha, a National Liberal like Simon, survived. Chamberlain replaced Inskip with a peer and former First Sea Lord, Admiral of the Fleet Lord Chatfield, for six years the dominant figure in the Chiefs of Staff Committee who had brought agreement between the heads of the three armed services where civil war had previously reigned.[48] Chatfield, like Hankey, was a Far East first man. He was however used to taking his political cues from the Foreign Office; and he was too much a professional not to recognize the German challenge, particularly once Hitler had successively doubled his submarine fleet and denounced the Anglo-German Naval Agreement.

Hudson was the more irrepressible. As a junior minister, he should have been kept in line by his betters; but the Department of Overseas Trade was unique, directly responsible to both Foreign Office and Board of Trade, and in practice controlled by neither. All Hudson wanted was a major personal success. So he swung between a visit to Berlin, one to Moscow where he awoke the waning hopes of Maxim Litvinov only to inflame Stalin's suspicions when Lord Halifax called him to heel for exceeding his brief.[49] His master stroke, however, was the abortive deal he discussed in July 1939 with Goering's deputy, State Secretary Helmut Wohltat, another self-appointed mediator outside his *métier*.[50] The Hudson–Wohltat talks, leaked to a hostile press either deliberately or indiscreetly by Hudson himself, it is now clear, were as unauthorized by Goering as they were by Chamberlain himself. They discussed the scale of the British loan to Germany, which would allow for the transformation of Germany's war economy to a peace-time orientation. This was several times beyond anything the Treasury would conceivably have authorized, involving anything between 25 and 200 per cent, according to which report one believes, of the total British foreign exchange reserves. Halifax said nothing; Vansittart was incandescent with rage. Chamberlain

complained to his sisters that Hudson was untrustworthy and disloyal, and assailed the whole episode as a Soviet plot[51]—presumably because of the role played by the *News Chronicle*, at least one of whose regular columnists was a more than occasional mouthpiece for the Soviet embassy.[52]

One area in which the Cabinet backed Chamberlain was in the reluctance with which he was prepared to court the United States, save in the person of the American Ambassador, Joseph Kennedy. It is clear that, even after the clandestine approach made by Roosevelt in the winter of 1938 via Lord Murray of Elibank from which the President made clear that he wished the American embassy in London totally excluded,[53] neither Chamberlain nor Halifax understood the degree to which the President and the Ambassador were alienated from each other, or the futility of cultivating the Ambassador rather than the President. The trade issue poisoned the attitude of Hull and the State Department to Britain until well into June 1939;[54] while on the British side, Halifax had been forced to override Oliver Stanley, President of the Board of Trade, and the ministers for the Dominions, India and the Colonies in November 1938, to secure Cabinet agreement to the Anglo-American trade agreement.[55] Apart from Runciman, who as President of the Board of Trade in 1936–37 had initiated the negotiations with a surprise visit to the White House immediately following Roosevelt's second inauguration,[56] and remained in regular correspondence with him,[57] none of Chamberlain's Cabinet were natural believers in the Special Relationship.

Nor, at the end, whatever he subsequently said, or was subsequently written on his behalf, was Anthony Eden. Eden never disagreed with the fundamental premise underlying the Baldwin version of appeasement or the metamorphosis which came over it when Chamberlain became Prime Minister,[58] that it was for the European great powers to settle Europe's problems, not for the future big three of Teheran, Yalta or Potsdam. The circumstances of his disagreement with Chamberlain over the President's message of January 1938 have been used by Winston Churchill and his followers to paint Chamberlain as anti-American and Eden as the reverse.[59] But the issues of substance were nothing like so clear-cut,[60] and what lay between Chamberlain and Eden was Eden's resentment of Chamberlain's continued invasions of his prerogative.[61] Eden found playing second fiddle to anyone difficult, even to Churchill. Like Simon, however, his experience of the back benches was to cure him of any future tendency towards resignation.

What is more at doubt is Eden's reputation as an opponent rather than an exponent of appeasement. His greatest triumph in the 1930s was the Nyon Conference of September 1937 which put a temporary halt to Italian submarine policy in the Mediterranean. There was little else. His vain pursuit, after the Rhineland crisis, for a substitute for Locarno displays little real understanding of his failure. The successful negotiation of the Anglo-Italian Easter agreements in April 1938, in time to disarm any chance of Mussolini

accepting a German alliance during Hitler's visit to Rome in May, shows his resistance to an agreement with Italy to have been ill-conceived.[62] In later life he was to reveal himself as a consummate negotiator. The course of the Geneva conference on South-East Asia in 1953, and the solution of German rearmament after the final collapse of EDC, are triumphs of which anyone should be proud given the forces opposed to success. But there is little in his two years from 1936–38 to account for the reputation he was later to enjoy. He was a man who buried himself in lengthy detailed scrutiny of files. His reputation was won only because the opponents of Chamberlain and the *vieillards* of his Cabinet needed a hero.[63] It was the projection of their needs and visions, not of his abilities. He stood for youth, and hope, the survivor of the lost generation of the 1914–18 war. His meteoric rise and final catastrophic fall are a measure of how great a loss that lost generation really represents for Britain.

Appeasement has been much misunderstood. There were would-be isolationists who supported it. But it was essentially an interventionist policy. Its practitioners agreed with its critics in assuming that it was for Britain to lead in Europe. They disagreed over methods, they disagreed over taking risks, they disagreed over the opportunity costs of action, they had a different calculus of honor. Chamberlain saw no honor, only waste, in the casualties of Flanders fields. He saw no honor in risking war as a form of diplomatic maneuver. He was never happy with a policy based on deterrence alone, and on war if deterrence failed. But Hitler, the "bully" who should be "pulled down" as he himself expressed it in Cabinet in April 1939,[64] in the end left him no choice.

Fall Semester 1989

NOTES

1. John Charmley, *Chamberlain and the Lost Peace* (London, 1989), has the fullest and most sympathetic exposition so far of Chamberlain's foreign policy.

2. D.C. Watt, *Personalities and Policies: Studies in the Formulation of British Foreign Policy in the Twentieth Century* (London, 1965); Ann Trotter, "Tentative steps for an Anglo-Japanese Rapprochement in 1934," *Modern Asian Studies,* 8 (1974); Ann Trotter, *Britain and East Asia, 1933–1937* (Cambridge, 1975), pp. 88-131; O.S. Ogbi, "British Imperial Defence and Foreign Policy in the Pacific and the Impact of Anglo-Japanese Relations" (Birmingham University Ph.D., 1975), chap. 11.

3. On which see David Dilks, *Neville Chamberlain,* vol. I, *Pioneering and Reform, 1869–1929* (Cambridge, 1984).

4. Neville Chamberlain Papers (University of Birmingham), NC 18/1/1043, N.C. to Ida Chamberlain, 29 March 1938.

5. On Sir Warren Fisher see D.C. Watt, "Sir Warren Fisher and British Rearmament," in *Personalities and Policies;* Eunan O'Halpin, *Head of the Civil Service: A Study of Sir Warren Fisher* (London, 1989).

6. On Hankey see Stephen Roskill, *Hankey: Man of Secrets,* vol. III, *1931–1963* (London, 1974).

7. On Chamberlain's staff at No. 10 Downing Street, see Richard Cockett, *Twilight of Truth: Chamberlain, Appeasement and the Manipulation of the Press* (London, 1989).

8. Nicholas Pronay and Philip M. Taylor, "'An Improper Use of Broadcasting.' The British Government and clandestine radio propaganda against Germany during the Munich crisis and after," *Journal of Contemporary History,* 18 (1983).

9. Neville Chamberlain Papers, NC 18/1/1108, Neville to Ida Chamberlain, 23 July 1939; Sir Robert Vansittart Papers, II/2/32, Memoranda on "The Control of the Newspaper Truth"; "Report on Truth and the Truth Publishing Company," cited in Cockett, *Twilight of Truth,* pp. 10-11.

10. This is a reasonable deduction from Chamberlain papers, 18/1/1099/1100, letters to Hilda Chamberlain, 14 May, and to Ida Chamberlain, 21 May 1939 about the Russians "working hand in hand with our opposition" and "in continuous and close communication with the opposition and Winston."

11. Sir Alexander Cadogan manuscript diaries (Churchill College, Cambridge), entries of 28, 29, 30 November, 1, 2, 5, 6 December 1938, 3 May 1939.

12. On Steward, see Cockett, *Twilight of Truth,* pp. 15, 35-36, 67, 85-86; *Documents on German Foreign Policy,* Series D., vol. I, p. 52, no. 29; ibid., vol. II, p. 624, no. 389, Enclosure I, 470, 579; ibid., vol. IV, p. 306, Doc. 259, annex 2; Fritz Hesse, *Das Vorspiel zum Krieg, Englandberichte und Erlebnisse eines Tats-zeuges 1935–1945* (Leone am Starnbergersee, 1979).

13. Rosario Quartararo, "Inghilterra e Italia. Dal Patto di Pasqua a Monaco: con un'appendice sul 'Canale Segreto' italo-inglese," *Storia Contemporanea,* 7 (1976).

14. Cockett, *Twilight of Truth,* pp. 5-8.

15. Philip Taylor, *A Call to Arms: British Rearmament, Propaganda and Psychological Preparations for World War II* (Leeds, University Historical Film Consortium, 1985).

16. On Perth's embassy see D.J. Rotunda, "The Rome Embassy of Sir Eric Drummond, 16th Earl of Perth, 1933–1939" (London Ph.D. thesis, 1972).

17. Henderson still lacks an adequate biography. See, however, Rudi Strauch, *Sir Nevile Henderson, Britische Botschafter in Berlin 1937–1939* (Bonn, 1959).

18. Sir Eric Phipps Papers (Churchill College, Cambridge), folder 311.

19. J.A. Cross, *Samuel Hoare* (London, 1977).

20. British Public Record Office, PREM 1/266a, Stanley to Chamberlain, 4 October 1938; Chamberlain Papers, NC 18/1/1071, N.C. to Ida Chamberlain, 9 October 1938.

21. On Henderson, see John Harvey (ed.), *The Diplomatic Diaries of Oliver Harvey, 1937–1940* (London, 1970), entry of 6 April 1939; on Phipps see, ibid., entry of 20 May 1939; Roskill, *Hankey*, vol. III, p. 393.

22. On Vansittart, see Norman Rose, *Vansittart: Study of a Diplomat* (London, 1978).

23. O'Halpin, *Head of the Civil Service*, pp. 251-52, citing Chamberlain Papers, NC 7/11/29/19, Fisher to Chamberlain, 15 September 1936; NC 7/11/30/49, Fisher to Chamberlain, 15 December 1937.

24. On Cadogan, see the introduction by David Dilks to D. Dilks (ed.), *The Diaries of Sir Alexander Cadogan, O.M., 1938-1945* (London, 1971).

25. Cadogan manuscript diaries, entries of 1, 2, 5, 6 December 1938, 3 May 1939.

26. On Loraine see Gordon Waterfield, *Professional Diplomat* (London, 1973).

27. Private information from the Craigie family. On Lindsay see Victor Mallet, draft unpublished memoirs, chapter 7 (Churchill College, Cambridge).

28. Brian McKercher, *The Second Baldwin Government and the United States, 1924-1929: Attitudes and Diplomacy* (Cambridge, 1984), pp. 175-76; Martin Gilbert, *Churchill Companion*, vol. V, Part 1, *1922-1929* (London, 1979), pp. 1380-82, Cabinet memorandum CAB 35/8(28), 19 November 1928.

29. Information from Sir William Hayter and Sir Fitzroy Maclean, both of whom served as junior members of the British embassy staff under Lord Chilston.

30. On Seeds see Sidney Aster, "British policy towards the USSR and the Onset of the Second World War, March 1938–September 1939" (London, Ph.D., 1969); Dr Aster interviewed Sir William Seeds extensively. See also Sidney Aster, *1939: The Making of the Second World War* (London, 1973).

31. D. Cameron Watt, "John Herbert King: A Soviet Agent in the Foreign Office," *Intelligence and National Security*, 3 (1989).

32. D. Cameron Watt, "The Foreign Office Failure To Anticipate the Nazi-Soviet Pact," *Intelligence and National Security*, 4 (1989).

33. Lord Strang, *At Home and Abroad* (London, 1956).

34. Lord Strang, "The Moscow Negotiations 1939" in David Dilks (ed.), *Retreat from Power: Studies in British Foreign Policy of the Twentieth Century*, vol. 1, *1906-1939* (London, 1981).

35. On Leeper and the Foreign Office press department, see Cockett, *Twilight of Truth*, passim.

36. On Wigram, see Martin Gilbert, *Winston S. Churchill*, vol. V, *1922-1939* (London, 1976) passim; Valentine Lawson, *Bound for Diplomacy* (London, 1963); Sir John Wheeler-Bennett, *John Anderson, Viscount Waverley* (London, 1962).

37. Information from the late Toby O'Brien, who collaborated with Victor Gordon-Lennox on the *Whitehall Letter*.

38. On *The Week*, see Claud Cockburn, *In Time of Trouble* (London, 1956); Patricia Cockburn, *The Years of "The Week"* (London, 1968); D. Cameron Watt, "*The Week* that Was," *Encounter* (May 1972).

39. Information from the late Kenneth Younger, who was an MI5 employee in the late 1930s.

40. Watt, *"The Week* that was," *Encounter* (May 1972); Marion C. McKenna, *Borah* (Ann Arbor, 1961), p. 364; Robert Maddox, *William E. Borah and American Foreign Policy* (Baton Rouge, 1969), p. 241; Wayne S. Cole, *Roosevelt and the Isolationists, 1933–1945* (Lincoln, Nebraska, 1983), p. 318.

41. F. Ashton-Gwatkin, *The British Foreign Office* (Syracuse, N.Y., 1950).

42. Martin Gilbert, *The Roots of Appeasement* (London, 1967), pp. 130-32.

43. *Documents on British Foreign Policy, 1919–1939,* 3rd Series, vol. IV, Appendix II(1), (2).

44. Public Record Office, CAB 27/624, FP (38) 31st meeting, 21 November 1938.

45. On this episode, see the memoranda in the Leslie Hore-Belisha papers (Churchill College, Cambridge) and the diary of Sir Thomas Inskip, Lord Caldecote (Churchill College, Cambridge).

46. Peden, *British Rearmament,* pp.19-20; Gibbs, *Grand Strategy,* vol. I, pp. 791-92.

47. In 1959, Sir Ian Jacob, who had served under both Inskip and Chatfield, wrote that they should both have refused the job of Minister for the Co-ordination of Defence unless "they were given some authority," Jacob to Lord Ismay, 24 January, 15 May 1959, Ismay Papers (Liddell Hart Archives, King's College London), I/14/69a.

48. Admiral of the Fleet Lord Chatfield, *It Might Happen Again* (London, 1947).

49. On Robert Hudson's visit to Moscow, see Aster, *1939*; D. Cameron Watt, *How War Came* (London, 1989), pp. 219-20.

50. Helmut Metzmacher, "Deutsch-englische Ausgleichsbemühungen im Sommer 1939," *Vierteljahresheft für Zeitgeschichte,* 14 (1966); Watt, *How War Came,* pp. 397-403.

51. Chamberlain Papers, NC 18/1/1108, N.C. to Ida Chamberlain, 23 July 1939.

52. Franklin Reid Gannon, *The British Press and Nazi Germany, 1936–1939* (Oxford, 1971), p. 40, and pp. 28, 185, 209.

53. Lord Elibank Papers, National Library of Scotland, folios 8808, 8809; D. Cameron Watt, "Roosevelt and Chamberlain: Two Appeasers," *International Journal,* 28 (1973); Watt, *How War Came,* pp. 129-32.

54. Jay Pierrepont Moffat Papers (Harvard University), Moffat Diary, entries of 29 March, 19 May 1939.

55. Public Record Office, CAB 13/94, CP(38), 36.

56. Elibank Papers.

57. See the correspondence in Lord Runciman's papers (University of Newcastle), and in F. Schewe, *Franklin D. Roosevelt and Foreign Affairs, 1936–1939* (10 vols., New York, 1979).

58. On Eden, see David Carlton, *Anthony Eden* (London, 1981); Robert Rhodes James, *Anthony Eden* (London, 1986); A.R. Peters, *Anthony Eden at the Foreign Office, 1931–1938* (London, 1986).

59. Winston Churchill, *The Second World War,* vol. I, *The Gathering Storm* (London, 1948), pp. 230-33; Ronald Tree, *When the Moon was High: Memoirs of War and Peace* (London, 1975), pp. 73-74; Sir John Wheeler-Bennett, *Knaves, Fools and Heroes: In Europe between the Wars* (London, 1974), pp. 14-15.

60. Francis L. Loewenheim, "An Illusion that Shaped History: New Light on the History and Historiography of American Peace Efforts before Munich" in Daniel R. Beaver (ed.), *Some Pathways in American History* (Detroit, 1969).

61. Norman Rose, "The Resignation of Anthony Eden," *Historical Journal,* 25 (1982).

62. D.C. Watt, "Gli accordi mediterranei anglo-italiani del 16 aprile 1938," *Rivista di Studi Politici Internazionali*, 26, 1959; Lawrence W. Pratt, *East of Malta, West of Suez: Britain's Mediterranean Crisis, 1936–1939* (Cambridge, 1975); D. Cameron Watt, "Britain, France and the Italian Problem, 1937–1939," in *Les Relations Franco-Britanniques de 1935 à 1939* (Paris, 1975); Rosario Quartararo, *Roma tra Londra e Berlino: Politica Estera Fascista del 1930 al 1940* (Rome 1980); D. Bolech Cecchi, *L'Accordo di due Imperi: L'Accordo italo-inglese del 16 aprile 1938* (Milan, 1977).

63. For example, Tree, *When the Moon was High,* pp. 74, 76-77, 79-83.

64. Public Record Office, CAB 23/98, CAB 13(39), 20 March 1939.

Bertrand Russell's Politics: 1688 or 1968?

ALAN RYAN

If Bertrand Russell is remembered in the United States by anyone other than formal logicians and analytical philosophers, it is almost certainly as the ferocious critic of America's role in the Vietnam War, and on account of the energetically anti-American stand he took at the time of the Cuban missile crisis. The violence of his rhetoric during those years opened wounds that have not since healed. When my account of Russell's politics was published, Hilton Kramer deplored the whole book in his *Wall Street Journal* review because I was not as wildly hostile to Russell's stand on Vietnam as he thought proper. Sidney Hook's much more kindly review chided me nonetheless for not opposing John Stuart Mill's defense of liberal interventionism to the high-pitched anti-imperialism of Russell's last years.

That Russell's last writings were unfair, that they verged on the hysterical and that they employed a rhetoric he would earlier have thought preposterous, it is hard to deny. Nor did he entirely deny it himself. When scolded by a writer in *Tribune* for the "unsociological" quality of his writings on nuclear disarmament, Russell replied that he had earlier devoted a good deal of time and thought to the sociology of contemporary politics, but now he felt as though he was watching "a man dropping lighted matches on heaps of TNT," and just had to act as best he could. Elsewhere, he said over and over that even if logic was one of the greatest achievements of the human mind it would have no point if mankind had blown itself to bits.

Still, there is no denying that what came out over his name during the middle and late 1960s was very extraordinary. I say "what came out over his name," because there is every reason to suppose that much of it was written by other people. In content, and even more importantly in style and grammatical carelessness, it reads like the standard outpourings of the student left of the time, and not at all like the immaculate and stylish prose in which Russell had previously couched his views—however outrageous those views may have seemed at the time. *War Crimes in Vietnam*, for instance, offers this

characteristic "anti-imperialist" trope. "The people of Vietnam are heroic, and their struggle is epic; a stirring and permanent reminder of the incredible spirit of which men are capable when they are dedicated to a noble ideal. Let us salute the people of Vietnam."

Russell had years earlier written an essay which was intended as a prophylactic against just such guff. "The Superior Virtue of the Oppressed" was a light-hearted assault on the idea that the victimized are always right. On Russell's account of the matter, the resonances of which for contemporary Eastern Europe are all too obvious, the deepest wish of the oppressed is commonly to throw off their oppressor in order to victimize somebody else. That does not mean that victimizing them is therefore all right, but it does mean that we ought not to sentimentalize them. Had Russell applied his own analysis to the case of Vietnam, he ought to have argued that North Vietnam was yet another deeply unpleasant Communist autocracy, that the Viet Cong were certainly brave and ingenious, but were also cruel and brutal, in the interest of causes with which he had no sympathy—but that none of this justified the Americans in risking world peace by making war in Vietnam. The argument against the American presence was not a matter of some high-flown principle of non-intervention, but an argument of expediency. The United States could do little good to Vietnam, but it could do a great deal of damage to the American political system. There is something very odd, not to say disheartening, about the anti-Americanism of Russell's last years; even if he was simply interested in lending his fame and prestige to young people battling in a good cause, he ought surely to have insisted on better terms for the use of a name as good as his.

Many Americans, however, remember an earlier Russell, who starred in the small courtroom drama that led to his losing the professorship at the City College of New York to which he had been appointed in 1940. On that occasion, Russell was assailed by respectable America, and liberal philosophers including John Dewey and Sidney Hook did their unavailing best to defend him against the forces of unenlightenment. At the end of the 1930s Russell found himself in an embarrassing position; he had no university position, and had for years made his living by a combination of journalism and lecturing that he very much disliked. Though he could never have made a satisfactory professor whether in a British or an American university, he hoped for some such position to be offered to him. After a series of visits to Chicago and Los Angeles, he was finally offered a post at City College, resigned from the temporary appointment at the University of California and made ready to take up the new job.

At this point, his old enemies fell upon him. He had long been regarded as a menace to good morals by Catholics, and more generally by enthusiasts for female chastity, by the foes of birth control, and by believers in the sanctity of marriage. First, the Episcopalian Archbishop Manning of New York wrote

a circular letter to the press denouncing the appointment as a threat to the morals of the young. Catholic journals joined in the hue and cry. Then the mother of a CUNY student, a Mrs McKay, brought suit against the city Board of Education, alleging that the appointment was *ultra vires* because Russell's teaching (in logic and the philosophy of mathematics) was, among other things, "lecherous, libidinous, lustful, venerous, erotomaniac, aphrodisiac, irreverent and narrow-minded." Astonishingly, the court found in her favor and the appointment was quashed.

Since Mrs McKay had brought suit against the Board of Education, Russell had not been a party to it, and could not defend himself. The Board behaved cravenly, and would not appeal against the decision, in spite of the urgings of the AAUP and of educators across the country who feared that if this sort of thing could happen in relatively liberal New York there was no knowing what might happen elsewhere. If Dewey had not induced Albert Barnes of the Barnes Foundation to hire Russell to lecture on the history of Western philosophy, he would have found himself unemployed and unemployable, three thousand miles from home with no hope of crossing the Atlantic in wartime, with a wife and young child to support. It is not surprising that Russell was thereafter a bit sharp about freedom of speech on American campuses.

For our purposes what is most interesting is the way Russell managed to combine two views not ordinarily found together. He detested many, perhaps even most, of the characteristic features of American life and yet thought that the United States ought to be the self-conscious, unabashed leader of the western world; indeed, from 1946–48 he argued that the USA ought to use her then monopoly of nuclear weapons to force the Soviet Union to disarm, to get Russian troops out of Eastern Europe, and, at his most ambitious, to exercise a world hegemony that would eventually lead to some form of world government. How he arrived at what seems on the face of it to be the paradoxical position that the United States is both intolerable and the only hope for the human future provides much of the substance of this lecture. But, perhaps the first thing to observe about it is that it does complicate any simple picture of Russell as just anti-American, just an elderly hanger-on of the movement for nuclear disarmament, and the anti-imperialist movements of the 1960s.

Russell used to joke that he could not be accused of being anti-American when his first and last wives had both been Americans—Alys Pearsall-Smith and Edith Finch respectively, both of them from the high-minded Philadelphia academic upper-class that Russell somehow enjoyed and disliked, mocked and abused, and yet fell in love with. In fact, his relations with his first wife give at least one clue to the anti-American side of his work. Though he fell madly in love with Alys Pearsall-Smith when they were brought together by his elder brother Frank, during the whole marriage he was driven wild with

irritation at her middle-class habits. What one might have expected him to pass over as mere nervous good nature, he felt to be intolerably vulgar. It is significant that when he embarked on the affair with Lady Ottoline Morrell, which ended his first marriage and set him on the path of personal and social emancipation that he never left thereafter, he remarked that it was a tremendous relief to be in the company of someone genuinely aristocratic, where real uninhibited laughter and enjoyment were possible. America, for Russell, never quite recovered from the disadvantage of being the land of the Pearsall-Smiths.

All of this is historically explicable enough. Russell was born in 1872, the second son of a somewhat eccentric Liberal, Viscount Amberley (third son of Earl Russell), and his wonderful wife, Kate Stanley. His birth was a radical event; he was delivered by Elizabeth Garrett Anderson, as yet unable to practice as a doctor, but soon to lead the movement that brought women into medicine as something other than nurses and midwives, and eventually to give her name to the best-loved hospital in London. He was born into two ruling families—the Russells and the Stanleys—who were unusual among the English aristocracy in welcoming intellectuals into their midst. Gilbert Murray thus became a cousin by marriage some years later. In addition to the advantages of birth, he had the symbolic advantage that one of his godparents was John Stuart Mill, who had campaigned with his parents for the extension of the vote to women, for the rearrangement of the laws of property to the benefit of agricultural tenants, and for a league of nations. Mill, of course, died when Russell was only some seven months old, and his impact was not felt until Russell was eighteen. Then Russell read Mill's *Autobiography*, came across the passage where Mill remarks that the First Cause argument for the existence of God is invalid because it only provokes the further question, "What caused the First Cause?", and promptly lost his faith. The story seems so nearly a parody of the inner life of the rationalist philosopher that one would not credit it but for the fact of a contemporary entry in Russell's (secret) diary recording the event.

Both Russell's parents died before he was four, and he was brought up in the household of his paternal grandmother, Countess Russell. She was by this time in her late fifties; his grandfather, Earl Russell (Lord John Russell, "finality Jack" of the First Reform Act), was twenty-three years older than she, and died in 1878, when his grandson was only six. So it was his fierce, strict grandmother who inevitably had most influence over him. He could never quite make up his mind how much he hated her.

He was appallingly lonely, stuck away in the large grace and favor house in Richmond Park that a grateful nation had bestowed on his grandparents. Visitors were agreed that it was no place for a small boy. Worse still, his older brother Frank showed early signs of the talent for getting into matrimonial trouble that eventually resulted in his being the last peer to be tried, literally,

by a jury of his fellow peers—they sent him to jail for six months for inadvertent bigamy in 1912. Frank's career at Winchester persuaded Countess Russell that Bertie was better off at home where she could keep an eye on him, and at home he stayed until he was seventeen.

The regime had its advantages. Round his grandmother's table assembled Liberal luminaries by the score; few fourteen-year-olds were brought up to entertain Mr Gladstone after dinner, even though Russell complained that he only spoke one sentence, and that was to wonder why the excellent port had been served in a claret glass. Irish Home Rule was hotly debated—friends like John Morley were enthusiastically pro-Home Rule, while Russell's Stanley grandmother was fiercely anti. Countess Russell was puritanical, devout in whatever ways a Unitarian can be devout, but not particularly interfering in her management of the succession of governesses and tutors that looked after the boy's education. Whatever Russell's miseries, his mind was taken care of.

Moreover, by the time Russell was of an age to take an intellectual interest in the world, Frank had begun to bring home interesting friends, among them the American philosopher George Santayana, and scientists such as John Tyndale. There were, however, some deep wounds. One was that his grandmother was terrified of the streak of madness that ran in the family—not absurdly either, for Russell's own elder son, John, the fourth Earl Russell, was mentally ill for much of his life, and one of John's daughters committed suicide in her early twenties. When Russell wanted to marry Alys Pearsall-Smith, his grandmother used the threat that they would produce mad children as an argument against marriage, but she had obviously dwelt on the matter before. What made it more corrosive was that there was a suggestion that somehow sexual passion and lunacy were closely allied. His Aunt Agatha had been engaged; had been forced to break it off because she suffered from delusions; she was now more or less mad, while Uncle William had spent most of his life in a hospital. What could one infer from that? Russell recorded a pathetic dream he had while the argument over his marriage to Alys was going on; he dreamed that his mother was not dead but locked up in a madhouse. It is tersely recorded, but it makes one wince. It is no wonder that Russell's *Autobiography* sends, as one might say, very mixed signals. Sometimes, he says his childhood was happy enough, sometimes that all that kept him from suicide was the urge to learn more geometry.

The effect of going to Cambridge after this was what one might expect. Intellectually, it was like going to heaven. One might think anything about anything, and nobody would disapprove—though they might try to argue one out of it. On the other hand, it was almost as socially narrow as the background he had come from. Moreover, the entire social and political tone was what he would afterwards have dismissed as decidedly precious; it was the background to Bloomsbury, and Russell and Bloomsbury got on very badly. Still, all his life, the effect of it stuck. He always thought that the goods

that G.E. Moore's *Principia Ethica* celebrated as absolutely good in themselves—beauty and personal friendship—really were among the very greatest goods, even though he added to them something one may suppose that Moore took for granted too, the thought that the knowledge of abstract, universal truths such as those of philosophy, mathematics and logic was one of the great glories of human existence. What Kenneth Blackwell has labelled a "Spinozistic ethics of impersonal self-expansion" was thereafter Russell's creed; unlike Spinoza, he did not think it a dictate of reason, nor did he think one could derive one's duties from it with the lucidity of the lemmas of a geometrical theorem; still, it was what held together virtually everything he wrote thereafter on ethics and politics.

As that suggests, it was a doctrine at some distance from everyday political life. Russell always wavered, sometimes inclining towards the view that for everyday purposes, a rough and ready utilitarianism had to serve because it was impossible to tell what impact political action would have on those exalted and ultimate ends to which it was appropriate to direct our individual allegiance. At other times, he was much more prepared to invoke these ideals directly; as we shall see, this was generally when some kind of international catastrophe threatened them with the gravest damage—as in modern warfare. To the extent that this implied something recognizable as a political theory in the ordinary sense, it was simply that some political system or other was required to give a shelter for almost any human good; these human goods required more than that, for they required a government properly sensitive to the needs of private life, to the pursuit of knowledge, for the creation of art and other sorts of beauty, and therefore a government attuned to what he called in a letter to Ottoline Morrell, "the spark of the divine" in each of us. But not *very* much follows from this. Certainly a liberal political theory of some sort, but one that has little that is decisive to say about economic policy, or about many other issues of the nitty-gritty of policy-making. It is a view that inclines one to caution about the *positive* contributions of government. Governments can certainly do much damage, but it is less clear that they can do very much directly to aid these ultimate values.

Later, he advocated a form of guild socialism in his *Principles of Social Reconstruction* (1916), based on a dichotomy between the "possessive" and "creative" impulses that he understood to be fundamental to human nature. This picture of human nature suggested to Russell that private property and capitalist economics made for competition, divisiveness and in the last resort for war, while an emphasis on satisfying work, political participation, and educational and sexual liberation made for peace, happiness, and an emotional security that is not merely conservative and narrow minded. Though the *Principles* is to my mind the best thing Russell wrote on politics, it is not unkind to observe that it operates at a high level of abstraction, and that its tone owes a great deal to the exigencies of the First World War and Russell's

own activities on behalf of the No-Conscription Fellowship. Indeed, the slenderer volume of lectures on *Political Ideals* that gave an abridged version of the *Principles* was published in the United States under the title of *Why Men Fight*.

At times of something other than the exaltation of the battle against the forces of darkness, Russell's political loyalties so far as Britain was concerned tended to settle in a 'lib-lab' mould. That is, he thought it impossible to achieve the Liberal program of Asquith and Lloyd George except through the medium of the Labour Party, and at the same time was fearful that the Labour Party would have too little regard for intellectual distinction, and too little awareness of the need to tolerate unpopular opinions for the sake of progress and variety. His mature position was summed up in his Reith Lectures—the first series to be given and in many people's view one of the very best—on *Authority and the Individual*. He took it for granted that in the middle of the twentieth century governments needed the capacity to preserve not only civil order in the simple military sense but also economic order; they needed to be able to reproduce an intelligent and skilled workforce; they needed, in short, to be able to manage a complicated modern society. This implied at least a social democratic government. But after the experience of Hitler and Stalin, we all know that the search for managerial efficiency can exact far too high a price. Efficiency easily becomes liberticide, and even benevolent despotism is despotism. What falls short of despotism may nonetheless be intolerably boring. "Give me the old days," he quotes an old Indian as saying, "it was dangerous, but there was glory in it." Sober Russell was Russell reminding everyone that the task was to reconcile society's need for authority for the sake of order with the individual's need for liberty for the sake of his or her pursuit of the ultimate goals.

Liberal democratic sobriety was not Russell's most characteristic style. The rest of this lecture is devoted to the less sober aspects of his ideas—some of which were sparked by his horror at modern warfare, others by his simple irritation and anger at modern society, as represented usually by the United States as most recently encountered. His interest in politics began early; his family assumed that he would go into public life, or at any rate that he would start in the Diplomatic Corps and migrate to active politics in due course. This vision of his future he rejected fairly energetically, though he stood for Parliament three times in seats he knew there was no risk of winning.

His first interest in theoretical issues in politics was evoked by the Marxism of the German Social Democratic Party; his first published work was his *German Social Democracy* of 1896. The real Russell came to life more visibly in 1901, and then completely in 1914. When the Boer War broke out in 1899, Russell found himself questioned by foreign friends and colleagues who could not see the justice of Britain's war against Paul Kruger's Boer Republic of the Transvaal. To them it looked like simple bullying by a strong imperial

power, directed at a bunch of possibly obnoxious and certainly amazingly ignorant but otherwise apparently harmless Afrikaner farmers who happened to have stumbled on the world's richest seams of gold.

Russell's response was by later standards very odd. He was entirely hostile to the British Empire and at the same time a firm imperialist. His arguments were characteristically Russellian—acute, but counter-intuitive. He scorned all forms of militarism, the fully-fledged Prussian variety more than the dilute British form, but for none of them did he feel anything but loathing. British imperialism threatened to turn Britain into a militarist state indistinguishable from the Kaiser's Reich, and was therefore to be deplored. Yet, he took it for granted that the spread of European influence was a good thing, and that most of Africa and Asia would progress faster under European tutelage than under its own steam. European domination was the way to make progress; the only policy issue was how to carve up the continent tidily and peacefully rather than messily and by warfare. The British were absolutely entitled to squash the Boer Republic; "Je suis utilitaire," he wrote to the mathematician Couturat, and in that light he argued that justice lay with the advanced nations whenever they encountered the less advanced. In the First World War he employed the same line of reasoning to argue that wars of self-defense were not justified, if it were a matter of war between two civilized powers, but that the conquest of uncivilized nations was entirely acceptable. Who, he asked in a tone that one would hardly risk today, can regret the passing of the American Indian? It was doubtless bad luck for the American Indian that the white man had triumphed, but viewed from a global perspective it was all to the good.

In fact, he had scarcely produced this defense of the British case than he turned against it. From his *Autobiography* one might almost be led to think that he simultaneously fell out of love with Alys, was turned into a mystic by his experience of the shocking loneliness of Evelyn Whitehead in her painful heart attacks, and became a "pacifist" under the combined impact of these events. Re-reading his letters shows a much slower process taking place; it also shows that he never became what he would have called a pacifist. That is, he never departed from the view that violence was not absolutely evil, and never held that war was never justified. What he held was that war was justified only to the extent that it promoted the ultimate values of European civilization. These were the values we have discussed already; in that light it is easy enough to see that wars between civilized countries are very unlikely to pass the justificatory test, while wars against uncivilized societies will have a much easier time.

There were instances of something closer to principled anti-imperialism before the First War, but the only striking example was his detestation of British and Russian policy towards Persia. There, he thought, there was a developed democratic movement, and a developing political culture. For the

British to agree to a carve-up with the autocratic Russians—like all good liberals, Russell loathed Czarist Russia for its own sake and the Soviet Union as a nastier version of its Czarist parent—was the betrayal of British liberal values. For the Russians simply hanged or murdered without trial such of the local democrats as they could lay hands on, and this they did knowing the British would not interfere.

Still, it took 1914 and the outbreak of European war to bring out his activist nature. From the moment war was declared he threw himself into opposing it. He wrote endlessly against it in whatever journals would still open their pages to him; he organized meetings of the Union for Democratic Control in Cambridge until his college barred their rooms to them—provoking G.E. Moore to suggest that the college chapel ought also to be closed, since it was full of people saying they worshipped the Prince of Peace. He lectured widely, giving as lectures what became the *Principles of Social Reconstruction*. When conscription was introduced he promptly became a full-time organizer for the No-Conscription Fellowship led by Clifford Allen; it cost him his lectureship at Trinity, even though the move was violently deplored by the young men of Trinity on active service. They took the admirably high-minded view that they were fighting to preserve the liberties of independent people like Bertrand Russell, not to gratify the patriotism of dim and elderly Fellows of Trinity.

Eventually, it landed him in jail, when he rashly wrote in *The Tribunal*— the magazine put out by the No-Conscription Fellowship—that after the war was over he expected Britain to be policed by the American Army, which would be employed to put down strikers in Europe as they had traditionally been in America. This was held to be "insulting an ally" and he duly got six months, reduced on appeal to six months in the "first division"—that is, in a large cell, with no duties, meals brought in, a fellow prisoner to clean the room, and endless books. Though it had a certain comic side to it, it was effectively the end of his career as an academic, and the beginnings of his extraordinary career as a nomadic journalist, lecturer, popular broadcaster— and deeply influential part-time philosopher.

The discrepancy between his violent antipathy to the war and the philosophical underpinnings of that antipathy is still something to puzzle over, and not altogether different from the discrepancy between the violence of his opposition to the war in Vietnam and the pragmatism of the political theory that he claimed to base it on. In a series of essays on "Justice in Wartime" that appeared in the *Atlantic Monthly* during 1915—they were intended to sway American opinion against the war—he argued, as he always did, that pure pacifism was implausible. War was justified if its consequences were good enough, and not unless they were. Self-defense was not an argument; if one were to be held up by a highway robber, one would not be right to shoot him dead to preserve one's purse or even one's life—though

one might if one had an overwhelmingly important mathematical discovery to communicate to the world. Nations had to be held to the same standard. It was certainly wrong of Germany to violate Belgian neutrality, but once they had done so, launching a war was a bad response. It would destroy European civilization, and that was an evil that nothing could exceed. This line he held through thick and thin; he engaged in an acrimonious debate with T.E. Hulme, who was deeply enraged that the Russell he had once admired for professing a heroic view of the world was now apparently ratting on it. No, said Russell, he stood by his old view; he merely thought that killing millions of young men was a perversion of these values.

This was the attitude that led him in 1946 to advocate the compulsory pacification of the world by nuclear blackmail. In 1918, his experience of war and wartime politics did much to persuade him that mankind was collectively all but mad and that he individually was inept as a practical politician. He repeatedly claimed that he longed to return to pure philosophy, but could never stand the atmosphere of the traditional universities. So, although he spent much time with old Cambridge friends and attended meetings of the Apostles with some regularity, he drifted away from that setting. He had discovered a considerable talent as a popular lecturer and writer; now, having given away the rather substantial fortune he had inherited at twenty-one, he had to turn that talent into cash. The need to do so grew more urgent when he married Dora Black, some twenty years his junior, and promptly begot two children; the need became even greater when they opened Beacon Hill School in Hampshire, which ran at a chronic loss and needed all the help Russell's lecture tours and occasional writings could give it.

This interwar phase of Russell's life produced a curious sort of semi-political intervention in public life. It is one that induces a good deal of ambivalence; on the one hand Russell usually fought for good causes—birth control, religious, racial and political toleration, a more egalitarian society, livelier educational systems, and so on—while on the other, he did so by relying on simple cleverness and a gift for dazzling phrases to carry him over complexities that a writer more respectful of his readers would have acknowledged. "What fools they must be, to take us so seriously," he remarked to Max Eastman, after a public debate between the two of them; Eastman recoiled from the remark and never forgave Russell for it.

Whatever one's ambivalence about it all, it is hard to regret the talent that turned out over fifty "penny dreadfuls" as he used to call them, including *Marriage and Morals*, which won him the Nobel Prize for Literature in 1951. Along with *The Conquest of Happiness, Sceptical Essays, Popular Essays,* and *Unpopular Essays*—so called, said Russell, because a reviewer had objected that *Popular Essays* contained several sentences that even an intelligent five-year-old might find difficult—they formed a library of dissident ideas that excited more teenagers and alarmed more parents and school

teachers than one can count. Speaking for myself, the discovery of Russell in 1956 when I was just sixteen remains one of the aspects of my education for which I remain most grateful.

Nor did Russell always wait to turn his work into penny dreadfuls. For several years he wrote little columns for the Hearst newspapers; he could dictate 1500 words to a secretary in one go, with never a mistake, and always had something quirky and unlikely to say. Moreover, he never compromised his views. "Who May Wear Lipstick?" is not Russell the erotomaniac discoursing on the means of sexual attraction, but a deft little piece of mockery denouncing American local school boards for forbidding female employees from wearing make-up. Nor does he engage, as radicals of a later age might have done, in elaborate appeals to First Amendment rights of free expression and all the rest. He observes that it would do children a lot of good to be taught by cheerful, warm and friendly young women, not by a lot of frumps. All his life he feared that the relentless pressures of respectability deprived most women of the capacity of uninhibited thought. Many of his arguments for a more liberated outlook on sex were drawn less from a concern for sexual happiness—though that certainly moved him—than from a concern that the constant policing of young women was terribly bad for their brains.

The disquieting thing, as suggested above, is how much he disliked doing it all. Instead of cherishing a genuine, and publicly useful—if in the great scheme of things a rather minor—talent, he always fretted that he was not advancing the frontiers of pure philosophy. Between Russell the political essayist and the Russell who communed with the eternal verities, there was not merely an emotional chasm but positive hostility. The tension made for a political flightiness that could often be alarming. His daughter, Katherine Tait, suggests in her memoir of her father that he had "an essentially religious temperament." Given his lifelong detestation of all organized religion, it is hard to go along with that in any simple way; still, there is evidently something in it. Whatever his motives for going along with Ottoline Morrell's florid mysticism in the years of their grand affair, he evidently found it no trouble to do so. He had already written "A Free Man's Worship" and the other essays that make up *Mysticism and Logic*. His utilitarianism was always skin-deep, and something wilder and less calculable was always waiting for expression.

In that vein, he easily dropped into a rhetoric that suggested the choices before us were simple, vast, and to be taken on pure moral conviction. Harold Macmillan was "more wicked than Hitler" because he would not agree to immediate unilateral nuclear disarmament; *Has Man a Future?* offered the choice between heaven on earth and a radioactive ash-heap. The thought that mankind might somehow muddle along between both extremes seemed not so much rhetorically less powerful, though it plainly is that, as intellectually less inviting. One extreme example that again shows Russell's

ambivalence about the United States in a striking light is the transformation of his views about the morality of war between 1936 when he wrote *Which Way to Peace?* and his post-war advocacy of nuclear blackmail.

In 1936, he was straightforwardly defeatist; Hitler was certainly a menace, the Nazis certainly disgusting. Anti-semitism he hardly mentions, and after the war regretted having failed to take it seriously as a genuine driving force of Nazi policy. In 1936, he took something close to the usual appeasers' position. The Germans wanted to regain their place in the sun; in that case the British should give them as many colonies as they wanted. They were no use to the British, and might as well encumber the Germans—or indeed the Americans, who would probably purchase the British West Indies for a "good round sum in dollars." The larger question was what to do about British reactions to German aggression and invasion. Russell's reply was that the only possible response was passive resistance. Non-cooperation and an attitude of contempt for Nazi views and projects would soon induce the occupiers to give up and go home.

The grounds of this view were what one might expect. In the age of the bomber, civilization would lie in ruins within days of the opening of air war. Gas and high-explosives would kill thousands, and reduce everyone else to gibbering incapacity. At a time when the British had only used bombs against villagers in Afghanistan, Iraq, and occasionally in the Sudan, it was easy to project their panic to a city like London, and imagine the results on a vast scale. That the actual course of events was so different, both in Britain and in Germany and in Japan until the use of the atomic bomb, does not entirely discredit him. What is harder to accept is the dichotomous style that suggests that domination by Hitler would not be too bad, while resistance would be the end of absolutely everything.

Russell never liked *Which Way to Peace?* He never allowed it to be reprinted. He backed away from it, and from the company it brought him into, almost as soon as he had written it. When the war actually came, his never very latent British patriotism boiled up. He desperately tried to get back to England, to lend what aid he could to the war effort. He saw that Hitler was an infinitely nastier proposition than he had supposed, not merely a German nationalist of a familiar kind, but a moral nihilist whose aim was to destroy precisely the values by which Russell thought political policies were to be judged. But he had always thought Stalin as obnoxious and dangerous as Hitler. Russophobia was never far from the surface in Russell; among the many reasons why the First World War was intolerable was the way it brought France and Britain into alliance with Russia. During the Second World War, he had told Gilbert Murray that he thought Stalin at least as evil as Hitler. As the war ended, he turned to thinking of ways in which Soviet Russia could be contained.

In 1946, in the American magazine *Cavalcade*, he proposed that the United States should in effect blackmail Russia into disarming. This was not because he thought the United States particularly a model for western society; as always he thought American politicians vulgar, hysterically anti-communist, hypocritical in their religious professions, and largely contaminated by greed and racism. Still, America was a liberal democracy and the Soviet Union was entirely opposed to the values of liberal democracy; moreover, America was not bent on world conquest and Russia was. Quite what he had in mind remains somewhat mysterious. In later years he claimed never to have made the proposal; when it was pointed out that he plainly had done so, he claimed he had never been serious; but that is hard to believe when he made the suggestion several times, and in various places over a period of three years. Moreover, the idea is not wholly at odds with Russell's way of thinking. He was not, as he said, a pacifist on principle. He was a consequentialist. Even nuclear warfare had to be treated in that framework.

Sometimes it seemed that he thought that the mere threat of nuclear war would suffice to induce Russia to disarm. But Russell understood better than most what nuclear weapons in their then state of development could and could not do, and he knew that limited nuclear attacks would be unable to halt the Red Army, or bring Russia to its knees overnight. So he more usually envisioned Russia refusing to disarm, refusing to open its military sites to inspection, refusing to forswear the attempt to develop nuclear weapons itself. In that case, there would have to be war. Sometimes he optimistically envisioned a quick nuclear war as when he speculated that "it would not be difficult to find a *casus belli*." More often he accepted that it would be more protracted. What World War Three would be like was hard to say, but he thought that it might well kill five hundred million people and set European civilization back for five centuries. This, however, was a price worth paying for saving European values.

It is hard to assess such ideas. At one level they have the slightly mad logic of the thought that it had been necessary to destroy the town of Hue in order to save it from the Viet Cong. To kill half a billion people and push Europe back five centuries is a strange way of advancing European values. One would have to be very certain indeed that all the alternatives had been carefully thought out and rejected before one started thinking along those lines. In a way it is an example of something close to the religious mode of thought that I have suggested came naturally to him. Heaven and Hell were the only alternatives worth contemplating; that Europe had to pass through a half millennium of purgatory in order to reach Heaven and escape Hell was not unthinkable. The oddity is to bolt such a way of thinking onto the rationalist, consequentialist forms of political argument that came equally naturally to him. It is no wonder that many American readers of Russell in the last twenty years of his life wondered quite what he had against them, when he swung

from the cool rationalism of the case for restraint in American foreign policy in a dangerous world to a rhetoric more reminiscent (though twenty years in advance) of the Ayatollah Khomeini's denunciations of the Great Satan.

What is one to make of it all? Three things perhaps. In the first place, the Russell whom one might describe as the heir of 1688 and the Whig Revolution was a vastly useful liberal influence. Liberals tend to suffer from a shortage of rhetorical vigor and a lack of vital energy. Russell's astonishing refusal to grow old and behave respectably was a useful counter to that depressing characteristic of liberal politics. His workaday politics were curiously, but usefully, Whig, liberal and democratic socialist all at once. The need to combine respect for an aristocracy of intellect with the benefits of the welfare state is a genuine need and one he could state better than most, as the possessor of an aristocractic intellect who had given all his money to good radical causes in his youth. His dislike of Marxism, while still recognizing its rhetorical power and the ills it fed on, was useful when he first broached it in 1896, more useful in 1920 when he wrote *The Practice and Theory of Bolshevism*, and entirely up to date in the 1950s. His violent attacks on American foreign policy in the 1960s ought not to blind us to the fact that the last political statement he wrote was a condemnation of the Soviet invasion of Czechoslovakia in August 1968. All his life, he was more nearly right than most people about the effects of both the policies he approved and those he loathed, though one result is that when people nowadays read Russell's books of the 1920s on education, marriage, sex, and social policy, they seem models of elegant prose but politically rather tame.

In the second place, there was about him an anti-political streak. This was not 1688 but 1968 when there was a demand for new visions, for the total reconstruction of everything. In this vein, he did not contribute to politics, though he certainly contributed to the vividness with which those who were totally hostile to the existing order set about attacking it. Most of the time, he saw quite clearly that it was not something one could ask from politics; but he also, and to my mind rightly, saw that it was a side of human life that one needs to protect—to find a political framework within which people can pursue these quasi-religious intimations, and find some ultimate value in their lives. As is evident, I am cautious about all this, and mistrustful of the effects of confusing salvation and political action. Still, it must be said both that this was a powerful strand in Russell's intellect, temperament and political style, and that it is hard to see how people would be motivated to take part in politics at all if they were not to a degree propelled by such passions.

And lastly, there was the side of Russell that it is impossible not to like— the Socratic gadfly, whose aim is not to rally us to a cause, but simply to stir up our grey cells. That he did wonderfully well, not just in his popular work but also in his more academic writing too. There is a lovely phrase in his

essay "On Denoting" where he accuses Meinong of failing to preserve the sense of reality that should accompany even the most abstract work, and somehow he managed to convey both that sense in his abstract work—and in his potboilers the converse, the sense that there was also a higher and nobler realm of intellectual light, whose rays might if we were lucky sometimes illuminate everyday life. His ability to make hard thinking and surprising conclusions attractive to such a wide audience is one that anyone with pretensions to teach must surely find it as hard not to envy, as it is impossible to emulate. But we can at least take in it the sort of pleasure Russell evidently aimed to give.

Spring Semester 1991

How Liberal Was John Stuart Mill?

JOSEPH HAMBURGER

O*n Liberty* enjoys the reputation of being a seminal document in the
liberal tradition. It is perhaps the most famous defense of liberty
that we possess. Everyone knows that it is an eloquent paean to
liberty and individuality and that it is regularly cited by teachers, journalists,
and Supreme Court justices. Who is not familiar with Mill's defense of liberty
of thought and discussion (in chapter two) as the best way of sifting out
truth from error? And whose heart has not been stirred by the eulogy to
individuality (in chapter three), where Mill condemns conformity and
sameness and the despotism of custom which denies choice, enfeebles the
mind and character, and induces ape-like imitation that diminishes our
prospect of fulfilling our greatest potentialities? In this chapter he also drew
a picture of the person with wholesome individuality who was energetic,
choosing, courageous and capable of growth, originality, and even genius.

Mill's reputation as an unqualified liberal and as one who wished to enlarge
the realm of individual liberty to the utmost also extends to the world of
scholarship. With few exceptions, political scientists and philosophers who
work on Mill hold this view. The most prestigious of Mill's interpreters, Sir
Isaiah Berlin, for example, regards Mill as an advocate of negative liberty.
Mill's *On Liberty*, according to Berlin, "is still the clearest, most candid,
persuasive, and moving exposition of the point of view of those who desire
an open and tolerant society."[1]

But is this the whole story? Before deciding that it is, we should examine
some of Mill's examples of how his principles would be applied in practice.
He considered the case of a person who while drunk commits an act of
violence; if that person were ever afterwards found drunk, Mill said, he should
be penalized—if only found drunk, even if the violence were not repeated.[2]

He also considered idleness. We cannot without tyranny be legally
punished for it. But note what follows: if because of idleness a man fails to
perform his legal duties, for example, fails to support his children, "it is no

tyranny to force him to fulfil that obligation, by compulsory labour, if no other means are available."

He also hesitated to allow divorce if "third parties [are called] into existence, [for] obligations arise on the part of both the contracting parties towards those third persons." He was even uncertain about allowing divorce if it disturbed the expectations and calculations and plans of life that were formed when entering into an agreement to marry.

Mill goes even further. He would have us be draconian in enforcing the state requirement that parents educate their children. A parent's neglect of this duty he regarded a "moral crime" against both child and society, and Mill would enforce this law by examination. If a child could not demonstrate his or her ability to read, the father would be subjected to "a moderate fine, to be worked out, if necessary, by his labour."

One more example. To cause the existence of a human being is one of the most responsible acts in all of life. "To undertake this responsibility—to bestow a life which may be either a curse or a blessing—unless the being on whom it is to be bestowed will have at least the ordinary chances of a desirable existence, is a crime against that being." Thus he approved of the laws in continental countries where marriage was forbidden unless the parties could show that they had the means for supporting a family. Such a law did not exceed the legitimate power of the state and it was not objectionable as a violation of liberty.

These examples should make us pause before portraying Mill as the pure, enthusiastic advocate of liberty or as the libertarian for whom the region of negative liberty is very large. And as we pause, we should examine arguments buried in Mill's book that justify not liberty but control.

Before doing this, it is important to remember Mill's famous distinction which is usually regarded as the foundation of his argument. He distinguished actions which are self-regarding from others that harmed others. If there is harm to others, a penalty or interference is justified; if there is no harm, there is immunity from penalty. "The only part of the conduct of any one, for which he is amenable to society, is that which concerns others. In the part which merely concerns himself, his independence is, of right, absolute. Over himself, over his own body and mind, the individual is sovereign." Mill's discussion of this distinction gives the strong impression that the self-regarding realm will be very large and that the occasions for interference or punishment will be quite infrequent.

This liberal—even libertarian—appearance arises not only from his flavorsome rhetoric, but also from the substance of his arguments in the first three chapters. In chapter one he presents general liberal principles. In chapter two he justifies unrestricted liberty of thought and discussion, including speech and publication. And in chapter three he criticizes restrictions on liberty arising from custom and upholds an ideal of individuality as a type of

character that spontaneously expresses tastes, ideas, and preferences without either self-imposed or external restraints. When we reach chapter four, however, things change, and it is to this chapter, where the unfamiliar Mill can be found, that we now turn.

Taking up, first, the actions that harm others, here Mill is prepared to impose punishments, either through law or opinion, but his statement of principles suggests that most conduct will be self-regarding. Only if a person "is led to violate a distinct and assignable obligation to any other person or persons, the case is taken out of the self-regarding class." Harmful conduct is narrowly circumscribed: "The only purpose for which power can be rightfully exercised over any member of a civilized community, against his will, is to prevent harm to others. His own good, either physical or moral, is not a sufficient warrant. He cannot rightfully be compelled to do or forbear because it will be better for him to do so, because it will make him happier, because, in the opinions of others, to do so would be wise, or even right." If harm is not done by such an individual, "the interest which society has in him individually...is fractional, and altogether indirect." With regard to his own affairs, "Individuality has its proper field of action."

Mill's examples, however, show that society's interest is anything but fractional. As we have seen, he would punish persons on welfare if they lived in idleness and parents that neglected the education of their children; and he also would forbid marriage to those likely to have children without ordinary chances for a desirable existence. Going even further, he would also punish as harmful to others falsehood or duplicity in dealing with them; unfair or ungenerous use of advantages over them; and selfish abstinence from defending them against injury.

But Mill goes beyond even this. He takes an extraordinary step and enlarges this sphere of harmful conduct to include "not only these [harmful] acts, but the dispositions which lead to them." These are "properly immoral, and fit subjects of disapprobation which may rise to abhorrence," that is, harsh moral judgments operating through public opinion may be used to punish such dispositions or features of character and personality. The examples of such punishable dispositions that Mill mentions are illuminating:

> Cruelty of disposition; malice and ill-nature; that most anti-social and odious of all passions, envy; dissimulation and insincerity; irascibility on insufficient cause, and resentment disproportioned to the provocation; the love of domineering over others; the desire to engross more than one's share of advantages...; the pride which derives gratification from the abasement of others; the egotism which thinks self and its concerns more important than everything else, and decides all doubtful questions in its own favour;—these are moral vices, and constitute a bad and odious moral character.

All of these are punishable, even though they are only dispositions, vices, manifestations of character and not actions. It need not be emphasized that some of them are commonplace, especially where competition is fierce. Whenever the dispositions mentioned by Mill appear, liberty would be restricted by him. By making dispositions and character defects punishable, Mill was giving extraordinary discretion to those who set standards and defined what constituted a character defect.

When we turn to the self-regarding sphere—where the individual is supposed to be sovereign—there are also many occasions for restricting liberty. This was supposed to be the area in which the individual is free to do as he likes—and presumably also to be what he is—provided harm is not done to others. This was the sphere of action "comprehending all that portion of a person's life and conduct which affects only himself"; it was "the appropriate region of human liberty"; and it included "liberty of tastes and pursuits; of framing the plan of our life to suit our own character; of doing as we like, subject to such consequences as may follow: without impediment from our fellow-creatures, so long as what we do does not harm them, even though they should think our conduct foolish, perverse, or wrong." And in another passage, we are told that here "there should be perfect freedom, legal and social, to do the action and stand the consequences."

The consequences, it turns out, will be considerable. In spite of appearances that the self-regarding sphere is a great open space, personal to ourselves, where individuality will flourish, Mill provided a vast opening for the intrusion of coercive social pressures in this realm. Mill revealed his belief that "the feelings with which a person is regarded by others ought...to be...affected by his self-regarding qualities or deficiencies."[3] If the person is eminent in qualities conducing to his own good, he will be admired; but "if he is grossly deficient in those qualities, a sentiment the opposite of admiration will follow." When we discover what elicits harsh judgments we find that it is a mixture of conduct and aspects of character—such things as rashness, obstinacy, self-conceit, not living within moderate means, inability to avoid hurtful indulgencies, the pursuit of animal pleasures at the expense of feeling and intellect. (It may be asked, except for the saints among us, who is not at least occasionally guilty of some of these defects?) Without liking the words, Mill describes such persons as having "lowness or depravation of taste" and as "being[s] of an inferior order."

Right-thinking persons, he revealed, would regard depraved and inferior persons as objects of "distaste, or, in extreme cases, of contempt." They would avoid the society of such persons, and though he avoids the word ostracism, he tells us "we have a right, and it may be our duty, to caution others against him, if we think his example and conversation likely to have a pernicious effect on those with whom he associates."

It turns out that conduct or a way of life or even character traits that Mill labels depraved and inferior are subject to social pressures from the right-minded that in effect are punishments, and that even in this self-regarding sphere, liberty can be restricted. Mill confirms this: "A person may suffer very severe penalties at the hands of others, for faults which directly concern only himself."

Mill wrote a couple of sentences indicating that these penalties ought not be intended as punishments. They were the inevitable, natural consequence of right-thinking persons acting in accord with their individuality. His normative language, however, made it clear that he advocated the making of harsh judgments by the right-minded. Such judgments ought to be made. It would be well, he said, if politeness were overcome and this good office were more freely rendered. When such judgments were made, those subject to them were "justly censured."

The penalties for self-regarding faults so far mentioned have been contempt and ostracism—varieties of social pressure. It should be noted that he also advocated *legislative* interference and therefore legally sanctioned punishment in this sphere. He held that there are "obvious limitations to the maxim, that purely self-regarding misconduct cannot properly be meddled with in the way of prevention or punishment," and these limitations derived from "the right inherent in society, to ward off crimes against itself by antecedent precautions." In this connection he gave the example of drunkenness in a person previously convicted of violence to another while under the influence of drink. Such a person, it will be recalled, has committed a crime, even if the violent act is not repeated.

There is clear evidence, then, that Mill would penalize, restrain, restrict and generally greatly limit the liberty available to the persons he called depraved and inferior, even though their conduct was self-regarding. His willingness to penalize such persons was not an insignificant exception to his argument, nor was it a matter of unnoticed inconsistency, nor was it present as a result of careless composition, for Mill said, "there was not a sentence in [*On Liberty*] that was not several times gone over by us [he and Harriet Mill] together, turned over in many ways, and laboriously weeded of any imperfection we could discover either in thought or expression." His friend Alexander Bain knew about the non-liberal side of Mill's argument. He made the cryptic observation that chapter four (where many of these passages are to be found) "helps us better to his real meaning."[4]

Although the description of the disapproved conduct subject to penalties is inconspicuous in *On Liberty*—much of it confined to the fifth and sixth paragraphs of chapter four—it is supplemented in other writings of this period, especially *Utilitarianism* and "Utility of Religion," where we also find a more elaborate account of the ways it will be controlled and by whom. In *Utilitarianism* where Mill describes the truly human, higher pleasures to which

all might aspire, he also portrays the contrast—the quest for animal pleasures, selfishness, the want of mental cultivation of the fool, the pig-like person whose condition is that of "a selfish egotist, devoid of every feeling or care but those which centre in his own miserable individuality." This description in *Utilitarianism* is entirely consistent with what appears in *On Liberty* where the depraved and inferior persons are also characterized by selfishness and the wish for gratification of animal appetites.

It should be noted that Mill's phrase "miserable individuality" can be juxtaposed with his well-known celebration of individuality in chapter three of *On Liberty*. By doing this it becomes clear that not all manifestations of individuality had his approval and not all would be unleashed and unrestrained in his favored regime.

In passing it should be noted Mill's argument is based on a distinction, but not the one usually attributed to him—between self-regarding actions and those that harmed others, which was supposed to distinguish between those actions subject to penalties and those that were free. Mill provided for penalties and restraints on both sides of what consequently became a non-distinction. His real distinctions, on the other hand, were between conduct that he approved and that which he condemned; between the depraved and inferior and those who were (by implication) wholesome and superior; between those subject to restraint and those deserving liberty; between those with the attractive individuality described in *On Liberty* and those labelled elsewhere as having "miserable individuality."

When Mill condemned "miserable individuality," he provided for what can only be called social control. This becomes evident in "Utility of Religion" where he relied heavily on the power of public opinion—a device condemned in much of *On Liberty,* though implicitly sanctioned in the passages in chapter four which already have been quoted. This included the power of praise and blame and favor and disfavor from others, and it was called "a source of strength inherent in any system of moral belief." Mill recognized that through public opinion one could appeal to the love of glory, of praise, of admiration, of respect and deference, and love of sympathy. On the other hand, public opinion also had a "deterring power"—from fear of shame, dread of ill repute and of being disliked and hated. These fears and dreads could be manipulated in even harsher ways—by exclusion from social intercourse and from the innumerable good offices which human beings require from one another; and by bringing about the forfeiture of success in life, even the means of subsistence, and by ill offices sufficient to render life miserable.

There is no question that Mill approved the use of some of these sanctions, for he described their use in an imaginary society that gave "to freedom and spontaneity...their proper province" (this was not in *On Liberty*), and in this society the inferiors were to be deterred from disapproved conduct by using "the superadded force of shame." This, of course, is a more candid description

of what he advocated in *On Liberty* where he had right-minded persons disapproving of and expressing distaste and contempt for those inferior beings who had self-regarding faults.

Why, we might ask, did Mill include these arguments for control, penalties, and restraint in his famous plea for liberty? This becomes evident, I believe, by examining his visionary hopes for the future developed during the mid-1850s when he redefined his goals as a reformer. At this time Mill reassessed the reform movement he had been associated with since his youth. It had accomplished a great deal in the way of institutional reform, but the considerable changes that had been made produced fewer benefits than anticipated, for "they had produced very little improvement in that which all real amelioration in the lot of mankind depends on, their intellectual and moral state." Consequently he shifted his attention away from policies and institutions and towards the "habits of mind" from which all else flowed. Now he looked for change in "the fundamental constitution of their modes of thought," and therefore he devoted himself to bringing about nothing less than "a renovation...in the bases of belief." This modest undertaking aimed not only to remove existing errors and false beliefs, but also at nothing less than "the reconstruction of the human intellect."

This project was to unfold in two stages. First, it was necessary to clear away the false notions and bad mental habits that prevented the growth of something better. "The old opinions in religion, morals, and politics," although discredited among advanced thinkers (that is, among Mill and his like-minded friends), "have still vitality enough left to be an effectual obstacle to the rising up of better opinions on the same subjects." This undergrowth—and he had in mind, mainly, customary morals and religion—had to be cleared away in order to set the stage for a renovation in the basis of belief. Once the old ethos had disintegrated, a new utilitarian ethics was to emerge. After first becoming established by advanced thinkers, it would become part of "some faith, whether religious or merely human." Thus it would be incorporated into and be reinforced by the "religion of the future." This made him look favorably (in spite of some hesitations) on the idea (derived from Comte) of "making *le culte de l'humanité* perform the function and supply the place of a religion."

The old ethos that had to be cleared away was distinguished by a belief that the greatest good was experienced by individuals regardless of what accrued to others. These goods were animal pleasures, and it was assumed, in the old ethos, that selfishness and egotism were inherently part of human nature. This selfish morality was closely tied to Christianity, which, Mill claimed, also appealed to selfish motives—in its case, the selfish wish for salvation. For this among other reasons, Mill wished to extirpate what he called the "poisonous root" of Christianity.

The new ethos, in contrast, emphasized an altruism which reflected "the ideal perfection of utilitarian morality." It called for "the happiness, or...the interest, of every individual [being] as nearly as possible in harmony with the interest of the whole." Each person was to consult the welfare of others, and more, he was "to identify his *feelings*...with their good."

This vision and its validation was the work of philosophers, but its implementation was to come from fundamental changes in political and social institutions. The new "feeling of unity with our fellow creatures" was to be deeply rooted in our character and in "our own consciousness as completely [as if it were] a part of our nature." Such an ethical outlook, were it to be established, would require a vast cultural transformation, and, understanding this, Mill recognized that only something as compelling as a new religion could bring about the changes in consciousness, motivations, and beliefs that would be necessary. With this in mind, he recommended that the new outlook "be taught as a religion, and the whole force of education, of institutions, and of opinion, [be] directed...to make every person grow up from infancy surrounded on all sides both by the profession and by the practice of it." Mill regarded this as entirely feasible, and, in spite of uneasiness about some of Comte's proposals, he cited Comte's arguments as proof of "the possibility of giving to the service of humanity, even without the aid of a belief in a Providence, both the psychical power and the social efficacy of a religion; making it take hold of human life, and colour all thought, feeling, and action." Of course, this was the Religion of Humanity, which in writings published during his life time, Mill sometimes alluded to but hardly ever mentioned by name.

Mill's goal as a reformer was now nothing less than the transformation of the moral culture—the ethos—that shaped the motives and purposes of most persons. He promoted a moral class struggle between those he labelled (with only a modicum of embarrassment) as possessing inferior and superior natures. Whereas the inferiors were unthinking, custom-bound, imitative, selfish, vain, egotistical, hedonistic, and pig-like, the superiors were energetic, choice-making, interesting, eccentric, original, sceptical of Christianity, cultivated, and modelled on Socrates. This struggle was between those with wholesome individuality and those with miserable individuality; the latter represented the old, selfish ethos, whereas the new altruistic ethos, based on utilitarian morality (as re-defined in his essay *Utilitarianism*), was represented by those few—a kind of vanguard—with the desirable kind of individuality.

On Liberty was the first published work in which Mill proposed some of the changes that were to lead to the ultimate implementation of his program for "the reconstruction of the human intellect." Here he laid out the plan of battle between those with "miserable individuality" and those with the better kind; between the old ethos and the new. In chapter two, he provided for free discussion, which when applied to religion would lead to the erosion of

Christian belief. In chapter three, he analyzed the defects of customary morality, infused as it was with Christianity, and here its defenders were described as the adversaries of those with individuality. That he assumed a battle between these two outlooks is strongly suggested by his symmetrical opposition of the individuality he upheld and the culturally entrenched kind of character which he found abhorrent. On the one side, there was his ideal character, which is self-assertive, eccentric, experimental, unafraid, original, active, and open to change. All these qualities are polar opposites of the custom-bound character tied to Christian morality, which was described as passive, conformist, self-denying, obedient, low, abject, servile, unadventurous, and resistant to change.

In *On Liberty* Mill also outlined the ways in which the persons with desirable individuality would implement Mill's program for reconstruction of the human intellect. They had functions to perform at every stage. They would "point out when what were once truths are true no longer," that is, they would bring people to recognize that Christianity was a false belief. They would also "discover new truths," that is, they would contribute to the development of the revised utilitarian ethics which would inform future belief. And finally, they would "commence new practices, and set the example of more enlightened conduct, and better taste and sense in human life," that is, they would promote the growth of new institutions that would make the new ethics a matter of established habit. If successful, the new ethos would become something like a secular religion, and in laying the groundwork for it, Mill was serving as its architect—or, dare it be said?—its prophet.

These passages listing the functions of the persons with individuality appeared in chapter three. There was one other function which was introduced—inconspicuously, and with reason—in chapter four. It was to discipline the depraved. As the superior natures, those with individuality were to show contempt for, ostracize, and shame the inferiors. In this connection, it should be mentioned that while they were to enjoy tolerance from others, those with individuality were called upon to be judgmental and censorious—the very opposite of tolerant.

With these functions in mind, I suggest that individuality was less an ideal kind of character than a term that identified a new kind of intellectual and politician. Those few that qualified had to be skeptical critics, constructive philosophers, artful founders of a new regime, and moral police. Such varied skills were necessary in view of the magnitude of the task, which included cultural transformation and the reconstituting of our ways of thinking and feeling. He had in mind situations in which "the mind of a people [is] stirred up from its foundations"; where "the yoke of authority was broken"; and "an old mental despotism [is] thrown off." The magnitude of the change he looked forward to is indicated by his historical analogies—the intellectual fermentation in Germany during the Goethian and Fichtean period; Europe

immediately following the Reformation; and the speculative movement at the end of the eighteenth century associated with the *philosophes*.

Mill had always been ambitious. As a young man, he wished to be in Parliament, to lead the Radical party, to provide the intellectual foundations for reform. When he listed the functions of the person with wholesome individuality, his ambitions had not changed, for there are close parallels between them and Mill's own activities. Perhaps he did not qualify as the moral disciplinarian, but, like the person with individuality, he was the skeptical critic of the old ethos, the constructive philosopher of the new, and an architect—perhaps only with a vision and not yet a plan—for a new moral order. Therefore I suggest that when he wrote *On Liberty,* far from being in retreat into a world of theory, his political ambition was never greater.

If this analysis is correct, it remains to explain why the argument for restraint and control is not candidly presented and more visible in the book. This non-liberal argument *is* present, but it is anything but conspicuous.

It was a matter of rhetoric. One purpose of *On Liberty*, in light of Mill's grandiose plan for moral reform, was to promote the undermining of Christianity and Christian morality. This required liberty to engage in completely free discussion, for Mill believed that in a fully open debate Christianity inevitably would be defeated and customary, Christian morality would be undermined. Thus Mill emphasized the usefulness of liberty. He said *On Liberty* was a "philosophic text-book of a single truth", and this was it.

There was another truth, however, and another purpose, and it concerned his substitute for Christianity and customary morality—what he thought of as a Religion of Humanity.[5] There are passages in his *Diary* and in letters to Harriet Mill contemporary with the writing of *On Liberty* in which he reveals his belief in the desirability of such a secular religion. It is not likely that this belief was suspended while *On Liberty* was being composed. Yet the Religion of Humanity was not mentioned, and provision for it can barely be discerned in this book. In other contemporary writings, however—notably in *Utilitarianism*, "Utility of Religion," and even in *Auguste Comte and Positivism*—he praised and promoted the attitudes, the moral standards, institutions, self-restraints, and social controls that were essential ingredients of a Religion of Humanity, without, however, often mentioning it by name.[6]

There was, however, great difficulty in openly promoting the Religion of Humanity in a work emphasizing liberation, for its distinguishing features included an ideal of unity with others, altruism, and the definition of individual wishes in a way that made them coincide with the demands of society. In the language of *On Liberty,* a religion of humanity seemed to intrude into the self-regarding realm and diminish individuality. It had the stamp of restraint and control, and it justified interference. Thus to uphold a new doctrine requiring a great increase of intrusion and pressure and

censoriousness in a book apparently celebrating liberty would have appeared inconsistent. Mill regarded these two things—liberty for those with true individuality and the demands of his new altruistic regime—as complementary, but he recognized that others would only discern contradiction. Therefore, he played down control, which in any case, he knew, was contrary to the spirit of the times. Thus we have Mill weighing his words, as he had always done (for example, when discussing Christianity), being cautious, evasive, and politic but not dishonest, in order to emphasize one part of his message while not being false to the other part and to all his purposes.

Although he was not dishonest, it is difficult to avoid concluding, however, that he tried to mislead. He gave the impression that individuality is an unqualified good even though he believed that some manifestations of it were "miserable" and "depraved." Yet this disapproved kind of individuality appears in *On Liberty* only in a couple of inconspicuous paragraphs, whereas the phrase "miserable individuality" is used in another work.

He also misled by investing his rhetoric with attractive libertarian language even though he believed in the necessity of restraint and in the need for coercive social pressures. Another example of the inconspicuousness of his provision for control might be offered. In chapter five he mentioned drunkenness, idleness, fornication and gambling, indicating that each was "not a fit subject for legislative interference." While this statement implied such activities would not be penalized, it should be recalled that each of the four activities nicely illustrate Mill's view (in chapter four) that hurtful indulgence and the pursuit of animal pleasures inevitably and properly were to be treated with contempt and ostracism.

All this was deliberate. To a few close friends he did not conceal. For example, he told George Grote that the essay would "point out what things society forbade that it ought not, and what things it left alone that it ought to control." There was as much emphasis on control as on liberty, which was how Grote understood his meaning: "It is all very well for John Mill to stand up for the removal of social restraints, but as to imposing new ones, I feel the greatest apprehensions."[7]

Finally, to answer the question in the title, I would say, it depends. In some ways, Mill advocated liberty virtually without qualification; for example, with regard to thought, discussion, speech and publication. With regard to conduct, however, and this includes what he called dispositions to conduct—in that wide and diverse area associated with individuality, the waters are muddied. For there are those with the features of the wholesome individuality celebrated by Mill; and there are others—many others—whose tastes Mill called miserable and depraved. Their claim to liberty, especially from social

pressures, is quite uncertain, and therefore I suggest that Mill does not deserve his reputation as an unequivocal defender of an expansive liberty.

Fall Semester 1990

NOTES

1. Isaiah Berlin, *Four Essays on Liberty* (London, 1969), pp. 139, 201.

2. This lecture refers to *On Liberty, Utilitarianism,* "Utility of Religion," *Early Draft* and *Autobiography*, all in John M. Robson (ed.), *Collected Works of John Stuart Mill*, 33 vols. (Toronto, 1963-1991). Page numbers with volume numbers can be found in the original version of the lecture published by the Harry Ransom Humanities Research Center at the University of Texas in 1991. A more elaborate statement of the argument in this lecture can be found in the author's article, "Individuality and Moral Reform: The Rhetoric of Liberty and the Reality of Restraint in Mill's *On Liberty*," *Political Science Review,* 24 (Spring 1995).

3. This statement is taken from an assertion that uses a double negative. The full statement is: "I do not mean that the feelings with which a person is regarded by others, ought not to be in any way affected by his self-regarding qualities or deficiencies."

4. Alexander Bain, *John Stuart Mill: A Criticism, with Personal Recollections* (London, 1882), p. 107.

5. Maurice Cowling, *Mill and Liberalism* (Cambridge, 1963) p. xiii; and *passim*, where he identifies many authoritarian features in Mill's outlook.

6. Examples of his very infrequent use of the phrase "Religion of Humanity" are to be found in "Auguste Comte and Positivism." Although this essay is known for his criticisms of some features of Comte's version of the Religion of Humanity, in it Mill endorses the idea of such a secular religion as well as many of Comte's proposals regarding it.

7. Bain, *Mill,* pp. 103-4.

9

British Post-War Sterling Crises

DIANE KUNZ

It seems...that the time and energy and thought which we are all giving to the Brave New World is wildly disproportionate to what is being given to the Cruel Real World.[1]

John Maynard Keynes
June 1944

From 1947 until 1967 systemic financial rigidity, both domestic and foreign, triggered a series of crises in Great Britain with attendant economic, political, and diplomatic damage. Yet British political leaders of both parties persisted in pursuing a sterling policy which in retrospect seems so wrongheaded as to be completely misguided. This pattern is even more surprising when it is realized that the same factors, though in different degrees, repeatedly fed the financial octopus that nearly strangled Britain. But, handicapped by changing world conditions while simultaneously hamstrung by inherited preconceptions and practices, ministers and their permanent officials proved unable to escape from a disastrous financial and foreign policy course.

AFTER THE WAR: 1945–1951

The two decades under discussion fall into three periods: 1945–1951, 1951–1964, and 1964–1967. The first of these three was the most obviously desperate. Britain at war's end found itself in a parlous financial state. Unlike the First World War, which the British had paid for by massive government public and private loans funded largely by the United States, the Exchequer defrayed the enormous cost of the Second World War by using American lend-lease ($21 billion net to the United Kingdom) and by using sterling balances, which were enforced loans from the Empire and Commonwealth. In 1945 the sterling balances amounted to £3.355 billion ($13.5 billion).[2] With

the unexpectedly abrupt ending of the Second World War and the concurrent termination of lend-lease, Britain found itself facing, in Keynes's term, an "economic Dunkirk."[3] Worse yet, the cessation of hostilities caused an increase in British economic responsibilities. For example, Britain now had to feed Germans living in the British occupied zone.

In meeting this challenge, the Labour government led by Clement Attlee became entangled in a web of five interlocking constraints. The immediate post-war consensus supporting both the Beveridge Report's scheme of cradle-to-grave social insurance and a policy of full employment set the boundaries of economic choices. Several reasons explain the virtually universal support for these policies. Having worked full tilt to defeat Hitler, the British became convinced that victory would bring not only peace but a brave new world.[4] Bitter memories of the drastic slump after the First World War and the consistently troubled economy which had plagued Britain throughout the interwar period also fed this belief. In the 1920s and 1930s British governments had decreed deep spending cuts as the answer to economic troubles, but this time the political consensus ensured that no Geddes Axe would appear, no May Report would be produced and domestic deflation could not be used to improve British accounts.[5]

In the immediate post-war period the effect of this unanimity was marked. While attempting to resurrect British trade and revive exports (down to 30 per cent of their pre-war level), the Labour government simultaneously enacted social measures such as the National Health Insurance plan and nationalized key sectors of British industry. These actions bore generous fruit in the improvement in British health and well-being, but also prevented the wholehearted concentration on industrial recovery which characterized the German and Japanese economies during the same period.

The general support for maintaining full employment had repercussions. In a tight market employers took on more workers, enabling labor unions to exploit their power to the fullest. The strong connection between trade unions and the Labour Party further increased the influence of the working class. The three decades following the war's end marked the zenith of British trade union power and influence. The Attlee years began the pattern of a persistently large gap between real wage increases and productivity increases.

During the same period the terms of trade turned heavily against Britain, deteriorating by 15 per cent from 1938. For Britain, whose economy was so thoroughly integrated in the world financial system, this development had dire consequences. Exacerbating the problem further, much of the decline derived from the upward-price pressure on raw materials and reconstruction equipment that Britain, in company with much of the world, needed to fuel its recovery. In reaction politicians and bankers increased their devotion to a strong pound. A country dependent, as Britain long has been, on imports of food and increasingly reliant on imports of fuel as well as other raw materials

is always predisposed towards a strong currency. Not surprisingly, with Britain's manufacturing sector facing ever-greater competition, invisible exports became increasingly consequential. Yet a price would be paid: a strong currency further discouraged export growth.

The imperial dimension also played a major role in determining British policy. Without dissension all major political leaders saw London as a full partner in the new post-war order. Indeed men such as Winston Churchill and Foreign Secretary Ernest Bevin, architect of the Labour government's post-war foreign policy, perceived Britain as in some ways having a more exalted position than that of the United States. By virtue of history and geography Britain would serve as the bridge to three groups of democratic countries: the Atlantic Alliance, Western Europe and the Commonwealth and Empire. These links would not only be diplomatic. The third of Britain's three circles intersected with the position of sterling which was meant to support the Empire and give substance to the ephemeral Commonwealth. As the case for an autarchic sterling area lost favor, especially during the 1940s and 1950s, the alternative version, that sterling as an international currency would link the Empire and Commonwealth with the metropolitan country, waxed stronger.[6]

Furthermore, Empire and Commonwealth trade grew in importance during the immediate post-war period.[7] This development proved greatly advantageous to Britain; among other things, any such trade was conducted in sterling, thereby lessening the dollar gap. Indeed, for one brief shining moment the vision of Joseph Chamberlain seemed to enjoy a renaissance. But these neo-mercantilist benefits came at the price of limiting financial innovation.

While Bevin cooperated with European nations on many occasions, he, along with most of his compatriots, spurned the notion of British leadership in Europe as incompatible with Britain's other interests. The rejection of the number one position in Europe, which was Britain's for the asking, contributed to Britain's financial difficulties as did its enormous defense commitment. Both parties were pledged to maintain a high level of military expenditure for conventional as well as nuclear weapons. Indeed, of free world nations, British defense budgets were only exceeded by those of the United States.[8] As a victor in the Second World War no British government contemplated the affordable foreign policy that Germany, for example, adopted in the years after 1945. Once again, the net effect was that Britain adopted a foreign policy well beyond its means, one that had crippling economic results as well as an increased British dependency on the United States and international financial institutions.

Finally, psychological pressures played a large role in determining British post-war sterling policy. While it is certainly an exaggeration to say that Britain had gone to war to preserve the position of the pound, victory made it much

easier to cling to an outdated sterling parity, particularly as the British have always exhibited a marked preference for a strong pound. Contrast the situation in Germany where the memory of the hyperinflation of the 1920s led to a similar antipathy to inflation and preference for an undervalued mark.

Not surprisingly, the British economy in 1945 urgently needed American aid. When the high level delegation led by Lord Keynes arrived in Washington in the autumn of 1945, it found that its expectations of a multi-billion dollar American grant were misplaced. The best the deputation could secure proved to be a fifty-year loan of $3.75 billion which, apart from a low rate of interest by commercial terms (2 per cent) and a five-year grace period, was also laden with conditions such as a British return to convertibility and an end to imperial preference. Yet Washington officials could plausibly claim that they had contributed to the start of Britain's post-war recovery because simultaneously they had presided over a reasonable settlement of lend-lease claims as well as a Canadian credit to Britain for $1.159 billion.

The reaction in Britain was not favorable. Robert Boothby, a prominent Conservative backbencher, decried this "economic Munich."[9] Leo Amery, a prominent imperialist, launched a vigorous campaign against the loan. Since the beginning of the Second World War, Amery had been concerned with the ill effects of American anti-imperialism and free trade ideology, which were espoused both by ideologues and pragmatists alike. Indeed, in the long run, Amery feared that the Americans would dominate supra-national institutions such as the International Monetary Fund (IMF), and that palliatives such as the American loan would erode British independence. His judgment proved to be absolutely correct.[10] Unfortunately his solution, increased British reliance on the Empire and Commonwealth for financial sustenance, ignored post-war financial realities. As Keynes, in one of his last speeches in the House of Lords, pointed out: a separate sterling-based system would consist only of countries "to which we already owe more than we can pay, on the basis of their agreeing to lend us money they have not got and buy only from us and one another goods we are unable to supply."[11] Keynes's cold logic triumphed. Although the Conservative front bench, including Churchill and former and future Foreign Minister Anthony Eden abstained, Parliament approved the American loan in December 1945.

The British economy fared better during the first full year of peace. British exports expanded and the American Congress, pushed partly by a constantly increasing perception of a clear threat from the Soviet Union, approved the American loan in the spring. Unfortunately, the rosy economic news soon dissipated. Britain, in company with the rest of Europe, found its recovery paralyzed by the dollar gap. Furthermore, the winter of 1946–1947 proved to be one of the coldest of the century. As factories ground to a halt and employees shivered in offices, American planners realized that Europe needed massive, immediate American financial sustenance. While Britain was

ostensibly stronger than Continental nations, its position had grown increasingly difficult. The dollar drain during the first half of 1947 had accounted for over half of the American loan, which was expected to last until 1951. The loan's terms required that the pound become convertible on 15 July 1947.[12] London complied with this commitment and as a result lost another $542 million within the next four weeks. By 18 August, when the British government suspended convertibility, only $400 million of the American credit remained.

Of course, Marshall aid rescued Britain. Trade balances improved impressively in 1948 as the dollar gap narrowed. But the following year again proved to be disastrous. At the beginning of the Second World War the British government had fixed sterling's parity at $4.03. In December 1948 British Treasury officials urged a devaluation of the pound. The pound was now clearly overvalued and officials also hoped that reducing sterling's value would redirect sterling area exports toward dollar markets and increase dollar income.[13] But Harold Wilson, the President of the Board of Trade, proved to be unenthusiastic.

Had devaluation come in 1948, it would have appeared as a considered and rather brave policy. By April 1949 the American recession and the gap between sterling's fixed and black market rates indicated that devaluation was imminent. Yet many in the British government still opposed the move, on several grounds. The immediate effect on dollar earnings would be negative. It would alienate sterling area countries and, given the nature of import controls and labor and material shortages, the room for export growth was decidedly limited. But British costs, which were glaringly high, combined with still falling American costs to make a currency readjustment unavoidable.

Officials decided on a big devaluation. Whitehall reckoned that the resulting shock waves would be outweighed by the need both to boost competitiveness and to quash rumors of further sterling devaluations. Accordingly, on 19 September 1949 Stafford Cripps, Chancellor of the Exchequer, announced a 30 per cent devaluation, to £1 = $2.80. While concurrent devaluations by most other European nations somewhat eroded the impact of this action, British gold and dollar reserves rose, from $1,425 million in September 1949 to $2,422 million nine months later. This increase symbolized the stable economic fortunes Britain enjoyed during 1950 and into the beginning of the following year. Thus ended the first of the three post-war periods. The six years had been a tightrope for British officials; the next fifteen years would prove no simpler.

YOU NEVER HAD IT SO GOOD: 1951–1964

The second interval, 1951 to 1964, exhibited three repetitive cycles now labelled as "stop-go" or "zig-zag" economics. Each displayed the same

characteristics: a boom would lead to increased imports which would cause balance of payments and trade deficits. A sterling crisis would begin a run on the pound. The government of the day, always Conservative, would respond with drastic measures: hikes in interest rates, hire purchase (installment payment) restrictions, cuts in expenditures for nationalized industries, and tax increases combined with, particularly in later years, loans from abroad. These measures would cool down the economy to the extent that recession or near depression would result. Recovery would eventually come, and with it, the beginning of a new cycle.

During this thirteen year cycle the same factors discussed above delimited the range of options available to successive Cabinets. The Butskellite consensus demanded that the Conservative Party embrace many of the domestic priorities set by its rival.[14] Accordingly, no Conservative Prime Minister of the period, neither Churchill, nor Eden, nor Macmillan, nor Home, ever mooted cutbacks in welfare state expenditures or significant changes in nationalized industries. These men proved equally committed to maintaining full employment and showed themselves thoroughly unwilling to take any stern action to lower British wage costs. Their decisions became increasingly costly after the middle of the decade when strong continental competition surfaced, unhampered by the aging capital plant left to the British after their victory.

The terms of trade in this period provided one bright spot. After 1952 they steadily eased in Britain's favor. This development helped fuel the increase in consumer expenditures which noticeably improved the British standard of living at mid-century. However, it also had the pernicious effect of contributing to the illusion that the international reserve position of sterling could be continued with ease.

Part of the desire to preserve such an exalted position for the pound stemmed from the continued British perception of London's superpower status. Cabinets continued to favor an extensive British defense commitment including an independent nuclear deterrent. The loss of India set in train an increased attachment to Britain's Middle Eastern and African possessions. These expensive policies strained the British economy as did the continued belief in the importance of the sterling area. After 1949 Commonwealth central bankers made it clear to the Bank of England that any further devaluation would spell the end of the sterling area. Such a warning was sufficient to end most serious discussions about a currency realignment during this period.

The continued attachment to the special and imperial relationships also meant that British leaders almost to a man rejected joining the European Economic Community which was formally inaugurated in January 1958. While the successful Franco-German cooperation under the auspices of the European Coal and Steel Community, founded in 1951, closed off the

possibility of London's continental domination, Britain certainly could have influenced the community significantly if she had joined as a founding member. However, only in 1961 did Macmillan conclude that Britain's future, at least partially, lay in Europe. The decision came too late—Charles de Gaulle and his successor succeeded in blocking British entry into the Common Market until 1973, and in the process diminished much of the value that entry could have brought to Britain.

Psychological forces again played a role in the continuation of a disastrous policy. As the military, geographic, and diplomatic sources of British power steadily declined, British financial and political leaders increasingly clung to the pound's role in international finance. They saw sterling transactions accounting for over 40 per cent of the world's trade during the 1950s (making it the most used currency for international transactions) as a point of pride and strength, not the potential noose it really was.

Two sterling crises triggered by external events were superimposed on the expected stop-go cycle which marked the period 1955–1960. The better known of these was the Suez crisis of 1956. After stern measures in December 1955 and March 1956 to combat the strained sterling position, the pound seemed on solid ground when, on 26 July 1956, Egyptian President Gamel Abdul Nasser nationalized the Suez Canal Company thereby setting in motion one of the most dramatic episodes in post-war history. British finances suffered immediately. As with any weak currency, sterling came under siege as investors, newly empowered by the pound's return to *de facto* convertibility in February 1955, sought safer harbors. In this world of fixed rates any such sales were no-lose propositions, since, if Britain did devalue, foreign holders could buy back sterling at cheaper rates. If sterling remained at its parity holders could always repurchase sterling at the price for which they had sold it. Furthermore, the military build-up and the threat to shipping and oil deliveries immediately took their toll on British reserves. It was the Eden government's decision to launch an Egyptian invasion in cooperation with Israel and France but behind the back of the United States that began a massive sterling crisis. British leaders knew that their paltry reserves of dollars and gold would not suffice to keep sterling afloat but they assumed that, come what may, the administration led by President Dwight D. Eisenhower would support its closest ally and, in particular, the position of the pound.

Within days after launching the Suez strike, British leaders began to realize to their horror the error of this assumption. While Washington did not itself dump sterling, Eisenhower refused even to discuss aid for the pound or oil for Western Europe until Britain and France committed themselves to a firm evacuation from Egypt.[15] During the month of November 1956 Britain officially lost $279 million of its gold and dollar reserves (12 per cent of the total).[16] Only when Foreign Secretary Selwyn Lloyd announced the British withdrawal from Egypt on 3 December did the United States agree to aid

British finances. While aid then proved more than sufficient to allow Britain to avoid a devaluation, this experience clearly illustrated to what extent Britain's financial policy had left its foreign policy dependent on American goodwill.[17]

Scarcely nine months later Britain found itself embroiled in another financial crisis. The refusal of Germany to revalue the mark upwards and the reluctance of France to agree to a necessary devaluation triggered the September 1957 run on the pound. Again, sterling was caught in the middle and suffered. Severe belt tightening, marked by an increase in bank rate to an unprecedented 7 per cent, led to a depression in 1958. In January 1959 unemployment reached a post-war record of 2.8 per cent and in response Prime Minister Harold Macmillan, intent on calling an election during the year, took steps to initiate a recovery which then triggered a full-scale boom in 1960, and another crisis in 1961, marking the end of this cycle.

The third cycle, 1961–1964, once more began with severe internal financial restrictions designed to end another huge drain on sterling. The bank rate rose again to 7 per cent, the government increased excise and purchase taxes, and Britain obtained £323 million in loans from European central banks as well as £535 million from the International Monetary Fund. The resulting recession continued into the next year but in 1963 recovery came, laying the groundwork for the balance of payments crisis of 1964 which ended the final cycle of the period 1951 to 1964.

HURTLING TOWARDS DISASTER: 1964–1967

It is no exaggeration to describe the three years 1964 to 1967 as virtually one continuous crisis. The sterling drain began during the election campaign of October 1964. Immediately upon taking office, Prime Minister Harold Wilson, heading the first Labour government since 1951, in company with Chancellor of the Exchequer James Callaghan and George Brown, soon to be head of the newly created Department of Economic Affairs, decided that the sterling parity would be defended.[18] The forces which earlier dominated British thinking again molded the shape of this three year struggle. Having returned to power after thirteen years out in the cold, Labour Party leaders neither could nor would alter the social welfare policies their party had supported since its inception. They were equally committed to the goal of full employment. Labour's connection with the trade unions at a time of increasing union militancy meant that the Wilson government would also find itself handicapped in its search for a new economic policy which could shrink the increasingly large gap between British wage increases and productivity, on the one hand, and the respective costs of its foreign rivals, on the other.

The terms of trade during this period continued to favor Britain. Again this blessing had its price as it helped the Wilson government cling to the

reserve status of the pound well past the proper time. The always precariously balanced British budgets were constantly buffeted by world conditions. Having a reserve currency, rather than being an advantage, turned out to be a crippling weight. For both political and financial reasons the pound became a hostage to fortune as holders of sterling repeatedly jettisoned their pounds for fiscal or foreign policy reasons. A weak currency always suffers in the wake of a political crisis and during the 1950s and 1960s this fate was the pound's, particularly as fixed rates ensured that the gamble of holding sterling was, for speculators, virtually risk-free.

Notwithstanding the fears of the Johnson administration, the Wilson Cabinet initially embraced an imperial British role. But gradually various ministers began to realize that Britain's defense commitment was a luxury too costly to bear. The British decision taken in 1967 to withdraw all forces east of Suez did not transform Britain into a second-class power such as Holland, but it did recognize that the post-war British defense role no longer remained tenable.

Concurrently the 1967 devaluation of sterling ended the sterling area, in the process severing one of the important bonds between London and the Commonwealth countries. While British leaders knew this consequence would likely follow on the devaluation, the existence of the sterling area no longer mattered to the same degree as earlier. The steady decline of Commonwealth and Imperial trade during this period accompanied by a solid increase in European trade helped ease the transition. While nostalgia for sterling's imperial role continued (as it does today), ministers realized that Britain could no longer afford the luxury of a major reserve currency with its attendant domestic costs.

The Wilson government found itself even more hamstrung psychologically than had been its predecessors. Ever since the 1931 decision to jettison the gold standard, Labour had been tarred as the party of devaluation. This factor had inhibited the Attlee government's financial policy and equally affected the Wilson Cabinet. The Prime Minister himself had then been one of the men responsible for the dithering response to Britain's economic problems in 1948. After the Cabinet finally agreed to devalue in November 1967, Wilson found it necessary to say that the 14 per cent reduction did not mean "that the pound in Britain, in your pocket or purse or bank, has been devalued." He still remained wedded to the importance of a strong pound.[19]

The 1964 baptism of fire well illustrated the interplay of these various ingredients in determining the sterling policy. Crisis measures included the first of five budgets during the next twenty months, an increase of bank rate to seven per cent, and a 15 per cent surcharge on imports of manufactured and semi-manufactured goods which violated the rules of GATT and enraged many of Britain's trading partners. The government pledged itself to a vast improvement in Britain's competitive position, seeking to harness the "white

heat of technological revolution" and also to keep a lid on Britain's egregiously high wage costs. Britain also obtained an emergency Central Bank credit of $3 billion. France conspicuously refused assistance, at times appearing to revel in British difficulties. American support was generous but it came with a *quid pro quo:* Wilson pledged to maintain a British military presence East of Suez and ordered cuts in domestic spending.[20] These measures led to a brief and false dawn from April 1965 to April 1966. Foreign central banks together with the Bank of England launched a massive bear raid against the gnomes of Zurich in September 1965. But while hot money returned and income and imports rose, exports did not.

By early summer 1966 British finances faced renewed pressure. In July Wilson and his Chancellor once again repeated the familiar litany: hire purchase restrictions, a surcharge on purchase taxes, petrol and excise duties, and savage spending cuts combined with a wage freeze. Moreover, the government announced its intention to save at least $280 million in overseas expenditure both by shrinking foreign aid and by cutting British defense commitments. These measures, severe though they were, proved insufficient. During 1967, growth slowed but exports did not rise. Furthermore internal and external political events, the dock strike of September 1967, De Gaulle's veto of Britain's application to join the Common Market, and the 1967 Six Day War which caused both an increase in oil prices and the closure of the Suez Canal, wreaked havoc on foreign confidence in British finances. Therefore, by autumn 1967, despite the Cabinet's decision to order a withdrawal of British forces East of Suez, the question was not whether but when devaluation should occur. The date chosen, 18 November 1967, saw a 14.3 per cent devaluation with the pound's dollar parity lowered to £1 = $2.40. This change marked the end of the sterling area although not the end of Britain's financial problems, which continued until the late 1970s when North Sea oil temporarily but definitively altered the picture.

Ironically, measured by historic standards, the British economy during the Cold War era performed better than it had ever done previously. But relative to other European nations, London's economic record after 1945 showed a steady deterioration. Yet for twenty-two years British governments lurched from crisis to crisis, never able to formulate a policy which could adequately cope with the cruel real world.

Spring Semester 1991

NOTES

1. Bank of England, London, England, OV 21/119, J. M. Keynes, "The Problem of Our External Finance in the Transition", 1 June 1944.

2. Sidney Pollard, *The Development of the British Economy: 1914–1980* (London, 3rd ed., 1983), p. 219.

3. Kenneth O. Morgan, *Labour in Power 1945–1951* (Oxford, 1984), p. 144.

4. See e.g. Paul Addison, *The Road to 1945: British Politics and the Second World War* (London, 1975), pp. 217-28.

5. The "Geddes Axe" refers to the massive cuts instituted in domestic spending in 1922 pursuant of a report of a committee of important business leaders headed by Sir Eric Geddes. The May Report issued in July 1931 predicted a massive government budget deficit and prescribed draconian cuts to meet the situation. Unfortunately the determination not to repeat the mistakes of the interwar period also blocked consideration of the positive sterling policy that developed after September 1931. Then, following six years of increasingly futile effort to maintain the pound on the gold standard at the pre-war parity of £1 = \$4.86, the British government had decided to liberate the pound from its constricting external harness. The results included the birth of the sterling area, greatly increased British fiscal flexibility, and domestic economic improvement. See Diane B. Kunz, *The Battle for Britain's Gold Standard in 1931* (London, 1987).

6. The term "sterling area" initially referred to those nations that after 1931 linked their currencies to sterling rather than gold. After the outbreak of the Second World War the arrangement became formalized with the acceptance by these nations, basically those of the Empire and Commonwealth, of British exchange control. The Bank of England became the central banker for the sterling area, handling gold and dollar reserves for the area. After the war the sterling area functioned both as a currency and trading bloc.

7. The figures were:

	Imports	Exports
1939	39.5%	49%
1946-9	48%	57.5%
1950-4	49%	54%
1955-9	47%	51%

Source: Bernard Porter, *The Lion's Share: A Short History of British Imperialism 1850-1983* (London, 2nd ed., 1984), p. 320.

8. Pollard, *The Development of the British Economy*, pp. 363-64.

9. Morgan, *Labour in Power*, p. 149.

10. See Leopold S. Amery, *The Washington Loan Agreement: A Critical Study of American Economic Foreign Policy* (London, 1946) and *The Awakening: Our Present Crisis and The Way Out* (London, 1948). On Amery's wartime thoughts see John Barnes and David Nicolson (eds.), *The Empire at Bay: The Leo Amery Diaries 1929–1945* (London, 1988); Wm. Roger Louis, *In the Name of God, Go! Leo Amery and the British Empire in the Age of Churchill* (New York, 1992), pp. 123-79; and David Reynolds, *The Creation of the Anglo-American Alliance 1937–1941: A Study in Competitive Co-operation* (London, 1981), pp. 269-72.

11. Robin Edmonds, *Setting the Mould: The United States and Britain 1945–1950* (New York, 1986), p. 102.

12. Convertibility in this context meant that foreign holders of sterling could exchange their holdings for dollars held by the Bank of England as part of its reserves used to bolster the pound. Obviously such demands weakened the support for sterling; after a point they would force a devaluation.

13. For the debate on devaluation see Alec Cairncross, *Years of Recovery: British Economic Policy 1945–1951* (London, 1985), pp. 165-211, and Alec Cairncross, ed., *The Robert Hall Diaries 1947-1953* (London, 1989), pp. 55-84.

14. "Butskellite," a term derived from the names of R.A. Butler, a senior Conservative Cabinet Minister, and Hugh Gaitskell, the leader of the Labour Party and shadow Prime Minister, referred to the similar liberal, social, and economic policies of the two parties during the 1950s and 1960s.

15. American government holdings of sterling declined from £30 million on 30 September 1956 to £26 million on 31 December 1956. See National Archives, Washington, D.C., State Department, 841.10/2-1857, Jordan-Moss to Lister, 18 February 1957.

16. The actual total was $401 million or 17%.

17. For more on the Suez crisis see Diane B. Kunz, *The Economic Diplomacy of the Suez Crisis* (Chapel Hill, N.C., 1991).

18. On the Wilson government's struggle to avoid devaluation see, e.g., Alec Cairncross and Barry Eichengreen, *Sterling in Decline* (London, 1983), pp. 156-217; James Callaghan, *Time and Chance* (London, 1987), pp. 149-225, Diane B. Kunz, "Cold War Diplomacy: The Other Side of Containment" in Diane B. Kunz, ed., *The Diplomacy of the Crucial Decade: American Foreign Relations during the 1960s* (New York, 1994); Ben Pimlott, *Harold Wilson* (London, 1992), pp. 348-492; Clive Ponting, *Breach of Promise: Labour in Power 1964-1970* (London, 1989), pp. 61-84, 184-203, 281-95; Philip Ziegler, *Harold Wilson: the Authorized Life* (London, 1993), pp. 186-286.

19. *The Times,* 20 November 1967.

20. See *e.g.*, Lyndon Baines Johnson Library, Austin, Texas, National Security Files, Country Files, Box 208, Fowler to Johnson, 28 June 1965; Country Files, Box 215, Bundy to Johnson, 28 July 1965, Bator to Bundy, 29 July 1965; NSF Memorandum to the President, Box 4, Bundy to Johnson, 2 August 1965.

10

The Lure of the *TLS*

ADOLF WOOD

The first issue of *The Times Literary Supplement* appeared on Friday, January 17, 1902. It came free with that day's copy of *The Times*, and consisted of eight pages, half the size of the normal page, so that it could go flat inside the folded paper. Over the next few years, it was to establish itself in its own right (much helped, of course, by being able to partake of the enormous prestige of *The Times*) as the most famous and influential critical journal in the English language. Yet the *TLS* came into the world with no preliminary announcement, nor with any indication, when it appeared, that it was to be more than an occasional supplement to *The Times*.

Book reviews had for long been a regular feature of *The Times*, popular and profitable (because of publishers' advertisements), but liable to be judged awkwardly space-consuming when the clamor of political events was greater than usual. In 1901, the paper printed some 260 columns of reviews, of which fifty-five columns were given to novels. Even so, under the self-imposed constraints on size more in evidence then than today, it had not been able to publish reviews enough to keep abreast of the flood of new titles, especially while Parliament was in session, with priority being given to reports of debates. Parliament was due to meet again at the beginning of 1902, and it was decided to relieve the expected pressure on space by putting book reviews into an occasional supplement, which would be given away with the paper, and come out "as often as may be necessary." Yet later that year, even after the situation had eased, with Parliament no longer sitting, the *Supplement* continued to appear: according to the traditional version, this was because the management had forgotten about it; and presumably the member of the editorial staff who was in charge of the *Supplement* was in no hurry to remind them. Thus, in the words of the anonymous author of an article in the *TLS*'s fiftieth anniversary number (January 18, 1952—an invaluable record of the paper's beginnings, on which the above account is based), "the *Literary Supplement* was started as a makeshift and continued through an oversight."

Oversight or not, the *Supplement* was there to stay; and as the weeks went by, its reputation steadily grew, with many new names being added to the list of reviewers (with occasional exceptions, all were anonymous—a policy that would last until 1974): among them Sir Arthur Quiller-Couch, Andrew Lang, Sir Donald Tovey, E. J. Dent, George Gissing. Although by the end of 1902, it had won its autonomy, the *Supplement* continued for a time to be given away with the paper of which it was supposed to be part. Something approaching independent sale was the next stage; and recognition that it had acquired its own readership, distinct from that of *The Times*, came at the end of 1904. The issue of December 9 that year carried the remarkable statement that the "*Literary Supplement* has attained a circulation which exceeds by several thousands that of the daily issue of *The Times*. It is in demand to this large extent by people who, while not regular patrons of the daily numbers, take the other publications issued by *The Times* and buy the *Literary Supplement* for a penny extra."

It was to be almost a decade before the *Supplement* was allowed to end its marsupial connection with *The Times*. On the first page of the issue of March 12, 1914, it was announced that the "*Literary Supplement* formerly supplied with *The Times* is now sold separately for One Penny." And on August 20, a few days after Britain's entry into the First World War, the *Supplement* was officially registered as a newspaper. Since then, apart from the suspension of all *Times* publications between December 1978 and November 1979, it has appeared weekly without serious interruption (there were two minor hiatuses, those caused by the General Strike of 1926 and the great freeze-up in winter, 1947); Northcliffe's sudden order in March 1922 to kill off the *TLS*, issued between bouts of insanity, and ignored by the Editor and management, luckily came to nothing with his death in August.

The founding father of *The Times Literary Supplement* was Bruce Richmond, to all intents and purposes the first Editor (his predecessor, J. R. Thursfield, put in charge at the very beginning, stayed in the job only a few weeks; why his tenure was so spectacularly brief is not clear). Educated at Winchester and New College, Oxford, Richmond joined the editorial staff of *The Times* in 1899, at the age of twenty-eight. When he became Editor of the *TLS*, his status was defined as that of "assistant editor [of *The Times*] in charge of the supplement." Richmond's editorship lasted almost four decades: he gave up the chair in 1937, having been knighted three years previously.

John Gross, Editor of the *TLS* from 1974 to 1981, in his *Rise and Fall of the Man of Letters*, notes the indebtedness many young writers, including T. S. Eliot, bore to Richmond for the encouragement he gave them. Much later in his career, Eliot expressed his gratitude to Richmond on two counts: "first for the work he gave me to do and for the discipline of writing for him, and second for illustrating, in his conduct of the weekly, what editorial standards should be." He testified to Richmond's generous patience with

him in a letter to Richard Aldington in 1922: "Richmond has been unfailingly kind to me, and about my repeated delays in producing an article on Seneca has been angelic." Writing to his mother in 1920, Eliot described how he had been trying to make a Jewish-American writer, Maxwell Bodenheim, who had vainly been knocking on the door of literary London, see that "getting recognised in English letters is like breaking open a safe." But Eliot himself had already made his way in, quite peaceably, thanks to Bruce Richmond, who liked what he had read of the newcomer's criticism in the *Athenaeum*, and engaged him to write for the *TLS*. The first fruits of this were the famous essays on Elizabethan and Jacobean drama, later republished by Eliot in book form.

Richmond, it seems, was also capable of rousing ire. The story is told of how, from a lengthy and magisterial piece written by Henry James for the paper, one and a half sentences had been removed in the editing. The proofs were duly sent to James at the Albany where he was staying, and subsequently returned by messenger with a note saying, "Dear Richmond, Here's the bleeding corpse. Yours is a butcher's trade."

Somewhat more troubling for the Bruce Richmond-as-Hero tendency is the exchange with him on the telephone recorded by Virginia Woolf in her diary – the entry is dated "Monday 19 December" (1921):

> "Mrs Woolf? I want to ask you one or two questions about your Henry James article...you used the word 'lewd.' Of course, I don't wish you to change it, but surely that is rather a strong expression to apply to anything by Henry James? I haven't read the story lately of course—but still my impression is..." "Well, I thought that when I read it; one has to go by one's impressions at the time." "But you know the usual meaning of the word? It is–ah–*dirty*—Now poor dear old Henry James— At any rate, think it over, and ring me up in 20 minutes." So I thought it over and came to the required conclusion in twelve minutes and a half.
>
> But what is one to do about it? He made it sufficiently clear not only that he wouldn't stand "lewd," but that he didn't much like anything else. I feel that this becomes more often the case, and I wonder whether to break off, or to pander, or to go writing against the current. Anyhow, for the present I shall let it be.

Just over a fortnight later, Richmond is again under attack:

> Tuesday 3 January....In the morning I wrote with steady stoicism my posthumous article upon Hardy [eventually published as the leading article in the *TLS* of January 19, 1928]. No more reviewing for me, now that Richmond re-writes my sentences to suit the mealy mouths of Belgravia; it is odd how stiffly one sets pen to paper when one is uncertain of editorial approval.

There is no mistaking, in Richmond's manner of dealing with Virginia Woolf, the tone of the man used to getting his own way (a tone also to be found in his letters to another long-serving, and perhaps long-suffering, reviewer, Edmund Blunden—though in them there is more flattery than cajolery). Arthur Crook, the paper's sixth Editor, neatly described Richmond's no-nonsense style: "Under Richmond the *TLS* was very much a one-man band. Two large oblong drawers in a table measuring about seven feet housed the reviews not yet put into type. Richmond did his own sub-editing of most articles, to be destroyed about six weeks after publication." He also, like W. H. Auden, threw away letters once he had answered them. Because of this, and the fact that he chose not to employ a secretary, always answering letters in his own hand, records of Richmond's long tenure are very scanty, almost non-existent. The researcher would be lost without the wonderful series of editorial diaries of *The Times* for the period of his editorship, which include weekly lists of names of contributors of (mostly anonymous) "Litt. Supp." reviews, all elegantly handwritten. These lists—containing such names as Edith Wharton, Max Beerbohm, Edmund Gosse, Katherine Mansfield, Robert Bridges, John Middleton Murry, E. M. Forster, Edward Thomas, Walter de la Mare, E. K. Chambers and Sir J. G. Frazer—are perhaps sufficient indication of Richmond's achievement. And there was, too, under his editorship, the wealth of extensive and historic contributions to scholarship which appeared in the letters pages of the *Supplement* (particularly in Shakespearean studies—from J. Dover Wilson and numerous others). In Richmond's hands the paper took on the attractive and compelling qualities which for generations of writers, scholars, and readers have constituted its "lure."

Although Eliot told his mother, "Richmond of *The Times* I like very much," and made generous public acknowledgment of his indebtedness to him, there was also something of contempt in his view of the man. In his 1984 biography of Eliot, Peter Ackroyd writes that, in his early years in England, he was "dissatisfied with the lack of values and beliefs in English life" and "it was in this spirit that, in a letter to Paul Elmer More [in 1933], he criticized the type of English mind represented by Bruce Richmond...editor of *The Times Literary Supplement....*" As far as one knows, Richmond at no time publicly expressed a "credo," and what his personal "values and beliefs" may have been can therefore only be guessed at. Certainly, he was cast in a conventional mold: something of a patrician (a profile drawing shows him to have been courtly, handsome, even a touch military, with an ample Roman nose in a commanding head), and doubtless he possessed all the limitations, as well as the strengths, of his class and background.

Towards the end of his career at the *TLS*, a certain effeteness creeps into its pages, and it is easy to see, looking through the volumes for the 1930s, that the paper had become "out of touch": not only with the modish, talented

young writers of the Left, but with the deep springs of English culture and of political and intellectual morality. Liberal democracy, to generalize very broadly but not unfairly, does not get even as much as "two cheers" in the *TLS* of the inter-war era.

It is especially dismaying to turn to the year 1934 in the archive: surely a more shocked and urgent response to the rise of Nazi Germany might have been expected, rather than the pallidly cautious strictures on Hitler's conduct that did appear. Emergent Soviet totalitarianism, too, warranted severer, more forthright treatment than nervous dislike.

And what is this? An imposing twenty-eight-page supplement of "Recent Italian Literature," from which Mussolini and Co. emerge as weighty and impressive, even heroic, figures, deserving of our respect, if not admiration. A gullibility is demonstrated here that, in the space of a few short months, with the invasion of Abyssinia, would be made to seem ridiculous and shameful. There are, it is true, scholarly and elegantly presented things in the survey, but they are outweighed by the preposterousness; here is an example, a passage from the leading article, "Fascism and Italian Thought":

> But a change comes over [Mussolini] when he is sent to the front and begins the War diary printed in the second volume of the collection. It is not merely that the thought becomes more profound....His thought demands an austerity of expression; and remembering Caesar, he achieves it in curt sentences very different from his journalistic days....The sentences may not be particularly well shaped, but beyond doubt they have backbone. Words are, as it were, hurled into the place in which they will tell; and the effect, for English readers, is not dissimilar from that which so often comes in Hardy's poetry.

The Duce must have been pleased.

At the beginning of 1938, Richmond was succeeded by D. L. Murray. Arthur Crook describes Murray as a "large, heavy, ebullient man, who, despite having been a John Locke scholar at Balliol, and the author of a book on pragmatism, was very much involved in the writing of historical romances (*Commander of the Mists; Trumpeter, Sound*) and had no desire to take on the editorship." According to the *TLS* fiftieth anniversary article already mentioned, Murray "began his connection with the *Literary Supplement* by reviewing books on dancing and books on philosophy, being equally well-informed about pragmatism and the *pointes.*" The article maintains a tactful silence about the decline under Murray's editorship (the continued decline, that is: it had already set in during the last years of Richmond's editorship), referring only to the physical changes he initiated: "the makeup of the paper was again changed—the front page was given up to an illustration and some notes, and the long article was moved to the middle." According to Crook, "The new dispensation was little short of a disaster, falling lamentably between half-hearted popularization and informed, scholarly guidance," though

(striking a cautious note) "the quality of the reviews never fell beneath tolerable standards."

Murray's successor, Stanley Morison, was already internationally famous as a typographer when he joined the paper. Nicolas Barker, in his 1972 biography of Morison, gives a brief account of how he brought about the recovery of the paper's fortunes between 1945 and 1948. He writes: "Morison had said in 1936 that [the *TLS*] needed cheering up: Murray's editorship had only succeeded in lightening it."

The recommendations which Morison made to the then Editor of *The Times*, R. M. Barrington-Ward, as a recipe for the *TLS*'s improvement, are fully set out in Barker's biography. Revealing attitudes that would simply be unthinkable today, they are fascinating for the light they throw on the relationship then existing between the *TLS* and what used to be called the "parent organ." These were some of Morison's proposals:

> That I should act as an assistant of yours, placed in charge of the editorship. Thus I should continue to keep in intimate touch with *The Times*...That the reviews and other contents of the *Supplement* be arranged on a generous basis that takes into account political consistency. Reviewers should not contradict one another on points upon which the policy of *The Times* is known. Where it is known the *Supplement* should adopt it. Literary matters also come under this ruling. Whether the *Supplement* should side for or against such a controversial subject as "Basic English" should depend upon the policy of *The Times*....That there should be a policy towards religion similarly consistent with *The Times*....That the best critical pens available [be brought to bear] to deal with the output of philosophical, religious, political and historical works, while giving poetry, biography, memoirs, art and art history, and fiction their due.

One notes a hint of uneasy acquiescence in the need for poetry, fiction and that kind of thing—borne out by Arthur Crook in a BBC radio program of 1969 devoted to Morison, in which he recalled him saying, just after taking on the job of Editor: "I don't want too much of that Keats and Shelley stuff."

The "new" *TLS* under Morison was an almost instantaneous success, measured as much by improvement in critical reputation as rise in circulation. Barker writes that the historian Lewis Namier, "who had ostentatiously given up reviewing for [the *TLS*], now came back. He entertained Morison at Manchester in May, only a few months after he had started, and even then was prepared to admit that, though it had sunk very low, it was already greatly improved." Obituaries were, so to speak, given the death sentence. Another item that had been going for some time, the "literary" crossword puzzle, was summarily removed; Morison did not even deign to print the solution to the last published puzzle. As Arthur Crook recorded in 1977, "in again came the

authoritative front-page article and more concentration on 'serious' subjects, until Morison could say with some satisfaction, 'I've made the *Supplement* difficult to read again.'"

Morison's biographer describes him as growing up in a milieu identical to the Pooters' in *The Diary of a Nobody* (except that the family house was not in Holloway, but Harringay). He had little formal education, yet was prodigiously intelligent and ambitious, achieving not only pre-eminence as a typographer (in the process of carrying out the typographical revolution at *The Times* in 1932 he devised what is generally thought to be the most successful typeface of the age), but also a position of remarkable power behind the scenes at *The Times*, engineering the appointment of at least one Editor of the paper. He was a man of contradictions, though of a kind not unfamiliar at the time: a Roman Catholic convert (via the Farm Street Jesuits), and a Marxist—of sorts; certainly a fierce hater of capitalism, though it would seem not of all its works, nor arch-exponents (he was, for example, a great friend of Max Beaverbrook). A close colleague of Morison's remarked on his "almost magical gift for making morally sound ideas palatable and understandable to powerful monied men." Arthur Crook: "Morison was really fascinated by the question of power, always fascinated by the power and influence that the press in general could exert..." Such power as the editorship of the *TLS* gave Morison, he was judged by some to have used not wisely but too well, especially after the publication of the extraordinary, not to say bizarre, leading article, a few months after he took over, on the centenary of Cardinal Newman's entry into the Roman Catholic Church (*TLS*, October 6, 1945). For all the world as though the piece had come straight from the news desk, the main heading read "Newman Decides," followed by "Into Port After a Rough Sea."

The article was accompanied by two specially taken photographs: of the letter in which Newman announced his decision, and of his surplices and hood, one of the surplices shown draped round a bust of the man. Barker writes: "These personalia at the Birmingham oratory [were] ingeniously disposed not as *nature morte* but *nature vive* (this was specially arranged by Arthur Crook—its effect was carefully calculated by Morison)." To add insult to Anglican injury, the article concluded: "After having rendered signal and lasting service to the Church of England, [Newman] still had the second half of a long life to devote with unfaltering loyalty to the service of a greater Church." In answer to criticism levelled at him by some in the inner circle, Morison revealed that the piece was written not by a Catholic but a member of the C of E (a Canon Hutchinson: who, unsurprisingly, was High Church).

At this difficult stage in history, the *TLS* was clearly hedging its bets. Earlier in the year, the front-page piece was a review of a book about Stalin, with the heading "Marshal Stalin: The War Leader of Russia." With the

wisdom of what Stravinsky once called perfect 20–20 hindsight, we are entitled to some grim enjoyment of the piece, particularly the final paragraph—

> The war has added immensely to the prestige not only of the Soviet Union but of Marshal Stalin himself, who has emerged both as a more commanding and as a more human figure; and the author is able to leave him at the age of 65, at the height of his authority and activity, "confidently facing his people with frontiers secure and an era of social and economic expansion ahead such as the world has never known."

—except that fundamentally the same view of the Soviet Union (with the necessary corrections and accommodations made, of course) persisted in the *TLS* until well into the 1960s and is to be found sometimes later still; witness the enthusiastic reviews (which, as everyone knew, or guessed, were written by Morison's fellow *éminence grise* at *The Times*, E. H. Carr) of the extended *apologia pro vita sovietica* that were the works of the brilliant Isaac Deutscher (and, no less deplorably, the converse is true: Deutscher regularly reviewed Carr's books). Thus, in what the paper kept on referring to as the "Jubilee Year"—the fiftieth anniversary of the Russian Revolution—Carr (for it was he) opened his review of *The Unfinished Revolution: Russia 1917-1967* by Deutscher with these words: "The October Revolution of 1917 may reasonably be celebrated on its fiftieth anniversary as the greatest event of the twentieth century," going on to say, later in the piece, "In the space of fifty years a primitive and backward people has been enabled to build up for itself a new kind of life and a new civilization. The magnitude, the extent and the speed of this advance are surely without parallel..."; and concluding:

> The stupendous progress made by backward Russia over the past fifty years in face of the most adverse conditions points the way to what the western nations might achieve by giving effect to "the great principle of a new social organisation." With this eloquent and well-argued appeal Mr. Deutscher ends what is in every way a remarkable and masterly book.

Fortunately, the *TLS* in those years did not express itself with one voice only, nor has it ever since; and it is enough to point to the vigorous and trenchant way in which the Commentary pages at the time drew attention to the plight of dissident writers, artists and intellectuals in the Soviet Union and Eastern Europe, as well as the excellent, authoritative reviews of the works of Alexander Solzhenitsyn, Anna Akhmatova and others: preparing the ground, as it were, for the developments of the 1970s and 80s. And there is evidence that what the *TLS* said then counted in those countries.

The British novelist Anthony Powell did a stint as fiction editor at the *TLS* in the immediate post-war period. In his memoirs, with characteristic dryness, he recalls his first impressions: "When parties began slowly to come

into being again, there were truancies from the office. At the same time *TLS* reviewers seemed to become a shade less stodgy overnight, a faint but perceptible odour of chic sometimes drifting through the caverns of Printing House Square." This was in 1948; Alan Pryce-Jones was now in the chair, having agreed to take over from Stanley Morison once the question of salary had been settled. While in the process of deciding, he had, Nicolas Barker tells us, received a tempting offer from the *Observer*: "What Pryce-Jones?" Morison had asked the management, and the answer was satisfactory.

On the foundation laid down by Morison, Pryce-Jones proceeded, with the full backing of the management, to take the *TLS* into the second half of the twentieth century, nudging it forward rather than dragging it screaming and kicking. As he writes in *The Bonus of Laughter*: "I conceived it my job to enlarge the changes introduced by Morison, and, to begin with, to fight the insularity imposed by six years of war and their aftermath." In his war against insularity, he brought, not only what may have been judged a much-needed chic to the paper, but an enthusiasm, an appetite, for what the intellectual and cultural worlds of Europe and America, and other places besides, had to offer. Noel Annan, writing about Pryce-Jones's editorship in *Our Age*, sees his values and outlook as stemming from the Oxford milieu of the inter-war years which produced the Oxford Wits. Pryce-Jones was a member of the group, as also were Powell, Evelyn Waugh, Cyril Connolly and Harold Acton. The Oxford Wits "mocked parochial England. You were expected to know the work of those Continental artists, writers and musicians who composed the true avant-garde....The Wits took the Continent of Europe as their playground." The European awareness, the taste for cultural excitement which Pryce-Jones brought to bear on his task as Editor, he acquired at Oxford, but at the expense, it must be said, of the academic side of his life there: as Annan records, "Alan Pryce-Jones, who later edited *The Times Literary Supplement* in one of its best periods," was one of those who "did not stay at Oxford all that long...[he] was sent down after two terms for gross idleness." There is a moral in that somewhere.

Pryce-Jones's endeavor to create what could be described as a more cosmopolitan *TLS* entailed, as he puts it in his autobiography, "a good deal of movement." "I noticed," he writes, "that other editors confined their view to London, Oxford, Cambridge, just as years later I found that the pace-setters of New York or California knew very little of any province other than their own. So I asked myself: how about Swansea, Keele, Durham, East Anglia? How about Budapest, Uppsala, Montpellier?" Insular attitudes were a matter of how you regarded your own country, as much as the world beyond. He describes how as Editor he moved all over the globe, "often finding contributors on subjects which amply repaid the trouble of unearthing them." He introduced a series of special numbers, "so as to cast light on neglected subjects"; and he encouraged young and unfashionable writers. His ambition

for the *TLS* was that it should cover "the whole spectrum of contemporary writing." Here he invoked the traditional claim of *The Times* itself to be the paper of record. "An Albanian epic? The work of the Uruguayan Symbolist, Herrera y Reissig? Should we not know something of each at first hand?"

Pryce-Jones describes with justifiable pride how two friends, Eithne Wilkins and Ernst Kaiser, arrived at the office one day with a published fragment of a long novel in German, the rest of which was in a trunk. It was called *Der Mann ohne Eigenschaften* (*The Man without Qualities*, as it later became known in English), and the writer was almost totally unknown. Pryce-Jones recalls:

> I encouraged my friends to write a long essay on what the published fragment showed to be a masterpiece. To begin with, close acquaintances suggested that, even if I revelled in obscurities, to invent a writer and his work was going too far. But Secker and Warburg thought differently. They commissioned a translation from my contributors, and it was the success of the English version which launched Musil in Central Europe and added a name – alas, posthumously – to stand beside Proust and Joyce and Thomas Mann in the first line of European novelists in our century.

When John Gross made the historic break with the tradition of anonymity in 1974, and, in the space of a few years, with brilliant flair and acumen gave back to the *TLS* the pre-eminence it had not enjoyed since its Edwardian heyday, it was the journal as refashioned by Pryce-Jones, and kept up by Arthur Crook (1959–1974), that he built on. Under Gross's successors, Jeremy Treglown (1982–1990), and now Ferdinand Mount, the *TLS* has remained essentially the same paper.

Fall Semester 1991

"Drinking Tea With Treason": Halifax in India

SARVEPALLI GOPAL

In the long public career of Lord Halifax, for much of which he has received a hail of severe criticism, there are two occasions when he merits commendation. In the summer of 1940, when the prime ministership of Britain was within his reach, he let it pass, in the national interest, to Winston Churchill; and nine years earlier, in the spring of 1931, towards the end of his term of five years as Viceroy of India, he signed an agreement with Mahatma Gandhi. That positive achievement has also been often condemned, at the time and since, as part of Halifax's general policy of appeasement; but in fact the approach to Gandhi was very different from the pusillanimity shown towards the European dictators. British policy in India, from the revolt of 1857 to the transfer of power ninety years later, was in essentials determined by governments; but there have been times when what was seen as the personal touch of understanding has helped. Lord Ripon in the eighties of the last century testified by his actions that British rule was not always wholly unprincipled, and the personality of the last Viceroy, Lord Mountbatten, enabled him to leave India to resounding cheers. But perhaps the most substantial contribution by any individual to the building of goodwill between India and Britain was made by Lord Irwin (as Lord Halifax was then known).

The five years of Irwin's Viceroyalty, 1926 to 1931, seemed to me so seminal a period that thirty-five years ago, in 1957, I dared to write a book dealing with the events of those times.[1] It was a rash undertaking, because the records of the period in Britain were still closed and the Government of India, while it permitted me to read its files, insisted that no precise references should be given. Most of the collections of private papers in Britain and India were not accessible. On the other hand, I had the advantage of being able to talk to Lord Halifax and to discuss what I had written with Lord Hailey, one of the key officials in India at that time. Since then, Lord Halifax and several others have published their memoirs, there have been quite a few authorized biographies, and the primary sources now open to scholars are legion. How

do the analyses and conclusions in my book of long ago stand up in the light of all this fresh evidence?

The main drive of my argument at that time was that Irwin's character, with its sincerity and religious dedication, made a marked impression on Indians and especially on Mahatma Gandhi, and convinced them, for the time being at any rate, that, as Irwin was the spokesman of British authority, it could be accepted that the British were genuinely committed to withdraw ultimately from India. I now believe that the additional evidence does not invalidate this analysis but adds many nuances. Irwin was certainly a man of honest purpose but he had no intent to hasten the end of British rule; and his keenness to reach a settlement with Gandhi was, I now realize, to a considerable extent motivated by a desire to divide the forces of the opposition. He was a devout Christian but a Christian imperialist who, like many of his friends at All Souls College at Oxford, acted on the assumption that the British Empire was a part of the Divine order. This feeling is summed up by the reported comment of Leopold Amery, who incidentally was no great admirer of Irwin: "The empire is not external to any of the British nation. It is something like the Kingdom of Heaven within ourselves!"[2]

The selection of Edward Wood to go to India as Viceroy in April 1926 was to British public opinion generally a surprise. He had no obvious qualifications for the job nor was he himself, with an old father and very young children, anxious to spend five years out of Britain. But in a general consideration of possible choices his name floated to the surface. He was a personal friend of the Prime Minister, Stanley Baldwin, who was not keen on letting him go; but King George V, once his own candidate, Lord Haig, was ruled out, supported the selection of Wood; and Lord Birkenhead, the Secretary of State for India, agreed to it but with no great enthusiasm. "How much better in life," he observed to Lord Reading, Wood's predecessor as Viceroy, "and how much more paying it is to be blameless than to be brilliant, and it certainly pays in such a connection never to have attacked anyone."[3]

When Wood landed in Bombay as Lord Irwin, the urgent issue in Indian public life was not the meaning to be attached to British acceptance in 1917 of the progressive realization of responsible government as the objective of their rule and the pace at which this commitment should be implemented. It was the growing tension between Hindus and Muslims which dominated the scene, and Irwin's first speech as Viceroy, devoted to this topic, enabled him to show India how deeply religious a person he was and what religion meant to him. He appealed for toleration not only in the name of Indian national life but also in that of religion, because he said he could appeal to nothing nobler, and because religion was the language of the soul and it was a change of soul that India needed. All religions assumed a sense of personal deficiency in the mind of the individual, a consciousness of failure to apprehend more than a fraction of life's mystery, leading to an irresistible yearning to reach

out for higher things. Achievement was hard and the attempt would result in a wide tolerance of the deficiencies of others. There could be no greater tragedy than that religion, which should be the expression and the support of man's highest instincts, should be prostituted by an alliance with actions through which these instincts were distorted and disgraced.[4]

This was no definition of religion in any narrow, denominational sense. Though "a Christian who really believed in Christianity,"[5] Irwin in this speech gave utterance to broad aspirations and human values which would appeal to men and women of religious feeling whatever their particular creeds. While the speech had little immediate consequence because rioting continued despite the efforts of Indian leaders to improve the atmosphere, Irwin had presented to the Indian public his credentials as a Viceroy who was concerned with more than mere execution of policy and management of the administration. However, any good that this speech may have done was soon overlaid by a decision taken in 1927 for which Irwin himself bore the major responsibility. Trust in British declarations about their role in India had been destroyed by General Dyer's wanton slaughter in Amritsar in 1919 and, even more, by the widespread support in Britain for his action.[6] Reading, as Viceroy, did little to rebuild such trust. He favored the long game and, rather than take firm stands, let matters slide. Could Irwin do any better? The chance came when the British Government decided not to wait for ten years as stipulated by the Government of India Act of 1919 but, in order to prevent the decision being taken by a possible Labour Government, to appoint in 1927 a commission to inquire into the working of the Act and recommend what, if any, further steps should be taken. Birkenhead believed in the British Empire as almost a fact of nature and did not think that India would ever attain Dominion Status. In a pot-boiler, *The World in 2030,* which he wrote in 1930, he assumed without argument that even by the year 2030 India would be under British rule. But in 1927 even Birkenhead was prepared to consider the appointment of a commission with British and Indian members and it was Irwin who advised him against it. The Viceroy had as yet little knowledge of India and no imaginative comprehension of her people, their problems and their attitudes; and he was guided mainly by Sir Malcolm (later Lord) Hailey, whose experience till then was confined mainly to the Punjab. Their recommendation to Birkenhead was that the inclusion of Indians would make the commission unwieldy and probably result in two separate reports; so it would be far better to confine the choice to members of Parliament, thereby making the exclusion of Indians seem not a deliberate decision but a fortuitous circumstance. Birkenhead, who had felt that the arguments against exclusion of Indians were a priori very strong, now acquiesced. He added that he was concerned about a boycott of such a purely British commission, which would be disastrous to its prestige and authority; but Irwin assured him that such a general boycott was in the highest degree improbable.[7]

In my book I had described as "the first and greatest mistake of Irwin's Viceroyalty" what I had assumed to be his acceptance of Birkenhead's die-hard decision to exclude Indians from the commission. Now we know that Irwin's was the prime responsibility. The general resentment roused by the announcement of the commission and the widespread boycott faced by the commission on its arrival took Irwin by surprise. Because Gandhi, released in 1924 on grounds of health even before his sentence had been completed, felt himself morally bound to refrain from political activity, Irwin concluded that his power as a political force had suffered a great decline. He did invite Gandhi to see him and Gandhi came all the way from the far south; but at the interview neither made any impression on the other. Irwin was reticent and found Gandhi remote: "It was like talking to someone who was spending three weeks in this planet from another."[8]

If Irwin too readily wrote off Gandhi and at this point took little trouble over him, it was because he attached scant importance not only to Gandhi but also to the Congress party which he saw as losing support and riven by dissension between the sober elements and the younger radicals. Primarily under Hailey's influence, he looked forward to the emergence with increasing authority of alternative political groupings, such as the Liberals and the landowners; and the spreading rancor among Hindus and Muslims seemed to hold out hopes of some Muslim leaders moving away from the boycott. "I think," Irwin wrote to Birkenhead in 1929, over a year after the commission's first arrival and with the boycott showing no signs of yielding, "it is really very much like a child refusing to eat its supper. There comes a point when it is no good pleading or reproaching any longer and when, if its tempers are ignored, it may return to eat it on its own."[9] Various concessions were offered to make it easier for the political parties to change their attitude; and both Gandhi and his senior colleague, Motilal Nehru, thought that this might well happen.

However, the boycott held. The chairman of the commission, Sir John Simon, lacked the personality and the political flair to weaken the ostracism; and the general bitterness was intensified by the publication at this time of *Mother India*, a vicious attack on Indian society by an American journalist who was suspected of having received official assistance. Irwin began to realize that the Congress was not to be despised nor Indian politicians ignored; and the lesson was underlined by developments in a corner of Gujerat, at that time part of the Bombay presidency. In an agricultural country, land revenue is an obvious danger-point, and Bardoli was an area which Gandhi had accustomed to no-tax campaigns. The land was held by relatively prosperous peasant proprietors and Irwin, on a visit in 1927 to witness flood relief measures, had been impressed by the consideration shown by these landholders to the poor.[10] Yet now the Bombay Government ordered an enhancement of land revenue in this area, where settlements were made once

in thirty years, on the basis of a rough-and-ready recommendation by the Settlement Officer and despite the protests of his superior, the Settlement Commissioner. The landholders retorted by refusing to pay anything until the enhancement had been cancelled. Thereupon the Bombay Government attached crops and movable property and considered forfeiture of occupancy rights; but the peasant proprietors, under Congress leadership, stood firm. In the face of this, the Bombay Government planned to seize, if necessary, the whole cotton crop and to move troops into the area. But at this point Irwin decided to intervene. He thought that the case for the provincial government was weak and realized that the eyes of political India were on him. If he hesitated, then official rigidity, coming in the wake of the inept decision about the composition of the commission, would take the Viceroyalty beyond the point of no return into the desert of mindless repression. So, before it was too late, Irwin directed the Bombay Government to reach a compromise. Prisoners were released, forfeited lands restored and, after a public inquiry conducted by experts, the land revenue rates were considerably reduced. Even Hailey was concerned that, by seeming to yield to the Congress on an issue regarding the peasants, the Viceroy might be opening up dangerous possibilities in the future.[11] But in fact this was the turning point of the Viceroyalty. Relying on his own instincts and strength of character, Irwin was moving towards an answer to the key question of how Britain could regain the trust of Indian opinion.

Though Irwin had not given up hope of building up loyalist parties as a counter to the Congress,[12] he recognized that, for the time being at any rate, there was no alternative to it. But the Congress was no monolithic body. A committee presided over by Motilal Nehru produced a report in the summer of 1928 asserting that Dominion Status was the immediate objective and demanding the transfer of "full responsible government" to the people of India. The secretary of the committee was Jawaharlal Nehru, Motilal's son. He signed the report with reluctance, for a few months earlier, at the session of the Congress in Madras in December 1927, he had pushed through a resolution declaring the goal of the Indian people to be complete independence. He was, of course, aware that there was no substantive difference between Dominion Status and independence; but he attached importance to the mental attitudes which these two concepts indicated, and was determined that India should break completely with the past and with the British connection. Gandhi and other senior Congressmen did not take the independence resolution seriously; but its significance lay not in itself but as a reflection of the non-compromising stance of the younger elements in the party. This caused concern to the British authorities. Not that they worried about the empty debates regarding the relative merits of Dominion Status and independence; but it troubled them that Jawaharlal Nehru's Independence for India League advocated not only complete independence but also

economic change on socialist lines. A Communist party had been formed in India and the Government of India, in an attempt to scare the Indian public by painting in dark colors what a Communist society would mean, arrested some leading Communists on charges of conspiracy and started legal proceedings not in any major city where Communists were active but in Meerut, a small town just outside Delhi. The reason for this was to avoid trial by jury—a petty subterfuge which does no credit to a government of which Irwin was head. But even had this lengthy trial succeeded in stifling the Communist party, there remained, from the official viewpoint, the danger of nationalism and socialism converging under the leadership of Jawaharlal Nehru; and if Nehru and his supporters extended their influence from the urban areas, in which the Congress had till now largely functioned, to the countryside and roused the peasantry to defiance and rejection of their economic wretchedness, then, as Hailey never tired of warning Irwin, the *raj* would be shaken to its foundations. It was in this mood of alarm that in October 1928 Irwin's Government directed the provincial administrations to scan Jawaharlal Nehru's speeches carefully and in December suggested that the Bombay Government consider prosecuting him for a speech in his usual vein, castigating British imperialism and calling for a revolt against evil and for the establishment of a cooperative, socialist commonwealth. But the Bombay Government, with a greater sense of reality, replied that everyone would agree with much of what Nehru had said and it would be difficult to prove that he had advocated not just socialism but Communism and revolution.

Official hopes that the Congress would split in 1929 were defeated by the compromise which Gandhi effected at the annual session of the party in Calcutta in December 1928. It was resolved that if the British Government did not accept by the end of 1929 the Nehru report seeking Dominion Status, then the Congress would initiate a campaign of civil disobedience in order to gain independence. So those supporting Motilal Nehru envisaged months of negotiation while Jawaharlal Nehru and his followers looked on 1929 as a year of preparation. The younger Nehru's position appeared to be strengthened by the Viceroy's prompt and public response to the resolution of the Congress that, while the Nehru report was doubtless entitled to serious consideration, the British Parliament could never agree to being reduced to merely endorsing the opinions of others. He also told Vithalbhai Patel, the President of the Central Assembly, with the intent that the message should be passed on to the leaders of the Congress, that the Calcutta resolution had created an impossible situation from which, so far as he could see, there was no issue.[13] But Irwin did not intend to leave matters at that. Motilal Nehru told Geoffrey Dawson, the editor of *The Times*, then on a visit to India, that what was really wanted was an assurance that Dominion Status was on the way;[14] and he informed the Chief Justice of the Allahabad High Court that

the Congress would be content with Dominion Status of any quality and however limited a degree so that Indians could prove themselves responsible and deserving of more powers.[15] So too Gandhi, when he met Irwin at a social function in Delhi in February 1929, said that if India had the predominant voice in constitution-making, she would astonish Britain by showing how much she would desire to leave in British hands through lack of self-confidence.[16] Dominion Status with reservations, while logically contradictory, obviously formed the immediate aspiration of the larger part of Indian political opinion. It sought a firm recognition of full rights to come rather than a major constitutional advance at once; and this seemed to Irwin worthy of consideration.

In England on leave in the summer of 1929, the Viceroy found his authority increased by a change of government. Labour was now in office and the Prime Minister, Ramsay MacDonald, was committed publicly to seeing India becoming a Dominion within months. But the Government was weak and preferred to leave the initiative to a Conservative Viceroy who could rely on the personal support of Baldwin, the Leader of the Opposition. Irwin proposed that, to redress the affront caused to Indian opinion by the composition of the Simon commission, a round table conference of British and Indian delegates be convened to consider India's constitutional future; and that it be clearly affirmed that Dominion Status was the goal. There was considerable opposition to this in the Conservative and Liberal parties and Baldwin, on learning that the Simon commission had not been consulted, withheld the support of the Conservative party and cabled to the Viceroy, now back in India, not to make any such public statement. But Irwin went ahead and made his announcement on 31 October 1929, with the approval of the Labour Government and in defiance of the leadership of his own party.

The Declaration of itself surrendered no ground. It committed the British Government merely in the sphere of ultimate purpose. The objective was Dominion Status but no immediate transfer of any measure of authority was contemplated. Indeed, Irwin believed that the Declaration would ensure that the essential mechanism of power would remain in British hands as long as one could foresee and with the support of all Indians except the few who advocated independence. But it was more than a mere reaffirmation of earlier British statements about their objectives in India. Coming as it did after Balfour's definition of Dominion Status in 1926, it was taken by Indian opinion as a firmer commitment than any made before by the British Government; and this understanding was underlined by the criticism of Irwin in Britain, especially by Simon, Reading and Birkenhead. "Refusal," wrote Irwin bluntly to Reading, "to make our purpose plain affords ground to our enemies to say that we intend India to occupy a permanently subordinate place in an Empire of white nations."[17]

The crucial question, however, was whether Irwin, by this clear proclamation of British good faith, would succeed, as he hoped, in dividing the Congress and tearing apart the compromise which Gandhi had achieved in Calcutta. Hailey had approved of the Viceroy's Declaration in "that it seems to me wisdom to provide an occasional landing stage for more sober people to rest on while the extremist is being swept down the tide;"[18] but would the Declaration in fact serve such a purpose? Gandhi reacted positively, for, as Hailey noted, while the British thought of Dominion Status objectively as a state of things, Gandhi thought of it subjectively as a frame of mind, "a special kind of political kiss-in-the-ring."[19] He associated the Congress with the Liberals and others in signing a joint manifesto offering cooperation if the Government adopted a policy of general conciliation, granted an amnesty to political prisoners, ensured that progressive political organizations were adequately represented at the conference with the Congress having predominance, and acknowledged that the conference was not for discussing when Dominion Status was to be established but was for framing a scheme of a Dominion constitution suited to India's needs.

Gandhi even persuaded Jawaharlal Nehru, the president-designate of the Congress, to sign the manifesto, which marked a retreat by the party; for, far from preparing for a struggle for independence and even from insisting on a full acceptance of the Nehru report, the Congress was now willing to hold negotiations with the British Government without the latter making any precise offer. Tej Bahadur Sapru, the Liberal leader, and Hailey suggested to Irwin that he might make some reciprocal gesture, such as the release of those prisoners who had not advocated violence.[20] But Irwin took no such action, presumably because he had by now gathered that, after the first warm response, the attitude of the Congress was stiffening. Sherwood Eddy, a young American who had just spent three days with Gandhi, reported to the Viceroy that Gandhi was no longer looking for a compromise. This was not, as was thought at the time, primarily due to Jawaharlal Nehru, who was drafting his presidential address in terms which left no room for negotiations. It was the criticism in Britain of the Viceroy's statement which led Gandhi and the Congress to believe that little purpose would be served by relying on a single individual, however sincere, with the backing of a weak Government in London. Irwin, in his memoirs published many years later, concedes "that the situation had chilled and hardened under the impact of the unfriendly debates in Parliament."[21] When Gandhi and Motilal Nehru, along with some others, met the Viceroy on 23 December 1929, the break was clear. Gandhi said that he doubted the sincerity of British intentions though he recognized that of individuals; India and not Parliament ought to frame India's future and unless the establishment of Dominion Status could be presumed as an immediate result of the conference he could not attend. Irwin replied that

there was no common ground and reported to London that Gandhi and Motilal Nehru had been "very impossible."[22]

So attention shifted to the session of the Congress. Irwin considered banning the session but then thought better of it. The Congress pledged itself to the goal of independence and a campaign of civil disobedience under the leadership of Gandhi. The Government decided to wait and watch developments and rejected the suggestion of the Punjab administration that Jawaharlal Nehru be prosecuted for his presidential address. The official assessment of the situation was summed up by a writer from India in *The Round Table* that Gandhi and the Nehrus were isolated not only from all other political parties but even from the right and left wings of the Congress party.[23] On 26 January 1930 the Independence pledge was administered at meetings held throughout the country, but Gandhi vetoed processions and speeches so as not to precipitate a crisis; and the Government refrained from action. Then, towards the end of February, Gandhi decided to initiate civil disobedience by collecting salt from the sea and challenging the imposition of the salt tax. Setting out from his *ashram* in Ahmedabad with a band of disciplined followers on 12 March, he reached the seashore after twenty-four days and picked up salt. Irwin thought that the issue was so trivial and the incidence of the tax so minimal that Gandhi should be allowed to become a figure of ridicule rather than be converted into a martyr by arrest, when he might well embarrass the Government by starting a fast. The Viceroy did toy with the idea of putting Gandhi and his followers in lorries and transporting them back to the *ashram*;[24] but even this proposal, intended to show contempt, he abandoned in favor of doing nothing. The belief that civil disobedience, which had ended in 1922 in tragedy,[25] would in 1930 end as farce showed a deficiency in imaginative understanding. In fact, Gandhi's march to the sea has a high place in the history of the Indian freedom movement and indeed of freedom in the world. But by now Irwin, even if as yet he lacked a full grasp of the situation, had gained enough confidence to act on his own. Hailey, with long years of service in the country, was worried that inaction would reduce the authority of the Government of India. "I myself see the Central Government, and I suppose most other people in India now see it, as presenting the picture of a person once dignified if unwieldy, but now entirely without position or respect, because its beard is pulled and its hat knocked over its eyes by every urchin in the street....The East has far more respect for a ruler who misuses his powers than for one who allows his authority to be flouted."[26] The Viceroy too seems to have doubted his own judgment as the march proceeded with public interest not evaporating and with no popular resistance to Congress actively developing. For there is a tinge of frustration as well as an element of banter in his report to the Secretary of State. "The will power of the man must have been enormous to get him through his march, which must have been a very severe physical strain. I was always told that his

blood pressure is dangerous and his heart is none too good, and I was also told a few days ago that his horoscope predicts that he will die this year, and that this is the explanation of this desperate throw. It would be a very happy solution."[27]

Two events in April, a raid on armories in Bengal and the temporary loss of control of Peshawar in the predominantly Muslim North-West Frontier Province, forced Irwin's hand. He took drastic action to assert the authority of the Government, causing Gandhi to condemn what he described as a veiled form of martial law, in face of which even Dyerism paled into insignificance. He himself was arrested on 5 May. For the rest of the year there was no slackening of official efforts to break the campaign of civil disobedience. Considering later criticism in Britain that Irwin had been a weak and appeasing Viceroy, it is worth mention that he virtually set aside ordinary law and ruled by ordinance, imposed tight control of the press and placed about 60,000 political workers in prison. He was also not above minimizing to his British superiors the rigors of his rule in India in 1930. On one occasion, for example, some British and American journalists, who witnessed the beating back of an attempt to enter a salt depot, reported that they had been sickened by police brutality. But, in writing to the King, Irwin sounded a different note. "Your Majesty can hardly fail to have read with amusement the accounts of the severe battles for the Salt Depot in Dharsana. The police for a long time tried to refrain from action. After a time this became impossible, and they eventually had to resort to sterner methods. A good many people suffered minor injuries in consequence; but I believe those who suffered injuries were as nothing compared to those who wished to suffer an honourable contusion or bruise, or who, to make the whole setting more dramatic, lay on the ground as if laid out for dead without any injury at all."[28]

While taking stringent steps to hold civil disobedience at bay, Irwin was surprised and impressed by the influence in the country, which the campaign revealed, of Gandhi and the Congress. As the correspondent of *The Times* reported in May 1930, the "Gandhi spirit" had obtained a great hold;[29] and thereafter it showed no signs of loosening. This led Irwin, even as he took strong action against civil disobedience, to encourage in August the Liberals, Sapru and M.R. Jayakar, to talk to Gandhi in prison. Special arrangements were also made for the two Nehrus, themselves in prison in the United Provinces, to join Gandhi to see if any compromise could be worked out between the Government and the Congress. These talks failed; but the first session of the Round Table Conference, where a surprising, if temporary, consensus of agreement emerged between the Princes and the delegates from British India, made even clearer than before the need to bring the Congress into the constitutional discussions. As Irwin told the Secretary of State, logically there were only two alternatives, to govern without consent or to make terms with Gandhi, and the concept of the knock-out blow had become

futile.[30] So, by the end of the year, he decided, rather than relying on the mediation of others, to plan for direct negotiations with Gandhi; and, as officials in the Foreign Office of London noted in later years when Halifax was Foreign Secretary, although he took a long time to reach a decision, once it was reached his mind hardened like cement.[31] He had also learnt by 1931 the right approach to Gandhi. Banking on his reputation as a deeply religious person, Irwin addressed the Central Assembly on 17 January 1931 in what one may call the Christian style of imperialism. While deploring Gandhi's policy, he recognized the spiritual force impelling him, thought he would be as willing to recognize that the British were sincere in their attempt to serve India, and suggested that ultimate purposes differed little if at all. Two days later the Prime Minister, Ramsay MacDonald, followed this up by offering full provincial autonomy and a central executive responsible to a federal legislature; some safeguards would be provided but only for a period of transition and in the interests of the minorities. And then, to cap it all, on 25 January Gandhi and his chief colleagues were released and the notification declaring the Working Committee of the Congress an unlawful body was withdrawn.

It was now for Gandhi to respond. Jawaharlal Nehru pressed him not to be carried away by these gestures of the Government which to Nehru amounted to nothing; but Gandhi knew that the Congress party was suffering from war-weariness and that the businessmen who supported the Congress were by now keen on calling off civil disobedience. His first move, however, gave nothing away. He wrote to Irwin demanding an inquiry into police excesses during the previous year and, when Irwin refused, proclaimed his disappointment.[32] But he was persuaded by the Liberals to see the Viceroy, "to meet," as he wrote in his letter, "not so much the Viceroy as the man in you." Irwin agreed, and set out not to convince Gandhi on any subject but to gain his confidence. He succeeded in that Gandhi came back from the first interview with the feeling that Irwin's sincerity was beyond question. Thereafter they had seven more sessions and talked in all for a little less than twenty-four hours. Irwin was struck by Gandhi's force of character and his immensely active and acutely working mind, a singularly winning directness accompanied by a subtlety of intellectual process which could be disconcerting.[33] Gandhi on his part was impressed by Irwin's understanding and frankness. At this time, unlike in December 1929, he did not worry about the sharp attacks on Irwin in Britain. The "change of heart" to which he attached much importance and which he thought he saw in the Viceroy was sufficient for him not to insist on any of the fundamentals of the Congress program.

In contrast to his stand during the talks with Sapru and Jayakar in August 1930, Gandhi now made no demands on the constitutional issue and accepted responsibility with safeguards or, as he preferred to call them, adjustments,

provided they were in the interests of India and could be discussed with Britain on equal terms. The talks moved to the verge of a breakdown on the question of an inquiry into police excesses, but finally Gandhi gave way when Irwin told him the Government could not afford to weaken the morale of the police for the Congress might resume civil disobedience and then the police would be needed again. On picketing and the manufacture of salt Irwin made minor concessions. He permitted peaceful picketing for economic objectives in the belief that if it were not a political weapon it would be dead in three weeks. As for salt, he agreed to its collection for domestic consumption and for sale within the villages where it could be found. But on every other point the Government had its way.

After the settlement had been reached, Gandhi asked Irwin to commute the death sentences, which were to be executed that week, on those held responsible for the murder of a police officer in Lahore. This would have made it easier for Gandhi to secure support for the agreement at the session of the Congress due to be held in Karachi. Irwin replied that a reprieve was not possible and to postpone the hanging till after the session of the Congress would be dishonest. So the three men were hanged on the eve of the meetings at Karachi. This made Gandhi's task even more difficult than expected; but he said publicly, in accordance with his promise to Irwin, that, while he had pleaded for the lives of these men—"Charity never faileth"—he did not see what other course Irwin, from his point of view, could have taken. The whole episode is evidence of the uprightness of both men and the high level of their negotiations.

By transforming the conversations from parleys between implacable political opponents into discussions between two spiritually sensitive individuals, Irwin had gained the advantage on most points. The Working Committee of the Congress, and particularly Jawaharlal Nehru, were deeply critical of what they regarded as surrender and ratified the settlement only out of personal loyalty to Gandhi. The major gain to the Congress lay not in any clause of the settlement but in the tacit recognition that it was the voice of the people and that the Government had been obliged to deal with it as almost an equal partner. It was this which horrified Irwin's critics in Britain. His whole attitude, said Winston Churchill, had been an apology; he had not shown sufficient confidence in Britain's work in India. British civil and military officials in India too, for the most part, disliked Irwin's approach of, in Lord Lloyd's phrase, "drinking tea with treason," and, after Irwin's departure from India in April 1931, the Government of India rapidly and with relief reverted to its traditional policy of confrontation with Indian nationalism.

Irwin himself contended that even by negotiating with Gandhi he had not deviated from this policy of seeking to weaken and thwart nationalist forces in India. On his return to London, he claimed at a private meeting of the Conservative party that his settlement would ensure the loyalty to Britain

of Gandhi and the older politicians and that it had built a breakwater against the dangerous agrarian forces which were being harnessed by the younger Nehru and would cause the serious problem of the future.[34] Dividing the Congress was an objective of which he never lost sight. Later, as ambassador in Washington during the war years, he regularly reiterated the stock arguments in favor of British imperialism in India; and one of his speeches in April 1942 was so extreme that Sir Stafford Cripps, negotiating in India, was driven to protest.[35] Some amends for this Halifax made five years later by his speech in the House of Lords supporting Attlee's plan for the transfer of power. He was not prepared, said Halifax, to condemn the Government's action unless he could honestly recommend a better solution. This speech changed the temper of the debate and infuriated Churchill.

Irwin's Viceroyalty was more important in improving the atmosphere of relations between India and Britain than in the day-to-day course of events. Remarkable testimony to the impact of his seeming sympathy and understanding was the suggestion in December 1931 by Vithalbhai Patel, then president of the Congress, that Irwin be invited to give a ruling as to whether it was the Government or the Congress which was violating the settlement. Irwin had an earnest, unspeculative and unimaginative mind. He never broke through the accepted British view of the indispensability of empire and had no far-sighted vision of the relations between the British and the Indian peoples. On coming to India he made grave mistakes, but he grew in the job and gradually realized that he had to deal with the Congress party and particularly with its "super-president," Mahatma Gandhi. He saw, what all his successors except Mountbatten failed to see, that it was in Britain's interest to win Gandhi over. In dealing with Gandhi, the fact that Irwin was a devout believer helped a great deal. Gandhi, and hence the Indian public, accepted Irwin as an honest Viceroy with decent impulses; and this lifted the fog of suspicion at least for a while. Even when bitterness and conflict returned, the memory of the assessment of Irwin's term of office was not wholly erased from the Indian mind.

For Irwin too the negotiations with Gandhi, begun on grounds of expediency, soon gained deeper significance. He who had the previous year lamented that Gandhi was "regrettably hale and hearty"[36] now warmed to Gandhi's personality and spiritual strength. "I shall always," he wrote in 1949 after Gandhi's death,[37] "be thankful for the opportunity of knowing and being, I hope, a friend of Mr Gandhi....I can think of no person whose undertaking to respect a confidence I should have been more ready to take than his." Nor was this just a tribute born of hindsight after India had become independent and Gandhi had been assassinated. When, while the talks were proceeding, a senior official asked Irwin if Gandhi had been tiresome, the Viceroy replied, "Some people found Our Lord very tiresome."[38] On 6 March

1931, after the settlement had been reached, he wrote to Gandhi a letter which merits quotation in full.

> Dear Mr Gandhi,
> I want to write you a personal note of my own very great thanks to you for all you have done, while we have been working together during these last difficult days.
> It has been a great privilege to me to be given this opportunity of meeting and knowing you; and I hope that, either before I leave India or in England, you will give me the pleasure of seeing you again.
> I do pray—as I believe—that history may say you and I were permitted to be instruments in doing something big for India and for humanity.
> Believe me, with again much thanks and with deep understanding,
> Yours very sincerely,
> Irwin"[39]

This unique document in Viceregal correspondence forms a fitting conclusion to Irwin's years in India and does much to correct the balance as against the several shortcomings of his tenure.

Spring Semester 1992

NOTES

1. S. Gopal, *The Viceroyalty of Lord Irwin* (Oxford, 1957).

2. Quoted in W. Studdert-Kennedy, *British Christians, Indian Nationalists and the Raj* (Oxford University Press, Delhi, 1991), p. 195.

3. Lord Birkenhead, *Birkenhead: The Last Phase* (London, 1935), p. 250.

4. Speech at Simla, 17 July 1926, Lord Irwin, *Indian Problems* (London, 1932), pp. 231ff.

5. Penderel Moon, *Gandhi and Modern India* (London, 1968), p. 125.

6. For an analysis of the causes for this support, see Derek Sayer, "British Reaction to the Amritsar Massacre 1919-1920," *Past and Present* (May 1991), pp. 130-64.

7. Irwin to Birkenhead, 19 August 1926, Birkenhead to Irwin, 23 March and 12 May 1927, and Irwin to Birkenhead, 6 January and 26 May 1927, Halifax Papers, India Office Library, Mss. Eur. C152, vols. 2 and 3.

8. Irwin to Hailey, 6 November 1927, Hailey Papers, India Office Library, Mss. Eur. E220, vol. 11.

9. Quoted in Lord Birkenhead, *Halifax* (London, 1965), p. 255.

10. Irwin to Lord Goschen, Governor of Madras, 11 July 1928, Halifax Papers, vol. 22.

11. Hailey to Sir C. Rhodes, 5 July 1928, Hailey Papers, vol. 12.

12. Irwin to all Governors of Provinces, 7 September 1928, Halifax Papers, vol. 22.

13. Birkenhead, *Halifax*, p. 257.

14. Dawson's memorandum, 25 March 1929, Evelyn Wrench, *Geoffrey Dawson and our Times* (London, 1955), p. 272.

15. Sir G. Mears to Irwin, 26 March 1929, Halifax Papers, vol. 23.

16. Irwin to Lord Peel, Secretary of State for India, 21 February 1929, Halifax Papers, vol. 5.

17. Irwin's note to Reading enclosed with letter to Wedgwood Benn, Secretary of State for India, 14 November 1929, Halifax Papers, vol. 5.

18. Hailey to Sir M. O'Dwyer, 4 November 1929, Hailey Papers, vol. 14.

19. Hailey to Irwin, 4 December 1929, Halifax Papers, vol. 23.

20. Ibid.

21. Lord Halifax, *Fullness of Days* (London, 1956), p. 145.

22. Irwin to Wedgwood Benn, 26 December 1929, Halifax Papers, vol. 5.

23. *The Round Table,* XX (January 1930).

24. Irwin's telegram to Sir F. Sykes, Governor of Bombay, 15 March 1930, Halifax Papers, vol. 24.

25. In 1922 Gandhi called off civil disobedience after a police station was set on fire and a number of policemen burnt to death.

26. Hailey to Sir A. Hirtzel, 4 April 1930, Hailey Papers, vol. 17.

27. Irwin to Wedgwood Benn, 7 April 1930, Halifax Papers, vol. 6.

28. Birkenhead, *Halifax*, p. 284.

29. Report of the correspondent on 18 May in *The Times*, 19 May 1930.

30. Irwin to Wedgwood Benn, 5 September and 3 November 1930, Halifax Papers, vol. 6.

31. Birkenhead, *Halifax,* p. 419.

32. Interview with Robert Bernays, 12 February 1931, Robert Bernays, *Naked Fakir* (London, 1931), p. 86.

33. Irwin to the King, 13 March 1931, Harold Nicolson, *King George the Fifth* (London, 1952), pp. 507-08; Halifax, *Fullness of Days,* p. 146.

34. Lord Butler, *The Art of the Possible* (London, 1971), p. 41.

35. Sir Stafford Cripps to Secretary of State for India from New Delhi, 11 April 1942, *Transfer of Power,* vol. I, no. 600.

36. Irwin to Wedgwood Benn, 26 March 1930, Halifax Papers, vol. 6.

37. Article in S. Radhakrishnan (ed.), *Mahatma Gandhi: Essays and Reflections* (Memorial Edition, London 1949), p. 396.

38. Birkenhead, *Halifax,* p. 299.

39. Halifax Papers, vol. 26.

The Interpretation of Fairy Tales: Implications for Literature, History, and Anthropology

DEREK BREWER

Fairy tales are a branch of folktales, which are traditional stories. Traditional stories have some special characteristics that are important to recognize. The folktale or fairy tale is a story already known, recognized and repeated. It has to be the same story. On the other hand, every telling is slightly different. Every telling is an interpretation of the so-to-speak idea of the story according to its own emphases. And every interpretation is another telling. For this reason alone folktales are different from novels. Imagine *Tom Jones* being recognizably re-written by Jane Austen, whose version is re-written by Dickens, and so forth. The novel, at least in theory, has to be original. On the other hand, I shall suggest that the deep structure of many novels does owe much to the basic fairy tale. Characterization, motive, cause and effect, description, are more superficial, though not artistically less important.

Fairy tales are not the only kind of folktale, but they do have a special human centrality because they are, in a word, about growing up. They are powerful among the founding myths of Western and some other cultures because they center on the problems of growing up in the nuclear family. They partake of the nature of myth without being sacred—of legend with no historical seed, of gossip with no personal animus. Although each story can vary considerably in itself, they have a remarkable capacity for survival. The story of growing up that they tell is one we all know and need to repeat to ourselves: about overcoming difficulties, behaving well, integrating the personality, integrating with society. They, incidentally, very rarely tell of fairies and the term is a complete misnomer. I only use it because it is the accepted one. Library classification systems use it, and it could not be more firmly fixed than that. For this reason I continue to use the term "fairy tale"

though the phrase is often used to mean either "self-deluding fantasy" or plain "lies," a meaning first found, like the term, in the late seventeenth century, that pivotal period in Western culture. It was also in the seventeenth century that fairy tales came to be associated with children.

Fairy tales seem to have become settled as a particular kind of folktale in the later Middle Ages, when they are closely associated with romance, but their roots are very ancient. That very typical fairy tale, *Cinderella*, has been traced back to ninth-century China and there is an Egyptian analogue of 2000 B.C. The Biblical story of the selection of David by the prophet Samuel and his fight with Goliath dates from about 1000 B.C. and has clear fairy-tale elements. The story of David is none the less profound for that.

The sort of fairy tales I have in mind are *Cinderella* and its variant form represented by *Catskin; Snow White and the Seven Dwarfs, The Sleeping Beauty, The Frog-Prince, Beauty and the Beast*, all of which have female protagonists; and *Puss-in-Boots, Jack and the Beanstalk, Tom Thumb*, as examples with male protagonists. I have taken here stories known in England, but one of the important points about these stories is that they are spread through many parts of the world, with many variations. Although Charles Perrault in late seventeenth-century France was the first to tell these stories particularly for children (*Histoires ou Contes du temps passé*, 1697), there is the somewhat similar *Pentamerone* by Basile, 1634, and of course the *Household Tales* by the German Grimm brothers from 1812 onwards. The edition of tales known in England that I have used is the collection of such tales reprinted in the form of their first appearance in English, edited by Iona and Peter Opie, *The Classic Fairy Tales*, 1974. This edition is particularly useful for my present purposes as the editors are normally explicitly opposed to psychological, anthropological, historical analysis of a symbolic nature. They cannot therefore be said to open the way to the kind of structural or symbolic interpretations that I am proposing to offer.

Before I turn to these interpretations it may be helpful to say that I did not start my investigations originally from fairy tales. I was following a more general track in traditional stories, especially in medieval romance, and particularly in the story of the medieval English poem *Sir Gawain and the Green Knight*. I began to notice certain recurrent patterns centered on the hero or heroine of these and related stories. Then I noticed similar patterns underlying several of Shakespeare's plays. They had two characteristics. First they had to do with relationships within the nuclear family: in brief, protagonist, father, mother. Second, there was an element of fantasy or improbability, which nevertheless seemed deeply satisfying. The critical problem was how to reconcile the satisfaction with the nonsense. The problem became only sharper when I noticed similar problems in novels which set out to be plausible and realistic. The novels of Jane Austen, Charlotte Bronte, Charles Dickens, unlike each other as they are in so many ways, showed at a

deeper level than the surface narration (which I call the verbal realization) the same play of tensions, similar problems and solutions. Nor did the matter stop there. In various modern romances of a very different kind, such as *The Lord of the Rings*, or even stories by P. G. Wodehouse, I could detect underlying similarities.

It was in this situation that fairy tales offered a clarification. I am inclined to think now that it is not I, or other critics, who offer interpretations of fairy tales, but fairy tales which offer interpretations or clarifications to us. They are so evidently symbolic and schematic in structure that what they have to say seems obvious. What they are talking about is the play of tensions within the nuclear family, the protagonist's need to leave the nest and find a mate, the protagonist's ambivalent feeling towards his or her parents, the protagonist's and mate's re-integration into society. I have called this in general "the family drama."

This process of escape, discovery, test and return is the great rite of passage in our lives. There are two other great passages in our lives, each normally accompanied by ritual. One is birth and the other is death. But in these cases we are conscious, or at least alive, on only one side of the passage. Before birth we are nothing, and after death, who knows? The poignancy of the central passage is that we are alive and conscious on both sides. We can both foretell and remember. Moreover, this central passage is as it were imitated or repeated in a thousand different ways, especially in late adolescence and early maturity when we are at our most vigorous and sensitive. (After, it is downhill all the way.) Repetitions of the central passage of our life occur, as we may easily see within universities, in examinations (which are highly ritualistic) and other initiatory experiences. But the major central passage is that breaking or at least drastic changing of our emotional bonds with our parents and the establishment of a passionate and committed relationship to a peer, usually of the opposite sex. In the traditional story this new bonding is naturally represented by marriage. This breaking and remaking, essential to the continuity of life and society, is the inner subject of the fairy tale but also of innumerable other tales, romances and novels.

This may sound either reductive or escapist and before further analysis I should like to deal briefly with these objections.

Of course the aim of all analysis is in one sense reductive. That is its point, to explain by simplifying, by clarifying the underlying structure. We understand the human body and appreciate it more if we know something of its skeletal and chemical structure. Another aim of analysis is classification. To establish a basic similarity between apparently very different phenomena helps us to understand them, and judge them on appropriate assumptions. Such classification does not reduce but enhance enjoyment. So with the structures and classifications of literature.

The view of fairy tales that I propound is also not reductive because it presents the innermost structure, the nucleus of the story. All traditional stories have to realize this nucleus verbally in all sorts of different ways in which the artistry or ingenuity of the narrator, his command of motifs, his invention of happenings, power of characterization and description, provide the artistry and much of the pleasure. (And though I use the inclusive masculine pronoun for convenience we must be aware that a number of the great storytellers recorded by folklorists have been women, and that mothers have traditionally been the supreme carriers forward of the traditional culture especially as represented in stories.) So to detect the underlying pattern is not reductive of the verbal realization. Rather, we appreciate the richness and variety of the verbal realization, the variation, all the more if we recognize the underlying theme. We are also less likely to misunderstand or misjudge the story if we understand its deep nature and judge it according to appropriate standards.

Another objection is that fairy tales are escapist fantasies. The accusation is partly based on their inherent improbabilities, but also on their happy endings, their optimism, their love of beauty. They therefore go against much experience of life which even for the luckiest of us is sometimes nasty, brutish and may be even too long. Modernism, or post-modernism, has taught us by precept and example that art and literature have no necessary connection with beauty, or goodness, or consolation, or supporting the human spirit under adversity. Favorite critical words are "disturbing," "subversive," not to speak of "frank"; and most remarkable of all on the popular level "adult," meaning "sexually obscene" or "horrifyingly violent."

I agree that, contrary to the general belief held since the Renaissance that underlies the British Obscene Publications Act and our educational system, art need not be beautiful, consolatory, supportive, moral or constructive. Art may well be, and today often is, dismaying, disruptive, ugly, and destructive, emphasizing all that is squalid and meaningless in our lives. That raises many important questions, too various and wide-ranging to be dealt with here. It will be enough to recognize that nowadays art is free, and if free to be nihilistic is also free to be constructive. Fairy tales, and most traditional literature, are constructive. Not all life is squalid and meaningless. There *is* beauty and meaning. The very facts that some people grow up and live purposeful lives, and that some people help other people, establish at least some grounds for the encouragement and representation of goodness and hope. That has been the traditional function of traditional literature. If art *need* not be beautiful or good, equally it does not *have* to be sad and bad.

Moreover, such stories as I have in mind by no means neglect the existence of evil and suffering. Some schools in the United States today have even banned *Snow White and the Seven Dwarfs* on the grounds of the violence and cruelty portrayed. (When one compares this with the sort of films regularly available to children on television and video, one is left gasping.)

All this still leaves the critical problem unsolved, the undoubted power of traditional stories evidenced by the very fact that they *are* traditional, that is, loved and repeated over generations, combined with their improbabilities. The improbability inheres not only in the happy ending but often in the apparently arbitrary sequence of events, not linked by cause and effect but by luck and coincidence, and in the characters, including many fantastic creatures such as talking animals. We know we receive satisfaction deeper than simple amusement from such stories.

It is here that fairy tales come to our aid in several ways, very suitably, since fairy tales are full of incidents when somebody comes to the aid of the hero. One insight is offered by the highly stereotyped structure of action and character, of which the most typical and best-known tales naturally give the best examples. Fairy tales are very schematic, the characters are given very few individualizing traits, and the action, taken abstractly, is foreseeable.

If I may digress for a moment, I once tested the foreseeability of a fairy tale on three students, who were intelligent and articulate but like so many young people today had been deprived of much detailed knowledge of fairy tales by educationists who disapprove of stories. All the same, they were able to respond. I led them, or rather they led me, through the story of *Dummling, or the Golden Goose*, which they did not know, by proposing a basic proposition and then asking what happened. I said, "There was a woodcutter and his wife who had three sons: who do you think was the worst treated?" They all knew it was the youngest, and knew he alone would share his meager dinner with the poor old man and so forth. They knew the pattern. What they couldn't guess was that the magic discovery and gift was a golden goose. In this item lies the individualizing genius of that particular story. The general pattern is known, because it is deep in the psyche, but not the specific point or points on which it turns.

But my exposition must be even more schematic than fairy tales themselves, especially as you all know the pattern and I devoted to it a long chapter of a book I published over ten years ago, and which now I want to take a little further. There are certain general rules that the classic fairy tale follows. If the rules are broken you may be sure that you are reading a modern literary fabrication.

The classic tale has a protagonist, usually older than a child and younger than an adult. In the old days we were allowed to call the females "girls." The word "boy" is for etymological reasons not quite symmetrical with "girl" so we may vary it with "youth," if we may keep that as male-specific. Occasionally, the protagonist is "split" as it were, giving us a double hero, as in the world-wide folktale of the *Two Brothers*. The only example I can think of with a female protagonist "split" in the same way occurs in the story of *Rose-red and Snow-white* (two sisters), but it is also evident in Shakespeare's *As You Like It*, Rosalind and Celia. But, anyway, this split is a minor example

of a larger phenomenon. All the other characters in a story are splits—that is to say, variants of one of the main three. Giants for example are splits of the father figure: wicked step-mothers are splits of the mother figure. These splits allow different emotions to be expressed towards the complex parent-figure. There is one exception. That is the Other: the one whom the protagonist seeks, his or her equal.

At the beginning the protagonist is discontented, or as the folklorists say, suffers from a "lack," a deficiency, often by being ill-treated in some way at home. In a profound sense the lack is precisely that of the "other," the prince or princess, combined with the sense of constraint, the anxiety of the chicken to break the once protective, now restrictive, shell.

The male protagonist chooses, or is forced, to leave home. He then meets opponents of various kinds, possibly dragons, or giants, or hostile kings. He may first help, and then be helped by poor strangers or magic animals. Sooner or later he hears of a princess, and may have to rescue her, or fight for her, but eventually he marries her. Sometimes he then goes off again on more adventures but he returns safely and settles down. He may well win magic riches at some stage, perhaps by acts of bravery or selfless generosity.

It is quite likely that at some stage in his adventures a female will hinder him, either by too much love, or as a hostile witch. This happens in medieval European romance, which is closely allied to fairy tale. In any given tale there will probably be only a selection of possible adventures, helpers and opponents, but the general pattern will be clear. It is the pattern of growing up.

All art is symbolical as well as being itself. The symbolism is the meaning, or sets of meanings, that are generated. At this time of day psychological or psychoanalytical meanings are not likely to seem extravagant as underlying structures in so very schematic a form as the fairy tale. Characters are themselves at a literal level, but they all relate to the protagonist, and at a deep level are part of the protagonist.

The protagonist is a kind of everyman. The menacing figures that oppose him are splits of the father-figure and of his own character in the form of his inhibitions. It should console all of us who are fathers that those father-figure splits who are giants are always stupid, and easily disposed of. Mothers will not be surprised. This is the case even with Oedipus. Killing his father gave him no trouble. The story of Oedipus is a tragedy because the hero could not escape from his mother, and his story is therefore not a fairy tale, which is a success story—that is, a romance or a comedy. But the symbolic interpretation of the story of Oedipus is of the same kind as the fairy tale calls for. In the fairy tale the hero has to kill his father, dodge his mother, and find his girl.

When the protagonist is a girl the pattern is a little different. She rarely leaves home, and if she does she soon settles in another. We remember the ultimate origins of such tales in primitive societies in which the functions of

the sexes are clearly divided, going back to perhaps paleolithic times when the man hunted and the woman looked after the children and was necessarily constrained; though it is sometimes argued that such stories originally gave the heroine a more active role. The female protagonist will find that the most hostile figure is a mother-figure, but the father-figure is a nuisance too. If he is kind he is weak and under the thumb of the hostile mother-figure. But he may be strong, and there may be no mother-figure, in which case he is even worse, because he may wish to marry his daughter. So she has to dodge her father and get rid of her mother. In some way her peer has to find her. She may be helped in this by another split of the mother-figure, a helpful animal for example, or even the bones of the helpful animal as in some analogues of *Cinderella*. There are many variants.

Fairy tale structures therefore present stories of the family drama at its most intense. Fairy tales are those stories which give a happy outcome. They closely resemble many medieval romances. (The word "romance" has also been treated as meaning a falsehood, just like the word fairy tale.) Great writers create remarkable variations within the structure of the family drama. The author of *Sir Gawain and the Green Knight* turns it around. The hero does indeed have to leave home on a quest of great danger, but he arrives at Christmas time at a castle which it turns out is still symbolically his home. The great danger turns out to be at home itself, from a seductive female mother-figure. The giant who threatens to kill him is his own host in another guise, and obviously a split of the father. Once he has defeated by his endurance these parent-images, they become friendly and he is free to come and go as he pleases. He can leave home and need return only for weekends when he has nothing better to do.

Shakespeare is the most astonishing of all in the ingenuity with which he treats such tales, often twining two together, a hero and a heroine, and often giving the heroine the principal part, as in *As You Like It*, *Twelfth Night*, and *Cymbeline*. All these are most interesting versions of the family drama which conclude, especially in the late romances, with evil met and overcome, lovers united, the generations reconciled, the family re-established in strength and harmony.

Jane Austen has the same pattern with her strong-minded Cinderellas, like Fanny in *Mansfield Park*, with some wonderfully satirized mother-figures, though the hero tends to be too close to a perfected father-figure. Dickens too, as in *Great Expectations*, but in many other novels, sets his story within the family drama, with great psychological power.

The family drama does not always work out happily, and then we have tragedy, as opposed to romance, comedy, or fairy tale. I have already mentioned Oedipus. The difference is simple. When parent-figures destroy the protagonist, as happens for example in *Hamlet* or *King Lear*, it is tragedy. When the protagonist destroys the parent-figure it is comedy, romance, fairy

tale. A fairy tale can be changed, as happens in *King Lear*. The play is regarded as a variant of *Cinderella*. An intolerable burden of love is placed on the protagonist, who is of course the youngest of three daughters, by the father. In *King Lear* he does not want to marry her in the literal sense, but he demands everything from her. She is at first rescued by the Other, but by a bitter twist is captured again, and in effect destroyed by her father, the embodiment of a rigidly patriarchal society.

This last example leads me to a final main point about fairy tales that is true of all traditional stories. They have a nucleus which identifies them, and maintains their continuity, but it is pre-verbal, held in the mind. The story can be verbally realized in many different ways, softening or omitting some features, emphasizing or adding others, taking now one, now another point of view. The classic example of traditional story, though not a fairy tale, is the existence of four Gospels, with the three synoptic Gospels varying to some extent between themselves, and St. John being very different. Yet they are all the same story.

Fairy tales have a certain didactic quality in so far as they favor goodness, beauty, generosity. They lead the mind in wholesome ways, and they tend towards unification of the psyche. But when they came to be adapted for children from the seventeenth century onwards, a good deal of express moralization was added in the verbal realizations, not always appropriately— hence the modern impression that they are inherently moralistic. They are not.

Granted the continuity of the inherent nucleus, it is clear that historical and cultural changes will affect the style and quality of the tellings.

More recently, fairy tales have been discussed from Marxist and feminist points of view. I have in mind two good books, one by the Marxist, or semi-Marxist, Jack Zipes, entitled *Fairy Tales and the Art of Subversion*. He is unlucky in that Marxist theory has taken a bit of a knock since his book was published. The collectivist socialist utopia has been revealed as a bizarre and extreme incarnation of the deplorable characteristics he attributes to the bourgeoisie. He gives what can only be called comical examples of fairy tales devised for a workers' paradise, and fails to show that fairy tales are in any way subversive of the so-called "bourgeois" sense of family. Rather, he illustrates how constructive they can be if genuinely rooted in the growth process of human nature, which his modern examples are not. Knowledge of medieval literature would have benefitted him, as it would so many other modern critics and theorists of literature. But perhaps he does show, if inadvertently, that post-modern, post-industrial society, may not be able to respond to the family-based values of the fairy tale, or perhaps of humanity at large.

Another line of discussion is the feminist, represented by Jennifer Waelti-Walters, *Fairy Tales and the Female Imagination*. She rightly emphasizes that

many fairy tales have been formulated in a patriarchal society. She is much influenced by the French authors, Lacan and Foucault. Waelti-Walters discusses some modern novels which she regards quite plausibly as unconscious versions of *Beauty and the Beast*, *Snow-White*, *Cinderella*, *Sleeping Beauty*. While she makes some reasonable, if anachronistic, criticisms of what these tales say about the situation of women, a good deal of her message may be summed up as saying "unfair to witches." The book occasionally becomes a tirade against men, no doubt well-deserved but rather beside the point here. Again, while she emphasizes the flexibility of the fairy-tale nucleus, the variety of narration, it seems to me as an old fashioned literary historian, that the persistence of the inner psychological pattern of the fairy tale is illustrated even in perverted modern versions, of which she gives examples, and of which there are many others today, intentionally cynical, ironical and discouraging.

Whatever happens to the family in modern society, it is pretty certain that each individual person making his or her own way to adulthood will find, or create, images both friendly and adverse of parent-figures. Thus, the family drama will find its setting. It will remain of intense interest. To make stories is to be human, indeed to be human is to make stories. The great stories are repeated, and with repetition comes variation according to circumstance. But the inner nucleus, however vague, controls the verbal realization. Nowadays, fairy tales are told by such writers as Angela Carter with a cynical or morbid twist characteristic of the dominant literary mode of our times. Or they may be adapted to feminist or Marxist social modes, either in narration or interpretation. Nothing remains quite the same. No man, or woman either, can jump into the same river twice. But, something very closely associated with man, woman and river continues to flow and be recognized. So I believe it will be with fairy tales.

For an audience such as this, focussed on British Studies, there will be a number of literary, historical and anthropological implications, both direct and comparative. What I have attempted to do is in part an anthropological analysis of such tales, as if they constituted a society in themselves. The concept of the rite of passage is anthropological. My analysis obviously owes much to Freud and Jung in general terms. Individual forms of narration tell us much about social levels and the relation of popular literature to high culture. But all that must be left for the moment as ongoing questions, subjects of further literary, historical and social enquiry, guided by the concept of the traditional story with its persistent yet flexible structure rooted in the human psyche.

Spring Semester 1990

BIBLIOGRAPHICAL NOTE

The standard and most inclusive book on the fairy tale is Max Lüthi, *The Fairy Tale as Art Form and Portrait of Man*, translated by Jon Erickson (Bloomington, Indiana University Press, 1984), which has a selection of bibliographical references. The standard survey of the varieties of folktale is A. Aarne and S. Thompson, *The Types of the Folktale*, 2nd rev. ed. (Folklore Fellows Communications no. 184, Helsinki, 1973). The particular line of argument advanced here was developed by Derek Brewer, *Symbolic Stories* (Cambridge: D. S. Brewer Ltd., 1980, repro. pbk. Longman, 1988) with further references. Further study from different points of view and valuable bibliography is provided by Jennifer Waelti-Walters, *Fairy Tales and the Female Imagination* (Montreal, Eden Press Inc., 1982), and Jack Zipes, *Fairy Tales and the Art of Subversion* (London: Heinemann Educational Books Ltd, 1983; republished New York, Methuen Inc., 1988.) Fairy tales, seen as a branch of folktale, are not only worldwide themselves but have received an enormous amount of scholarly attention in recent years.

13

Toynbee Revisited

WILLIAM H. McNEILL

The rise and fall of Arnold Joseph Toynbee's reputation as an historian between 1947 and the early 1960s constitutes a remarkable encounter of scholarship with popular (or at least quasi-popular) American culture. The adventure began in March 1947, when *Time* magazine declared that *A Study of History* had superseded Karl Marx's *Communist Manifesto* by offering a reliable explanation of the past and future course of world history. Public response was sudden and strong, for the United States was then trying to adjust to the onset of the Cold War. Academic historians were more tepid, but they admired the scope of Toynbee's learning and treated him politely even while criticizing errors of detail that they found in his writing. No historian before or since has attained such public prominence or commanded so much deference—not solely in the United States, but in many other countries of the world.

Yet fashion is fickle, and after about a decade of world fame Toynbee's reputation collapsed almost as swiftly as it had arisen. The most notable landmark came in 1957, when Hugh Trevor-Roper, then newly installed as Regius Professor of History at Oxford, wrote an article for *Encounter* in which he denounced Toynbee as a puny, pretentious prophet who was also a traitor to the West. Subsequently, a noisy clash with Canadian Zionists in 1961 discredited Toynbee in a different way so that by now, more than thirty years later, his name has been almost forgotten, both by historians and by the public at large.

Since reading the first three volumes of Toynbee's *A Study of History* played a critical role in my own intellectual growth when I was a graduate student, I feel that his oblivion today is as lop-sided as the adulation that he had attracted earlier. Consequently, when Lawrence Toynbee invited me to undertake a biography of his father, promising full access to his papers and complete freedom to publish whatever I might find, I decided to accept, and to try my hand at a different scale of historical work than I was accustomed

to. I hoped, of course, to redress the balance between the excessive praise and the no less excessive disdain from which Toynbee has suffered. But when *Arnold Toynbee: A Life* came out in 1989 the reviews it received show that I failed, at least in the short run. Instead, nearly all the reviewers found reason to denounce him anew, in some cases using information about his private life that I had uncovered. I was disappointed, and somewhat disconcerted by this outcome.

Discrepancy between hope and reality is the stuff and substance of human life and of our collective historical experience, so I ought not to be surprised at how this book missed the mark I aimed at. But it galls me all the same, so when I was invited to speak on the problems of writing a biography of Toynbee and my reaction to its reception, I accepted—incautiously as always, and in hope of making clearer to myself what went wrong with my initial expectations and actual performance.

The best place to start, is to explain something about my intellectual debt to Toynbee and the personal encounter with him that ensued. It began in the Cornell University Library in 1940, when as a beginning graduate student of history, I happened upon three fresh green volumes, sitting demurely on the shelves and bearing the enigmatic title, *A Study of History*. The author was completely unknown to me, but I took the books down anyway and started to look them over. Soon, I was engrossed and in the days that followed read them through with a sustained sense of excitement that I have never duplicated before or since. Other books and articles have sometimes brought sudden enlightenment about a matter of interest to me—great or small; but Toynbee's volumes addressed the fundamentals of my vision of the human past in a sustained fashion, and did so for days on end, as no other text has ever done. It was, in short, a conversion experience. When I emerged from reading his pages I was in some important respects a new man, and my subsequent career as an historian is little more than an effort to explore the widened perspective on the past that Toynbee put before me.

To understand my reaction one must go back to the way history was taught in American schools and universities before World War II. My professors were heirs of a liberal tradition that viewed the human past as a prolonged struggle between tyranny and liberty, error and enlightenment. Sporadically at first and then, starting in the eighteenth century, with increasing momentum, political liberty and secular truth had prevailed, and what mattered in the past were the times and places when the struggle between tyranny and freedom and between error and truth had been joined.

Attention was distributed accordingly. This meant, for instance, that ancient history focussed on how Athens held off the Persians, grew great and then collapsed, followed by a confusing Hellenistic Age, after which Roman republicans more or less replicated the Athenian experience of liberty leading to greatness and an ultimate collapse. Medieval history, likewise, focussed

mainly upon the rise of national states and of representative institutions. Modern history turned on renaissance and reformation, the enlightenment, the French revolution and the subsequent triumphs of liberalism and nationalism in the nineteenth century.

But by the 1930s, when I was coming of age, the disasters of World War I and the Great Depression constituted an inexplicable addendum to this optimistic vision of the human past. It was awkward to believe that the fine fruit of the triumph of liberty and truth in the nineteenth century was the capacity to wage war so destructively, only to suffer uncontrollable boom and bust in peace time. My teachers met this problem by neglecting it. For them, history ended in 1914 in a vigorous debate over war guilt—i. e. which government bore the diplomatic responsibility for starting the war.

Communism, masquerading in a Russian guise since 1917, challenged the liberal faith from a different angle; but my teachers were not impressed by Marx either. When I was growing up that intellectual critique of the liberal viewpoint flourished independently of the classroom among extra-curricular student organizations and in private, late night conversations. But from an historian's point of view, Marxist ideas did not depart very much from the liberal vision of the past. Marx's history focussed almost wholly on the European past in the same way that liberal historians did. To be sure, Marxists emphasized economics rather than politics; and the more radical among them demoted the liberals' precious truth into no more than conscious or unconscious defence of class interests, even though (like liberals) they simultaneously affirmed their own version of "scientific" truth as set forth in the pages of Marx, Lenin, and the speeches of Stalin.

In retrospect, therefore, the Marxist-liberal debates of my youth look very like a tempest in a teapot. The really serious defect of the historical understanding that I inherited from my teachers was that it left out most of the past. Eras in European history that could not be conveniently connected with the history of liberty and truth were simply skipped over. Eastern Europe was *terra incognita*. Islam was accorded the dignity of preserving a few scientific and philosophical Greek texts before passing them on to medieval Europe. But China and India, like Africa and the Americas, existed solely to be discovered by Europeans, whose role, presumably, was to correct their various errors and apprentice them to liberty.

This was, assuredly, a grotesque portrait of the human past; and that, quite simply, was what I discovered by reading Toynbee's first three volumes. The relevant past simply could not be construed as narrowly as my teachers and the pioneers of historical scholarship in Europe and the United States had done. Other peoples and civilizations demanded consideration, and so did the European past in its entirety. The only question was how to fit everything together into an intelligible whole. Toynbee did so in a fashion I eventually came to feel was wrong because he assumed that civilizations were

self-contained wholes with only restricted, occasional contacts across their borders, whereas I convinced myself that contacts with strangers with different skills and ideas was a continual stimulus to innovation in all societies, not least in the most skilled and complex, i.e., most civilized centers. But it was many years before I worked out a (more-or-less) coherent history of the world in the light of this assumption; and when I first encountered Toynbee's scheme of the rise and fall of separate, civilizational histories I did not know enough to criticize his segmentation of human history into almost watertight compartments.

Moreover, I was already predisposed to look for repetitious cycles in history by the uncanny way the approach of World War II cast a shadow upon our lives in the late 1930s. Sixty years have passed since then, so this may require a bit of explanation. The fact was that for at least three years before fighting began again in Europe, renewal of the contest of 1914–1918 appeared to be both immanent and inevitable. Human purposes were irrelevant. The international situation prevailed over everyone's wishes. Political leaders, including Hitler, became mere puppets, propelled by the abstract geometry of the struggle for power among the states of Europe. Analogies with the struggle among the Greek states in the fifth century B.C. and between Rome and Carthage in the third century B.C. seemed compelling. One of my teachers, for instance, actually altered a passage from Thucydides by substituting 'Germany' for 'Sparta' and 'Britain' for 'Athens' and published it as an article in *The Nation*, where it served as a telling commentary on current events.

Toynbee, like Spengler and many other classically educated Europeans, had been haunted during World War I by the thought that European nations were re-enacting these same disastrous passages of ancient history. The eeriness of such an unwilling iteration was, in fact, what provoked Toynbee to construct his pattern of civilizational rise and fall. He applied it first to the ancient Greek and Roman world in an elegant lecture, entitled "The Tragedy of Greece" which he delivered at Oxford in 1920. Whereupon, he spent the ensuing decade trying to make the history of all the rest of the world fit into the same pattern. The initial result of his labors, published in volumes I-III of *A Study of History* in 1934 was what I encountered in 1940.

A revised and fundamentally altered vision of the human past began to emerge in volumes IV-VI, published in August 1939, on the very eve of World War II; but they had not reached the shelves of the Cornell Library in 1940 and I did not explore them until 1955, when I plodded through the entire ten volumes in preparation for participation in a colloquium on Toynbee that took place at Loyola University in Chicago. By then I had formed my own views about world history and was consequently impervious to Toynbee's revised message. But in 1940 Toynbee's parallels among separate civilizations seemed very plausible (perhaps convincing: I cannot remember any more).

But what mattered above all was that the study of history, as I had previously conceived it, took on an entirely new grandeur by embracing all the peoples of the earth instead of being confined to a few privileged fragments of time and space. What Kant said of Hume, I therefore say of Toynbee. He awakened me from my dogmatic slumbers, and I remain profoundly grateful, even—indeed especially—because I have since had occasion to diverge from so much of what Toynbee had to teach.

Toynbee's pioneering role in enlarging the scope of historical scholarship was what I hoped to make clear in my biography. But before I come to that experience, and my apparent failure to correct the current disdain in which he is held by historians, I ought perhaps to explain more about how I came to Lawrence Toynbee's notice as an appropriate biographer. Probably the precipitating factor was that after others declined to do so, I agreed to write Toynbee's obituary for the British Academy. My qualification for this task, in turn, was that I had written an appreciation of Toynbee's history for the Loyola symposium in 1955, and before that had worked under Toynbee's supervision at Chatham House for two years, 1950–51, writing a volume in what was colloquially referred to as the "War-Time Survey." This enterprise, in turn, resulted from the intersection of Toynbee's professional career with the sympathy and support of the directors of the Rockefeller Foundation.

Toynbee's principal occupation between 1924 and 1939 had been the preparation of an annual survey of international affairs for the Royal Institute of International Affairs. (Incredible as it may seem, he did the research and writing for *A Study of History* in vacation time.) When World War II began, the annual surveys were interrupted; and when peace returned Toynbee decided to turn the task of writing these annual volumes over to others in order to concentrate on finishing *A Study of History*. A grant from the Rockefeller Foundation allowed him this luxury; but the terms of the grant also required him to supervise writers who would fill in the war-time gap. The format of annual volumes seemed unsuitable for the six years of war and post-war peacemaking. Instead, Toynbee organized the projected survey of war-time international relations around a series of topics, times and places, and when I first met him in 1947 he was on the lookout for persons who could take on parts of the task. I was young and eager, and a few months later he invited me to write about relations among the three Allied powers. The result was more than 800 pages devoted to *America, Britain and Russia: Their Cooperation and Conflict, 1941–1946* (1953).

During the two years when I worked on this book I saw Toynbee almost every working day and had ample opportunity to ask him questions about the patterns of human history that he had defined in *A Study of History*. He was always courteous and kind; but I also discovered how impervious he was to any real challenge to his ideas. He was in his early sixties by then, at the height of his fame, and was working hard to complete the four final volumes

of his great work. It was no time to revamp basic ideas (or even details of his scheme) and he made no effort to do so. He asked me to read and criticize one of the final volumes; but when I made a few suggestions for change, he decided to publish my observations (along with those of one or two other critics) as footnotes to an unaltered text. I thought it odd at the time and feel so still. But that was Toynbee's way of reacting to differences of opinion. He did not like to quarrel openly; still less to alter his own views. Instead he acknowledged divergences with distant, benign courtesy, and let it go at that.

Soon after my obituary of Toynbee appeared in *The British Academy Proceedings for 1977* his widow asked me to undertake a full scale biography. I was already scheduled to go to Oxford as Eastman Professor in 1980–81 and told her that I would be glad to use my time at Oxford to look through Toynbee's papers, which she had deposited at the Bodleian, and see what I could do. But shortly before arriving at Oxford, I got a brief, crabbed note from her retracting the invitation on the ground that a clause in Toynbee's will forbade the preparation of a biography until fifteen years after his death. No such provision was actually incorporated in Toynbee's will, though he had once said that his biography should be delayed for fifteen years after his death so as not to injure or offend persons close to him. Mrs Toynbee died very soon afterwards, and I do not know what lay behind the note she sent me. In practice, her retraction was convenient, since it allowed me to complete another book, *The Pursuit of Power*, which I had failed to finish before showing up at Oxford. Still, I was surprised and a bit puzzled. Mildly disappointed too, since working with primary documents—the canonized form of historical research—was something I had looked forward to as a way of testing my authentic qualifications as an historian.

Some three years later, Toynbee's (by then) sole surviving son, Lawrence, renewed the invitation, saying nothing about a fifteen-year waiting time, nor referring to the previous negotiation with Mrs Toynbee. I did not inquire, since I still wished to undertake the task. Instead I applied for a Guggenheim Fellowship which, in 1986–87, allowed me to spend another year at Oxford and work my way through Toynbee's papers. I did take the precaution beforehand of asking Lawrence to sign a paper giving me full control over the content of the projected book. He did so readily, and in fact was completely cooperative with me throughout the book's gestation, even though some of the things I discovered about his parents were surprising to him, and may have been mildly disquieting as well.

This brings me at long last to discourse on the problems of writing a biography of Toynbee; and my reaction to its reception. Let me say, first, that Toynbee was a very prolific writer, and his papers on file in the Bodleian are extensive—about 200 cartons in all—and their arrangement remains rather haphazard. Looking through them, day after day, required diligence; and transcribing notes in long hand was a chore. Still, when it came to

composition, the excerpts I had copied into my notes made it possible to string a narrative together, allowing Toynbee and his family and friends to speak in their own voices as often as not. Copies of his books, most of which I owned, were even easier to rummage through for appropriate quotes since I could then copy from a fair text instead of from my crabbed handwriting.

From this point of view, writing the book was easy. A substantial part of the end product is excerpted from others' prose—Toynbee's first and foremost. Since he and his circle all wrote well, the end result reads smoothly and, I hope, authentically. Yet it is also true that despite the abundant primary documents to which I had access, writing this biography required me to make some critically important assertions that actually contradicted the written evidence. This was a surprise to me—indeed a rather distressing surprise— because, on some significant points it required me to revise the admiration for Toynbee with which I began. Moreover, by uncovering shameful aspects of his behavior, as I did, I provided readers and reviewers, who were so predisposed, with fresh ammunition for attacking him—thus defeating my main purpose in writing the book. What an ironic upshot for my researches! What an unhappy way to deconstruct the hero of the lamp whom I had embraced so enthusiastically in the Cornell stacks in 1940!

The central discovery I made was that Toynbee made fictitious excuses in 1914–15 for not volunteering for the army, as almost all the men of his age and station were doing. Later in life he probably convinced himself that he had real health reasons for remaining a civilian. At least he said so in print repeatedly, declaring that his life had been preserved in 1914–1918 by the accident of having contracted dysentery in 1912 while travelling in Greece. This presumed that his dysentery in 1912 continued to be a debilitating physical condition in 1914 and subsequently, but in fact he had fully recovered and never suffered recurrence of the infection. Yet, a Quaker doctor (and family friend of his wife) who opposed the war on principle, signed a paper (preserved in the Bodleian) saying that if he were exposed to life in the trenches the infection would recur. Toynbee then used this medical opinion (written without even the formality of a physical examination) to justify his failure to enlist.

Whatever he came to believe in later life, at the time he surely knew that this was a falsehood. He was in fact physically vigorous. His mother expected him to join up and urged him to do so. In refusing to volunteer he rejected his mother's stalwart patriotism and instead submitted to his wife's wishes. (She subscribed to an extreme Whiggish form of Liberalism that opposed Britain's entry into the war, and for reasons of her own wanted her husband with her). But this choice between mother and wife also involved a profound self-betrayal. For Toynbee failed to live up to a heroic self-image that he had cultivated from childhood. It was a desolating action, made all the more bitter by the fact that in conforming to his wife's will he also pandered to his

own longstanding distaste for the rough and tumble male camaraderie of schoolboy games and, of course also, escaped the physical risk of war.

Toynbee's subsequent career, nonetheless, turned upon the anguish this self-betrayal aroused in him. Or so I convinced myself. Many of his actions are unintelligible otherwise. For example, he gratuitously broke his ties with Balliol College where he had been a tutor when the war started, even though he had no other peace-time job, and the Master wanted him to remain. But had he stayed he would have had to face returning heroes; and this, I suspect, he felt he could not do.

His extraordinary personal feud with Lloyd George in the post-war years, 1920–1922, also became intelligible to me when I realized that Toynbee had come to justify his failure to enlist by persuading himself that, as a temporary member of the Foreign Office, he could help to make a just and durable peace and prevent future wars—but, of course, only if the Government followed his advice. When, however, Lloyd George disregarded his recommendations for a peace settlement with Turkey, Toynbee saw this justification for his conduct during the war suddenly snatched away from him by the wanton irresponsibility of the Prime Minister. The young man, thirty years of age, took the matter personally, and vehemently wished to prove himself right. He succeeded too, for in the next two years, through journalistic work for the *Manchester Guardian,* and in other ways, he did contribute significantly to the failure of Lloyd George's policy of backing Greece in Asia Minor against the Turks.

But this personal vindication had its costs. In particular, Toynbee paid for his pursuit of a just and durable peace with the Turks by losing his job at the University of London, where he had been appointed Koraes Professor of Greek History and Literature. Greek donors, who had established the chair, protested against his criticism of Greek atrocities against Turks in Asia Minor; and after considerable controversy within the university, the matter was resolved by the termination of his appointment.

His unbending and almost frenetic conduct throughout this affair rested emotionally on the profound need to justify what he had done in 1914–18. Nothing else explains it; and at the same time his growing sympathy and insight into the Turkish side of the struggle propelled him away from seeing the issue from a traditional Liberal, Western, Christian viewpoint. *The Western Question in Greece and Turkey* (1922), written at top speed in a few weeks, is indeed one of the most powerful books he ever wrote, and prefigures some of the central ideas of *A Study of History.*

Toynbee's life assumed a more stable pattern only when an invitation to write an annual survey of international affairs for the newly established Institute of International Affairs—at first for only a single year—gave him a new source of income and simultaneously offered a new justification for his wartime evasion of military service. For by propagating knowledge of

international affairs more widely, he and the new Institute hoped to create an enlightened public opinion that would make renewal of war forever impossible. By devoting his life to that task, Toynbee came to believe that he could atone for not having fought and died in the trenches as so many of his contemporaries had done. This created new difficulties for him when the failure of the League to stop Mussolini from conquering Ethiopia in 1935–36 showed how fragile peace had become. Toynbee's denunciation of the British government's policy became so vehement that he endangered his position with the Institute. But this time his established reputation, and the fact that a good many members of the Institute agreed with him, meant that compromise prevailed and he kept his position until World War II brought him back into government service.

All this, together with turmoils in his family life that were related to his self-betrayal in obeying his wife and his own (perhaps cowardly) impulses, was a side of Toynbee's life that his published memoirs and reminiscences carefully suppressed. Nor did his papers explain the motivation of his actions as I eventually came to do. He was, I concluded, profoundly ashamed of himself, but hid it from the world, and eventually perhaps also from himself, by harking back to his attack of dysentery in 1912. Yet in interpreting his life in this fashion I was, in effect, disregarding the paper trail of evidence that he had artfully created.

I do not recall any similarly reckless departure from available evidence in other writing I have done. World history is, from this point of view, far simpler and more straightforward. Maybe I should have expected it. Private lives, I suppose, always have their embarrassments and shameful episodes. Seldom I think are they as central and shaping as in Toynbee's case: but hiding or suppressing evidence of shortcomings is presumably normal for all of us. It was what I found anyway; and though I am sure my reconstruction of the dynamic of his acts and emotions is correct, I must also confess that it rests wholly on an imaginative reconstruction of what mattered to him, and contradicts written testimonies.

Historiographically speaking, this may be instructive. Getting closer to the sources and relying more directly on primary documents does not, after all, establish truth unambiguously. Men and women sometimes wish to deceive; and can deceive themselves as well as those around them. Penetrating such deception depends on an intuitive sense of human nature and probabilities. I believe I did penetrate Toynbee's (self) deception, and tore off a carefully adjusted mask. But what a rash, brash and heartless thing to have done! I destroyed one work of art—his painstakingly reconstructed self image—and substituted my own work of art. It is a truer image of him, I think, but that merely means that it quivers in painful nakedness.

The diminution of his stature as a man that my interpretation involved still troubles me. For my discoveries of less than admirable qualities did not

end with the self-betrayal of 1914. Toynbee also suffered from a compulsive fear of impoverishment—inherited from his childhood. This provoked a miserly style of petty greed, even when money flowed towards him abundantly in later life. He was also an ineffective father to his sons, and so submissive to his first wife that she eventually came to despise him and ran away with a Roman Catholic priest instead. Not, then, a very admirable figure. Yet it is also true that defects of his personality were what drove Toynbee to the extraordinary feats of scholarly and literary accomplishment that I admired so much. Every personal failure attached him more strongly to his desk. Every private shortcoming made him work harder, read more strenuously, explore more widely and construct his vision of the history of humankind more ingeniously. Without his defects, in other words, his authentic heroism of the lamp would have been impossible. That, as least, is what I concluded, and sought to convey in my biography.

Yet my praise of his pioneering role in enlarging the scope of history by embracing all the civilizations of the earth in one conspectus seemed less interesting to reviewers, and perhaps to readers at large, than my portrait of a deformed and strangely contorted personality. For most readers, I fear, his real intellectual attainment is all but entirely obscured by the personal details of his life. Moreover, the balance of narrative and evaluation in my biography invites a negative reaction to his attainments because I also felt it right to indicate what I believed to be limitations and errors of his historical vision. By the time I set forth my reservations, the passages of praise begin to sound hollow.

Perhaps they have really become at least partly hollowed out by what I now know about his life. Certainly, after writing the book I can no longer admire him as unreservedly as once I did. And that is a small private sorrow, since no one likes to see his youthful enthusiasms wilt and decay. But I still maintain that Toynbee deserves to be honored by historians for a tremendous intellectual accomplishment; and should not be dismissed as a cranky bore or old fool, as most of my reviewers were eager to do. Let me therefore conclude my remarks with as careful a statement as I can make of what I think the reviewers and readers of my book ought to have gathered from its pages.

First, he was a man of his time and place, whose private life was unusually tangled and painful, despite professional successes and the extraordinary burst of adulation that showered down on him after 1947.

Second, the pains and eccentricities of his private life contributed directly to his intellectual accomplishment, not just by driving him to escape into desk work, but also by pulling him away from the beaten track, impelling him to seek out "the other side of the moon" (as he once said of himself) by looking beyond the boundaries of the traditional historical learning that had been transmitted to him. Therein lay his greatness; and we ought to be able

by now to recognize it without being put off by the less than admirable qualities of his private life—however essential they were for his professional accomplishment.

Third, like a Moses who only glimpsed the promised land from afar, Toynbee did not attain a truly satisfactory vision of the human past as a whole. Civilizations were not as separate as he supposed, and the cycles he ascribed to their genesis, growth and breakdown were not as uniform, nor as regular, as he made them out to be.

In later life, Toynbee half acknowledged these defects. His book, *Reconsiderations*, published as a twelfth volume of *A Study of History* in 1961, leaves very much up in the air the question of whether he then still adhered to his earlier ideas about the separateness of civilizations and the patterns of rise and fall he had anatomized. He no longer cared very much about such questions because beginning about 1936 he gradually convinced himself that the real meaning of history lay not in the recurrent tragedy of civilizational breakdown, as he had once supposed, but in a progressive revelation of a "Spiritual Reality" that lay behind worldly appearances. Mystic experiences that came to him in moments of special personal crisis undergirded his revised understanding of the meaning of history, but it can also be understood as a reversion from the Stoic, pagan and cyclical vision of human reality that he had imbibed from his classical studies towards the providential, Christian vision of history that had been a prominent part of Toynbee's childhood training. He never became Christian in any full sense; instead he expected fresh revelation and new religious growth to develop from the Time of Troubles that he saw around him in the twentieth century. This transcendental theme of Toynbee's post-war thinking lent itself to Trevor-Roper's caricature in 1957. By making him absurd, it became possible to dismiss him from further professional consideration. That, in fact, is the opinion that now prevails among historians.

But, fourth and last: this dismissal is not justified. To be sure, I too, like Trevor-Roper, do not believe that Toynbee's mystical experiences prove the existence of a "Spiritual Reality" seeking to communicate with suffering human beings. I see nothing persuasive in Toynbee's religious speculations, and found much to deplore in his relations with the Sokka Gakkai of Japan, which were nourished by his hope that this sect might represent the sort of new religious growth the age required. But there was an earlier Toynbee—the Toynbee of the first three volumes of *A Study of History*, my Toynbee of 1940—who cannot be justly dismissed as professionally irrelevant. He was the man who first expanded the domain of history to embrace all the major branches of humankind. He was the man who first affirmed the "philosophical equivalence" of the world's leading civilizations. He first exploited scholarly literature of the day to construct an intelligible pattern of world history that was not centered on the European and Christian past.

Since I believe the evidence amply sustains the idea that other peoples of Eurasia and Africa shared in an ecumenical system from the very beginning of civilization, and that European leadership of this inter-communicating area does not antedate 1500 A.D., it seems clear to me that Toynbee's role in exploring the possibilities of a history of the world that did not center on the West deserves our admiration. Others shared the adventure: not least Spengler; and before him, Herder, Voltaire, Vico and still others. But Toynbee's mastery of historical data was far superior to Spengler's; his array of civilizations was far more inclusive; his presentation was far less cluttered by *obiter dicta*. The same was true *a fortiori* with respect to his more distant forerunners.

Toynbee was, in fact, the man who came along at the right time to harvest the fruits of the historical scholarship that had begun to explore Chinese, Japanese, Indian, Middle Eastern, American and (less adequately) also African history down to his own time; and was able to do so with a level of detachment from naive identification with any particular civilization or part of the world because he fitted so awkwardly with the people immediately around him. No one had done it so well before him. No one had previously expanded the scope of historical understanding so suddenly and so persuasively. His errors were real enough. His religious speculations were naive. But his accomplishment of historical scholarship remains one of the landmarks of this century. We should honor him for it; and I wish that readers of my book could be persuaded to agree with me, while also recognizing the wonderful, intricate way that his private shortcomings nourished intellectual greatness.

So far as I can tell, this is not what has happened. Perhaps it will require further development of world history before academics become ready to renew respect for a man whose work was in fact received with deference and admiration in the 1930s before journalistic acclaim in the 1940s inflated his reputation so greatly as to invite the rejection that has subsequently obscured his name. My book did not redress the balance. Perhaps in time to come it can contribute to doing so, but the historical profession will have to change before that can happen. I very much hope it will, since my own reputation also depends on whether world history becomes a recognized, legitimate dimension of historical scholarship. Of late the drift has been towards greater and greater specialization, with attendant methodological sophistication and a proneness towards haughty myopia, disdaining all who do not share the most recent approach—whatever it may be. I am convinced that we need a vision of the whole as well; and if that effort continues to flourish, then surely in time Toynbee will come back into his own, not as a prophet and not as a

guide to public policy, but as a bold and admirable poet and pioneer of comparative, global history.

Spring Semester 1992

14

Keynes and the United States

ROBERT SKIDELSKY

John Maynard Keynes's involvement with the United States provides an important context for understanding both his economics and the origins of the "special relationship" between the two countries. Those who take their Keynes solely from the "closed economy" model of the *General Theory of Employment, Interest, and Money* forget that the problem which exercised him for most of his professional life arose from the effect of the unbalanced creditor position of the United States on the British economy. All his economic plans were concerned with ways to overcome or to offset this imbalance. They culminated in the establishment of the Bretton Woods system in 1944, and the negotiation of the American loan in 1945, as a result of which Britain tacitly accepted a junior role in an American-managed international economic order. But there was nothing inevitable about this culmination, and for much of the period covered in this lecture Keynes actively explored alternatives.

Equally, economic theory and policy was only one influence on the evolution of the "special relationship." Even before the First World War there were some Englishmen who looked forward to a union of English-speaking peoples. Two world wars, but especially the second, forged a close political and military relationship based on wartime habits of co-operation which was extended to the idea of joint Anglo-American responsibility for maintaining "world order." But again, there was nothing inevitable about this development, and it may be doubted that Keynes ever saw the future in quite this way.

Keynes's life spans what Corelli Barnett has called "the collapse of British power." As Marcello de Cecco has put it, with some rhetorical exaggeration: "He began life as a Roman, he ended it as a mere Italian."[1] Like most Englishmen of his generation, Keynes resented and resisted the passing of British power to the United States. There was no "natural" transition from a *Pax Britannica* to a *Pax Americana*, with Britain gracefully accepting the role of "junior partner" in an American-led world. Acceptance of American

leadership was a forced choice, brought about, in Lionel Robbins' words, by Europe's failure to "solve its problems internally."[2]

Britain lost its world position to the United States because it was bled dry in two massive wars. Many Europeans understood that a continuation of Europe's "blood feud" would destroy Europe's world position. But they were never in control of policy at critical moments in Keynes's life.

To this historical experience Keynes brought three attitudes. First, there was his extreme adaptability. People often accused him of inconsistency. Over the period covered by this lecture we must not expect to find consistency of plan. What we do find is consistency of purpose. As Schumpeter wrote, "his advice was in the first instance always English advice, born of English problems."[3] He strove always for what was best for England.

Second, Keynes was a firm believer in the virtues of the *Pax Britannica* and reluctant to accept that any other country could take on Britain's world role. He was an economist and held the peculiarly Anglo-Saxon view of economics as taming or neutering the violent propensities of politics. It had been Britain's special mission to spread the gospel of mutual advantage.

Third, and somewhat inconsistently, Keynes was pro-German. This was largely a matter of background. For much of the academic class, Germany meant culture, not barbarism. To the Cambridge don, Oscar Browning, Germany "set for us standards of cultivation and learning, which most of us have spent our lives trying to realize."[4] His contemporary Henry Sidgwick found the "moral and intellectual atmosphere at Cambridge" very inferior to that of Göttingen.[5] This attitude started to change after the Franco-Prussian war, but there remained a residue of anti-French feeling going back to the Napoleonic wars, reinforced by a hatred of Tsarism. As a boy in the 1880s, Keynes had German governesses. Like Bertrand Russell he found it hard, in 1914, to stomach the thought of fighting on Russia's side.[6] The idea that a chastened Germany might be a fit partner for Britain in the governance of the world survived the war.

Keynes's attitude towards Anglo-American relations may be approached by way of four episodes which trace the decline in Britain's world power.

FINANCIAL DIPLOMACY 1914–1923

Keynes joined the British Treasury in 1915, aged thirty-two, and was soon involved in the external financing of Britain's war effort, including subsidies to Britain's allies. Throughout 1915 and 1916, the British government borrowed in the American market through its agent J. P. Morgan, sold off privately-owned assets, and shipped gold. With the depletion of its own assets, it became increasingly dependent on borrowing from the United States to

supply its allies, especially Russia, with the sinews of war. By 1916 Keynes, whose support for the war had been unenthusiastic from the start, wanted a negotiated peace as soon as possible.[7] In October 1916, over the Chancellor of the Exchequer's initials (but almost certainly drafted by Keynes) appeared the words: "If things go on as at present...the President of the American Republic will be in a position...to dictate his own terms to us."[8] This fixes the moment when financial hegemony passed across the Atlantic.

American entry into the war in April 1917 removed the hope of direct negotiations between the European belligerents. Keynes's efforts were now concentrated on getting France, Italy, and Russia to borrow direct from the United States for all their purchases, thus minimizing Britain's own indebtedness to America. Britain's procurement outside America would be paid in the dollars the European allies had obtained from the US Treasury. The Americans, naturally enough, preferred lending to Britain than to France, Italy, and Russia.[9] Keynes went to the United States for the first time in September 1917, and did not like the experience. "The only really sympathetic and original thing in America is the niggers, who are charming," he wrote back. He was not a success with the Americans either. "Rude, dogmatic, and disobliging" to them in London, he made "a terrible impression for his rudeness out here," Basil Blackett wrote from Washington.[10] Keynes's despair at the course of events is summed up in two comments he made to his friend Duncan Grant: "I pray for the most absolute financial crash (and yet I strive to prevent it—so all I do is a contradiction to all I feel)," and "I work for a government I despise for ends I think criminal."[11]

With these consequences of the war in Keynes's mind, it is not surprising that the villains of his polemic, *The Economic Consequences of the Peace*, published in 1919, should have been the war leaders Lloyd George, Clemenceau, and Woodrow Wilson. What is not so often appreciated is that *The Economic Consequences of the Peace* was basically a plea for the restoration of the *status quo ante bellum*.

Its main proposals were to cancel all inter-Ally war debts; limit Germany's liability for reparation to a modest annual sum, payable to France and Belgium; and restore Germany as the economic powerhouse of the Continent—Russia would be re-built "through the agency of German enterprise and organization."[12] He repeated all this in *A Revision of the Treaty* in 1921, writing "Germany's future now lies to the east, and in that direction her hopes and ambitions, when they revive, will certainly turn."[13]

The cancellation of inter-Ally war debts was designed to de-couple American finance from Europe. Keynes supported US loans in the aftermath of the war for pump-priming purposes: to get European industry re-started, pay for essential food imports, and stabilize currencies. But he was adamantly opposed to Europeans borrowing from the United States to service old debt rather than to create new capacity to restore Europe's competitive position.

(He opposed a large German indemnity for the same reason.) Further, Keynes endorsed America's rejection of a League of Nations committed to the territorial settlement of Versailles.[14]

Far from opposing American isolationism, Keynes wanted it to be more complete than it was. In a striking case of reverse isolationism, he refused to visit America between 1917 and 1931, despite many invitations. He made only two American friends at the Paris Peace Conference, neither of them in the official delegation: Felix Frankfurter and Walter Lippmann. They were to be important later in plugging Keynes into the American circuit, but only under the New Deal in the 1930s.[15] His most important new friend from Paris was a German, Carl Melchior, of the Hamburg firm of Max Warburg, with whom he negotiated details of the armistice agreement.[16] With the Germany of Melchior, Keynes felt that he, and Britain, could work.

Although Keynes's desire for an European solution to the problems arising from the war was shared more intermittently by Britain's two first post-war prime ministers, Lloyd George and Bonar Law, by the summer of 1922 the British government finally realized that the United States was the key to the settlement of the reparation imbroglio. But Keynes vehemently opposed Baldwin's debt settlement with the United States in January 1923, writing "Let America discover that they are just as completely at our mercy, as we are at France's and France at Germany's."[17] Once the French had occupied the Ruhr the same month, Keynes undertook an extraordinary piece of personal diplomacy. Using Carl Melchior as a conduit to the German Chancellor, Wilhelm Cuno, he visited Berlin early in June 1923 personally to draft the official German Note designed to win Germany British support in its resistance to France. It was all fruitless. No version of an European solution to the reparation problem, whether Franco-German, or Anglo-German, was possible. The Dawes Loan of 1924 brought private American money back to Europe, establishing what has been called the "phantom" hegemony of US finance which Keynes had resisted.

KEYNES AND THE GOLD STANDARD 1923–1931

Keynes's hostility to partnership with the United States is brought out even more clearly in his opposition to Britain's return to the gold standard at sterling's pre-war parity with the dollar, which brought him into conflict with the Bank of England. The Bank's governor, Montagu Norman, believed in a restored gold standard system jointly managed by the Bank of England and the Federal Reserve Bank of New York.[18] He relied on his personal friendship with Benjamin Strong, Governor of the Federal Reserve Bank of New York, to ensure a structure of interest rates which did not put too great a burden on

British industry. Norman's relationship with Strong marked the real start of the Anglo-American "special relationship" in the financial sphere, as the Washington Naval Treaty of 1922 had in the military sphere.

Keynes drew a completely different conclusion from the decline in Britain's competitive position. This was that Britain should remain free to manage its exchange rate in accordance with the needs of its domestic economy. His *Tract on Monetary Reform* (1923) marked a conceptual breakthrough by distinguishing between the requirements of external and internal balance, and suggesting there might be a conflict between the two. Keynes claimed that a restored international gold standard was bound to be a managed standard, and managed by Washington, not London. By resuming free gold exports, Britain would be surrendering control over its domestic price level and level of employment to the Federal Reserve Board in Washington, whose interests might diverge from those of the Bank of England, and which was not to be trusted as manager of the international system.[19] Keynes envisaged two main currency blocs, based on dollars and pounds, with an adjustable peg between them.[20] His insistence on monetary independence for Britain was coupled with considerable admiration for the monetary nationalism displayed by the Federal Reserve Board. "For the past two years," he wrote, "the United States has *pretended* to maintain a gold standard. *In fact* it has established a dollar standard; and, instead of ensuring that the value of the dollar shall conform to that of gold, it makes provision, at great expense, that the value of gold shall conform to that of the dollar. This is the way by which a rich country is able to combine new wisdom with old prejudice."[21] In the short-run, the Federal Reserve Board's policy of sterilizing gold gains to maintain stable domestic prices would impose deflation on the rest of the world if it returned to the gold standard. In the longer-run Keynes feared that the eventual dishoarding of America's gold stock would lead to world-wide inflation—as did eventually happen, but not till the 1960s.

Keynes attacked Britain's return to the gold standard in April 1925 at sterling's pre-war parity with the dollar on the specific ground that, by overvaluing the currency, the British authorities had compounded the difficulties of Britain's already depressed export industries. They had lowered the sterling receipts of all British exports by 10 per cent, which could be met only by lowering British money wages by 10 per cent. Overvaluing the currency logically required a deflation of wage costs. Keynes then asked what he took to be the crucial question: by what *modus operandi* does credit restriction reduce money wages?

> In no other way [he answered in 'The Economic Consequences of Mr. Churchill'] than by the deliberate intensification of unemployment. The object of credit restriction, in such a case, is to withdraw from employers the financial means to employ labour at the existing level of prices and wages. The policy

can only attain its ends by intensifying unemployment without limit, until the workers are ready to accept the necessary reduction of money wages under the pressure of hard facts...Deflation does not reduce wages "automatically." It reduces them by causing unemployment.[22]

Keynes was the first to realize and state clearly that an overvalued currency is a weak not strong currency. Out of the complex of debates surrounding the return to the gold standard, Keynes developed a new line of attack on the policy of rigidly fixed exchange rates which fed into his theoretical book, *A Treatise on Money*, published in 1930. The central object of national monetary policy, as here defined, was not to maintain stable prices, but to maintain a rate of interest consistent with full employment at a price level governed, in the long run, by the behavior of "efficiency" wages—money wages per unit of output. Such interest rate autonomy could only be guaranteed by periodic adjustments in the exchange rate. The existence of downward wage rigidity, Keynes argued, was incompatible with a "laissez-faire attitude to foreign lending." Hence he doubted whether "it is wise to have a currency system with a much wider ambit than our banking system, our tariff system and our wage system."[23] This was a pretty extreme statement of monetary nationalism, yet it was not entirely inconsistent with the idea of a more flexible international currency system.

The characteristic employment-raising projects associated with Keynes in the period 1925 to 1931—notably loan-financed public works and import controls—are worked out within the constraints of the restored international gold standard system—in other words, a system in which British interest rates were set by New York at a level too high to allow a satisfactory volume of domestic output and employment. The collapse of this system in 1931, in the depth of the world depression, opened up a new phase in Keynes's approach to Anglo-American relations.

"LET FINANCE BE PRIMARILY NATIONAL": 1931–1939

Keynes's immediate response to the disintegration of the gold standard in 1931 was characteristic: "At one stroke Britain has resumed the financial hegemony of the world," he announced, "chuckling like a boy who has just exploded a firework under someone he doesn't like."[24] The spontaneous emergence of a sterling bloc suggested to him a "reputable sterling system for the Empire...managed by the Bank of England and pivoted on London."[25] He applauded the Bank of England's nationalistic policy of sterilizing gold inflows to keep the pound undervalued against the dollar and franc which remained on the gold standard—just as he had praised the same policy pursued by the Federal Reserve Board in the 1920s.

This euphoria did not last. Roosevelt's devaluation of the dollar in terms of gold on 19 April 1933 eliminated Britain's short-lived competitive advantage. Keynes now suggested that Britain and the United States might link their currencies together in a modified gold standard so long as they pursued reflationary policies in tandem. Nevertheless, he proclaimed "President Roosevelt is Magnificently Right" on 4 July 1933, when Roosevelt scuppered the World Economic Conference by denouncing all plans to stabilize currencies as "the fetishes of so-called international bankers." Each country, Keynes had proclaimed in Dublin a few weeks earlier, must be free to pursue its own fancy, work out its own salvation. A greater degree of economic self-sufficiency would help the cause of peace. "Let goods be homespun whenever it is reasonably and conveniently possible; and, above all, let finance be primarily national."[26]

The way to make sense of these twists and turns is to remember that Keynes was offering advice he thought suited Britain best. The pound and dollar, he thought, might be safely linked if Britain and America expanded together, if capital exports were controlled, and if wage movements were broadly similar; otherwise they should be left free to fluctuate against each other.[27]

Keynes's attitude towards the United States softened in the 1930s. He visited it twice, in 1931 and 1934. On the second, and much more important visit, he went to study the New Deal, saw Roosevelt, and explained his new theory of effective demand in Washington and New York. Frankfurter had fixed up the appointments in Washington, and Keynes was greatly impressed. "Here, not in Moscow, is the economic laboratory of the world," he wrote Frankfurter on 30 May 1934. "The young men who are running it are splendid. I am astonished at their competence, intelligence and wisdom. One meets a classical economist here and there who ought to have been thrown out of [the] window—but they mostly have been."[28] The commitment of the Administration, and of the younger section of the economics profession, to a policy of economic expansion was to be crucial in winning Keynes over to the idea that an American-led world economic system might not be as damaging to Britain's interests as he had feared.

There is a paradox here, for Hitler's New Deal was much more successful than Roosevelt's in getting rid of unemployment. But except for a guarded reference to the advantages of totalitarianism in planning output as a whole, in the German preface to his *General Theory*, Keynes made no public comment on the Nazi economic system, either laudatory or critical. However, he freely condemned Nazism as a barbaric political system, and took to calling Germany and Italy "brigand powers." The main reason for Keynes's lack of approbation of Nazi economics was his detestation of the regime. But a subsidiary factor was that, unlike in the United States, there was no body of professional economists, in Germany or anywhere else in Europe outside Sweden, with whom he could seriously engage.[29]

"LEARNING TO WORK TOGETHER": 1940–1945

The United States was not at first involved in the European and Asian wars, and *all* the belligerents' plans for a post-war economic order left out the United States. Initially, these were based on the reasoning of the 1930s, when Britain, Germany, and Japan had tried to form economic blocs which discriminated against the United States, since none of them felt they could live with America's unbalanced competitive power. The United States, by contrast, had become increasingly internationalist. Once involved in the war, its major war aim was to dismantle the neo-mercantilist blocs established by the other belligerents. (These hopes extended, more vaguely, to the even more autarkic system established by the USSR). The defeat of Germany and Japan would automatically eliminate their systems; but the United States could also exert powerful pressure on its dependent ally, Britain.

The first post-war plan was produced by Germany. Dr. Walther Funk, Hitler's Economics Minister, proclaimed a European "New Order" in Paris on 25 July 1940. This called for a European economic bloc with fixed exchange rates and a central clearing union in Berlin. Relations with the United States would be on a barter basis. The purpose of the plan was to restore within Europe what Funk called "an intelligent division of labor," while shielding Europe as a whole from the deflationary consequences of an international gold standard.[30]

Keynes, once more at the British Treasury, saw much virtue in the Funk proposals. He wrote to Harold Nicolson on 20 November 1940: "If Funk's plan is taken at its face value, it is excellent and just what we ourselves ought to be doing. If it is to be attacked, the way to do it would be to cast doubt and suspicion on its *bona fides.*"[31] Even more striking was Keynes's formal response to the German plan on 1 December: "It is not our purpose to reverse the roles proposed by Germany for herself and for her neighbors...Germany must be expected and allowed to assume the measure of economic leadership which flows naturally from her own qualifications and her geographical position. Germany is the worst master the world has yet known. But, on terms of equality, she can be an efficient colleague."[32] On 25 April 1941, Keynes envisaged a sterling system enlarged to include some European countries, free to discriminate against American goods if the United States "persisted in maintaining an unbalanced creditor position."[33]

He received a rude jolt when on 28 July 1941, the day before he left Washington on the first of his wartime visits to the United States, he was handed a State Department draft which pledged Britain to avoid "discrimination against the importation" of American goods in return for Lend-Lease—a scheme for supplying Britain with goods which Roosevelt had announced the previous December. Britain had no alternative but to meet American wishes. By 8 September Keynes had drafted a new plan for

an International Currency Union which included the United States. The essential feature of the plan was that creditor countries would not be allowed to "hoard" their surpluses, or charge punitive rates of interest for lending them out; rather they would be automatically available as cheap overdraft facilities through the mechanism of an international clearing bank whose depositors were the central banks of the union. However, he was still prepared to fall back on the alternative of a British-led currency bloc, maintained by "Schachtian devices" if the United States refused to play.[34]

American requirements were spelt out explicitly once the United States entered the war in December 1941. The United States insisted that, in return for aid, Britain should pledge itself, after the war, to abandon trade discrimination. This pledge was incorporated into Article VII of the Lend-Lease Agreement signed on 23 February 1942. Earlier Keynes had denounced "Mr. Hull's lunatic proposals." Now he realized that the economic bloc alternative was a non-starter. America would not finance the British war effort to allow Britain to emerge as head of a "Schachtian" system which discriminated against American exports. Keynes had to apply himself to the intellectual problem of how to fit the British demand for freedom to pursue full employment policies into an American free-trade framework. There was, of course, an alternative, suggested by the First World War, when Keynes had urged that Britain should fight the kind of war which minimized its dependence on American largesse. This would have entailed, as it did in the previous war, renunciation of victory over Germany as a British war aim. But there is no evidence that Keynes thought along such lines. He now accepted that the post-war world would be shaped by American power, as modified by American idealism and British brains. Keynes would also have been less than Keynes, and less of an economist and liberal, had he not been seized by the possibility of using a unique historical moment to recreate an improved version of the liberal economic order which had collapsed in the First World War. For someone of Keynes's theological and cultural background, the chance to play God was bound to be more attractive than supping with the Devil. Keynes also understood a moral and geopolitical fact. Assuming the defeat of Germany, the choice after the war would be between what he called "the American and Russian bias"—that is, between world capitalism and autarkic socialism, with not much in between. "Is there not much to be said," he wrote, "for having a good try with the American bias first?"[35]

There is no space to trace the stages of the Anglo-American negotiations leading up to the signing of the Bretton Woods Agreement on 22 July 1944. As is well-known, Keynes's concept of a currency union based on a central bank providing automatic overdraft facilities to debtors was defeated by Harry Dexter White's plan for a modified gold standard, to which was attached an adjustment facility in the shape of a Stabilization Fund on which subscribing

members could draw up to the amount of their subscriptions; a scheme which by strictly limiting United States liability, upheld, in qualified form, the orthodox doctrine of debtor adjustment. What needs to be emphasized is that British and American conflicts on such matters as exchange rate management, access to reserves, tariff policy, and responsibility for adjustment reflected national interests, as filtered through the experiences of the inter-war years and expectations of the future. Britain's negotiating achievements were limited to obtaining safeguards, postponements, and derogations within the framework of the American plan. As in subsequent negotiations with the European Community the British were reduced to the position of modifying blueprints drawn up by others.

According to James Meade and Lionel Robbins, members of the British negotiating team who kept diaries, Keynes's performances at the two Washington conferences of September-October 1943 and July-August 1944 were mixtures of extraordinary eloquence, verbal as well as intellectual, and extraordinary rudeness to and about the Americans. After one negotiating session, Harry Dexter White told Robbins, "Your Baron Keynes sure pees perfume." Robbins wrote, after another, how "The Americans sat entranced as the God-like visitor sang and the golden light played around."[36] On the other hand, Meade reported Carl Bernstein of the US Treasury "smarting from Keynes's ill-manners." (Keynes had said of one of Bernstein's drafts: "This is intolerable. It is yet another Talmud.")[37] Keynes's bad manners as a negotiator no doubt reflected exhaustion and failing health, but also his frustration at Britain's impotence. This mingled sense of idealism and consciousness that America ultimately called the tune was true of all the British negotiators. "A mixture of American 'imperialism,' Anglo-American alliance, United Nations organization and full blooded Wilsonian idealist universalism is probably the best for which one can hope," wrote James Meade.[38] "In the world of the future we shall have to live more by our wits," noted Lionel Robbins.[39] The trouble was that wits, too, had to be muted, in deference to the American fear of being made suckers "especially by the diabolically clever Lord Keynes."[40]

In the House of Lords on 23 May 1944, Keynes commended the agreed Anglo-American plan in terms both of idealism and necessity. "What alternative is open to us...?" Unlike in the First World War, he now took pride in the fact that "in thus waging the war without counting the ultimate cost we—and we alone of the United Nations—have burdened ourselves with a weight of deferred indebtedness to other countries beneath which we shall stagger." Specifically, without the new framework afforded by the Anglo-American agreement, "London must necessarily lose its international position, and the arrangements...of the sterling area would fall to pieces. To suppose that a system of bilateral and barter agreements, with no one who owns sterling knowing just what he can do with it...is the best way of

encouraging the Dominions to center their financial systems on London, seems to me pretty near frenzy." The "technique of little Englandism" was incompatible with England's imperial heritage. "With our own resources so greatly impaired and encumbered, it is only if sterling is firmly placed in an international setting that the necessary confidence in it can be sustained."[41] To place American power and money, on terms, behind Britain's "impaired and encumbered" system of earning its living was thus the ultimate object of the "special relationship" which the war had made necessary.

This brings me to the Anglo-American loan negotiations of September-December 1945. The defeat of Keynes's Clearing Union plan had highlighted the problem of financing Britain's current account deficit after the war, which Keynes eventually estimated at nearly seven billion dollars over the three years 1946–48.[42] The problem became immediate with the cancellation of Lend-Lease on 17 August 1945. That the Clearing Union proposal had been explicitly designed to make American help unnecessary is clear from Keynes's draft of 15 December 1941: "It would...be a mistake to invite, of our own motion, direct financial assistance after the war from the United States to ourselves, whether as a gift or as a loan without interest. The assistance for which we can hope must be *indirect* and a consequence of setting the world as a whole on its feet and of laying the foundations of a sounder political economy between all nations."[43]

Under the Keynes plan, "overdrafts" from the Clearing Bank would have been made automatically available to plug Britain's post-war "dollar gap." But Britain's quota from the International Monetary Fund, amounting to just over one billion dollars, was far too small to tide over such a transition. Curiously, neither Keynes nor apparently anyone else thought of devaluation. Like all British officials he probably thought the priority was to preserve the sterling area, to which Britain owed fourteen billion dollars. Ironically, the man who had so strongly advocated devaluation in 1923, now regarded the sterling-dollar parity—fixed at $4.03 during the war—as sacrosanct. Instead he tried to frighten Lord Beaverbrook, who objected to American assistance, with false horrors:

> Do you really favour a barter system of trade which would mean, in practice, something very near a state monopoly of imports and exports à la Russe? Do you welcome an indefinite continuance of strict controls and (probably) severer rationing? Do you look forward to our stepping down, for the time being, to the position of a second-class power...?[44]

Keynes hoped that assistance from the United States would take the form of a grant, not a loan. Dalton recorded that "Keynes in his talks with Ministers just before leaving for Washington, was almost starry-eyed. He was very confident that...he could get six billion dollars as a free gift....Nor did he...say

much to us about the 'strings.'"[45] The details of these incredibly sticky negotiations are well known: how the six billion dollar "free gift" was whittled down to a loan of 3.7 billion dollars at 2 per cent interest, with the "string" that sterling be made convertible a year after the agreement was ratified; how Keynes drove the Labour government, step by step, to accept progressively less favorable conditions; how Keynes's health collapsed; how he so annoyed the Americans that he virtually had to be replaced as joint head of the British delegation. Keynes's eloquent defence of his handiwork in the House of Lords on 18 December 1945, twelve days after the loan agreement was signed, summed up the logic of events as they had unfolded since 1914. There was first the argument from necessity. The alternative to the loan agreement, he said, "is to build up a separate economic bloc which excludes Canada and consists of countries to which we already owe more than we can pay, on the basis of their agreeing to lend us money they have not got and buy only from us and one another goods we are unable to supply."[46] Secondly, there was the appeal of a shared, reconstituted liberalism:

> The separate economic blocs and all the friction and loss of friendship they must bring with them are expedients to which one may be driven in a hostile world....But it is surely crazy to prefer that. Above all, this determination to make trade truly international and to avoid the establishment of economic blocs which limit and restrict commercial intercourse outside them, is plainly an essential condition of the world's best hope, an Anglo-American understanding....Some of us, in the tasks of war and more lately in those of peace, have learnt by experience that our two countries can work together. Yet it would be only too easy for us to walk apart. I beg those who look askance at these plans to ponder deeply and responsibly where it is they think they want to go.[47]

CONCLUSION

The familiar context of Keynesian economics is the Great Depression of the 1930s—the collapse of the world economy. But a more persistent context was the unbalanced creditor position of the United States. For the first ten years after the First World War, the United States boomed, while Britain slumped. Keynes saw British unemployment as a problem of sterling's overvaluation against the dollar. From this point of view, his *General Theory* is an addendum to, rather than the culmination of, his line of thought—the theory of a deep world slump when no amount of monetary manipulation can restore full employment.

Following the collapse of the gold standard in 1931, the world economy broke up into trading blocs based on "key" currencies. It was as manager of

an imperial payments system known as the Sterling Area that Britain went to war with Germany in 1939.

Keynes's hope of an Anglo-German response to the American challenge had long since faded; but it took the Second World War to put paid to his hope of a British-controlled payments system as the monetary framework for the British economy. Much shared idealism and responsibility went into the making of the Bretton Woods system. Nevertheless it was the end of British monetary independence. The sterling system could not survive unless it was bolstered by the dollar. Keynes's lifetime spans the passage from control to dependence.

What was the fate of the "special relationship"? The political-military partnership has proved more durable than the financial one. Sterling's role as a key currency was doomed by the decline of the British economy, and finally killed off by the funding of the sterling balances in 1976. The collapse of the Bretton Woods system followed three years later. The European Community which was the eventual response to the American challenge was based not on the Anglo-German partnership which Keynes had sought in the early 1920s, but on a Franco-German axis. When sterling finally joined the European Exchange Rate Mechanism in October 1990, it did so at an unsustainable rate against the deutschmark—the British government ignoring Keynes's warnings of 1925 against overvaluing the pound. All Keynes's grand designs unravelled under a burden of choice too great for a declining world power whom economic success eluded.

Perhaps this does, after all, bring us back to Keynes the economic theorist. In his *Treatise on Money* Keynes noticed the tendency of British savings to flow into the "financial" rather than into the "industrial" circulation; but in the *General Theory* he anaesthetized this structural insight by calling it "liquidity preference" and treating it as an ahistorical response to "uncertainty," to be cured by maintaining a low rate of interest. What was in essence a supply-side problem for the British economy—the failure of London's financial institutions to channel savings into home investment— was partly misdiagnosed as a problem of demand. Post-war "Keynesian" British governments assumed that the supply-side problems of the British economy would yield to the stimulus of continual monetary expansion. As a result, they were never effectively tackled. This failure left Britain too weak economically to inhabit the international structures that Keynes designed to house it. The weakness persists to this day.

Fall Semester 1992

NOTES

References to Keynes's writings are to the editions in *The Collected Writings of John Maynard Keynes* (CW), vols. 1-30, D. Moggridge and E. Johnson (eds.) (London 1971-1981), followed by the volume. Keynes is JMK.

1. In Robert Skidelsky (ed.), *The End of the Keynesian Era* (London, 1977), p. 24.

2. Susan Howson and Donald Moggridge (eds.), *The Wartime Diaries of Lionel Robbins and James Meade 1943-45* (London, 1990), p. 182.

3. J. A. Schumpeter, *Ten Great Economists* (London, 1952), p. 274.

4. Oscar Browning, *Memoirs of Sixty Years at Eton* (London, 1910), p. 105.

5. Arthur Sidgwick, *Henry Sidgwick: A Memoir* (London, 1906), p. 122. See also pp. 94, 116.

6. Robert Skidelsky, *John Maynard Keynes*, vol. 1, *Hopes Betrayed 1883-1920* (London, 1992), p. 296.

7. Ibid., pp. 305-15.

8. Ibid., p. 334.

9. Ibid., pp. 344-45. Between 1914 and 1918, the United States lent £842m. to Britain, £550m. to France, £325m. to Italy, and £38m. to Russia. Britain lent £508m. to France, £467m. to Italy, and £568m. to Russia. France lent £160m. to Russia, and £90m. to Belgium. Keynes, *Economic Consequences of the Peace*; CW, 2, p. 172.

10. Skidelsky, *Keynes: Hopes Betrayed*, p. 342.

11. Ibid., p. 345.

12. CW, 2, pp. 170-87.

13. CW, 3, p. 128.

14. JMK to Paul D. Cravath, 27 November 1920, CW, 17, p. 203.

15. Skidelsky, *Keynes: Hopes Betrayed*, pp. 359-60.

16. CW, 10, p. 415.

17. JMK to J. C. C. Davidson, 30 January 1923, CW, 18, p. 103.

18. Andrew Boyle, *Montagu Norman* (London, 1967), p. 160.

19. CW, 4, p. 121.

20. Ibid., pp. 158-59.

21. Ibid., p 155.

22. CW, 9, pp. 218-19.

23. CW, 6, p. 299.

24. C. H. Rolph, *Kingsley: The Life, Letters, and Diaries of Kingsley Martin* (London, 1973), p. 203.

25. JMK Memorandum to F. Leith-Ross, 16 November 1931, CW, 21, p. 17.

26. CW, 21, p. 236.

27. JMK to Willy Luck, 13 October 1936, Keynes Papers, King's College, Cambridge, L/36.

28. Felix Frankfurter Papers, Library of Congress, Reel 66.

29. W. Carr, "Keynes and the Treaty of Versailles," in A. P. Thirlwall (ed.), *Keynes as a Policy Adviser* (London, 1982), pp. 103-06.

30. Armand van Dormael, *Bretton Woods: The Birth of a Monetary System* (London, 1978), pp. 6-7.

31. CW, 25, p. 2.

32. Ibid., p. 11.

33. Ibid., pp. 17-18.

34. Ibid., pp. 21-40.

35. JMK to H. D. Henderson, 9 May 1942, ibid., p. 156.

36. Howson and Moggridge, *Wartime Diaries*, pp. 106, 159.

37. Ibid., pp. 133, 142.

38. Ibid., p. 107.

39. Ibid., p. 58.

40. Ibid., p. 159.

41. CW, 26, pp. 9-21.

42. Memorandum, "The Present Overseas Financial Position of the U.K.," 13 August 1945, CW, 24, p. 404.

43. CW, 25, pp. 69-70.

44. JMK to Lord Beaverbrook, 27 April 1945, CW, 24, p. 330.

45. H. Dalton, *High Tide and After* (London, 1960), pp. 73-74.

46. CW, 24, p. 620.

47. Ibid., p. 624.

F. R. Leavis and the "Anthropologico-Literary" Group: We Were That Cambridge

IAN MacKILLOP

Fifteen years after his death F. R. Leavis (1895–1978) continues to distress and agitate, symbolizing all kinds of things he would never have recognized. In this lecture I would like to begin from one of his most dynamic attacks on received opinion. In 1962, at the end of his official career at Cambridge, he lectured on the Two Cultures orthodoxy and its proponent, Sir Charles Snow. His basic concern was reported by *Time* magazine (such was his notoriety) as "the tendency of technology to suffocate the humanities." It was indeed, and the lecture remains a classic call to arms against the ills of social planning by numbers. In the course of it, Leavis made one remark, seemingly outrageous and not central to his argument, to which I would like to give some attention. I believe that if its implications are unpacked it will help us to understand better the great literary critic. The remark was a reminiscence, of himself, his pupils and his peers in Cambridge of the 1930s. He said: "We were, and knew we were, Cambridge—the essential Cambridge in spite of Cambridge."

This is a grand claim, not only that the Leavisians were at the leading edge of English studies in Cambridge, but that they were Cambridge itself, the "real" Cambridge. A daring pupil once taxed Leavis in person: did he mean his group was more important than that of Ernest Rutherford? (The neutron was, after all, discovered in 1932.) Leavis replied, with a show of modest mischief, that he was employing "tactical hyperbole."

I want to explain Leavis's hyperbole, or go some way towards an explanation by trying to recapture the world of the 1930s to which Leavis referred. I will give a brief account of the "we" who were "Cambridge." (I should hasten to add that "we" does not include myself: I was a pupil of Leavis, but in the 1950s.) Then I shall argue that this group enacted some specifically *Cambridge* principles, principles of the celebrated school of

English, expressed institutionally in its curriculum and its examinations, the English Tripos. I hope to convince you that in the 1930s the English Tripos wrote the play and the Leavis group, or "we," performed it.

In the Harry Ransom Humanities Research Center at the University of Texas, there is a collection of nearly one hundred letters from Leavis to Ronald Bottrall, the poet, critic and educational administrator. Bottrall spent his life in foreign postings, mainly for the British Council. Leavis wrote to him in detail about his verse. One of these letters (December 11th, 1931) gives a snapshot that is very far from faded of the Leavis group. Bottrall was at Princeton in 1931 and Leavis reported on Cambridge doings to him, beginning with a reference to I. A. Richards, who had been in the United States:

> Lecturing in America has by all accounts been very bad for him. Girton finds his reading of poetry intolerably emotional, and he has given a good deal of offence by his gross contempt for his audience. But I haven't heard him. I did, however, hear him when he came to our house to address the inaugural meeting of the English Research Society. This has been formed by [L. C.] Knights and half-a-dozen exceptionally intelligent people who are researching here now. The ideal is to get the advantages of organization—exchange, discussion, stimulus, etc.—without the institutional disadvantages: in short, as far as possible to make up for the dearth of intelligent and qualified supervision. Well, Richards offered eagerly to address the first meeting, turned up with his wife and another feminine admirer, and dismissed with an amused superiority that was often close to a snigger every possibility of profitable research in English. It was impossible for me to say anything without endorsing the implication that it was all my little stunt. I think he was partly annoyed at the number of researchers whom I had helped with the formation of subjects and sent round to him in order that he might give them a pass to get by Mr. Potts and the Board. He was also partly getting his own back on my wife. She was viva'd by him and E. M. Forster a month ago, and after Forster had gone she had a violent passage of arms with I. A. Richards. She's apt to be terribly drastic, and she exhibited a complete furious contempt.

The graduate students met in Leavis's old family home, built for his father in Chesterton Hall Crescent. A little earlier, in 1929, at the age of thirty-four, Leavis had married Queenie Dorothy Roth, a Girton student. F. R. and Q. D. Leavis set up home in a small terrace house which they cheerfully called "The Criticastery." After the death of his mother, Leavis could not find a buyer for the family home, so the couple moved back into it, though they were ill able to afford removal expenses. In December 1931 Leavis was near the end of a probationary lectureship. It was non-renewable, though recent probationers had been upgraded to lectureships. Q. D. Leavis fortunately held a prestigious scholarship at Girton. Cambridge relied on untenured academics, who did much of the college teaching of individuals ("supervisions"). Some were purely free-lance, sometimes with *ad hoc* college positions. Such teachers were allowed to give lectures and on occasion act as

university examiners, and set and marked college scholarship examinations. Leavis did so for Girton and Newnham Colleges, and was soon to do so for Downing College. He had been in this position since he took his doctorate in January 1925.

You may have noticed that Leavis twice uses the word "intelligent" in the extract from his letter to Bottrall. A very Cambridge word it was. "Are you an *intelligent*?" was an awed or scornful question, depending on the company. The members of the exclusive Girton society ODTAA ("One Damn Thing After Another") were notorious for being "intelligents," and Q. D. Leavis was one of the most spirited. Leavis remarks on her taking issue with her Ph.D examiner, Richards, at her viva. It is not unusual for graduate students to be exasperated by their faculty. That there was a general cause for disquiet in 1931 is shown by the fact that Q. D. Leavis was successively supervised by Richards, by Mansfield Forbes and by G. H. W. or "Dadie" Rylands, for a subject not obviously connected with their interests. Cambridge English was ill-equipped for dealing with literature in its relations to society. Q. D. Leavis's thesis was sub-titled "A Study in Social Anthropology," and its theme intimately connected with the meeting at Chesterton Hall Crescent. In February 1932 Leavis told Ian Parsons at Chatto and Windus, who had accepted *New Bearings in English Poetry* for publication, about the graduate group and characterized what they had in common by saying they were doing work of an "anthropologico-literary kind." This is exactly what Q. D. Leavis did and what it was hard to find supervision for. If there is one thing to remember about the early aims of Leavis and his group it is, perhaps, this phrase. For *anthropologico-literary* study, a mode of sociology, was its prime aim. These "anthropologico-literary" young men gave Richards a hard time at Chesterton Hall Crescent. He

for once, at least, despised his audience too much. To deal with him on the spot was morally impossible, so half-a-dozen stalwarts drew up a reply. It's as devastating a document as I've seen. "Your main contribution seems to us not worth arguing about," etc. He had dismissed most intelligent kinds of research (my wife's in particular by implication) as involving "axes to grind." "Is that not merely a way of raising prejudice? Would you, or would you not, say there were no axes to grind in *The Principles of L. C.*, *Science and Poetry*, *Practical Criticism*?" But the most drastic effects depend upon close reference to what he had said. The society suggested ironically that he had of course been playing Devil's Advocate, and had meant to provoke this response. On receiving the document, he agreed that of course he had. And he has since been lavish in encouragement.

I think the research idea may come to something: the present group are good enough to set up a momentum. My present difficulty is to stop I. A. Richards helpfully initiating official changes—machinery—abolition of Ph.D ["researching" is deleted] etc. I'm sure the best thing to do is to make the best of the present conditions—in short, to establish a good tradition.

"Abolition of Ph.D" Can this be right? How could the abolition of a doctoral degree *favor* a research group? We cannot tell precisely what Richards meant, but the Ph.D was vulnerable. A recent invention, it was considered, in the humanities at any rate, to be somewhat vulgar. We must remember to distinguish the Ph.D from the D. Litt. The Ph.D was awarded after the successful submission of a thesis (as to Leavis) and the D. Litt after submission of a collection of published works (as to Richards). The Ph.D was devised after the First World War to help foreigners who wanted a substitute for the German doctorate and to take something better than a B.A. for the research that Cambridge offered. The degree was devised partly after Foreign Office pressure, and the campaigning of such a great visiting scholar as Ernest Rutherford. It was, therefore, an upstart degree. Leavis's own doctoral thesis on "The Relationship of Journalism to Literature, Studied in the Rise and Earlier Development of the Press in England" was perhaps the founding "anthropologico-literary" subject; dated 20th November 1924, it was only the 66th thesis for the Ph.D. In the humanities the usual route to the glittering prizes was still by college fellowship, prize essay or fellowship dissertation. It should be recalled that much was made of Leavis's "Dr" in his lifetime: it was used to enhance his supposedly "cold" or "scientific" approach to letters. On the same day that he wrote to Bottrall, he also asked Chatto and Windus to omit "Ph.D" on the title page of *New Bearings in English Poetry*: "It would raise the worst suspicions, and, anyway, looks comic." Nonetheless, in 1931 a Ph.D he was, and soon Q. D. Leavis would be one, too. That such a nicety of nomenclature was mentioned at all shows that Richards was dealing with a group of *modern* graduate students. Leavis was senior to them in years and experience, but he was in a similar category: the modernity of his degree could be allowed to place him socially as slightly "common," rather like the irritating Hooper in Waugh's *Brideshead Revisited*. He was a lecturer and supervisor, and soon to be an author; he was a mentor to graduate students. But in his insecure position he was not definitively out of the graduate milieu. He was not to leave it for some years, so that a curious anomaly arose when he was finally elected to a fellowship at Downing College. He became a permanent Fellow at the same time that one of his pupils was elected to a Research Fellowship, a young man whom he had seen through the years from scholarship examination to graduation. Leavis was formally "admitted" as Fellow one day ahead of R. G. Cox, "in order," he wrote to Cox, "to get ahead of you, so that you may be Junior Fellow and spare my having to hand the coffee round." At the 1931 meeting Leavis was insider-outsider. No wonder he later admired Conrad's wonderful story of conspiracy, *The Secret-Sharer*.

In the letter to Bottrall, Leavis next says what the 1931 secret-sharers sought:

Two or three intelligent well-wishers in the Faculty; but I. A. Richards would be enough, if he would. The present group will, I believe, produce several good books; Chatto's are bringing out my wife's "Fiction and the Reading Public" in the Spring. I've a man doing "The economic history of Eng. Lit. since Scott," a Ceylon Dutchman (English-speaking, of course) investigating "Engl. Lit. in Ceylon," starting in the educational field and going as much into the "conflict of cultures" as he can and dares; and a New Zealander asking why there's no distinctive literature in New Zealand (a type-case of the Anglo-Saxon world).

In the 1960s Leavis would write sardonically of research-factories, but in 1931, at his house in Chesterton Hall Crescent, he had about him the makings of a research school, though not one in "Eng. Lit." What Leavis proudly called "the pioneer performance" was his wife's *Fiction and the Reading Public* (1931), one of the first analyses of British popular culture. It was praised highly by T. S. Eliot, criticized drily and authoritatively by Michael Sadleir, the leading expert on Victorian popular fiction, and even teased in *Punch*. One project not specified in the letter is L. C. Knights's work on education, language and society in Jacobean England, to come out in *Drama and Society in the Age of Jonson* (1937). Another highly esteemed project from the group was that of the New Zealander, Eric H. McCormick, who discarded a study of *A Mirror for Magistrates* in order to make a pioneer cultural study on New Zealand, under the encouragement of Leavis. His work still continues in his present, productive old age. Besides books and theses, the "English Research Society" had other plans:

The same group, with others (notably an affiliated Princeton man, [Donald] Culver) are talking of starting a review on "Symposium" lines ("only better"). It would aim to do the criticism that is not done in the commercial press, and to focus a "minority" scrutiny upon contemporary civilization.

The group wanted a journal. The writings of D. H. Lawrence inspired McCormick with a plan for one called *The Phoenix*, but Leavis was not keen. The idea that commanded most attention was that of the Princeton man, Donald Culver, who reported on the New Haven journal, *The Symposium*, which started in January 1930 and published Richards, G. Wilson Knight, J. Middleton Murry and Lionel Trilling. When Q. D. Leavis's *Fiction and the Reading Public* came out, *The Symposium* gave it a magisterial review by F. Cudworth Flint, which symbolized why the young men wanted a new quarterly. Where was there the space for such consideration in Britain? (Was there to be any review of D. H Lawrence's letters in a British journal as dispassionate as that of William Troy's in *The Symposium* of January 1933?) In Britain there seemed to be no journal as serious as *The Symposium*, or *The New Republic*.

Two months later a journal called *Scrutiny* was being put together. Leavis told Ian Parsons at Chatto and Windus that it would be "no *Experiment* or *Hound and Horn*," meaning, one suspects, that he hoped it might be ("or better"), because they had no British counterparts. There were some models nearer home, notably *The Calendar of Modern Letters*, from which a collection called *Scrutinies* was published. An earlier model was visible in the cover design of *Scrutiny*, a homage by a jobbing Cambridge printer to the pre-war *English Review* under Ford Madox Ford. Leavis probably also had in mind the French *Commerce*, in which he read the first sections of *Ash-Wednesday*. Leavis told Parsons that he thought the new journal "may have considerable success," and it did. By the beginning of May 1932 *Scrutiny* was out, with a hundred copies sold in the first week and subscriptions coming in from T. S. Eliot, George Santayana, R. H. Tawney and Aldous Huxley. Its success was partly due to its being one prong in a multiple movement, as Leavis predicted to Bottrall:

> Not only is the group here, but I have a number of suitably intelligent ex-pupils scattered about the world who could be drawn on, and who would be glad of an opportunity to keep the lines of communication open. Research—the Minority Press—the review in co-operation have a chance of establishing a momentum.

Leavis also dominated the small publishing outfit, the Minority Press, run by the twenty-year-old Gordon Fraser, a former supervision pupil at St John's College. When Fraser was engaged to be married in 1936, his father, unwilling for him to live on a don's salary, put up the money for the design and building of a bookshop, in modern movement style, in Portugal Place, across the road from St John's. It was fully in tune with what Leavis called the *Scrutiny* "movement."

Before December 1931 Leavis had established himself as a leader, but the letter to Bottrall shows a new stage in the organization—a group around him. There is much more to say of the members of the group, but I shall now turn to Leavis's claim that it was "really" Cambridge. Its members, like many outlaws—Leavis called them that—were being true, in a literal manner, to principles already established, but not explicitly adopted.

These principles were enshrined in the Cambridge English school. As I shall argue that these principles were not only matters of opinion, but of institution, built into the very regulations themselves, it is necessary to know something of the Cambridge examination system and its curious terminology, notably the word "tripos," which has (predictably) little to do with "three." A tripos is a collection of examinations under a broad subject heading. The collection is divided into two groups of examinations, Part One and Part Two. For the Cambridge B.A. it is necessary to take two of these parts, either

in the same or different triposes. Roughly speaking, Part One is taken after two years of study and Part Two after one year. Usually the first part is a survey and the second part more specialized. To the English Tripos we may now turn.

There is a commonplace comparison between Oxford English and Cambridge English. One is said to be scholarly and historical and the other critical and evaluative. Oxford is supposed to have remained archaic, requiring philology; Cambridge had the reputation for being modern, with optional philology. Oxford changed slowly; Cambridge declared its modernity in English studies in 1926, when "Early Literature and History" moved from the ambit of English into that of archaeology and anthropology, at the same time as the establishment of an English Faculty, following the recommendations of a Royal Commission that Cambridge should organize itself by faculties.

However, the removal of "Early Literature and History" from the English course was not an index of the modernity of Cambridge English. It had plenty of other claims to modernity, and actually "Early Literature and History," sometimes just called "Anglo-Saxon," was, we shall see, favored by such modernist spirits as Leavis. The modernism of Cambridge English did not begin with the secession of Anglo-Saxon. It had been a force for nearly a decade: it was this force, that of the *original* Cambridge English, that informed the thinking of the *Scrutiny* group. Leavis made this point in 1975 when he stated forcibly that the English Tripos was not a growth of the mid-1920s:

> As I explained in the introduction to my printed Clark Lectures [1967], the strength of Cambridge English and the possibility of *Scrutiny* were vitally related to the fact that the tripos started ten years earlier [than 1927], during the war, when Mansfield Forbes, a disinterested courageous and robustly intelligent man found himself left in Cambridge to run it alone.

The conception of a Cambridge English course for a modern, post-war age was fashioned in 1916, with its first examinations, the English Tripos, set in 1919. Before 1919, students could take an examination in English literature, but it was included among those set for the Modern and Mediaeval Languages tripos. After 1919, a whole degree could be taken in English. English had a Tripos to itself, in two parts, (a) "English Literature: Modern and Mediaeval," and (b) "Early Literature and History." These parts could be taken separately, *à la carte*, with a part from another tripos. This is what Leavis himself did from 1919, when he returned from the Armistice in France to the university, which was also his home town. Before going to the war he had begun one part of the History tripos. In January 1919 he plunged back into History for four months and took the examinations. Then in October 1919, after the long vacation, he began reading English, taking his finals in May 1921.

Leavis drank down draughts of the original Cambridge English; it fortified his thinking for many years. People are lightly called a product of this or that and one must be wary of finding determinants for so independent a figure as Leavis. But it is near the truth to say that ideologically he *was* Cambridge English.

Leavis's practice as critic and teacher can be, though too brusquely, summarized in six factors. First, there is *contemporaneity*: he made the most recent writing part of criticism, and conducted criticism for the sake of innovation on the creative front. In 1929 Leavis often mentioned William Empson's poetry in his lectures; it was very unusual for an undergraduate poet to figure in a university lecture course. In the summer of 1931, while working on *New Bearings in English Poetry*, Leavis wrote despairingly to Bottrall, wondering about the sufficiency of his own criteria, which in the end seemed to come down to no more than what would help a young poet.

> I'm feeling very depressed about the whole undertaking; an hour's work at it suffices to convince me of my hopeless stupidity (this is an understatement). And who am I to pronounce that X rather than Y is qualified to influence young poets? (That's what, to my discomfort, my criterion insists on looking like.) But I shall grind on.

Next, there is *specificity*, not merely the close verbal reading ("practical" or "new" criticism), but what might be called an anthological method of criticism by the cunning juxtaposition of quotation. Then comes the use of the anthological method for *historical* purposes: Leavis's criticism aspires to being a historical slide show, not altogether alien to the spirit of Ezra Pound's *A.B.C. of Reading*. Next, there is *internationalism*. When Leavis's prospective pupils asked him what they should read before going up to university, he always directed them to the foreign classics. Internationalism is complemented by *nationalism*, or interest in national identity, shown in the "anthropologico-literary" concern for the public, the milieu or the community from which writing emerges. Finally, Leavis believed that English was a *complementary* subject, an unusual conviction because academics usually think that students cannot have too much of their own subject. Leavis encouraged his pupils to combine English with something else, and to be independent, stressing that English was a personal subject. (A subsidiary conviction was that too much lecture attendance could damage literary study.)

All these ideas, even the last, were inherent in the system of Cambridge English. Now, Cambridge English was what was heard from and written by its luminaries, but its spore can be found in its influential imprint upon official documents. The mundane documents of an educational system have a crude power. They are often *obeyed*. Let us look at the system at the highest point of its ritual, in tripos examination papers, and in the ones which Leavis himself

took in 1921. (The tragic circumstances in which he took them is another story.)

In May 1921 Leavis sat for one paper called "History of English Literature from 1602" containing this question:

> Proud Maisie is in the wood,
> Walking so early:
> Sweet Robin sits on the bush
> Singing so rarely.
>
> "Tell me, thou bonny bird,
> When shall I marry me?"
> "When six braw gentlemen
> Kirkward shall carry ye."... (Scott)
>
>
> Inexperienced critics have often named this, which may be called the Homeric manner, superficial, from its apparent simple facility: but [the] first-rate excellence in it is in truth one of the least common triumphs of poetry. This style should be compared with...the searching out of inner feeling, the expression of hidden meanings, the revelation of the heart of Nature and of the Soul within the Soul— the Analytical method, in short—most completely represented by Wordsworth and by Shelley. (Palgrave)
>
>
> Compare it, giving instance in such plenty as time allows.

So, there are two stanzas of Sir Walter Scott and eleven lines of Francis Palgrave, with the invitation to comment. This style of question became common in British examinations, but not in papers of this sort, that is, surveys of literary history. Extracts (horribly called "gobbets") were, and still are, set in examinations in critical analysis, but not for critical-historical examinations. This 1921 paper was unusual by later standards in its handling of history by asking for comment on specimens, and soliciting more specimens. This practice was followed in the other examination papers. The examination paper for "Special Period (1789–1870)" printed out two elegiac poems in full. "History of English Literature: 1350–1603" had a whole poem in old spelling, followed by the gruff demand to "write out lines 3 and 4 of the third stanza

in their old spelling and indicate the scansion..." In the appearance, in the typographical design, of these examination papers can be seen an interchange between textual study and history, and this interchange is a highly Cambridge phenomenon, perhaps more so than detailed verbal analysis. In this respect, Cambridge English differed from the English of the New Criticism in the United States. Ten years after the 1921 tripos, Leavis was to review a book of literary criticism which became notorious for the intricacy of its verbal readings. Leavis's accolade for William Empson's *Seven Types of Ambiguity* (1930) was that "there is more of the history of English poetry in this book than in any other that I know."

In Cambridge English, history also went with nationality. The concern of the English Tripos with both is well shown in a little dialogue which the arty undergraduate journal *The Granta* acquired from Sir Arthur Quiller-Couch. "Q" is interrogated by a fogey professor, in the employ of Whitehall, about the seemingly eccentric Cambridge English course.

> PROFESSOR: What, Sir, has a question on the styles of architecture to do with English Language and Literature?
> "Q" (wearily): The Professor, Sir, mistakes the very name of our tripos. It is not a tripos of "English Language and Literature"; but an English Tripos. We think that English architecture bears most importantly on English life and thought between 1350 and 1603.
> PROFESSOR (muttering): Not a single question upon *Ferrex and Porrex*...

"Q" wanted the tripos to school the undergraduates in England, of which literature was a part. And he wanted it to be a school of English in a literal sense. Whitehall could not understand the national-historical orientation of his tripos, nor did it realize that the English Tripos was meant to teach undergraduates to write. ("Q" thought that the conventional professors were often deficient in "the extremely difficult business of writing their mother tongue.") He wanted a school of lucidity *in* English as well as *of* England. He wanted people capable of exercising their disciplines in the literary reviews. "Already the work of several of our few first-class men—work in criticism especially—is being eagerly taken by London editors." Sir Arthur was a professor, but also an author and had been a Fleet Street man. He did not have the least objection to the tripos being a school of serious journalism.

The English Tripos, then, encouraged the study of literature as a study of national identity, using all sorts of evidence, and encouraged that study to engage with the weeklies and monthlies. These aspirations were fully in tune with Leavis's lifetime practice. If he later complained of the "metropolitan literary world," it was because of who ran it, not because there was one. If he campaigned against the stand-and-deliver style of three-hour examination

(encouraging a bad sort of journalistic facility) it was in reaction against the tripos.

Leavis returned to Cambridge in January 1919, "a retarded and war-bedraggled youth." It was then he began "to read seriously in contemporary literature." In April 1919 *The Athenaeum* came out under the new editorship of John Middleton Murry. In the English Tripos examinations of 1921 we find questions based on remarks in *The Athenaeum* of 23rd April and 25th June, 1920. The tripos papers were at the intersection of literary journalism and undergraduate writing. As for internationalism, there were such questions as this:

> Write short notes on any *four* of the following dramatists: Calderon, Lope de Vega, Racine, Voltaire, Otway, Kotzebue, Schiller, Alexandre Dumas (*fils*), Sardou, Shaw, Sudermann, Chekhov.

The English Tripos was not unlike a course in world literature.

However, a set of examinations is not a course, nor a syllabus a curriculum. How were the undergraduates taught? By college supervisions, one- or two-on-one, by lectures on English literature, and they were allowed (even required) to attend lectures in other faculties. But they were also expected to teach themselves, and immerse themselves in what they privately wanted to learn. The English Tripos was designed for the undergraduates' individual experiences of reading, as *The Student's Handbook* readily explained:

> For Section A [mediaeval and modern] the preparation depends less on teaching and more on the student's private reading than that required for any other Honours Examination.

and:

> The student who means to take both sections of the English Tripos will do well not to limit his reading exclusively to the subjects directly required in the examination. He should give up some part of his time to the study of general literature and history, and more especially to reading good translations of classical literature.

The handbook even remarked that "the student need not attend many lectures." There are several implications. The course was not examination-led. It was what would be later called student-centered. In *Practical Criticism* (1929), I. A. Richards was to analyze, fastidiously and correctly, the rather swashbuckling *simplesse* of undergraduate responses to poetry, and at least two of his colleagues (F. L. Lucas and E. M. W. Tillyard) were to expose to print selections of English Tripos howlers. But, in a sense, the English dons were asking for it. Their course—did not the handbook state it?—was *meant*

to involve the experience of undergraduates, most of whom were distinctly lacking in docility.

The men had come from the war, or (it could be as ominous) not come from the war. The women were experimenting with new sorts of education—and it must not be forgotten what a very high proportion of women there were in Cambridge of the 1920s. This was not Cambridge of the 1950s. The undergraduates were invited to be independent, so they were.

The final item in my crude summary of the Leavisian credo was a belief in English as a complementary subject. This raises an important issue and requires some recollection of the three stages of the evolution of English at Cambridge. You will recall that before 1919 there was an English course taken as one part of the Modern and Mediaeval Languages Tripos. In 1919 there was a two-part course, one on "Modern and Mediaeval Literature," and the other on "Early Literature and History" (Anglo-Saxon). In 1926, there was still a two-part course, but Anglo-Saxon seceded and was replaced by specialist second-part papers. I have been calling the 1919 course the original English Tripos and said that the founders of this tripos wanted English to be complementary, seeing it as a positive advantage of their tripos that only one part was taken. I should qualify this, because there were less idealistic reasons for taking only one part. Some people might want to come in from another subject, like Leavis from history, or later William Empson from mathematics, so the handbook had to make it clear they were welcome. Also, one part ("Early Literature and History") differed so much from the other that it had to be admitted some people would avoid it, with its language difficulty and its treatment of alien (actually non-literary) cultures. So there was some idealism and some pragmatism in the view that English was complementary to another subject.

In 1926 the situation changed, and some would say improved. "Early Literature and History" was removed from English by Hector Munro Chadwick, the great scholar of early European cultures who was happy to depart for several reasons. Thenceforth, the two English parts became a coherent sequence, a survey tripos and specialist tripos, both modern and medieval, with the international element retained. The Whig view would be that in 1926 an alien element was plucked out, the original English Tripos purged of ancient impurities and the Muse unchained.

But the position was not so simple. For the Whig view casts the early literature or period as the stranger in the course, which it was, but also casts it as the enemy, which it was not, to many people's way of thinking. And some such people were not in the least anti-modern, or in favor of studying early literature because it supplied some hardy linguistic grind. Some of the Leavisians, indeed, believed that the early literature was, in the original English Tripos, an integral and valued part of the course. One such person was Q. D. Leavis who took the tripos under the original regulations. It must be

remembered that to think of "Early Literature and History" as principally to do with Anglo-Saxon, the language, is misleading, for the course was at heart not a linguistic or philological one. Its guiding spirit, Chadwick, was undoubtedly a linguistic genius. He launched his students, groaning, on two new languages. But he had no time for mere philology. "D'ye knaw, I did a bit of philology meself one time," he once confided (unreconstructably Yorkshire) to a colleague. He remembered with scorn hearing Brandl in Berlin lecture tediously on vowel-shifts. The important thing about Chadwick's "Early Literature and History" was that it aspired to give a total account of ancient cultures, and, in so doing, it provided a model of study relevant to *any* period, even the modern, or, indeed, the present. In 1947 Q. D. Leavis wrote in *Scrutiny*, anonymously as "A Pupil," an excellent appreciation of why Chadwick's "Early Literature and History" mattered for modern English studies, or English studies at large. It was this course which partly inspired her *Fiction and the Reading Public*, even though the subject matter of that book, reading publics, communities, classics, best-sellers, and the industry of taste, analyzed with exuberant enthusiasm and sometimes distaste, was so distant from early English literature and history. "Early Literature and History" was the alien, but usable model for "anthropologico-literary" research of the kind discussed on the December evening in 1931, four months before the first *Scrutiny*. Chadwick's tripos, wrote Q. D. Leavis,

> opened for us the doors into archaeology, anthropology, sociology, pre-history, early architecture—all beginnings for future self-education, and he saw to it that these subjects, studied with reference to Scandinavia and England, should also extend to the Celtic and Mediterranean areas, opening fresh vistas.

Chadwick stimulated his students to look into the meaning of all artefacts, including a literature (if there was one). He showed, said Q. D. Leavis, "how literary studies could be linked up with that school of sociological studies which Cambridge so notoriously lacks." The relation of this idea of sociology or anthropology to the Leavisians is too large to be pursued here, though one little splinter of data might be mentioned. In the 1960s Leavis tried to persuade Cambridge University Press to bring out a new edition of a classic by the Cambridge scholar of early literature, Dame Bertha Phillpotts. He always recommended *Edda and Saga* (1932) when his pupils were studying for their "Tragedy" examination in the English Tripos.

It is time to look back to Leavis's pugnacious statement ("we were Cambridge"), with which I began, and conclude by turning away from detail, towards a wider world.

If "we were Cambridge," as Leavis pugnaciously stated in his lecture on the Two Cultures in 1962, then one Cambridge which they were was that of Chadwick. That was the "anthropologico-literary" Cambridge. That was the

Cambridge of the young people who met at Chesterton Hall Crescent in December 1931. I have tried to sketch what they believed. That they brought something powerful into the world of literary studies remains to be shown. That their power made people uncomfortable may be inferred. Their sociological bent could hardly sit easily with some creative movements of the time. Chesterton Hall Crescent, Cambridge, had to be at odds with the self-consciously gallant individualism of Gordon Square, Bloomsbury. "Anthropologico-literary" study was contrary to the human science which Bloomsbury favored, that is, psychoanalysis. Intellectual life in Britain was to lose from the fact that no treaty could be made between psychoanalysis and sociology, between Bloomsbury and the concern of those who believed, for some specific reasons, that "we were Cambridge."

Fall Semester 1992

BIBLIOGRAPHICAL NOTE

Leavis's claim that "we were Cambridge" is in *Two Cultures? The Significance of C. P. Snow, being the Richmond Lecture, 1962 with an essay on Sir Charles Snow's Rede Lecture by Michael Yudkin* (1962). His letter to *The Times Literary Supplement* of 12 December 1975, is relevant, as is "Introductory" to *English Literature in Our Time and the University* (1969), which is dedicated to H. Munro Chadwick and Mansfield Forbes, "to whom the world owes more than it knows." The Scott-Palgrave question in the 1921 tripos examination haunted Leavis. For it, see one of his best essays, "Thought" and "Emotional Quality: Notes in the Analysis of Poetry," in *A Selection from Scrutiny* (1968), compiled by Leavis. This is a section of a book on critical practice, to be called "Authority and Method," which Leavis never completed. One of Leavis's best, and neglected, books remains *Education and the University: A Sketch for an "English School"* (1943).

Wavell and the War in the Middle East 1940–1941

MICHAEL CARVER

S econd-Lieutenant Archibald Percival Wavell, later Field Marshal The Earl Wavell, joined the British army in 1901, just in time to serve in the later stages of the Boer War in South Africa. When the war was over, his battalion of the Black Watch was sent on to the north-west frontier of India, where he gained further active service experience.

His first-class brain and capacity for hard work when necessary won him entry to the Staff College in England at the exceptionally early age of 25. After that he went to Russia to learn the language and attend Russian army maneuvers. He therefore became an expert on the Russian army in the War Office, and it was as an intelligence officer at General Headquarters that he went to France in 1914. He was delighted to escape from that to a more active post as brigade major, that is chief of staff, of an infantry brigade. In an attack in June 1915, in which the brigade suffered heavy casualties, Wavell was wounded by a shell-splinter in his left eye. Consequently, he spent the rest of the war on the staff, interrupted by six months acting as the British liaison officer with the Russian Grand Duke Nicholas's Army of the Caucasus. When the Bolshevik Revolution brought that to an end, he became the liaison officer between the Chief of the Imperial General Staff (CIGS), General Sir William Robertson, and General Sir Edmund Allenby, the Commander-in-Chief in Egypt, who faced the Turks in Palestine. His time with Allenby, and experience as chief of staff of a corps under Allenby's command, had a critical influence on his general military outlook. It included contact with T. E. Lawrence, who was to have a significant influence on Wavell's predilection for irregular methods of warfare.

As a 35-year old brigadier-general at the end of the war, he had spent little of his service, either before the war or during it, in a combat unit, and had hardly ever exercised command. He had had remarkable opportunities, however, for observing at first hand how commanders, at every level from brigade to army, handled their formations.

By 1935 Wavell was recognized as one of the British Army's ablest soldiers, and was given command of the 2nd Division. He introduced the same sort of imaginative and unorthodox methods into its training as he had into that of the brigade he had commanded previously. In the following year he led a delegation of British officers to observe the Red Army's maneuvers in Russia, from which he returned considerably impressed, especially by their use of parachute troops. In August 1937 he was appointed to command the army in Palestine, then engaged in dealing with Arab insurrection in opposition to Jewish immigration. His taste for the unorthodox led him to support the activities of a highly unorthodox soldier, Captain Orde Wingate, who organized undercover operations against the Arabs in cooperation with the illegal Jewish army, the Haganah.

By that time Neville Chamberlain had appointed Leslie Hore-Belisha Secretary of State for War to shake up the War Office and the army's hierarchy. Hore-Belisha appointed as his unofficial adviser Liddell Hart, who recommended rapid promotion for Wavell, even possibly to the post of CIGS, the head of the army. But neither Hore-Belisha nor his political colleagues were impressed by this taciturn one-eyed general, who made no attempt to put himself forward, and Lord Gort was appointed. Nevertheless, Wavell was promoted in April 1938 to be Commander-in-Chief of England's Southern Command, a key appointment which carried with it the expectation of command of one of the two corps in any Expeditionary Force sent overseas. That did not prevent him from giving serious consideration to a proposal that he should be recommended for the prestigious Chichele Professorship of the History of War at Oxford University. In July 1939 he was offered the newly created post of Army Commander-in-Chief in the Middle East, based in Egypt. He knew the area well; it would be a more independent command than a corps in the Expeditionary Force, and should provide opportunities for more mobile and unorthodox warfare. He arrived in Egypt exactly a month before the outbreak of the Second World War, and found himself faced with wide and conflicting responsibilities, but with only extremely meager resources with which to deal with them, as he was throughout his time in the Middle East.

He was allowed a staff of five officers with which to co-ordinate war plans, such as they were, of the army in Egypt, Palestine, Iraq, the Persian Gulf, Aden and Somaliland, the Sudan and Kenya with those of the Navy both in the Mediterranean and in the Indian Ocean, and with the Middle East Air Force, which covered most of the same area, and with the Commander-in-Chief in India. At the same time he was to consult closely with all the Governors and Ambassadors in the area. The immediate threat was the 215,000-strong Italian army in Libya and that of 290,000 in Abyssinia, Eritrea and Italian Somaliland. To face this, he only had 86,000 soldiers of all kinds, scattered over the whole area, supported by a small air force, equipped with

obsolete machines, as the Army itself was. On the positive side there was the prospect of co-operation with the French forces in Syria and the Lebanon, and, as a threat to the Italians in Libya, the French forces in Tunisia, Algeria and Chad.

Wavell's immediate reaction was to plan offensive action designed to secure the Eastern Mediterranean, to include an expedition through Salonika, enthusiastically and unrealistically supported by his French colleague in Syria, General Maxime Weygand. But London poured cold water on the idea, Chamberlain's policy during the so-called Phoney War being to do nothing to provoke Italy actively to support her partner in the Rome-Berlin Axis.

The fall of France and Mussolini's quick jump onto the German bandwagon on 10 June 1940 immediately removed this positive balance. Wavell and his Navy and Air Force colleagues, over whom he exercised no authority but persuasion, found themselves alone facing greatly superior forces in every element. The collapse of British and French military effort on the continent of Europe, with the simultaneous advent to power of Winston Churchill, led immediately to pressure from the latter for offensive action in the only potential active theater of war against the Axis. Churchill at a distance was no more impressed by Wavell than Hore-Belisha had been. Wavell had resisted orders to send troops to Britain at the height of the disaster in France, as he did also pressure from Churchill for immediate attacks from the Sudan and Kenya on Italian East Africa. Churchill summoned him to London, which only made matters worse. Wavell's resistance to Churchill's impractical proposals took the form of a relapse into an even more silent and unresponsive demeanor than usual. Anthony Eden and Wavell's friend Sir John Dill, the CIGS, did their best to defend him, with the result that his request for three battalions of tanks to be sent out to him was agreed. It did not help matters that greatly superior Italian forces invaded British Somaliland, defended by only five battalions, on the day that Wavell left for London. While he was there, Churchill accepted reluctantly the inevitable loss of the colony and evacuation of the troops; but, when he learnt, after Wavell's return to Cairo, that the British casualties in defending and then evacuating the colony were only 38 killed and 222 wounded, he was furious and demanded both the dismissal of the general, A. R. Godwin-Austen, and that General Sir Claude Auchinleck from India should send another officer to conduct an inquiry. Wavell added fuel to the flames by replying with a curt refusal, ending his message with the words: "A big butcher's bill is not necessarily evidence of good tactics."[1] Wavell's stock with Churchill fell lower still a month later when the Italian Tenth Army advanced ponderously from the Libyan frontier fifty miles into the Western Desert of Egypt and settled down into a string of scattered defenses.

Wavell was a firm believer in the value of surprise, and he restricted to a very small number of senior officers and members of his own staff knowledge

of plans to take the offensive both against the incursion from Libya and against Italian East Africa from the Sudan and Kenya, to which South African forces had been sent. Ignorant of these plans, Churchill sent Anthony Eden, then Secretary of State for War, to Cairo to urge Wavell into action as soon as the reinforcement of tanks arrived at the end of September. Wavell revealed his plans to Eden, and, while Eden was there, on 28 October, the Italians invaded Greece from Albania. This was to add a significant new burden to those that Wavell already bore.

In his talks with Eden a week before the Italian attack, Wavell had given his priorities as the defense of Egypt, the liquidation of Italian East Africa, the support of Turkey and Greece, which he described as "in some ways the most pressing of all the problems,"[2] and finally dealing with internal disturbances in Iraq, Iran, and Syria which might result from enemy aggression. From the moment he assumed command, he had regarded his first priority as the establishment of a base in Egypt to support offensive action from the eastern Mediterranean into Europe. Egypt itself must, therefore, be secure, both externally and internally; but it was also essential to clear the Red Sea of any threat from Italian East Africa, so that seaborne supplies could use it freely. As long as it was under threat, American ships would not be allowed to use it.

Within days of the Italian attack, Wavell was being pressed by Churchill and the Chiefs of Staff to send help to Greece, which was to be given priority over everything else. The Middle East Commanders-in-Chief, backed by Eden, protested, stating "the security of Egypt is most urgent commitment, and must take precedence of attempts to prevent Greece being over-run."[3] The argument was not resolved until Eden returned to London on 8 November. By that time it had been agreed to send fighter and bomber aircraft and anti-aircraft artillery to Greece, and a small force to establish and protect a temporary naval base in Crete, all at some risk to the air defense of the naval base at Alexandria and the air support of the Western Desert Force under the command of Lieutenant-General Richard O'Connor.

The priorities that Wavell expounded to Eden explain certain of his decisions in the following months for which he has been criticized. The first is giving priority to the launching of the attacks on Abyssinia over exploitation of O'Connor's remarkable victory over the Italian Tenth Army in the battle of Sidi Barrani at the beginning of December. In his original directive to O'Connor on 20 October, Wavell had envisaged a "short and swift [operation], lasting from four to five days at the most,"[4] intended to eliminate the Italian forces that had entered Egypt and drive any remnants back behind the frontier. He then intended to switch the infantry element, the 4th Indian Division, to the Sudan, where it would be better suited to operations than a newly arrived Australian division, which would replace it as the infantry element of O'Connor's force. He did not tell O'Connor of this intention, although the

latter's immediate superior, Lieutenant-General Sir Henry Maitland Wilson, had to be informed. In spite of this, Wavell urged Wilson on 28 November to plan a bold exploitation of O'Connor's forthcoming operation and to "make certain that, if a big opportunity occurs, we are prepared morally, mentally and administratively, to use it to the fullest."[5]

There would be no difficulty over the moral and mental aspects, but, with only a week to go before the operation was to be launched and the need to maintain the highest level of secrecy about the intention to do so, nothing much could be done in the administrative field. In the event, the slender transport resources of O'Connor's force immediately after the battle were fully taken up in withdrawing the 4th Indian Division and replacing it with the 6th Australian, at the same time having to move, feed, and water 38,300 Italian and Libyan prisoners of war. Nevertheless, the Australians launched their successful attack on Bardia, the first main defences within Libya, on 2 January, three weeks after the end of the Sidi Barrani battle. If the 4th Indian Division had remained, that attack could probably have been launched at least a week earlier. If thereafter O'Connor's progress westwards had proceeded at the rate it actually did, his total victory over the Italian army, completed at Beda Fomm south of Benghazi on 7 February, could have taken place on 31 January, twelve rather than five days before Lieutenant-General Erwin Rommel and the first German troops landed at Tripoli, 500 miles further west. That could have made a significant change to the whole campaign. Long after the event, Wavell told O'Connor that his principal reason for sticking to his original plan was that, unless the 4th Indian Division had been withdrawn when it was, he would have missed the opportunity to use shipping that was returning empty down the Red Sea. It is possible that pressure from Field Marshal Jan Smuts, the South African Prime Minister, for the attack on Italian East Africa to start before the rainy season in Abyssinia was a more powerful argument.

By this stage, the competing demands of Greece were looming larger. There were increasing signs of German intentions to push through the Balkans. Churchill, Eden, who had now become Foreign Secretary, and the whole Defense Committee agreed on 9 January to "do everything possible, by hook or by crook, to send at once to Greece the fullest support within our power."[6] The principal purpose was not just to honor Britain's guarantee of support to Greece, made at the time of the Italian invasion, but to try and persuade Turkey to join the British in resisting German aggression in the area, and to demonstrate to the United States that the British were prepared to fight the Germans and not just confine themselves to the Italians. A signal from the Chiefs of Staff to Wavell and his colleagues told them that "assistance to Greece must now take priority over all operations in the Middle East once Tobruk is taken, because help for the Greeks must, in the first instance at least, come almost entirely from you."[7]

At that stage Wavell thought that German intentions were limited to securing their oil supplies from Romania, using Bulgaria as a buffer state. He and Air Chief Marshal Sir Arthur Longmore, his Air Force colleague, replied curtly: "With our present resources we can give no direct assistance to Greece and Turkey."[8] This brought a sharp rejoinder from Churchill: "We expect and require prompt and active compliance with our decisions for which we bear full responsibility."[9] The Prime Minister also ordered Wavell and Longmore to fly to Athens and find out what the Greeks wanted. That was the start of tortuous discussions, in which at first the Greeks feared that overt British help might provoke a German attack. Eden and Dill flew to the Middle East to join the discussions with both Greece and Turkey, towards the end of which Churchill and the Chiefs of Staff began to get cold feet. They realized that the chances were small that the help being provided would enable the Greeks successfully to resist a German invasion from Yugoslavia and Bulgaria, and that active co-operation by Turkey was even more doubtful.

Wavell played a significant and enigmatic part in the final decision to send to Greece a substantial force, a large proportion of which came from Australia and New Zealand. In the wake of the disaster that resulted, it was generally thought that Churchill had forced him into the operation against his will and better judgment; but a study of the record does not bear that out. Allowance must be made for Churchill's tendency to swing from one mood to another, from optimism to pessimism and back again, and for Wavell's high sense of duty. Wavell would protest against what he judged an unsound order to the point at which his superior, military or political, insisted. Thereafter, he would devote all his energies to the project, in the hope that it would succeed, including the assumption of an attitude of confidence in it and the inculcation of that attitude in his subordinates.

Of crucial importance was the fact that Eden and Dill were in the Middle East during the period when the final decision was taken. Eden was obsessed by the need for Turkey to see that Britain was prepared to commit herself to opposing the Germans on the mainland. Dill was initially skeptical, but he appears to have been greatly influenced by President Roosevelt's personal representative in Cairo, Colonel William Donovan, who never ceased to plug the line that passage of the Lend-Lease Bill through Congress depended on Britain demonstrating her determination to support Greece and fight Germany in Europe. The crucial meetings, both in London and in Cairo, were held on 20 and 21 February, and Dill dined with Donovan on the evening between the two. Eden and Dill pushed the burden of deciding whether or not the dispatch of an expeditionary force was militarily sound onto Wavell and his colleagues. Neither Admiral Sir Andrew Cunningham, the sailor, nor Longmore, the airman, were keen; but, if Wavell assessed the army prospects as at least possible, if not favorable, they were prepared to do their best. So, in effect, the burden of decision rested on Wavell. He was under the

impression that Churchill and the Chiefs of Staff attached great strategic politico-military importance to the dispatch of the force. We cannot tell whether or not he himself really believed that it had more than a 50 per cent chance of success. As so often happens in war, messages crossed. On 21 February Eden, after two days of discussion in Cairo, signalled Churchill: "We are agreed we should do everything in our power to bring the fullest measure of help to Greeks at earliest possible moment."[10] But the previous day Churchill had told the War Cabinet: "It was unlikely that it would be possible for a large British force to get [to Greece] before the Germans."[11] In tune with that mood of pessimism, he signalled Eden, their messages crossing each other: "Do not consider yourselves obligated to a Greek enterprise if in your hearts you feel it will only be another Norwegian fiasco. If no good plan can be made, please say so," but he qualified this by adding: "But of course you know how valuable success would be."[12]

Eden's reply, based on what had been agreed at the meetings with the Middle East Commanders-in-Chief, admitted that dispatch of the force to Greece would be a gamble. He reminded Churchill that, before he had left London, they had been prepared to "run the risk of failure, thinking it is better to suffer with the Greeks than to make no attempt to help them. That is the conviction we all hold here...we are not without hope that it might succeed to the extent of halting the Germans before they overrun all Greece."[13] Next day Eden, Dill, Wavell and Longmore flew to Athens, where Wavell took the lead in persuading the Greeks to accept the force and to agree that it would be deployed on the line of the River Aliakhmon, just north of Mount Olympus, to which Greek divisions further north in Macedonia would be withdrawn. On the day this was agreed, Rommel's reconnaissance units made their first contact with the British troops south of Benghazi, the first indication the latter had received that German land forces were in Libya.

In London, the Chiefs of Staff showed no enthusiasm for approving the dispatch of the force to Greece, but they advised the Defence Committee that, as the Middle East Cs-in-C "evidently think there is a reasonable prospect of successfully holding a German advance, we feel that we must accept their opinion."[14] Nevertheless, the Director of Military Intelligence in the War Office advised the Vice-CIGS, Lieutenant General Sir Albert Haining, acting for Dill in his absence, that "we must be prepared to face the loss of all forces sent to Greece."[15] Eden's signal had restored the confidence of Churchill, who more or less bulldozed the War Cabinet on 24 February into agreeing, and then signalled Eden: "Decision was unanimous in the sense you desire. Therefore, while being under no illusions, we all send you the order 'Full Steam Ahead.'"[16]

That was not the end of the matter. After a visit to Turkey, Eden and Dill returned to Athens on 2 March, three days before the force was due to sail from Alexandria, to find that the Greeks showed no sign of uncovering

Salonika by withdrawing to the Aliakhmon as agreed. Even before then, in the light of ULTRA information, Churchill was again getting cold feet, and Eden's party in Athens found themselves having to prove once more to London that the chances of success still justified implementing the previous decision. Cunningham and Longmore were certainly not optimistic. Wavell insisted that, given the uncertainty of the Yugoslav position, only the Aliakhmon line offered a reasonable chance for a successful defense. Dill took the lead in discussion and negotiated with General Alexandros Papagos, the Greek Commander-in-Chief, an agreement that the equivalent of three Greek divisions would join the British on the Aliakhmon. They returned to Cairo, where Wavell briefed the Australian and New Zealand commanders, Lieutenant-General Sir Thomas Blamey and Major-General Bernard Freyberg. After reconsidering the matter, Eden signalled Churchill: "We are unanimously agreed that, despite the heavy commitments and grave risks which are undoubtedly involved, especially in view of our limited naval and air resources, the right decision was taken in Athens."[17] The War Cabinet gave its blessing next day, 7 March, the day before the first troops were due to disembark in Greece.

There can be little doubt that, if Wavell, either in February or at the time of the second meeting in Athens at the beginning of March, had judged that the operation was so militarily dubious that it should not be embarked upon, his judgment would have been accepted to the great relief of his naval and air force colleagues, and perhaps to Dill also. Eden would have been bitterly disappointed, and, in spite of Churchill's wavering, it would certainly not have improved Wavell's standing with the Prime Minister. Looked at from the wider aspect of the strategy of the war as a whole, and with the advantage of hindsight, it is not easy to decide whether Wavell's attitude was right or wrong.

Wavell also had other concerns, notably in Libya and East Africa. Although the Chiefs of Staff had decreed that O'Connor must assume the defensive after the capture of Tobruk, which took place on 22 January, they changed their minds when it appeared that a German thrust into the Balkans was not as imminent as they had thought and that the Greek government under General Joannis Metaxas showed no sign of welcoming help in the form of troops. Wavell was encouraged to advance to Benghazi, provided that the move would not prejudice the formation of a strategic reserve for employment in Greece or Turkey. By 8 February O'Connor had not only captured Benghazi but cut off, surrounded, and forced the surrender of all that was left of the Tenth Italian Army as it tried to escape towards Tripoli.

O'Connor sought permission to push on a further 500 miles to Tripoli, but by then Metaxas had died and been replaced by Alexander Koryzis, a change Churchill hailed as likely to lead to the Greeks welcoming British intervention. Wavell was firmly told to "make himself secure at Benghazi

and concentrate all available forces in the Delta [of Egypt] in preparation for a movement to Europe."[18] Neither of them knew that, on the very day the message was sent, Rommel landed with the first troops of the 5th Light Panzer Division at Tripoli. Two days before, Wavell had signalled Dill in London that it seemed "possible that Tripoli might yield to a small force if dispatched without undue delay,"[19] and that it might have a favorable effect on the attitude of French North Africa; but he pointed out the logistic problems and the difficulties of naval and air support. Dill replied that he had already made the proposal to the Defence Committee but been shot down. O'Connor in later years blamed himself for not pressing his case more strongly; but the possibility of securing Tripoli in the few days between O'Connor's victory and Rommel's disembarkation is doubtful. The odds would have been more favorable if the victory had come a week earlier. As nobody knew of Rommel's impending arrival, however, the necessary urgency might have been lacking. In the event neither Wavell nor O'Connor protested against Churchill's decision.

O'Connor was replaced by Lieutenant-General Sir Philip Neame, who was left with a weak, ill-trained, inexperienced, and logistically precarious force to hold the awkwardly shaped area of Cyrenaica. It was not until 22 February that the presence of German troops was confirmed by a contact with Neame's reconnaissance troops 150 miles south of Benghazi. After the dispatch of the expeditionary force to Greece, Wavell visited Neame and told him that he did not think that the Germans would be in a position to take the offensive in Libya for another two months, that is in May. By that time the campaign in East Africa, which was going well, should have been completed, and troops from there could be sent to reinforce him. Meanwhile, the preservation of his force as a means of inflicting losses on the enemy was more important than holding ground. "The reoccupation of Benghazi by the enemy," he wrote in his directive to Neame, "though it would have considerable propaganda and prestige value, would be of little military importance, and it is certainly not worthwhile risking defeat to retain it."[20]

If Rommel had obeyed the orders he had received on a visit to Germany from which he returned on 23 March, Wavell's estimate would have been right. Once Rommel had been reinforced in May by the 15th Panzer Division, he was to be allowed to conduct a limited offensive to secure the area some 50 miles beyond the point where his reconnaissance troops were in contact with the British. He was only to advance beyond that later, if the manpower and supply situation permitted. But Rommel disobeyed all orders and rules. The day after his return, he exploited a local withdrawal by the forward British reconnaissance troops and forced them to retreat. Wavell flew up to see Neame, told him that he did not think the Germans could "make any big effort for at least another month"; and that his task was to prevent the

Germans from advancing further without incurring heavy loss to his own forces. He could not expect any reinforcement.

Rommel renewed offensive action the day after Wavell's visit and soon had the British armored division in the forward area in a state of utter confusion. Wavell flew up again two days later and countermanded Neame's plan to leave the coast road to Benghazi unguarded. Having lost confidence in Neame, he proposed to replace him with O'Connor, but he was persuaded by the latter to leave Neame in command with O'Connor as adviser. The result was that both Neame and O'Connor were captured and their forces driven all the way back to Tobruk to which Wavell flew on 8 April. The decision to hold Tobruk firmly with Australian troops had been taken by the Middle East Commanders-in-Chief in the presence of Eden and Dill two days before, after cancelling an expedition to the Italian Dodecanese islands. Although surrounded by Rommel's forces three days later, Tobruk was to hold out until relieved six months after Wavell's departure from the Middle East.

Wavell's reputation was not enhanced by these events. He has been criticized for not pressing harder to advance on Tripoli; for his failure to estimate more accurately the threat posed by Rommel; and for his conflicting orders to Neame. It is of some interest that Wavell was first given access to Ultra on 14 March, ten days before Rommel attacked. London's priorities and Wavell's preoccupation with Greece must bear much of the blame; but nobody, working by normal rules, could have forecast Rommel's lightning 300 mile advance from Agheila to Tobruk in less than two weeks.

This blow in Libya was balanced by success in Italian East Africa. When, after O'Connor's victory at Beda Fomm, Wavell received the War Cabinet's firm decision on 12 February to give top priority to the support of Greece and Turkey, neither Lieutenant-General Sir William Platt's advance into Eritrea from the Sudan nor Lieutenant-General Sir Alan Cunningham's from Kenya through Italian Somaliland into southern Abyssinia had begun, although both were imminent. Wavell has been criticized by some for not cancelling them, transferring most of the forces to Egypt, and thus avoiding the risks in Libya that he faced. The Italian forces in East Africa, cut off from oil supplies, could, those critics suggest, have been left to wither on the vine. Apart from the logistic problems of such a transfer, which in the event could not have been completed in time, and the trouble this would have caused with Smuts, Wavell gave high priority to the removal of even a potential threat to the Red Sea. In the event, his decision to go ahead was justified. Four days after Rommel routed Neame's forward troops in Libya, Platt's Indian divisions cleared the formidable pass at Keren, and by the time Rommel had surrounded Tobruk, Platt had captured the Red Sea port of Massawa, allowing President Roosevelt to declare the Red Sea and the Gulf of Aden no longer a combat zone under the American Neutrality Act. By this time Cunningham,

advancing from the south, had entered Addis Ababa. The Italians were now squeezed between the two advancing armies, and, after the battle of Amba Alagi on 4 May, the Italian Viceroy and Commander-in-Chief, the Duke of Aosta, surrendered on 19 May, the day before the German attack on Crete.

The collapse in Libya coincided with the German attacks on Yugoslavia and on Greece from Bulgaria on 6 April, the day after General Maitland Wilson had assumed command of the British forces in Greece, which were beginning to arrive on the Aliakhmon line. By 9 April they were in contact with German troops, who began to attack two days later, while Wavell was visiting Wilson and Rommel was surrounding Tobruk. The collapse of Yugoslavia, and the failure of most of the Greek formations to co-operate, inevitably meant that the line would be outflanked, and a withdrawal to Thermopylae was almost immediately put in hand. Wavell returned to Greece a week later to find that a state of chaos reigned. He had little difficulty in deciding to evacuate the whole force if possible, and plans were immediately put into effect. Wavell personally explained his decision to the Australian General Blamey, who also had Freyberg's New Zealand Division under command, and persuaded the King of Greece to accept it. The Prime Minister, Koryzis, had committed suicide. This crisis saw Wavell at his best: calm, unruffled, decisive, persuasive, indefatigable and tough as nails. He did not expect to get more than a third of the force away; but of the 62,500 men sent to Greece, 50,700 were evacuated between 23 and 29 April, leaving behind all equipment that they could not carry personally.

Just over half went to Crete, principally in order to provide a quicker turn round of ships; and the question of Crete's future became an immediate issue. Wilson arrived there on the 27th and asked for orders. Wavell had just learned from Ultra that the Germans were planning an airborne assault on the island, possibly as a stepping stone to Cyprus, Syria or Iraq, where a political adventurer, Rashid Ali, had staged a successful coup against the government of the Regent, who had fled to British protection. Wavell told Wilson that Crete was to be denied to the enemy, who, according to London's intelligence estimate, would probably combine an airborne with a seaborne attack, and were unlikely to attempt the former without the latter. Based on this, Churchill signalled Wavell that the island must be stubbornly defended and it ought to be "a fine opportunity for killing the parachute troops." The trouble was that the 5,000 British troops already on the island had been sent there solely for the close defense of the temporary naval base at Suda Bay.

No preparations had been made for a major defense of the island, which would not have been threatened if the expedition to Greece had succeeded in its aim. The 20,000 troops that arrived from Greece had no transport and no heavy weapons. They had expected to move on back to Egypt. Freyberg was far from pleased when, on 30 April, he was told by Wavell, who had flown to Crete, that, on orders from London, his troops were to stay there and he

himself was to be placed in command of the defense of the island. Next day, after Freyberg had studied London's estimate of the scale of enemy attack, he signalled Wavell that, unless air and naval support were increased to reduce the estimated threat, his forces were "totally inadequate to meet attack envisaged" and urged that the decision to hold Crete should be reconsidered.[21] He sent a similar message to the New Zealand Prime Minister, Peter Fraser, saying that there was no evidence that naval support would be capable of guaranteeing him against seaborne attack and that the air forces available on the island were hopelessly inadequate. Wavell, backed by Admiral Cunningham, replied that the Navy would support him, and that, even if it were decided to reverse the decision to hold Crete, there was little time in which to evacuate the troops. Churchill followed up with reassuring messages to the New Zealand Prime Minister, who had decided to fly to London via Cairo, and to Freyberg himself, saying that he was confident that his "fine troops will destroy parachutists man to man at close quarters."[22] Freyberg's moods were as changeable as Churchill's. On 5 May, Freyberg replied:

> Cannot understand nervousness: am not in the least anxious about airborne attack; have made my dispositions and feel can cope adequately with troops at my disposal. Combination of seaborne and airborne attack is different. If that comes before I can get guns and transport here the situation will be difficult. Even so, provided Navy can help, trust all will be well. When we get equipment and transport, and with a few extra fighter aircraft, it should be possible to hold Crete. Meanwhile there will be a period here during which we shall be vulnerable. Everybody in great form and most anxious to renew battle with an enemy, whom we hammered every time we met him in Greece.[23]

Between the evacuation from Greece and the German attack on Crete on 20 May, Wavell had a major row with Churchill over Iraq. Auchinleck, the Commander-in-Chief in India, held responsibility for Army matters there, although the Royal Air Force, who were the only British forces stationed in the country, came under Longmore, the Middle East Air C-in-C. In response to Rashid Ali's rebellion, troops from India started disembarking at Basra on 30 April, the day after the final evacuation from Greece. Rashid Ali's reaction was to surround the RAF base at Habbaniya, 50 miles west of Baghdad, and to start shelling it on 2 May. To the consternation of Wavell, who justifiably felt he had enough on his hands already, the Defence Committee in London on that day transferred responsibility for Iraq to him and told him to send troops to relieve the siege of Habbaniya. Wavell, who had just returned from a visit to the troops facing Rommel on the Egyptian frontier with Libya, flashed back:

> I have consistently warned you that no assistance could be given to Iraq from Palestine in present circumstances, and have always advised that commitment

in Iraq should be avoided…my forces are stretched to the limit everywhere, and I simply cannot afford to risk part of forces on what cannot produce any effect.[24]

He suggested mediation by Turkey and the co-operation of the United States to sort out the problem. Not surprisingly this provoked a sharp rebuke from London. The Chiefs of Staff on 4 May signalled that it was essential to restore the situation at Habbaniya and control the oil pipeline from northern Iraq to Haifa, adding: "Positive action as soon as forces can be made available will be necessary."[25] Wavell made matters worse by starting his reply with the sentence: "Your [signal] takes little account of reality. You must face facts." He went on to list the small force he felt able to send, adding:

Very doubtful whether above force strong enough to relieve Habbaniya or whether Habbaniya can prolong resistance till its arrival. I am afraid I can only regard it as an outside chance. I feel it my duty to warn you in gravest possible terms that I consider prolongation of fighting in Iraq will seriously endanger defence of Palestine and Egypt. Apart from the weakening of our strength by detachments such as above, political repercussions will be incalculable and may result in what I have spent two years trying to avoid, serious internal trouble in our bases.[26]

Wavell was totally wrong. The spirited action of the garrison of Habbaniya and the arrival of the small force—a brigade improvised from the cavalry division in Palestine in the process of being converted from horses to trucks— resulted in the collapse of Rashid Ali's revolt. But his protest critically undermined the little confidence which Churchill had in him. The Prime Minister noted the contrast between Wavell's reluctance to become involved and the readiness of Auchinleck to send troops from India to Basra, discounting that Auchinleck was faced with no other commitment at the time.

Iraq was not the only source of Churchill's dissatisfaction. General Charles de Gaulle had arrived in Egypt in April and tried to persuade Wavell to support with tanks and aircraft an attempt by Free French forces to enter Syria, then held by French forces loyal to Vichy, in the hope that the latter, after token resistance, would change sides. Wavell refused. On 14 May it was confirmed that German aircraft were using Syrian airfields en route to Iraq to help Rashid Ali, and Wavell was pressed to reverse his decision, but he was reluctant to do so, saying that he was fully committed and that such an expedition "would be painfully reminiscent of the Jameson Raid and might suffer the same fate."[27]

That signal was sent on the day after the failure of an attempt to dislodge Rommel's forces from the area of the Libyan-Egyptian border. It was the final straw that caused Churchill to tell Dill on 19 May, the day before the

German attack on Crete, that he had decided to replace Wavell by Auchinleck. He was persuaded to hold his hand, but, as the attack on Crete was launched, Wavell was told by Churchill to undertake an operation against Syria:

> Our view is that if the Germans can get Syria and Iraq with a few aircraft, tourists and local revolts, we must not shrink from running equal small-scale military risks, nor from facing the possible aggravation of political dangers from failure. We of course take full responsibility for this decision and should you find yourself unwilling to give effect to it, arrangements will be made to meet any wish you may express to be relieved of your command.[28]

That night Dill wrote two letters, one to Wavell, imploring him not to rise to that fly, at any rate at the current critical period, and saying that he thought the Prime Minister must either trust him or replace him, and one to Auchinleck, warning him to be prepared to succeed Wavell.

For the next twelve days Wavell's attention was absorbed by the battle for Crete, which he had no means of influencing. It shook his usual robust and imperturbable spirit. Lady Wavell told Freyberg, when it was all over, that it had been the only time she had known when he had been unable to sleep. The search for scapegoats started immediately and Longmore was the first to suffer, both the Navy and the Army having complained bitterly of the lack of air support, which was no fault of his. It was clear to all, at any rate in London, that the axe would soon fall on Wavell.

The final blow fell after the failure of Operation Battleaxe, the next attempt to throw Rommel back from the frontier and relieve the siege of Tobruk. On 21 April, ten days after Rommel had surrounded Tobruk, the Defence Committee, in response to an urgent request from Wavell, had decided to take the risk of sending a convoy, nicknamed Tiger, carrying 352 tanks and 63 modern Hurricane fighter aircraft, through the Mediterranean rather than all the way round the Cape. One ship, carrying 57 tanks and 10 aircraft, was sunk on the way, but the rest arrived safely in Alexandria on 12 May. Churchill was anxious to see them in action against Rommel with no delay, and kept on pressing Wavell for early action, but they were not all unloaded for nearly another two weeks and then needed workshop attention and modification for desert conditions. Meanwhile Wavell had been forced to provide forces for the operation against Syria, which proved expensive, and was not finally concluded until 12 July, nearly a month after the failure of Battleaxe on 19 June, after all the hopes that Churchill had pinned on what he called his "Tiger Cubs," for the dispatch of which such risks had been taken. Nobody realized more clearly than Wavell himself that this meant the end of the road for him. Churchill sent the fateful telegrams on 21 June, telling Wavell and Auchinleck to change places. In reply Wavell asked for a short spell of leave in England to see his son and get some rest; but Churchill refused, and Wavell flew straight to Delhi. A month before, when Churchill told Dill that he had

decided to make the change, he had said that he could not have Wavell hanging around London, and that he would "enjoy sitting under the pagoda tree" in India.[29]

Wavell's time as Commander-in-Chief in India was not to provide him with any relief from having to face heavy burdens without adequate resources to help him carry them. When the Japanese launched their general offensive in the Pacific and South East Asia in December 1941, he was given the hopeless and thankless task of exercising nominal command of all American, British, Dutch and Australian forces facing them from Burma to the Philippines. When that collapsed and he returned to India, the failure of the campaign to evict the Japanese from Arakan on the west coast of Burma led to his replacement by Auchinleck, while Wavell became Viceroy and Admiral Lord Louis Mountbatten assumed operational responsibility with his South East Asia Command. Wavell's political problems as Viceroy proved to be as intractable as his military ones had been. He was replaced by Mountbatten in that post in 1947 and died three years later a sad and deeply disappointed man.

How should we assess Wavell as a general? He is best judged by the standards he himself set in a lecture he gave in 1935, entitled "The Higher Commander,"[30] which was later expanded into the 1939 Lees-Knowles lectures at Cambridge University. One of the first qualities he stressed was that of mental and physical toughness. He told a story in which prototypes of mountain artillery were dropped from the top of a 200-foot-high tower to ensure that they could withstand falling down the side of a mountain from the back of a mule. Generals, like mountain guns, must have a high margin over the normal breaking strain. War was a rough and dirty game for which a robust physique and robust mind were needed. He certainly met that test, surviving several aircraft crashes and even more challenges to the robustness of his mind and character. Next he listed a spirit of adventure. The general must have "at least a touch of the gambler in him." This certainly applies to Wavell in the early days in the Middle East, but the gambles did not come off in Libya and Greece in the spring of 1941, and the odds were heavily stacked against him in the Far East.

His next list of qualities fits him exactly. The general "should be as active as possible in mind as well as in body: he must be quite determined to know for himself—alive or dead—the conditions of battle on his front; he must be human; his character must be such that his troops will be confident of receiving square meals and a square deal and his superiors of receiving loyal support; he must know what he wants, and what he wants must be victory." Nobody was as brave and indefatigable in visiting the front line as Wavell. He spent hours in uncomfortable aircraft in hazardous conditions flying from one place to another to do so. He was human, and his immediate staff and subordinates loved him for it, and he was held in high esteem and affection by all under his

command, certainly in the Middle East. But he was an awesome, intimidating figure with his one eye and terse speech, usually limited to the response: "I see, I see." He was always seeking a chance to take the offensive. When he came to talk about professional expertise, he laid great stress on a thorough understanding of logistics, rather than strategy and tactics. "The principles of strategy themselves," he said "can be apprehended in a very short time by any reasonable intelligence." He emphasized the need for common sense: a knowledge of what is and what is not practical in military terms. That is interesting because one of Wavell's gifts was the clarity and independence of mind that enabled him to see the wider strategic wood beyond the clutter of trees caused by tactical problems pressing on him. This is seen in his early realization that the basic strategy in the Middle East should be to build up a secure base in Egypt from which eventually to enter Europe from the eastern Mediterranean.

Finally there is irony in what he had to say in his lecture about the relations between the general and the politician.

> A high commander...will have to deal increasingly with statesmen, politicians, and other civilians of his own nationality, and with soldiers of other nationalities. Unless he has a real gift that way, he had better not try to talk their language, but the more general knowledge he has of their characteristics and point of view the better. The politician, who has to persuade and confute, must keep an open and flexible mind, accustomed to criticism and argument. The mind of the soldier, who commands and obeys without question, is apt to be fixed, drilled and attached to definite rules. The comparison need not be taken further; but that each should understand the other better is essential for the conduct of modern war.

Wavell certainly did not try and talk the language of the politicians. Unfortunately, the fact that he did not—indeed hardly spoke at all—resulted in the politicians, especially Churchill, not understanding him. He had a clear, flexible, imaginative and reflective mind, but he revealed it only to a few. He was a lover of poetry and the arts, and a student deeply versed in history. It was a tragedy for him, and for many others, that he and Churchill, who in reality had much in common, should so often have been at loggerheads.

Fall Semester 1992

NOTES

1. John Connell, *Wavell: Scholar and Soldier* (London, 1964), p. 265.
2. Harold Raugh, *Wavell in the Middle East, 1939–1941: A Study in Generalship* (London, 1993), p. 87.
3. Ibid., p. 90.
4. Ibid., p. 87.
5. Ibid., p. 97.
6. Ibid., p. 110.
7. Ibid.
8. Ibid., p. 112.
9. Ibid.
10. Ibid., p. 150.
11. Ibid., p. 151.
12. Ibid.
13. Ibid.
14. Ibid., p. 154.
15. Ibid., p. 155.
16. Ibid., p. 154.
17. Ibid., p. 157.
18. Ibid., p. 120.
19. Connell, *Wavell: Scholar and Soldier*, p. 326.
20. Raugh, *Wavell in the Middle East*, p. 187.
21. Paul Freyberg, *Bernard Freyberg, VC: Soldier of Two Nations* (London, 1991), p. 271.
22. Connell, *Wavell: Scholar and Soldier*, p. 451.
23. Winston Churchill, *The Second World War*, vol. 3, *The Grand Alliance* (London, 1950), p. 246.
24. Raugh, *Wavell in the Middle East*, p. 211.
25. Connell, *Wavell: Scholar and Soldier*, p. 436.
26. Ibid., p. 437.
27. Raugh, *Wavell in the Middle East*, p. 216.
28. Ibid., p. 220.
29. Ibid., p. 217.
30. *Journal of the Royal United Service Institute*, 81 (February 1936) 15-32.

Reflections on Strategic Deception

MICHAEL HOWARD

This story opens, so far as I was concerned, one day towards the end of the 1960s, when my old Oxford tutor, J. C. Masterman, asked me to dinner. "Come early," he said; "I've got something rather interesting for you to read—connected with what I was up to during the war."

Masterman had recently retired as Provost of Worcester College, Oxford, and was living in a little house near his old college in Beaumont Street. He had tutored me in History in 1945 at Christ Church immediately after the war, when we had both just returned from military service. I knew that he had been working with MI5, the military security service, but what he had been doing I did not inquire. Nor did it occur to me to do so. It is difficult now to understand how deeply the habit of discretion had penetrated into wartime Britain. We simply did not ask awkward questions. If a friend said that he or she was working on something "rather hush-hush," we left it at that, and talked of other things. Masterman, we knew, had been working on something rather hush-hush, as had my other tutor, Hugh Trevor-Roper. But that, at Oxford in October 1945, was irrelevant to what to me really mattered: the constitutional development of England in the seventeenth century, on which I was to be examined frighteningly soon.

Two decades later, I was back at Oxford as a Fellow of All Souls College, working on a volume in the official history of the Second World War. It was probably the status that I now enjoyed as an "official historian," having signed the Official Secrets Act and being, therefore, regarded in high circles as a person of discretion, that led Masterman to choose me, from among his innumerable friends and former pupils, as a subject for his experiment. In any case, when I turned up at Beaumont Street one hot summer afternoon, he put a cup of tea into my hand and produced a grubby little pamphlet marked "HMSO—TOP SECRET." "I'll leave you to read that," he said. And disappeared for a couple of hours.

"That" was his account of the Double Cross System, the signing-off report that he had produced for MI5 as the secretary of the so-called "Twenty Committee" at the end of the war. This described how the British Security Services had captured every single agent that the Germans attempted to infiltrate into the United Kingdom during the Second World War, and used them as channels for feeding the German war machine with deceptive information about Allied military strength and intentions. Thus was it ultimately possible, when the Allied forces landed in Normandy in June 1944, to keep an entire German Army pinned down in the Pas de Calais awaiting the invasion of a non-existent United States Army Group. All this is now general knowledge, but to me, reading that drab little booklet on that hot afternoon twenty-five years ago, it came as a stunning surprise. Even "official historians" like myself had not been allowed to know about it, and I must admit that I experienced a slight twinge of annoyance. Of what value were our accounts, however scholarly, dispassionate and meticulously documented, if they left out so vital a dimension of military strategy?

Masterman reappeared two hours later as promised, with a glass of sherry. "Well," he asked, "what do you think of it?" I gabbled something appreciative, and he went on: "Do you think it should be published?" I replied emphatically, yes, and the sooner the better. Until it was, all histories of the war would be not only incomplete but positively misleading. "That's what I think," said Masterman, "but my former colleagues in the security services don't agree. And they have told me that if I do publish, I shall be prosecuted under the Official Secrets Act. What do you think? Would they actually prosecute me?"

I contemplated the prospect for a moment, and my imagination, as they say, boggled. Masterman was not only a leading member of the British Establishment. He had almost created it. Between the wars, as History tutor at Christ Church, that most élite of Britain's educational establishments, he had taught hundreds of pupils who had gone on to the top of the political, administrative, and educational worlds. He was a governor of half a dozen of Britain's most eminent public schools. His fame as an amateur athlete and cricketer was legendary. He was in fact the Greatest and Best of the Great and the Good. "No," I replied, "they won't prosecute you. But what about your publisher?"

"I had thought of that," he said. "But do you think they would prosecute the Yale University Press?"

So Yale, bless them, eventually published it, but I gather that the British government made it as difficult as possible for them to do so. Some years later I learned that the prosecution of Masterman himself had not been so unthinkable as I had believed. I found myself sitting at a dinner party next to Sir Alec Douglas-Home, a senior conservative politician who had served briefly as Prime Minister in 1963 and who both before and after that had held a succession of cabinet posts. More important, he was also a Christ

Church man, so our talk inevitably turned to gossip about that House, and particularly about Masterman.

"Let me tell you an extraordinary thing about J.C.," said Sir Alec confidentially. "You won't believe this, but when I was Foreign Secretary they tried to make me lock him up. They actually tried to make me lock him up. It was that book of his. Both MI5 and MI6 were determined to stop his publishing it. MI5 pushed it up to the Home Secretary, and he pushed it over to me. I squashed that pretty quickly, I can tell you. Lock up the best amateur spin bowler in England? They must have been out of their minds."

So when push came to shove, the British Establishment did look after its own, and on this occasion, I think, we should all be glad that they did. A little later, however, when I came to know the MI5 people rather better, I saw that they did have a point. Everyone concerned with the Double Cross system had been sworn to lifelong secrecy about it, and had so far faithfully kept their word. This was not because they were afraid of the consequences if they broke it, but because they were loyal team-players. Why should Masterman be allowed to get away with it, when a lesser figure would certainly have been prosecuted at once? And if he did get away with it, why should anyone else hold back his own account of equally secret and significant activities? What the authorities feared, indeed, did begin to happen. The ranks began to break.

Masterman stopped short of what would then have been regarded as the ultimate betrayal. His book contained no mention of Ultra, the successful decrypting of German ciphers based on the Enigma machine, without which the agents would probably not have been captured and certainly could not have been so successfully used. As an official historian, I did know a little about Ultra, but only, paradoxically, because I had promised not to divulge the little that I did know. When I joined the Cabinet Historical Office Section in 1958, I had been "indoctrinated." That is, I had been informed that the Allies had acquired a certain amount of information through breaking enemy ciphers. And I had signed a document even more binding than the catch-all Official Secrets Act, promising that, if I found it necessary to use such information in writing my history, I would not reveal its source. A number of reasons were put forward for this that seemed to make good sense. One was that the means of acquiring such information were still in active use; another, that we did not want to foster another "stab-in-the-back" legend in Germany by suggesting that they had been defeated, not by the destruction of their military might, but by some sinister and underhand means. I remember being surprised that the authorities made such a fuss about it. I knew, as did most people, that the concentration of academic talent at Bletchley Park had been working throughout the war on code-breaking. I assumed that they must have had some measure of success. I assumed also that similar techniques were now being employed by the successors of the Bletchley team at Cheltenham. So what was the big deal? It was later suggested to me that the

real reason for all this secrecy was that after the war the Allied authorities had sold off the German Enigma machines to friendly and not so friendly governments, to whose traffic they were thus able to go on listening with the minimum of trouble. I have no idea whether this was true or not.

In fact, the documents on which I had been working for the Official History contained very few references to Bletchley decrypts. Such references as there were described them simply as Most Secret Sources, which left all to the imagination. What no document revealed was the extent to which German ciphers had not only been broken, but were being read currently, so that messages from the German High Command to Rommel in North Africa, for example, were being decrypted at Bletchley and forwarded to Cairo almost as fast as they reached Rommel himself. The insight that the bulk and immediacy of this information gave the Allies into the mind and intentions of the German High Command must have been almost unique in the history of war. At the level of Grand Strategy with which I myself was dealing during the narrow period of 1942–1943, its significance was not very great, but my heart went out to my colleagues writing operational histories, especially those of naval warfare. The course of the Battle of the Atlantic, in particular, is unintelligible without the dimension of reciprocal code-breaking. It is like trying to write *Hamlet* without, not the Prince, but the Ghost.

Many of those working at Bletchley later became my professional colleagues, and in some instances close personal friends. They never breathed a word about what they were doing, and it never occurred to me to ask them. The length of time that Ultra remained secret can only be understood in the light of this wartime culture of discretion to which I have referred, and which now, after two generations, must seem almost incomprehensible. Most of those working at Bletchley, like those working on the Double Cross System and similar activities, truly intended to take the secret to their graves, and were shocked and angry when some of their colleagues began to break ranks. But break ranks they did. It would be too much to say that Masterman gave a general signal for defection, but the publication of *The Double-Cross System* in 1972 indicated that the world was moving into a new phase of acceptable openness, and others began to creep out of the closet.

Some did so under the harrying of enterprising investigative journalists of a new generation, who had none of the inhibitions of their predecessors. One in particular, Antony Cave Brown, acquired a mass of information, some accurate, some guess-work, some sheer invention, that he published in his unwieldy book *Bodyguard of Lies* in 1975. A senior member of the Bletchley security staff, Group-Captain F.W. Winterbotham, who had been interviewed by Cave Brown was so alarmed at the revelations that he foresaw would be made in that book that he obtained permission to write his own account of the activities at Bletchley. Permission was granted, curiously enough, on

condition that he did not consult any documents, but worked purely from memory.

The publication of Winterbotham's work, *The Ultra Secret*, in 1974 was greeted by his former colleagues with double outrage: first for its inaccuracies (among which was the famous or infamous canard that Churchill deliberately allowed the bombing of Coventry to go ahead rather than reveal that Ultra had given forewarning of it), and second because he had published it at all. Still, it was published, as was Cave Brown's *Bodyguard of Lies* a year later, which gave lavish if highly inaccurate accounts of the operations at Bletchley and the running of the double-agents. The cat was now truly out of the bag.

What was now to be done? The bold and sensible course was for the Security Services to come clean and publish their own accounts of these matters. This, amazingly enough, was what they did. The moving spirit in this initiative was another former pupil of Masterman's at Christ Church, Sir Dick White. White had not only served with MI5 during the war, rising later to become its head, but afterwards he transferred to become the head of MI6, the secret intelligence service. This was comparable to the head of the FBI in the United States becoming, on his retirement, the head of the CIA. It gave him a position of unrivaled influence both within the Security Services themselves and with the government.

Dick White was a man whose charm, intelligence, and integrity shines through the murky pages of the history of those services like a good deed in a naughty world. Even the most scabrous anecdotalists can find nothing but good to say about him. Probably no one else could have overcome the obsessive cult of secrecy that surrounded, and still surrounds, MI5 and MI6— a cult about which White had for long been deeply uneasy. Not only did it permit a degree of inefficiency and incompetence that made the services a source of public scandal in the 1950s. More important, it covered up some of the major British success stories of the war. Nothing was now to be gained, White believed, by concealing the wartime achievements of those services, and it was time that the individuals responsible for them were given due credit.

White was fortunate in having to deal, in the mid-seventies, with a sympathetic Labour Government (including a highly unconventional Foreign Secretary in the person of David Owen), and he persuaded them to authorize the publication of a new series of Official Histories dealing with the Intelligence Services during World War II, something that I think has not even happened in the United States. There were basically to be three parts. The first, a multi-volume affair, would cover the activities of MI6, the Secret Intelligence Service, and would chronicle in particular the part played by Bletchley in the allied war effort. This was to be written by the Cambridge historian F.H. Hinsley, who had himself worked at Bletchley during the war with a team of equally experienced associates. The second was to be a history of the operations of MI5, the body responsible for security within the United

Kingdom itself. This also would be written by a former member of that service, Anthony Simkins.

The third was to deal with the deception operations in the service in which Masterman had deployed his double agents. This was a more complicated matter. The double agents themselves had been run by MI5, but their effectiveness depended on information obtained, largely through Ultra, by MI6. The deception plans that they were implementing were drawn up by military authorities operating under the directions of theater commanders, and ultimately the Chiefs of Staff themselves. It seemed, therefore, appropriate to entrust this volume to an author already familiar with the general military history of the war at the highest level of strategic planning, who turned out to be me. The fact that I was also a member of the Christ Church mafia no doubt also helped.

I shall come to the contents of my book, *Strategic Deception*, in a moment. I worked on it for about five years, and when it was complete a new government had come into office under Margaret Thatcher—a government very much more rigid than its predecessor in its attitude towards security questions. To make the matter worse, the worst security scandal in the history of the United Kingdom exploded in the face of the unfortunate Prime Minister within a few months of her coming into office.

It had long been known that two members of the Foreign Office, Guy Burgess and Donald Maclean, and a senior official of MI5 itself, Kim Philby, had been active agents of the Soviet Security Service throughout the 1940s. Thanks largely to the digging of independent investigators, in particular the journalist Andrew Boyle, it was now revealed that the three had another active collaborator in MI5, a man who was now not only the most distinguished art historian in England but a member of the Royal Household, the Surveyor of the Queen's Pictures, Sir Anthony Blunt. Further, it emerged that MI5 had been aware of Blunt's treachery since the early 1960s, shortly after Philby's defection. But because they could produce no evidence that would stand up in court, they decided not to expose him but to keep him in play as a possible source of information—or disinformation. Whether they did so with the knowledge of the Queen still remains unclear.

In any case, this was the unsavory file that landed on Mrs Thatcher's desk at about the same time as the first draft of my own official history, and she was not pleased. It is hard to say whether she was more outraged by the fact of Blunt's treachery or by the attempts by MI5 to cover it up. Mrs Thatcher was emphatically not a member of the Establishment. She had not been to Christ Church, or played cricket with J.C. Masterman. To her the Blunt affair looked like another attempt by the Establishment to look after its own. So she insisted that Blunt should be exposed and disgraced, even if there was no direct evidence to send him to prison, and further she brought to an end the brief reign of liberalism at the security services by forbidding the publication

of any more volumes of the Official Histories. Since the first of the four volumes planned for the Hinsley series had already appeared, she allowed the rest to run their course, but both the Simkins volume on MI5 and mine on deception were put on ice indefinitely.

I could not complain. It had always been made clear to me that publication of anything that I wrote was entirely at the discretion of my employers, and I had been paid a handsome fee in lieu of royalties. But I must admit that it was irritating. My manuscript gathered dust for nearly ten years while the field was left free for journalists to put together and market inaccurate or at best incomplete accounts that I was powerless to correct. Worse, they began during the 1980s to produce rather accurate accounts, as MI5 and other officials, despairing of seeing their activities given credit during their lifetimes, began quite unscrupulously to leak their own stories and, indeed, to give independent writers access to their own documents. By the time the ban was lifted on my book in 1989, it did not have anything very fresh to say.

Still, this is not a consideration that should worry a historian, especially not an official historian. What mattered was that the full story would be told, and told with the greatest possible accuracy. And the story itself deserved it.

In a way the story did begin with Masterman and the double agents, since by the end of 1940 the British found that they had these reliable channels for feeding false information to the German High Command and had to decide what false information they were going to send. But these channels would not in themselves have been effective had it not been for the simultaneous breaking by British cryptographers of the Enigma cipher with which the *Abwehr* (the German Intelligence Service) was communicating with these and other agents. This enabled us to reconstruct and monitor the activities of the *Abwehr* all over the world. (The achievement was largely based on the work of another member of the Christ Church mafia, Hugh Trevor-Roper, now Lord Dacre). This information was of course absolutely vital. It enabled us not only to understand the relationship between the German agents and their spy-masters—how the agents were recruited, how and where they were trained, what contacts they were to make, how they were to be paid, how they were to communicate, and what they were to try to find out. We were also able to know how much of the information provided by those agents was believed by their employers, and why. A little later we were able to extend our range by breaking the ciphers with which the various branches of the German High Command communicated with its subordinate formations, and thus see what they did with the information we placed at their disposal. Ultimately, after much trial and error, it was possible to feed the *Abwehr* with false information and watch it being processed through every stage of the German war-machine, like a barium meal under X-ray.

It was not of course as easy as that. The German High Command had many other sources of intelligence, and did not hold *Abwehr* agents in very high esteem. But Ultra enabled the British—and after 1941 the Americans also—to discover what those other sources of intelligence were, and adopt measures to control, counter, or take account of them. With this knowledge we were able to make the information provided by the double agents that much more credible. Further, the Germans had few other sources of intelligence about the United Kingdom itself, and by the summer of 1944 they had virtually none at all. Britain in wartime was a fortress in a state of siege, where access and information could be tightly controlled. By the end of May 1944, almost the only information the German High Command was getting out of the United Kingdom came through the double agents, and we knew it.

It was in the full understanding of the advantage we possessed over the Germans in this regard that the British Chiefs of Staff Committee—and in this they acted virtually as the agents of the Allied Combined Chiefs of Staff—decided that every military operation conducted by their armed forces, on however small a scale, should have as its shadow a plausible cover operation, information about which would be conveyed to the enemy through all available channels. A body was established at the heart of the Chiefs of Staff Headquarters in London, called the London Controlling Section, working immediately under the Chiefs of Staff themselves, whose function was to devise and coordinate deception operations virtually throughout the world. It must be emphasized that this was an entirely military body. It used the intelligence resources provided by MI6, primarily Ultra, and the deception channels provided by MI5, notably the double-agents, but it served under the control of the military commander who was responsible for actual operations and who approved and did what was necessary to implement deception plans.

Thus, the first major deception operations, to provide cover for Operation TORCH, the allied landings in North Africa, were part of General Eisenhower's plans for that campaign. Information was made available to the enemy, through radio sources, gossip in neutral embassies, deliberate leakage of so-called confidential information, misleading display for possible enemy reconnaissance, and, of course, the double agents. Thus was the enemy led to believe that the United States forces concentrating in Atlantic ports were intended for an attack at Dakar and that the British training in Scotland were about to attack in Norway. Then the latter, just before they were embarked, were issued tropical gear and inoculated as if for service in the Far East. As the convoys approached the coast of North Africa, rumors sprouted throughout the Western Mediterranean that an expedition was on foot to relieve the beleaguered island of Malta, in preparation for an attack either on the coast of southern Italy or a landing in Libya to cut off the

retreat of Rommel after his defeat at el Alamein. All these possibilities were canvassed in the German intelligence reports intercepted at Bletchley. The enemy High Command bought none of these scenarios in their entirety, but the last place where they expected a landing was in French North Africa, where the Allies, after one of the most hazardous and complex operations yet seen in military history, achieved total surprise.

This was little more than a preliminary test of the machinery, which then became an intrinsic part of all Allied military planning. When the decision was made at the Casablanca Conference to continue attacking in the Mediterranean in 1943 and postpone an invasion of France until 1944, elaborate but not very successful plans were made to convince the Germans that an invasion of northwest France had been planned for later in the same summer. These proved enough to alarm the German authorities in France, but not enough to persuade the German High Command to take their eyes off the Mediterranean. More successful, and very much better known, was the effort to depict Allied intentions as being to land, not in Sicily as was planned, but in Greece. This did result in Hitler reinforcing the Balkan peninsula and leaving Sicily almost undefended. (The part played in this by Operation MINCEMEAT, the corpse washed ashore on the Spanish coast with a briefcase of forged documents chained to his wrist, is probably the best-known deception story from that or any other war.) By the time the plans for Operation OVERLORD, the invasion of France, were actually laid in the winter of 1943–44, all the machinery was in place to surround Allied plans with what Churchill famously called a "bodyguard of lies."

None of these deceptions would have been feasible had not the German High Command believed that the Allies possessed sufficient forces to implement them. They did believe, for example, in that non-existent First United States Army Group allegedly deployed in Kent in June 1944. This pinned down forces in the Pas de Calais that might otherwise have been used to destroy the Allied forces on the beaches of Normandy. Further, they believed in the existence of substantial Allied forces in North Africa and the Middle East as yet uncommitted to battle, and posing threats—especially against the Balkan peninsula. That had to be guarded against by German deployments that might otherwise have been used in Italy or Russia. But such notional Allied formations could not be simply conjured out of thin air. They had to be credible. If necessary, they must be visible to air reconnaissance. They had to have communications that might be monitored. Signals had to be transmitted about their administration and command. Their commanders had to figure in military records. They needed recognition signs that could be reported by enemy agents—whether the double agents operating under Allied control in the United Kingdom or the uncontrolled agents who roamed freely throughout the Middle East. United States units in particular needed

a history of formation, training, and trans-shipment to Europe. They could not just suddenly appear and disappear.

The cultivation of these notional formations in fact constituted the bulk of the activity of the deception authorities. The whole program began almost accidentally in the autumn of 1940. At that time General Archibald Wavell, commanding the British forces in the Middle East, was anxious to deter attack by superior Italian forces confronting him in Libya, and needed what we today would call a "force multiplier." So he fabricated a deception unit whose main task was to create a few such "notional forces" whose presence would be heard about by alert enemy agents and, if necessary, glimpsed through air reconnaissance. (This latter visual deception was entrusted to one of the greatest conjurers of the time, Jasper Maskelyne.) One such notional unit was an élite airborne formation that posed a continuous threat to enemy communications, entitled vaguely "The Special Air Service" or SAS for short. In fact, this consisted of a handful of jeeps and a dozen or so officers, the nucleus of the better-known SAS of today. Gradually over the years, this cast of extras was extended. Units became divisions, divisions became armies. By the end of 1943, German intelligence was overestimating Allied strength in the Mediterranean by a factor of almost one hundred per cent.

Operationally, it must be said that the existence—or non-existence—of these units made little if any difference to the course of the war in the Western Desert, but they made a considerable impact on German strategic deployment. If the Germans kept some 26 divisions in the Balkan peninsula until late in 1944, the reason was not, as is generally supposed, simply to deal with the activities of Tito's partisans. The main responsibility of General von Weichs, the Commander in Chief South East, was to guard against an invasion of the peninsula by the substantial British forces that were believed to be standing ready in the Middle East for just such an operation.

The success of the Allies in projecting this inflated image of their strength on to the mind of their adversaries can be judged by the fact that every one of the bogus units they invented was logged by German intelligence, and remained permanently on their enemy Order of Battle. In consequence, when the time came for the Normandy landings, German intelligence attributed to the Allies in the United Kingdom a strength of over 80 divisions when the true figure was barely 50, and in the Mediterranean theater the disproportion, as we have seen, was greater still.

It might be thought that the German intelligence authorities were exceptionally naive in swallowing so submissively all this bogus information. It has indeed been suggested that, in some cases at least, this credulity was the result of deliberate treachery, not on the part of the *Abwehr*, but of military professionals at Hitler's Headquarters, the *Oberkommando der Wehrmacht (OKW)*. Those professionals, however, were concerned specifically with the strength of the Allied armies in the West, *Fremde Heere West (FHW)*. The

military headquarters that dealt with the Eastern Front, *Oberkommando des Heeres (OKH)* had its own intelligence evaluation unit, *Fremde Heere Ost (FHO)*. *OKH*, facing the implacable advance of the Soviet armies, were increasingly insistent in their demands that the Eastern Front should be reinforced. *OKW* were equally reluctant to yield any of the formations they considered essential to deal with the enemy in the West. In consequence their intelligence authorities did not analyze with any great rigor any information that tended to inflate the strength of their potential adversaries. The best friends of the Allied deception authorities were thus the very people that they were attempting to deceive.

The credulity of *Fremde Heere West*; the insight that Ultra provided into German beliefs and intentions; the high level of security made possible by the insular position of the United Kingdom: those were the necessary conditions for the success of a sustained program of strategic deception perhaps unparalleled in the history of warfare. It is not only professional historians who can be grateful that the story can now at last be told.

Spring Semester 1993

Who Cares About Cyril Connolly?

JEREMY LEWIS

When I was young, in England, book reviewers tended for some reason to go in pairs. Then, as now, the most influential reviews appeared in the national Sunday papers. The oldest of these, the *Observer*, boasted Harold Nicolson and Philip Toynbee as their regular lead reviewers, hogging the top of the page while lesser lights clustered at their feet, while the *Observer*'s younger and more conservative rival, the *Sunday Times*, fielded Cyril Connolly and Raymond Mortimer. Of all of them, Connolly was perhaps the best-known and the most admired. He succeeded his old friend and mentor, Desmond MacCarthy—who had himself succeeded Edmund Gosse—as a lead reviewer in 1950, and he remained in harness, forever grumbling but never letting his employers down, until his death in 1974.

Like many writers of his generation, he never learned to type, and he would, I am sure, have been quite baffled by a fax machine. Every Tuesday his copy, handwritten on tiny sheets of blue writing paper, many pages of which have ended their days in the Harry Ransom Humanities Research Center, would be put on the train from his home in Eastbourne, on the South Coast, collected at Victoria Station by a man on a motorbike from the *Sunday Times*, typed up in the office by a secretary capable of deciphering his spidery scrawl, and set up—for these were still the days of hot-metal composition—in long strips of galley-proof. A day or so later Connolly would climb into a smart grey double-breasted suit, board the London train, eat lunch perhaps at White's, his club in St. James's Street, and then make his way to the *Sunday Times*, where he would correct his proofs—trimming if it turned out that space was in short supply—and choose himself another book to review some three weeks hence. Connolly's particular interests—dating back, in some cases, to his schooldays at Eton and his time as a rather restless and unsuccessful scholar at Balliol College, Oxford—were eighteenth-century France, the poets of the Greek Anthology, the Paris of Flaubert and Baudelaire, Latin poets

such as Tibullus and Petronius Arbiter, and the writers of the modern movement in America, France, Ireland and England. As a reviewer he had the breadth, the eclecticism, and the clarity of his friend and near-contemporary Edmund Wilson, with whom he was often compared—though, alas, he had neither Wilson's diligence nor his productivity when it came to the touchier matter of writing books. He was quite as likely to tackle a book about animals or Africa, or the assassination of JFK, or the Cambridge spies Burgess and Maclean, as a literary memoir or a biography of Joyce. His reviews were elegant, witty, astute and always beautifully written. Even as sharp a critic as Evelyn Waugh—who regarded Connolly with a sadistic, teasing mixture of derision and affection, admiration and disdain—saw in him a master of English prose; and the reviews were, very often, enlivened by his own knowledge and experience of the people and the places he was writing about.

For the great majority of his readers, I imagine, Connolly was an arbiter of taste who pronounced once a week in the *Sunday Times* and whose good opinion was eagerly awaited by a battery of publishers and writers. Those with longer memories knew him in other incarnations as well. He was the author of *The Rock Pool*, a novel about seedy expatriates in the South of France, which had been rejected in the mid-1930s by British publishers as obscene and had to be published instead by Jack Kahane—a Mancunian who had settled in Paris, where he published novels which had been banned in England or America, including early works by Henry Miller. Connolly's round, snub-nosed, slightly satyr-like face—looking, as he once rather ruefully noted, more like that of an escaped convict than an eminent man of letters—glared out from the Penguin Modern Classics edition of *Enemies of Promise*. The work had first been published in the year of Munich, and combined disarmingly honest autobiography with a survey of the current literary scene and a remorseful, lethally accurate account of the snares and the pitfalls—sex, politics, journalism, book-reviewing, drink, marriage, and worldly success—that lay in wait (and still lie in wait) to lure the young writer from the paths of promise. Writing under the pseudonym of Palinurus, he achieved a certain *réclame* as the author-cum-compiler of *The Unquiet Grave*. Part anthology, part aphoristic commonplace book, it was an elegiac evocation of the delights of life in pre-war France and nostalgia for a vanished love affair and a broken marriage, written from the bleak austerity of wartime London and the sad travails of early middle age.

Connolly was for ten years the editor of *Horizon*, the literary magazine he founded with Peter Watson and Stephen Spender in the year that war broke out, and which came to be seen—not least by some of those serving in the forces—as a beacon of culture and fine writing, American and European as well as British. And, of course, he was the friend as well as the champion of many of the writers of his own generation, from Orwell and Auden to

Isherwood and Anthony Powell. Life being the way it is, he was not universally admired: hostile fellow-writers like Geoffrey Grigson and Wyndham Lewis and Julian Symons thought him a lightweight and a snob; for academics like F.R. Leavis he was the epitome of the frivolous, self-serving metropolitan literary establishment; even his admirers regretted—as Connolly himself regretted, persistently and in print—that a man of such obvious brilliance had apparently frittered away his gifts on ephemeral book-reviewing without adhering to his own well-known dictum—printed in the opening paragraph of *The Unquiet Grave*—that "the true function of a writer is to produce a masterpiece and...no other task is of any consequence."

In the years since Connolly's death in 1974 his fame and reputation have failed to keep pace with those of his more prolific contemporaries. Among a younger generation, his name either means nothing at all, exciting a blank stare and a polite inquiry ("Cyril who, did you say?"), or rings faint bells as a character—overweight, greedy, lazy, daunting and yet, at the same time, something of a figure of fun—in the memoirs and the diaries and the letters of his friends. Evelyn Waugh and Nancy Mitford loved to feed each other with comical, inaccurate gossip about the follies and pretensions of "Smartyboots"—his amorous entanglements, his "seizures" induced by over-eating, or his subsisting on a diet of orange juice on a health farm. (The nickname had been invented by Virginia Woolf, who took an instant dislike to Connolly and his first wife when she met them at Elizabeth Bowen's house in Ireland before the war, comparing them unkindly to escapees from the London Zoo.) He appears in the memoirs of Anthony Powell and Frances Partridge and Edmund Wilson and John Lehmann and Alan Ross and, most vividly of all, in the bitchy, affectionate memoirs of his second wife, Barbara Skelton, a pantherine literary *femme fatale* whose early admirers had included King Farouk. Her account of their tempestuous life together in a tiny cottage in Kent—Connolly lying in bed for hours on end, paralyzed by sloth and self-pity, sucking the sheets and muttering "Poor Cyril, poor Cyril" like a mantra—is a classic of English comedy.

Every now and then *Enemies of Promise* and *The Unquiet Grave* are reissued in paperback. Philip Larkin, an unexpected admirer, has pointed out that Connolly still occupies more space in the *Oxford Dictionary of Quotations* than, say, T.S. Eliot, on account of his aphoristic turns of phrase. The best-known examples include "Inside every fat man a thin one is wildly signalling to be let out," "There is no more sombre enemy of good art than the pram in the hall," and the melancholy and resonant words with which he concluded his final editorial for *Horizon* in 1950: "It is closing time in the gardens of the West and from now on an artist will be judged only by the resonance of his solitude or the quality of his despair." Although it is unlikely that he will ever descend into the oblivion reserved for his patron Desmond MacCarthy, who provided a dreadful lesson about the perils of literary

journalism, having never got around to writing the book he knew he had
inside him, the modesty of Connolly's output, in book form at least, and its
seemingly haphazard, uncategorizable quality, suggests that he is in danger
of becoming a marginal and half-forgotten figure.

I believe he deserves better. His blend of wit and romanticism, and the
ruthless realism, both agonized and self-mocking, with which he diagnoses
feelings and failings common to us all, distinguish him as a writer of quite
unusual sympathy and acuity. But since, I suspect, he is even less well
remembered on this side of the Atlantic than in his native patch, it might be
helpful if I were to say something about his life—which was, as it happens,
his all-absorbing interest, both as a man and as a writer.

Cyril Connolly was born in Coventry in 1903. His father, a professional
soldier, was descended from a long line of sailors. Despite his Irish surname,
the Irishness came from his mother's side, from the Vernons, an Anglo-Irish
family with a large house outside Dublin and grand relations in the country
whom the schoolboy Cyril found a good deal more glamorous and exciting
than the more modest, middle-class English side of his family. When Connolly
was very young, his father's regiment was sent to South Africa. The time he
spent there provided him with memories of warmth and sunlight and the
image, recurrent through all his writings, of an Eden from which he had been
forever banished. (I should add, however, that an early draft of *Enemies of
Promise* conveys a slightly less prelapsarian picture than that provided by
the published edition.) He displayed the petulance, the precocity, and the
attention-seeking of a lonely and imaginative only child, made worse by the
fact that his parents failed to get on and eventually went their own ways. His
mother created a new life in South Africa, while his father moved to a series
of South Kensington hotels in which he pursued his obsessive interest in
snails and potted meats, on both of which subjects he was regarded as a
world authority. Through most of his life, Connolly seems to have been
ashamed and embarrassed by his father, a bibulous, rheumy-eyed figure who,
according to Connolly's old friend Peter Quennell, looked like an awful
warning in a Victorian temperance advertisement, and who spent occasional
afternoons watching naked girls in friezes at the Windmill Theatre in the
hope that one of them would topple and inadvertently spring to life. According
to the introduction Connolly wrote for an exhibition at the Harry Ransom
Research Center in 1971 in conjunction with his book on the Modern
Movement, he spent much of his youth hunting for substitute fathers. Among
these were Maurice Bowra, who introduced him to the work of T.S. Eliot
and Yeats's later poems while he was at Oxford, and Logan Pearsall Smith
and Desmond MacCarthy. Young Cyril was much closer to his mother, but
she remains, for the outsider at least, a far more shadowy figure than the
Major. Her vanishing to Africa with General Brooke inculcated in him a

lifelong dread of being deserted that bedeviled his relationships with women, and found literary expression in a pervasive nostalgia and sense of loss.

As a child, Connolly was small and round-faced. These looks remained with him to the end, though as he grew older, and indulged his passion for the pleasures of the table, the slimness of the schoolboy and the undergraduate gave way to a certain stoutness. At the age of ten, he was sent away from home to a prep school in Eastbourne called St. Cyprian's, where an austere regime and domineering headmaster's wife were memorialized by Connolly himself in the autobiographical section of *Enemies of Promise* and, far more savagely, in an essay entitled "Such, such were the Joys" written by George Orwell, his contemporary there and later at Eton. Whereas Orwell was a rebellious and uncompromising figure even as a schoolboy, Connolly was far more emollient and compliant. From an early age he was well aware of his smallness and his rather odd looks, but his ineptitude at organized games could, to some extent at least, be offset by his ability to entertain and to make people laugh. He was a clever if lazy little boy, and very witty and articulate if his youthful poems and parodies are anything to go by.

My mind tends to go blank and my eyes to glaze over at the very thought of a writer's juvenilia, and I feared the worst when, last spring, I found myself, rather half-heartedly, turning the pages of lined Edwardian exercise books, replete with ink blots and a round, childish script, in the collection of Connolly's papers at the University of Tulsa. But much to my surprise and relief, I found the poems he wrote at prep school astonishingly funny, sophisticated, and well-made, very much in the manner of Praed and Calverley or W.S. Gilbert. Years later, in *Enemies of Promise*, Connolly lamented that at Eton his potential as a poet had been debauched by a diet of Housman and Flecker, and by J.W. Mackail's translations from the Greek Anthology, and that this had somehow debarred him from entering into his rightful inheritance as a poet of the Modern Movement. The poems he wrote at Oxford in particular are indeed lush, doom-ridden affairs, hard to fight through and best forgotten. But reading his juvenilia I wondered whether, had life taken another turn, he might not have become another Betjeman or William Plomer.

While at St. Cyprian's, Connolly won a scholarship to Eton. Eton was, as it still is, the grandest, the most elegant and the most exclusive of the great English public schools, in which middle-class boys like Connolly mixed in with rich and titled grandees. As an ugly, ink-stained new boy, Connolly was inevitably beaten and bullied. Once again, though, he exploited his charm and his cleverness and, above all, his ability to make people laugh with his wit and his mimicry. By the end of his time at Eton he had not only won a scholarship to Oxford, which was not unexpected, but—quite out of the ordinary for someone who was neither a sportsman nor a swell—he had achieved his burning ambition of being elected to Pop, the tiny, self-appointed clique of senior boys chosen more on grounds of "character" and athletic

ability than on brain power. They ruled the school, condescending to the masters and strutting arm-in-arm about the town in particolored waistcoats, with blobs of sealing-wax attached to their top hats. With its passionate, platonic friendships and intoxicating schoolboy love affairs, its mixture of scholarship and grandeur, its lush green meadows and sparkling river, its red-brick Tudor buildings, and its elegant, raffish uniform of black tail coats and top hats, Eton became and remained a further variant on paradise lost, a womb from which he had been prematurely snatched. In this, one might say, he was no different from thousands of other Englishmen who looked back, usually through rose-tinted spectacles, at their school-days as the happiest of their lives. But his version of events is funny and shrewd as well as elegiac. According to his well-known Theory of Permanent Adolescence,

> the experiences undergone by boys at the great public schools, their glories and disappointments, are so intense as to dominate their lives and arrest their development. From these it results that the greater part of the ruling class remains adolescent, school-minded, self-conscious, cowardly, sentimental, and in the last analysis homosexual

—a persuasive insight into much of English upper- and middle-class life and culture.

After Eton, Balliol College, Oxford, seemed dim, provincial and dispiriting, peopled by "blokey" rugger-playing types with pipes in their mouths and scarves wrapped round their necks. This was—to use what has become a terrible cliché—the Brideshead era at Oxford, but though Connolly was a friend of aesthetes such as Harold Acton and Brian Howard, both contemporaries from Eton, and briefly shared Evelyn Waugh's infatuation with a don-to-be named Richard Pares, he was not a well-known Oxford figure. Nor did he play any part in the literary life of the university. He mixed almost exclusively with fellow Etonians and the occasional Wykhamist such as the future art historian, Kenneth Clark. He was also taken up by those dons, like Maurice Bowra, who liked to consort with bright, well-connected and, ideally, good-looking undergraduates. Unlike his Balliol contemporaries Graham Greene and Peter Quennell—but like so many of his ex-public school contemporaries—he haunted, at this stage in his life, an almost exclusively male and homosexual world, riven by intrigues, passions, and jealousies. Yet, despite the intensity of their relations, I suspect that much of this homosexuality was more a matter of theory than of practice, inflamed by the absence of women and too long an immersion in the literature of ancient Greece. Vacations were spent with reading parties in the Alps, or travelling round the Mediterranean, or, less happily, listening to his half-drunk father belching and stumbling about the house and slurping his supper down his chest during their lonely dinners together.

Connolly left Oxford with a poor degree and a litter of unpaid bills: Eton and Oxford had imbued him with a lifelong liking for luxurious living and for the company of those far richer than himself. After an unhappy stint as a tutor in Jamaica, he got a job through Kenneth Clark as private secretary to Logan Pearsall Smith, a rich, fastidious and rather catty American bachelor who had turned his back on his native country to devote himself instead to the study of seventeenth-century divines and to the composition of carefully crafted aphorisms, which he endlessly polished and reworked. Working with such a waspish old gentleman must have been wearisome to say the least: but it did instill in Connolly notions of perfection that he adhered to all his life. It also provided an entrée into the literary world. Pearsall Smith was a great friend of Desmond MacCarthy, a well-known critic and man of letters, and the literary editor of the *New Statesman*. MacCarthy sent Connolly books to review and so introduced the young man to a way of life that he came to both resent and rely upon.

Nor was MacCarthy's influence restricted to literary matters. His wife had a niece, Racy, with whom Connolly fell passionately in love. From now on his life was bedeviled, or enchanted, by a series of beautiful women. At Eton and Oxford, Connolly had managed to be simultaneously infatuated by a bafflingly large number of young men, each of them conforming to one of the four types to which he felt himself susceptible—the Redhead, the Extreme Blonde, the Dark Friend and, most fatally, the Faun. So too, when he switched his attentions from men to women, he was racked by that restless, romantic search for a Platonic other half, by nostalgia for what was lost and by longing for what might be. Or, in the words of *The Unquiet Grave*, "in one lovely place always pining for another; with the perfect woman imagining one more perfect..."

France, too, had become and was to remain one of Connolly's great passions. It was there that he met his first wife, Jean Bakewell, an American from Baltimore who was not only good-looking in a rather American Indian way, but had the additional advantage of being extremely rich—disruptively so, perhaps, for while many of Connolly's friends were making their ways as writers, he and Jeannie spent much of the 1930s "living for beauty" in London or in the South of France, indulging their delight in travel and high living. Jeannie was unable to have children, so they filled their houses instead with lemurs, which swung from the curtains and drank the brandy and peopled the pages of *The Unquiet Grave*. Overcome by sloth and racked by guilt and envy, Connolly claimed, implausibly but entertainingly, to be driven mad by the persistent clack of Aldous Huxley's typewriter drifting across the bay at Bandol in the South of France. He shared the left-wing views of most of his writer friends, was sent to Spain during the Civil War by the *New Statesman*, and, like Orwell, found himself siding with the Anarchists against the Communists.

As the decade ground to an end, their marriage fell apart, with Connolly claiming that his wife's addiction to the high life was making it impossible for him to concentrate on his writing. He involved himself with other women, while at the same time declaring that Jeannie was the only true love of his life. Going through the original of *Enemies of Promise* in the library at the Harry Ranson Humanities Research Center, I came across a passage that was not included in the published version, but that gives some idea of his life in the gilded Thirties. He tells us how he does all his writing in the evening. "But why not in the morning?" he asks.

> Unfortunately, there is never very much of the morning for me, for I never go to bed at night. I try not to eat breakfast so as not to get fatter. I have a glass of orange juice in bed. After that I stay in bed, reading the newspapers and then just reading. In winter I spend three-quarters of an hour in my bath, when I read faster than ever, and sometimes imagine having a slate beside me on which I can write waterproof maxims. Then I go back to bed again and usually come down to a light lunch in a dressing-gown, still with a book, for I hate not to read while I'm eating. This leaves the afternoon for work, and as it is also the time for going out or doing any of the other things other people do in the morning I tend only to write in it when I have to. And I would always rather talk than write. These words must be regarded as being like so many salmon, the few fine survivals of infinite accidents and hardships...

In 1939, when war broke out, Connolly must have seemed a brilliant but somewhat marginal figure, a dazzling but sporadic reviewer who had written one very short novel and that curious hybrid, *Enemies of Promise*. But over the next few years he was to become something of a national institution. As war approached, one literary magazine after another, including T.S. Eliot's *Criterion*, Geoffrey Grigson's *New Verse*, and Julian Symons's *Twentieth-Century Verse* ceased publication. Yet, at this most seemingly inauspicious time, Connolly decided to found a magazine that would, as he saw it, act as a defiant reminder of civilized values in a world of war, deprivation and censorship. Or, as he put it in one of the editorials that gave the magazine its especial flavor, "Our standards are aesthetic and our politics are in abeyance." Peter Watson, the millionaire son of a margarine manufacturer, put up the money and paid the printer's bills; Stephen Spender provided editorial help and the use of his front room; and the first issue of *Horizon* was published in January 1940 in the middle of the Phoney War.

For the next ten years, during the war itself, and the bleak aftermath of Attlee's Labour government, with its ration books and whale-meat steaks, *Horizon* and John Lehmann's *Penguin New Writing* provided soldiers and civilians with an insouciant reminder of what good writing, and European culture, were all about. Monthly sales never rose above 9,000 per issue, and dwindled away as the impetus faded along with Connolly's own enthusiasm. But it remained a noble and exciting venture, and one that put its editor very

firmly in the center of the literary map. Among poets, Auden, MacNeice, Betjeman and Spender were regular contributors. *Horizon* was an enthusiastic advocate of Dylan Thomas and younger poets such as Laurie Lee, and the first to publish stories by Angus Wilson and by those two undervalued men of genius, Denton Welch and Julian Maclaren Ross, alongside work by established writers such as Elizabeth Bowen and H. E. Bates. Many of George Orwell's best-known essays made their first appearance there. Space was given to contemporary artists, including the youthful Lucian Freud, and to European writers and philosophers.

Ironically, perhaps, given Connolly's loudly proclaimed indifference to the progress of the war, and his ambition to "help free writers from journalism," some of the writing that has survived best was essentially reportage, though of a very high order: Woodrow Wyatt's account of advancing across Normandy with the Guards Armoured Division; Alan Moorhead on Belsen; and Arthur Koestler, who had fled to England from Occupied France in 1940 and was among the first to describe, in a story entitled "The Mixed Transport," the rounding up of the Jews and the sealed cattle trains in which they were dispatched to the East.

Not long after Koestler's story had appeared, Sir Osbert Sitwell wrote to Connolly to protest at his publishing what were obviously absurd and exaggerated atrocity stories, the equivalents of the tales about German soldiers ravishing Belgian nuns and skewering Belgian babies with their bayonets that he remembered from the early days of World War I. Sir Osbert continued to write to Connolly in this bantering, derisive tone, betting him five pounds— a large sum of money in those days—that when it was all over, and the truth was known, Connolly would have to admit that Koestler was an alarmist who had been talking the most pernicious nonsense. Not surprisingly, perhaps, Connolly still saw himself as essentially a man of the left, and *Horizon*, like the magazine *Picture Post* and Sir Allen Lane's Penguin Books, helped to create the intellectual climate of opinion responsible for returning the Labour Government in 1945.

In the meantime, Connolly's private life had become more entangled than ever. Even before the war broke out, he had become involved with a young art student, who later became the first of the earnest editorial assistants on *Horizon* whom Waugh derided in his novel *Unconditional Surrender*, in which Connolly appears unflatteringly as the magazine editor Everard Spruce. After a good deal of agonizing, Jeannie went back to America in 1940; and when the art student decided that enough was enough, Connolly took up with a beautiful ex-model, Lys Lubbock, who also helped out on the magazine—as did the altogether more formidable Sonia Brownell, who married George Orwell on his deathbed and was once reported by Evelyn Waugh, who loved to mock Connolly and the *Horizon* ladies for what he considered their pretentious francophilia, as hard at work in the office "translating some rot

from the French." Connolly's romanticism, his longing for what was lost or unavailable, found expression in *The Unquiet Grave*, first published by *Horizon* in 1944, in which wartime longing for France and *la douceur de vivre* was interwoven with an agonized nostalgia for Jeannie, for their courtship in Paris, and for their life together in the South of France, for—in the most famous passage in the book—"Peeling off the kilometers to the tune of 'Blue Skies,' sizzling down the long black liquid reaches of Nationale Sept, the plane trees going sha-sha-sha-through the open window, the windscreen yellowing with crushed midges, she with the Michelin beside me, a handkerchief binding her hair."

Evelyn Waugh was not, alas, as admiring of *The Unquiet Grave* as Connolly would have wished. Years later, when Connolly came to The University of Texas for the Modern Movement Exhibition, he—unwisely, as it turned out—took a peek at Waugh's annotated edition of the book, with its unflattering observations about him, and was shattered by the contempt with which he appeared to have been held by someone he had thought of as a friend. Ever the professional, if reluctant, journalist, Connolly turned this unhappy experience into a rueful, funny, and beautifully crafted essay entitled "Apotheosis in Austin," which I recommend as an affectionate account of the city and its University. He consoled himself with the reflection that Waugh could not have despised him or *Horizon* quite as heartily as all that since he had allowed *The Loved One*, the novella in which he satirized the mortuary business in California, to be printed first, free of charge, in a single issue of the magazine.

By the late 1940s Connolly was losing interest in *Horizon*. Like a self-fulfilling prophecy from the *Enemies of Promise*, he was falling into that seductive authorial trap of dreaming about, and accepting advances for, books that he would never get around to writing. Cass Canfield in New York and Hamish Hamilton in London commissioned him, in vain, to write a book about southwest France, the lush, rolling countryside that he loved above all other; and a book about Flaubert was much discussed but never written. Whole novels surged through his head as he lay in the bath, laughing at his own jokes; sloth, guilt, and remorse seemed to sweep all before him while the fate he dreaded above all else, the weekly grind of regular book reviewing, fell upon him in 1950, when he became one of the *Sunday Times*'s two lead reviewers. In 1945 he had published *The Condemned Playground*, a dazzling collection of reviews, sketches, and autobiographical snippets written for the most part in the 1930s, including "Where Engels Fears to Tread," one of the funniest parodies in the language. Thereafter, his full-length books were, in effect, carefully arranged and selected collections of reviews and journalistic pieces, the titles of which—*Previous Convictions, The Evening Colonnade*—combine the comical and the elegiac, the rueful and the defiant.

Connolly's love life reached a farcical, painful apotheosis during his marriage to Barbara Skelton. She became momentarily infatuated with his publisher, George Weidenfeld, who was cited as the co-respondent in their subsequent divorce. Marriage to Weidenfeld turned out to be a less agreeable business than anticipated, and when, a year or two later, Weidenfeld and Barbara Skelton decided to go their separate ways, Connolly was in turn cited as co-respondent in the divorce proceedings. In 1959 he married for the third time and settled to domestic life in Sussex, turning in his copy as regularly as ever until his death in 1974.

So much, in brief, for his life. What then do his achievements add up to? Is he still worth reading, or is he doomed to be a brilliant bit-player in the lives and memoirs of better-known contemporaries, a frustrated footnote in literary history whose early diagnosis of the enemies of promise proved all too accurate?

One thing that can be said for sure is that he was not a natural novelist. Edmund Wilson was saddened and upset by Connolly's review of *Memoirs of Hecate County*, in which he said that, although Wilson was as eager as anyone else to write the Great American Novel, he was blighted as a novelist by his preference for writing about books and ideas rather then about characters and situations. As was so often the case with Connolly's writing, there is an element of autobiography here: Connolly longed to be a novelist himself, but it has to be said that *The Rock Pool* is pretty thin beer, far stronger in its abstract, aphoristic passages than in narrative or characterization. And although Edmund Wilson expressed sporting admiration for what he had read of *Shade Those Laurels*, which was skilfully completed and published after Connolly's death by Peter Levi, it remains a rather cumbrous intellectual exercise with little of the wit and lightness of touch of his other writing.

Nor, I suspect, is Connolly likely to be remembered as a heavyweight critic. His distinction between the Mandarin and the Vernacular Styles of writing in *Enemies of Promise* has, rightly, passed into common usage and remains as applicable as ever. He was a shrewd assessor of the literary stock market, and an invaluable guide to the mechanics and the pitfalls of the literary life. He was an early and enthusiastic advocate of Hemingway, Auden, and *Finnegan's Wake*, as well as the Modern Movement in general. The reviews he wrote in the 1930s for the *New Statesmen* are still astonishingly sharp, funny, and perceptive, and hold up better, I think, than the slightly blander work he did for the *Sunday Times*. He retained an intuitive sense of what was right or wrong with a book, and could praise or damn with incomparable clarity and elegance. But he remained, as he feared he would, a reviewer rather than a critic, an influential weekly commentator rather than a Leavis or an Eliot or an Empson or even an Edmund Wilson, all of whom changed the ways in which people thought about literature to an extent that Connolly may have aspired to but probably never attained.

Horizon, of course, was a mighty achievement. But magazine editors, like authors at their launch parties, are all too easily forgotten or overlooked; and despite the fine things he published and the authors he discovered, Connolly began to lose interest soon after the war ended. I am not entirely convinced that he had the obsessive eye for the unusual and the untried that marks out the really great editor like John Lehmann or, in our own day, his old friend Alan Ross on the *London Magazine* (in which, incidentally, Connolly published his celebrated spoof of the James Bond stories, "Bond Strikes Camp").

All this may sound both damning and dismissive. Why then, apart from the rackety fascination of his love life, and the gossipy intrigues of literary London, should I want to spend so much time in the company of a self-proclaimed failure? I believe, in fact, that Connolly was a brilliant and a very lovable writer. His genius lay in autobiography, an art in which the English, and the English middle classes in particular, have excelled in this century. The role of the autobiographer is not to regale us with the details—more often than not pompous, self-serving, and miserably discreet—of public events and well-known figures, but, like the poet and the novelist, to illuminate, reflect and explain attitudes and failings, elations and anxieties, common to us all. Like the rest of us, Connolly was self-obsessed, endlessly brooding on the past and trying to make sense of it. Even at Eton and Oxford he was writing to his friends, begging them to keep or return his letters, and during the Fifties and Sixties he tantalized publisher after publisher with the prospect of an autobiography based on the papers and the letters he had so carefully hoarded, which would take the story on from where the autobiographical section of *Enemies of Promise* left off. Alas, he never got round to writing the book he had in mind; yet all his writings are, to an even greater extent than is normally the case, permeated by his personality, and can often be read as autobiography in covert form. Those who fail, or are aware of failure, or find life a generally difficult business, are often, unless irremediably embittered, particularly sympathetic guides and companions to the perplexities of every day; and I can think of few other writers who speak to us with such honesty, exactitude, and absence of consolatory illusions.

Although academic critics may well be right to dismiss Connolly the critic as a light-weight, an old-fashioned man of letters, and a literary middleman rather than an incipient Regius Professor, he has, I suspect, suffered unfairly at the hands of the English literary industry in particular. Those who teach and study Eng. Lit. tend, all too easily, to assume that "literature," or at least the literature that deserves to be studied, and so taken seriously, is restricted to novels and poems and plays, and a limited number of those at that, and that all else—autobiography, memoirs, history and travel, as well as anything elusive and uncategorizable—is somehow peripheral or frivolous or second-rate. Someone like Connolly all too easily slips through the net. To make

matters worse, he is damned by that crude Stakhanovite tendency, inflamed by publishers and university departments, which prefers to promote second-rate writers to first-rate teachers, and to measure a writer's worth in terms of bulk and productivity rather than in terms of what he has to say and the grace with which he says it. Over lunch not long ago, Alan Ross told me that of all his friends who had died, he missed Connolly the most. Over the past eighteen months, I have spent much time in his company, and when I read about him sulking, or blighting a gathering by refusing to speak, I wonder whether I could have borne him for long. But I have come to love him more and more as a man, and my admiration for his writing, exiguous and disjointed as it is, remains undimmed. I find Palinurus, guiding us between Scylla and Charybdis, past the Harpies, the Cyclops and Etna in full flow, unique in his combination of wit, romanticism and unflinching realism; and that, surely, is all that really matters.

Fall Semester 1993

Chamberlain and Appeasement

R. A. C. PARKER

L ast year I finished a book. At first, it carried the title *British Policy and the Coming of War*. As I wrote it, a more succinct title imposed itself, *Chamberlain and Appeasement*.[1] For, in practice, British policy towards Hitler's Germany became Chamberlain's policy. Originally Chamberlain provided the vigor in the application of a policy that commanded overwhelming support; later on, in 1938 and 1939, he used his political skill to carry on that policy, though it provoked increasing disquiet in Britain. More and more, "appeasement" became the personal policy of the Prime Minister, carried on, in the end, despite growing opposition at home.

Comfortingly, or perhaps disconcertingly, those were the views I put forward, in a shrill and confident voice, as a small boy, in 1938 and 1939. I became interested in British policy towards Hitler when it was happening and have been interested ever since. Retrospectively, I was part of the consensus that passively acquiesced in "appeasement" before 1938. I did not become interested until policy became controversial, in 1938. It was not only that I was too small; I remember enjoying soundly respectable pro-League opinions on the Ethiopian crisis in 1935–36. At the time, in 1938 and 1939, it seemed that opposition to Chamberlain on the part of British opinion was on the way to become overwhelming. Since then the fashion among historians has been to argue that at least before March 1939, when German troops seized Prague, Chamberlain had to "appease," even if he did not wish to, because opinion made him do it. I have been glad to find evidence that Chamberlain did not himself share the view of those later interpreters of his motives. On the contrary, it seems, he felt unable to risk the general election he longed for, which he hoped would legitimize and strengthen his administration and his control over it.

Even before he became Prime Minister in May 1937, Chamberlain dominated the "national" (mainly Conservative) government formed in 1931. The United Kingdom recovered from the world slump more successfully than

many other democratic countries and Chamberlain, as minister in charge of the Treasury, got the credit—with how much justification it is, as yet, impossible to say. His clear, decisive manner of writing and speaking and the orderly diligence of his working habits secured his ascendancy over two successive Prime Ministers—Ramsay MacDonald, increasingly sunk in irritable confusion, and Baldwin, who specialized in emollient affability, and who found his politically most fruitful task in persuading voters that the Conservative Party was detached from class-interests. Chamberlain was aware of his own importance. He told one of his sisters—over many years he described his problems and his solutions in letters to Hilda and Ida—that, in the Cabinet, "You would be astonished if you knew how impossible it is to get any decision taken unless I see that it is done myself." MacDonald complained, after Baldwin succeeded him as Prime Minister, that the new leader made Chamberlain "adviser on everything" and "sole confidant" and he "holds the PM in his pocket." Lord Londonderry, a disgruntled ex-minister, in 1939 thought Chamberlain "responsible for all our troubles and may take credit for our successes, if any."[2]

In any case, until September 1938, ministers easily agreed on policy towards Germany. The problem of the revival of German militaristic nationalism in the early 1930s seemed urgent but soluble. The British blamed this revival, and the rise of the Nazis, not on Hindenburg or the German electorate, but on the follies of the French. In Britain, those who blamed the world economic depression for the rise of the Nazis readily agreed that that, too, was the fault of the French. The French had wrecked the Hoover moratorium, kept reparations going too long, ruined the gold standard, and failed to allow a limited German rearmament.[3] In 1933, the first year of Hitler's rule, British policy towards Germany meant policy towards the disarmament conference. British ministers hoped to persuade Germany voluntarily to accept limits on German armaments as a substitute for the limits imposed by the Treaty of Versailles. Skilfully, Hitler contrived to confirm the British in their belief that the French were the problem. In February 1934 he persuaded Eden that he was "sincere in desiring a disarmament convention." In April 1934 the French government rejected proposals incorporating the latest German suggestions on disarmament. The British ambassador in Berlin, Sir Eric Phipps, and the official head of the Foreign Office, Sir Robert Vansittart, both thought that the French thereby lost an opportunity of coming to terms with Germany and "that Hitler would have kept to his offer."[4]

In 1935 the British continued to seek French agreement to German rearmament. At first the British assumed that concessions to the French were all that were needed to secure new, agreed, limits to German armed strength. In the spring of 1935, however, Hitler restored conscription and announced the re-creation of a German air force without waiting for permission from the signatories of Versailles. As a gesture of friendship towards the British

Empire, however, he pressed on London a bilateral Anglo-German treaty to limit the size of the German navy to 35 per cent of the British. Chamberlain held that the treaty "looked so good as to make me suspicious." Eden hoped its conclusion might have "opened French eyes."[5]

In spite of this apparent success, the British authorities, with German rearmament going on steadily, at last recognized that some concession to German wishes would be needed to persuade Hitler to accept some limitation. The concessions the British proposed were, it now seems in retrospect, wholly inadequate for the daunting task of turning the Third Reich into a peaceful, non-aggressive state. Their limited dimensions reflected the British belief that France was the difficulty, not Germany. At the end of 1935, Vansittart proposed, as a concession to Hitler, either the return of German colonies forfeited by Versailles or permission to send German armed forces back into the Rhineland—where a demilitarized zone had been established at Versailles. The Cabinet politicians preferred to negotiate away a French strategic advantage rather than British-held territory, and they followed Eden's suggestion that the Rhineland demilitarized zone be traded for an air limitation agreement.[6]

On March 6, 1936, Eden accordingly called in the German ambassador in London and suggested discussion of an air pact, but the ambassador returned next day with the message that German troops were marching into the Rhineland. It is difficult to find anyone in Britain who advocated armed resistance to the new German breach of the treaty. Fear that the French might resist and, embarrassingly, demand that the British honor their treaty obligation by helping France to maintain the Demilitarized Zone was, for the British, the "Rhineland crisis." The problem that the crisis presented to the British government, therefore, was to prevent French resistance, while they pretended to support France against Germany. There was a difficulty, of course. The more convincing the promises of future support for France, the easier it would be to restrain the French government at the moment. But on the other hand, British public opinion disliked any promises which seemed to encourage France to reject concessions to German wishes. Hitler encouraged British eagerness to keep open the path to "appeasement" by announcing a new set of "offers" to accompany the forward march of the German army on March 7. The French ambassador in London found in Eden, when he saw the Foreign Secretary that morning, "a man who was wondering what advantages could be drawn from a new situation, not what barriers should be opposed to a hostile threat."[7]

In March 1936 Eden expressed generally shared attitudes, a task at which he excelled. "If peace is to be secured there is a manifest duty to rebuild. It is in that spirit that we must approach the new proposals of the German Chancellor," he told the House of Commons when it met two days after Hitler's move. Hugh Dalton, one of the most pugnacious of the Labour

opposition, commented "It is true that Herr Hitler has broken treaty after treaty. It is also true that the French Government have thrown away opportunity after opportunity of coming to terms with him." On March 26, 1936, Eden explained in a much admired speech, "It is the appeasement of Europe as a whole that we have constantly before us." He expressed a consensus. Both Churchill and Neville Chamberlain used the word that day. Churchill found "an overwhelming consensus of opinion" and Chamberlain was "struck, and perhaps a little surprised, at the general consensus of opinion."[8]

Chamberlain privately gave himself the credit: "I have supplied most of the ideas in bringing the French to reason and taken the lead all through." He was an active exponent of an agreed foreign policy towards Germany. It was in 1937, however, that the first signs of discord among British makers of policy became evident. The British settled the Rhineland crisis by promising that they would lead an active search for new arrangements to secure France against aggression in place of the broken Locarno Treaty. Nothing came of it. On one pretext or another, the German government evaded all proposals for any multilateral security pact that might hinder German expansion in the east of Europe. Some Foreign Office officials came to believe that there was no hope of persuading the Third Reich to co-operate in securing a peace until Britain became militarily stronger. An active search for German friendship, the Foreign Office began to think, was dangerous: it might encourage, rather than lessen German demands. British policy should be to gain time and "keep Germany guessing." Vansittart set out this line in a Foreign Office paper at the end of 1936.[9]

Chamberlain rejected this policy. He thought a protracted arms race unacceptable even as a means to peace and, in any case, more likely to lead to war. In 1937 he eagerly followed up encouragement from Hjalmar Schacht, the German Economics Minister, to seek a bargain with Germany in exchange for retrocession of colonies. When it fell through, apparently because of British failure to offer much, and French refusal to make up the deficiency, Chamberlain did not share the view developed in the Foreign Office that the best thing to do was nothing.[10] The contrast in attitudes came out when Lord Halifax, who had occasionally deputized for Eden as Foreign Secretary, was invited to Berlin, not as a diplomatist, but as a master of foxhounds. Chamberlain, now Prime Minister, seized on the visit as an opportunity to find out what Hitler wanted in order to negotiate about it. Eden, following Vansittart's ideas, wanted Halifax only to listen and, in particular, discourage German initiatives in Austria and Czechoslovakia. "We must keep Germany guessing as to our attitude. It is all we can do until we are strong enough to talk to Germany." The Prime Minister, as Halifax told Eden, was, on the other hand, "very strong that I ought to manage to see Hitler....He truly observed...that we might as well get all the contacts we could." It would be

wrong, however, to think that Eden's subsequent resignation came because of disagreement over policy towards Germany. As late as January 1938, he told Chamberlain "we must make every effort to come to terms with Germany." Eden, though, was less ready to brush aside the hesitations of his official advisers than Chamberlain thought necessary.[11]

Talking with Halifax in November 1937, the great men of the Third Reich made clear what Hitler wanted from Britain: that the United Kingdom should not interfere in eastern Europe. Chamberlain, however, felt encouraged to interfere. Britain, he thought, should help Germany find peaceful solutions to its problems. He led the way in trying to develop the contacts made by Halifax and in working out a new method of satisfying German colonial claims, by setting up a central African condominium, in order to improve Anglo-German relations. In the process he brushed aside the plan, presented by Sumner Welles in February 1938, in Roosevelt's name, for a conference to discuss and prescribe norms of international conduct. Chamberlain's effort reached its climax when Sir Nevile Henderson, the "appeasing" British Ambassador in Berlin, saw Hitler on March 3, 1938. Disappointingly, Hitler showed signs of impatience and irritation. He urgently repeated his demand for a free hand in the east of Europe.[12]

On March 11, 1938, when Chamberlain with Halifax, now his Foreign Secretary in succession to Eden, gave lunch to Joachim von Ribbentrop, the newly appointed German Foreign Minister, they proposed to explain their "disappointment." The meal turned out to be more tense than they expected. By that time the German army was invading Austria. Chamberlain felt confirmed in his opinion that British policy "was the right one." However, "the government's policy would have to be explained and justified to public opinion even more carefully and thoroughly than would otherwise have been necessary."[13] This remark, to the Foreign Policy Committee of the Cabinet, does not suggest that Chamberlain believed his policy to be forced upon him by an uncontrollable public opinion. Even before the Cabinet, Chamberlain and Halifax deemed it necessary to present again the arguments for "appeasement," for the continued search for concession that would make Germany and the Third Reich peaceful. The subject for concession leading to negotiated agreement was now Czechoslovakia. German threats and, worse still, Goering's pacific reassurances showed that Hitler's government intended to "solve" the Czechoslovak problem, that is to say, to secure some improvement in the status of the millions of ethnic Germans then living inside the borders of Czechoslovakia.

Chamberlain and Halifax presented to the Cabinet the justification for compromise that Britain and France were too weak to risk war. It was a justification for a course of action that they wished in any case to follow, not the reason for it. Chamberlain told his sister that "if we can avoid another violent coup in Czechoslovakia, which ought to be feasible, it may be possible

for Europe to settle down again, and some day for us to start peace talks again with the Germans." A German coup would be avoided not by resistance to German demands but by compromise with them. Halifax thought it unnecessary "to assume that Hitler's racial ambitions were necessarily likely to expand into international power lust."[14] Chamberlain and Halifax thought a peaceful settlement possible; if it were possible, of course, it was desirable. Would it be made easier to secure by threatening Hitler? Chamberlain and Halifax thought not. In Halifax's words, "the more we produced on German minds the impression that we were planning to encircle Germany, the more difficult would it be to make any real settlement with Germany." Moreover the British government worked hard to persuade, or compel, French ministers to go back on the Franco-Czechoslovak alliance and so to force the Czechoslovakian government to make the best deal it could with the German nationalists.[15]

After the German absorption of Austria in March 1938, opposition to appeasement in Britain grew. Yet consensus on foreign policy did not vanish. Though Churchill, from the right, and Labour, from the left, urged the making of an anti-German coalition, more or less linked with the League of Nations, these opponents of appeasement still in 1938 believed settlement possible inside the existing frontiers of Czechoslovakia, without armed intervention from Hitler's forces. Even Churchill thought that spring that Konrad Henlein, the leader of the German nationalists in Czechoslovakia, was genuinely seeking a basis of co-operation with the government in Prague, which may have been true of Henlein himself, and that Henlein's attitude gave a chance to Edward Benes to save Czechoslovakian integrity if he acted at once to offer concessions, which was certainly not true.[16] Until the summer of 1938, Chamberlain's belief that agreement with a contented Hitler was possible and should be worked for probably had majority support, even though many advocated increases in the strength of the forces opposed to Hitler, either by supporting the League of Nations or by alliances and by more rapid rearmament. A considerable measure of consensus still existed over foreign policy in the United Kingdom until the autumn of 1938. In August the preparatory German military concentrations began to create doubts.

In September 1938, the month of Munich, Hitler's actions aroused controversy, the most vigorous ever known about British foreign policy. By the end of that month Chamberlain, had he wished, could have found support for a radically changed policy. On the contrary he stuck with determination to his existing policy, not because he felt compelled to do so but because he thought it was succeeding. Twice in September Hitler destroyed the chance of agreements that gave him the concessions he claimed to require. The first time, early in the month, was when Henlein absconded to Germany and replied to Benes's concessions of his original demands by escalating them to separation of the Sudeten German territories from Czechoslovakia. The

second occasion was beside the Rhine in the Hotel Dreesen at Godesberg. There Neville Chamberlain met Hitler during his second visit to Germany that month. His first visit had been to Berchtesgaden where he had found out what Hitler wanted from Britain and France: to force the Czechoslovak government to accept the cession to Germany of territory inhabited by a majority of ethnic Germans. When Chamberlain flew back to Germany to convey British and French agreement, smiling happily in his role of savior of world peace, Hitler asked for more: immediate military occupation of the disputed territories. The Czechoslovakian government must give in or he would destroy the whole state. Chamberlain angrily warned Hitler that his attempt to dictate terms would make it hard to secure continued support for concession and conciliation.

Yet, he did his best to do so. When he returned to London, he urged the Cabinet to accept Hitler's new demands. He spoke to the Cabinet with eloquence and clarity. According to the record he asserted that "it would be a great tragedy if we lost this opportunity of reaching an understanding with Germany...it was a wonderful opportunity to put an end to the horrible nightmare of the present armament race." Chamberlain appended the justification that there were military reasons for refusing to risk war then. Obviously, however, he viewed the acceptance of Hitler's terms not at all as a means of gaining time for increased rearmament but as a means of making increased armaments unnecessary.[17]

Next day Chamberlain lost control of his Cabinet. Halifax changed his mind overnight; he led the Cabinet into refusal to press Czechoslovakia into surrender to the Godesberg terms. To the annoyance of the Prime Minister, he permitted the Foreign Office to publish a threat to Germany: France would go to war to defend Czechoslovakia against aggression and so would Britain and the USSR. Chamberlain, who believed that threats would make a peaceful outcome less likely, desperately tried to restore the appearance of "negotiation" by persuading Hitler to make some concession. Now, Chamberlain's period in office moved into its second phase, that in which his main effort in foreign policy had to be shrouded and disguised. As a means of winning a peaceful Germany he favored conciliation over coercion; much informed opinion began to think the reverse.

The Munich meeting itself followed ingenious maneuvers by the Prime Minister. He contrived to send his most trusted collaborator, Sir Horace Wilson, to appeal to Hitler, persuading the Cabinet to let Wilson go by offering to equip him with a warning to Hitler. Then, after Wilson's failure to shift Hitler's position, he and Chamberlain were unsuccessful in a renewed attempt to persuade the Cabinet to accept Hitler's Godesberg demands. Chamberlain finally ignored the Cabinet, making direct appeals to Hitler and to Mussolini to help to persuade Hitler to make some concessions. For still-unknown reasons, Hitler agreed to a new process of "negotiation" at the Munich

conference, where, with slight modifications, the Godesberg terms were forced on Czechoslovakia.[18]

The Munich agreement was eagerly and contentedly accepted by Chamberlain at the time as the basis for the peaceful settlement with Germany that he was seeking and as a preliminary to a disarmament accord. Before leaving Munich, Chamberlain got Hitler to confer with him alone. They discussed the freeing of trade and the abolition of bombing. Then they signed a paper setting out their belief in "the method of consultation" to deal with Anglo-German differences. Chamberlain brought this paper back to London. Radiant with triumph, he waved it at the crowd at the airport and, having appeared on the Palace balcony with King George and Queen Elizabeth, returned to Downing Street and told the crowd there "I believe it is peace for our time." Sound recordings and cinema film proclaim his confidence.[19]

"We have at last laid the foundations of a stable peace," Chamberlain wrote after Munich. He was irritated by Cabinet colleagues who were "harassed by constant doubts." They wanted acceleration of armaments production; Chamberlain thought it inappropriate to celebrate "the present détente" by a "great increase in our armaments program." Already, the Prime Minister, if he had wished, could have won support for a stronger, more coercive, policy towards Nazi Germany. At the end of the House of Commons debate on Munich, following repeated demands for accelerated preparation for war, he felt he had to disavow his own belief in peace for our time.[20]

Then, Halifax again showed himself unreliable from Chamberlain's point of view. Having talked to Eden, he urged on Chamberlain that he should bring Eden back into the government and seek co-operation with the Labour party. Halifax agreed with Eden that such co-operation would make easier an increase in arms deliveries. The Prime Minister did not like it. Eden, he thought, did not understand that "the conciliatory part of the policy is just as important as the rearming." Labour men in the Cabinet, he believed, would join with Eden in "a constant running fight" over international policy. "I have had trouble enough with my present Cabinet."[21]

On the contrary, Chamberlain wished to strengthen his own political position by holding a general election fought on his record and policies. The prospects were not encouraging. In by-elections Quintin Hogg held Oxford against united anti-Munich opposition, but his majority was unimpressive, while the Conservatives lost Bridgwater to an anti-Munich candidate. At the end of November 1938 a Conservative Party Central Office expert advised that a general election should be postponed. Chamberlain could have led a great national coalition to arm, make alliances, agitate the League, encourage the United States, and confront Hitler's Germany. He declined to do so even though, in the months after Munich, he was not helped by Hitler who, in a series of speeches, denounced British interference in continental Europe.[22] Chamberlain's policy, indeed, was for British interference to secure agreed

solutions of limited German grievances and to signal the taming of the Third Reich by disarmament. What is strange about "appeasement" is that its exponents obstinately rejected the evidence, freely offered in Germany, that it could only succeed, it at all, if it were backed by overwhelming force.

When evidence came, early in 1939, that Hitler was more and more worried about German shortage of foreign exchange, Chamberlain's confidence bounced back to the level of September 1938, the month of Munich: birds sang, flowers bloomed and, he told his sister, all the signs pointed in the direction of peace. In March he told journalists that a disarmament agreement was in sight for the end of the year.[23] A few days later German troops occupied Prague. Hitler ignored his Munich promise to follow the method of consultation in any dispute with the British. From Hitler's point of view, indeed, the question did not arise. German actions in central Europe, however arbitrary and violent, were, Hitler thought, no concern of Britain. Now, Munich had failed. Hitler had not renounced violence. His actions compelled Chamberlain to disavow in public the hopes of Munich and to adopt an attitude of resistance to future German aggression. Did his personal policy change? There is evidence to suggest that it did not; that he continued to hope for the best, for a freely negotiated settlement with Germany, even Germany led by Hitler.

He opposed an alliance with the Soviet Union to check Germany. He believed "that the alliance would definitely be a lining up of opposing blocs and an association which would make any negotiation or discussion with totalitarians difficult if not impossible." He noted that "Hitler still considered himself bound by the agreement he signed with me" and rejected the risk of offering "a challenge" to the dictators by bringing Churchill into the Cabinet. In June 1939 he set about exploring "one or two ideas" for "a peaceful solution," but he had to be careful to avoid accusations of betrayal. Soon he came to believe "that if I am allowed I can steer this country through the next few years out of the war-zone into peace and reconstruction."[24]

Today, many writers assert that Chamberlain made Munich to gain time to rearm. Such assertions are unacceptable. Forty years ago Keith Feiling defended Chamberlain and argued that the Prime Minister shrewdly assessed the evidence before him and was not deceived by Munich. He supported his view with Halifax's report that Chamberlain had told him in the car from the airport on his return that "this will all be over in three months." Halifax himself destroyed this interpretation in his letter to *The Times* in October 1948 explaining that Chamberlain had in mind transitory public enthusiasm for Munich rather than the fragility of the settlement. But some historians have continued to follow Feiling and have re-used this misleading quotation.

The opening of the records in 1969 and 1970 strengthened Chamberlain's defenders. The justifications he put forward to overwhelm those who might otherwise have obstructed his policies came to be treated as evidence of his

own cautious skepticism towards those policies. I followed the fashion and demonstrated how Trade Unions, or Roosevelt, or Morgenthau explained his delays in arming, and how the behavior of the French explained his delay in declaring war in September 1939. However, when the leading expert on Chamberlain, David Dilks, produced his elegant essay describing Chamberlain's rational stance, "We must hope for the best and prepare for the worst," uncertainty came into my mind. Perhaps Dilks had gone too far and exaggerated Chamberlain's cerebral detachment. It seemed a good idea to review the evidence. Hence this lecture and my book.

While Chamberlain never intended to leave Britain militarily weak and dependent on German goodwill, the evidence suggests that he did not allot the high priority to arms manufacture, even after Munich, that many even of his colleagues wished him to. After Munich when several ministers, "Buck" De la Warr, Oliver Stanley, Walter Elliott and, in his roundabout way, Halifax, pressed for accelerated rearmament, Chamberlain objected to the idea "that as a thank offering for the present détente, we should at once embark upon a great increase in our armaments program." He hoped to get the Soviet Union to join in persuading Hitler to abolish bombing aircraft. He worried about an Admiralty demand for 20 escort vessels.[25] Above all he did not try to give effective priority to arms production as against civilian manufacture. Skilled engineering workers, the essential factor in arms production, were not directed, or effectively influenced, to move to war work. Even after the German occupation of Prague, Chamberlain's main adviser on industry, William Weir, wrote that "nothing has yet been done effectively in regard to industrial production. Normality is still the keynote and a new note should be struck." The Advisory Panel of Industrialists, itself created by Chamberlain, explained that "ordinary trade commitments have prevented the productive capacity of the country being utilized to the fullest extent."[26]

Reaction to my book in the UK so far has been comfortingly acquiescent. No one has questioned the central proposition: that Chamberlain, if he did not invent "appeasement," applied the policy with unique energy and persistence. Frequently expressed, however, is the belief that, whatever Chamberlain's motives may have been, it was a valuable result of his policy that war did not come in 1938. In fact, of course, we do not know—too many variables come into play—whether or not war in 1939 was to be preferred to war in 1938.

Reviewers have not directly taken up my suggestion that Chamberlain frustrated chances of preventing war altogether. I had in mind two arguments. The first is the old one that lack of resistance outside Germany strengthened aggressive forces inside Germany. My second tentative suggestion is that the USSR could have been induced to work with Britain and France against Germany if sufficiently persuaded of British willingness to resist Hitler. That

has been indirectly criticized by those who have argued the inevitability of Nazi-Soviet collaboration in 1939 and the general unreliability of the USSR.

This is an issue that cannot now be settled. Perhaps evidence exists to show whether or not the terms for Anglo-Soviet cooperation set out by Molotov and Voroshilov in 1939 were a consequence of Soviet mistrust of Chamberlain or an inevitable product of Stalinist expansionism. We do not know. The documents have not yet been studied. It is probable that they exist: in Politburo archives or in the records of Stalin's secretariat. So far they are firmly closed, it seems in something called the "Presidential Archive." It is a strange plight for the historian still to be unable to explain a decisive aspect of the outbreak of the Second World War. Sometime, perhaps, things will change. But it would be an unwise historian who today would predict the fate of Russia and its archives.

Spring Semester 1994

NOTES

PRO, FO, CAB, PREM files are in the Public Record Office, London.

1. R.A.C. Parker, *Chamberlain and Appeasement* (London, 1993).

2. Neville Chamberlain Papers, Birmingham University Library [hereafter NC], NC 18/1/874; PRO 30/69/1752/2, MacDonald's diary, 7 April, 11 June 1936. MacDonald recorded that users of his diary should not regard it as a thought-out and definitive record. FO 800/328, HAL 39/29, Londonderry to Halifax.

3. David Lloyd George, *The Truth about Reparations and War Debts* (London, 1932), pp. 56-57; Simon MS 70 fos. 86, 132 (Bodleian Library, Oxford).

4. *DBFP* [*Documents on British Foreign Policy*, 2nd Series or 3rd Series] 2, 6, p. 488; 15, p. 773; FO 371/18847, C 5004/15/18; FO 371/18734, A 5573/22/45.

5. NC 18/1/923; FO 371/18848, C 5280/55/18.

6. *DBFP* 2, 15, appendix 4 (6) especially paragraphs 28, 42; CAB 23/83 fols. 233-40.

7. *DBFP* 2, 15, nos. 29, 42, 37; *Documents Diplomatiques Français* [*DDF*] 2, 1 no. 306.

8. *Parliamentary Debates* (House of Commons), 5th series, vol. 309, cols. 1812, 1840-41, 1926-27.

9. NC 18/1/952; *DBFP* 2, 17, appendix 2.

10. *DBFP* 2, 18, nos. 289, 307, 366, 445, 462.

11. FO 371/20751, C 7324/7324/18; PREM 1/330; PREM 1/276 fol. 118.

12. *DBFP* 2, 19, pp. 540-55, 995; CAB 24/275 fos. 256-58.

13. CAB 23/92 Cabinet 11 (38) 4; CAB 27/623, fol. 139.

14. NC 18/1/1041; CAB 27/627 fols. 35-42; CAB 23/93 fols. 32-44; FO 800/313 fol. 45.

15. CAB 27/623, fols. 153-94; *DBFP* 3, 1, pp. 198-234.

16. *DBFP* 3, 1, appendix 2.

17. *DBFP* 3, 2, pp. 463-73, 499-508; CAB 23/95 fols. 178-90.

18. CAB 23/95 fols. 178-90, 195-233, 288-89; *DBFP* 3, 2, pp. 63-65.

19. *DBFP* 3, 2, pp. 635-40; Gaumont British news "Munich"; BBC Sound Archives.

20. Churchill College Archives Centre, Cambridge, HNKY 4/30; NC 18/1/1072; CAB 23/95 fol. 304; *Parliamentary Debates* (House of Commons), 5th Series, vol. 339, col. 551.

21. FO 800/328, HAL 33/88; NC 18/1/1072.

22. Bodleian Library, Conservative Party Archives, CRD 1/7/35/15; N.H. Baynes (ed.), *The Speeches of Adolf Hitler*, vol. 2 (London, 1942), pp. 1534-46.

23. Keith Feiling, *Life of Neville Chamberlain* (London, 1948), pp. 396-97.

24. NC 18/1/1100, 1095, 1105, 1107, 1108.

25. PREM 1/266A fols. 19-25; NC 18/1/1071; CAB 23/95 fol. 304; PREM 1/318.

26. CAB 23/96 fols. 92, 141-2; NC 7/11/294; CAB 24/287 fols. 60-61.

British Attitudes Toward the Mexican Revolution 1910–1940

ALAN KNIGHT

Acccoording to one theory of British imperialism, British territorial expansion in the nineteenth and early twentieth centuries was not caused by a seismic shift in Britain's domestic political economy such as a move from competitive to finance capitalism. Nor was it prompted by domestic crises of under-consumption or falling rates of profit. Rather, in defiance of such "metropolitan" and economic explanations, expansion obeyed "peripheral" and strategic motives. In other words, British power was deployed in response to local crises, or breakdowns in existing "informal imperialist" relations that brought about political upheavals or nationalist challenges.[1] Such crises threatened existing British interests not only economically but also strategically, a classic case being Egypt in 1882.[2] Thus the logic and timing of British expansion depended on peripheral crises and, very often, strategic considerations, rather than shifts in the domestic economy.

With this in mind, the Mexican Revolution of 1910–20 may be seen as a classic "local crisis," a dramatic breakdown in a previous collaborative relationship that had served British capital well.[3] The Revolution brought political violence, economic upheaval, and a nationalist challenge.[4] But despite huffing and puffing, the British did not take aggressive action to halt the Revolution or to restore the Porfiriato.[5] Not that they approved of the Revolution or wrote off the old regime. As I shall suggest, their preferences were generally clear cut and conservative. But they perceived no major *strategic* threat. Mexico was not Egypt. Their hands were largely tied by their burgeoning commitments in Europe and Asia and their increased deference to the United States in the New World, especially in the Caribbean region.[6] While they deplored Mexico's fall from grace, they could do little about it. The threat or use of force was out of the question, so British interests in Mexico were left to the tender mercies of the Revolution and United States policy.

Thus any analysis of British reactions to the Revolution must also take into account, however cursorily, United States reactions. American hegemony in Mexico was a fact of life that the British could not avoid. They had to like it or lump it, and mostly they had to lump it. Therefore, the question arises of United States attitudes toward the Revolution, a subject that has generated a mountain of scholarship and a good deal of disagreement. The same question may be posed in respect to United States policy. Why did Mexico's local crisis, which occurred on America's doorstep, fail to provoke a full-scale United States intervention, leading to political control or even annexation? Why did Mexico, the "American Egypt" as it had been termed, not go the way of Egypt itself?[7] Certainly there were plenty of experts who either advocated or predicted such an outcome.[8] I do not want to enter the whole complex and contentious field of United States-Mexican relations. Rather, I want to touch on one aspect of this problem, since it sheds light on the British position, which is my main concern. Among the many factors that made a fully "imperialist" reaction by the United States unlikely, we may cite the American "official mind," which was wired up rather differently from its British counterpart.[9] Indeed, we may go further and suggest a difference in the two cultures within which their respective "official minds" were nurtured. The Mexican Revolution certainly represented a classic "local crisis," redolent with strategic significance, to which the dominant power had to respond. But the United States did not react in the classically imperialist fashion of Britain. In tautological terms, we might say, the Americans did not "Egyptianize" Mexico because, unlike the British, they were not imperialists. The American "official mind," we might also say, striving for linguistic fashion, operated with a quite different "official mind-set." More broadly, too, carriers of American culture perceived Mexico and the Mexican Revolution rather differently from their British counterparts. Thus, we may generalize, a significant rift was evident within "Anglo-Saxon attitudes" towards the Revolution, and it is this rift that I want to explore, though giving greater attention to the British side.

Of course, British, like American, reactions were far from uniform. It is possible to offer a rough breakdown, by both periods and sectors. As regards the former, it is useful to distinguish between the period of armed revolution, 1910–1917/20, and the period of revolutionary reconstruction, state-building and reform (1917/20–1940). I shall, therefore, deal with these sequentially. As regards the sectors I shall make a rough distinction between diplomats, consuls, and businessmen. These, in fact, occupy a sort of continuum: first, the diplomats in Mexico City, career officials, immersed in *Grosse Politik*, and often more concerned with what the Germans were up to than, for example, what the Villistas were doing;[10] second, the consuls, scattered in the provinces, taking a more local, commercial as well as political perspective; and finally the businessmen for whom property and profits were paramount

and whose appreciation of grand strategic and international questions was secondary.[11]

It is best to chart chronologically how the paths of these collective actors weave and cross. Under the regime of Porfirio Díaz (1876–1911) British capital flowed to Mexico, and Anglo-Mexican trade flourished. British officials as well as freelance writers were lavish in their praise of the shrewd dictator who had rescued Mexico from perennial instability and insolvency and created the Pax Porfiriana. Only a few dissident voices, mostly journalists emulating the United States muckraking school of the 1900s, questioned the bases of the Díaz regime. More typical were the eulogies of Díaz penned by the likes of Mrs. Ethel Tweedle (*Mexico from Díaz to the Kaiser*) over which I will cast a discreet veil of silence. Meanwhile, Díaz was eager to encourage British capital as a counterweight to the United States. True, United States economic interests came to predominate, especially in northern Mexico, but British interests built most of central Mexico's railways, and helped pioneer the infant petroleum industry. In all this, they were actively encouraged by the regime, which not only created a favorable environment for foreign investment, but also supplied key personnel who served on the boards of foreign companies, who acted as legal intermediaries, who eased concessions and contracts through courts and legislatures, and who took their percentage as they did so. Mexico's increasingly intimate liaison with British and other foreign capital was thus served by a recognizable "collaborating" or "mediating elite," a native group dedicated to the smooth integration of British investment within the Mexican economy.[12] At the top stood members of Díaz's narrow political clique such as Guillermo Landa y Escandón, Governor of the Federal District, who not only served on the boards of several British companies but who had also been educated, as several of his colleagues were, at Stonyhurst, the British Catholic public school, and who, an admiring British lady remarked, even "looked like an Englishman and is proud of it."[13] But collaboration stretched further down the social scale as provincial politicians, middle class lawyers, foremen and common laborers saw benefits from association with British economic interests. One British entrepreneur even claimed a little dubiously that he had employed Pancho Villa and found him an exemplary worker.[14]

An important consequence flowed from this: British interests, like American interests, were cocooned in a web of collaborative relationships that proved remarkably durable during the revolutionary upheaval. When foreign managers quit the Tampico oil fields at the time of the United States occupation of Veracruz, Mexican employees ran the industry without interruption. When rebels threatened the mining town of Cedral, the women of the town lined up and told the rebels to go away—which they did.[15] When insurgent peasants harassed a British-owned hacienda in Oaxaca "threatening to kill the administrator in order that they may proceed to divide up the property," the British owner, Mr. Woodhouse, was forced to flee but his wife

remained on the property, unmolested, since "by her charities she has much endeared herself to the Indians."[16] Such frequently neglected evidence of collaboration or clientelism must be set against evidence of xenophobia or "anti-imperialism," which is frequently exaggerated. If collaboration outweighed xenophobia, the very notion of a xenophobic revolution must be called into question.[17]

Collaboration was a two-way process. On the British side, businessmen worked hard to cement collaborative relationships with the President, the cabinet, state governors and, by no means the least important, the key local officials in the countryside, the *jefes políticos*. The classic, though not typical, instance was afforded by the Cowdray interests, which deserve a special mention. The Yorkshire entrepreneur Lord Cowdray—Weetman Pearson, as he was known prior to 1910—had built the Blackwall Tunnel under the Thames in London and the East River Tunnel in New York. He had also constructed railways in Spain and China, docks in Britain, Brazil, and Canada. In 1889 he came to Mexico and, at the behest of Porfirio Díaz, with whom he established a close personal relationship, he undertook the draining of the Valley of Mexico. Thus, he set out to complete the prodigious task begun nearly 300 years before by colonial engineers and dragooned Indians. It was a necessary task since the snake-eating eagle who, perched on a cactus on a marshy island in the middle of a lake, first bade the Aztecs to settle and build their capital, was a pretty poor judge of real estate. This aquiline error became all the more apparent as the teeming metropolis of late nineteenth-century Mexico City was recurrently flooded by the brackish waters of Lake Texcoco. In six years Pearson solved the problem by building the 29-mile Grand Canal. Subsequently, he completed several other major public works in Mexico, including the ports of Veracruz and Salina Cruz and a trans-isthmian railway that linked the Gulf and Pacific coasts. The railway briefly prospered until the Revolution, when the new Panama Canal undercut its business.

Then Pearson turned to oil, gambled £5m, and finally struck it rich with the huge Potrero strike in 1910.[18] During the years of Revolution, Pearson's Mexican Eagle Company racked up increasing output and profits. But by then the Pearson interests were coming under political pressure. Their relations with the old regime had been intimate. "We were almost considered a minor department of state," Cowdray recalled.[19] Pearson maintained close personal relations with Díaz and his family and offered the ousted dictator a retirement home in England. But Díaz sensibly opted for Biarritz and Paris; a little ironic, since he had made his name fighting the French in the 1860s. Pearson also distributed seats on the boards of his various companies to high-ranking Porfirians, and scattered his largesse yet wider. Although, a disingenuous British diplomat wrote, Pearson "probably never bribed any of the Mexicans,

he sometimes gave valuable presents and he appointed prominent Mexicans to positions which did not involve much work in his businesses."[20]

Come the Revolution, of course, Cowdray's intimacy with the old regime was a serious liability. He was alleged to have been pro-Díaz and, later, pro-Huerta. Even if exaggerated or unjustified, the latter allegation was logical, since Huerta sought, roughly speaking, a restoration of the Díaz regime. In particular, like most oil companies of the day, Cowdray's provided handy material for conspiracy theories. Just as Standard Oil had supposedly worked to overthrow Díaz and install Madero, so Cowdray's Mexican Eagle, a rival of Standard Oil's Mexican subsidiary, had worked to oust Madero and install Huerta. Ultimately, such allegations cannot be refuted since even before the days of the paper-shredder, good conspirators did not leave convincing evidence to hand. Still, my reading of the Cowdray papers, which finds corroboration in other business sources, is rather different. British companies certainly sought to keep in with Mexican *políticos* since business and politics were inseparable.[21] They also distributed favors and backhanders but they did not, and almost certainly could not, engage in the making and breaking of regimes. At best, or at worst, powerful foreign interests, such as the Anglo-American oil companies, could help make or break *local* regimes. That is, they had a say in who ruled the Huasteca, the oil-producing region inland from Tampico. Even there, however, they more usually responded to events beyond their control. Their supposed puppet and mercenary of the revolutionary period, Manuel Peláez, enjoyed a good deal of autonomy. He used the oil companies to raise cash just as they used him as a source of protection and as a lever against the central government.[22] Elsewhere, if we consider national regimes and lesser economic actors, the capacity of British or other private interests to influence the course of the Revolution was very limited. Rather than key players, they were passive victims or, given the shallowness of supposed revolutionary xenophobia, confused spectators.

The inability of British interests, even interests as powerful as Cowdray's, fundamentally to affect the course of the Revolution raises two questions that lead us to our second collective actor, namely, British officialdom, whether in Mexico or Whitehall. The questions are: [1] did business and government share similar ideas about the Revolution and the threats it posed to British interests? And, following from that, [2] did British interests enlist governmental help, lobby for British intervention of whatever kind, and thus establish the kind of effective union of business, government, and even military force that, according to conventional thinking, underlay "imperialism"?

The answer to the first question is, broadly speaking, yes. British businessmen and officials shared a common antipathy toward the Revolution. Their correspondence reveals alarm, hostility, and incomprehension. Certain themes were recurrent and worthy of note. The Revolution was readily equated with brigandage. Where today "terrorist" has become the all-purpose term

of opprobrium, then it was "brigand" or "bandit." Major revolutionary leaders were mere brigand leaders. No hope could be expected from a revolution led by such characters and manned by Mexican riff-raff. Mexicans had no capacity for self-government; to pursue it was a dangerous chimera. They needed a firm but benevolent despotism. As the British Chargé, Thomas Hohler, drawing on his ample imperial experience, patiently explained to Woodrow Wilson, the Mexican Indian, who comprised about 80 per cent of the population, resembled the Egyptian *fellahin* (note the parallel again): "people such as those needed a firm but benevolent hand: firmness to control them within the bounds of order and benevolence to educate them and elevate their moral standards."[23] Hohler was necessarily putting the case mildly since he was talking to President Wilson. In private, British estimates of the Mexican character were even more frankly racist and "imperial." Why attempt diplomacy with the Mexican, queried a British banker from Mazatlán, "as well talk diplomacy to a man-eating tiger who is attacking you as talk it to these half-civilized but conceited brute beasts;" by which he meant the ten per cent of educated Mexicans, whose "civilization is but a veneer." "The rest," he went on, "being the animals engaged in pure and simple robbery."[24] The solution for such savage people was the "iron hand," a tough authoritarian regime.

These British attitudes were hardly confined to the British. Many of the Mexican élite agreed that Mexico needed an iron hand, hence their support first for Díaz and then Huerta. British interests and their collaborating élites were of one mind, as British spokesmen sometimes admitted.[25] Many, perhaps most, Americans engaged in business in Mexico agreed. But some Americans dissented, and here the rift in "British and American attitudes" becomes apparent. The most obvious dissenters were Woodrow Wilson and his Secretary of State, William Jennings Bryan, who have received a pretty bad press in much of the literature on the Mexican Revolution.[26] To the disgust of the British, both businessmen and officials, and of many of their American counterparts (including, again, businessmen, State Department officials, and many United States politicians, even some within the Democratic cabinet), Wilson and Bryan saw the revolution as legitimate popular protest directed towards some valid political and even social goals. Thus, they saw Mexico somewhat as Lord John Russell had seen Italy fifty years before, as an oppressed people struggling to be free.

To Wilson and Bryan, it was the duty of the United States as a democratic society, born of an anti-colonial revolution, not to repress, intervene, or advocate the "iron hand," but to display sympathy with Mexicans' legitimate strivings for democracy and even social reform. Wilson and Bryan refused to recognize the military usurper Huerta, whom their Ambassador had helped install in power; they lent increasing support to his Constitutionalist enemies; they came round to the view (quite advanced for the time, and certainly out

of step with most foreign observers) that Mexico needed some kind of land distribution if popular grievances were to be satisfied. As Wilson told Hohler, "he knew of no instance in history in which political advance had been made by benefits from above; they all had to be gained by the efforts and the blood of the elements from below, of those who were struggling to be free and to acquire the enjoyment of their legitimate rights." Of course, the British were skeptical, even appalled. They saw Wilson conniving at revolutionary mayhem and upheaval. Hohler considered revolutionary plans for social reform "bosh"; the Mazatlan banker, cited above, denounced the President's "arrant humbug."[27] The Germans, who could hardly credit such half-baked idealism, concluded this was all a facade of Yankee hypocrisy, and that Wilson was deliberately encouraging the internal subversion of Mexico prior to an American take-over.[28]

We have here in Mexico in 1913–14 an interesting foretaste of the conflicting philosophies that would clash at Versailles five years later, as American idealism confronted European *Realpolitik* on a global stage. In France, American idealism came off worst. In the Mexican case, however, it enjoyed certain advantages. First, Mexico fell within the American orbit. No European power or even group of powers contemplated an intervention in Mexico in defiance of American wishes. Europe had to trail behind the United States, like it or not. As Arthur Nicolson minuted: "I confess that I do not see any way out of the Mexican imbroglio unless the United States propose some definite and positive line of policy in which other Powers could diplomatically cooperate."[29] But that did not happen, and the Europeans resigned themselves to witnessing the destruction of the old order in Mexico together with the old collaborating networks without being able to take effective action. At least, that was the official line.

The British Minister to Mexico, Lionel Carden, dissented. Appointed in 1913, just as Woodrow Wilson squared off against Huerta, Carden had a long record of service in Latin America (Mexico, Cuba, Guatemala), where he saw and regretted the rise of United States hegemony. United States intervention, he wrote to Sir Edward Grey, the Foreign Secretary, had harmed British interests and failed to help their supposed Latin beneficiaries.[30] The Americans, he told a German colleague (the British and Germans got on very well in Mexico prior to 1914), were "unscrupulous intriguers."[31] As Minister to Mexico, Carden backed Huerta, thereby offending the Americans, gratifying British businessmen, and making life difficult for the Foreign Office, which did not want to displease the Americans. In other words, Carden, like his United States counterpart Henry Lane Wilson, played something of a lone hand. Cecil Spring-Rice, the British Ambassador in Washington, who was desperately trying to appease the Americans, compared Carden's solo performance to that of Russian representatives in Persia, whose forward policies often contrasted with the reassurances emanating from St. Petersburg.

It was a rough example, in other words, of what David Fieldhouse denotes as sub-imperialism: expansion at the periphery in defiance of metropolitan restraint.[32] But Carden's rearguard action did little more than ruffle American feathers. The advice and support he lent Huerta could not save the Huerta regime, which was doomed not so much by external United States pressure as by internal Mexican opposition. When the revolutionaries triumphed in 1914, they promptly handed Carden his passport.

That coincided almost precisely with the outbreak of the First World War, an event that *confirmed* rather than *created* British deference towards the United States and British impotence in Mexico. Impotence still frustrated red-blooded Britons. In 1917 two British employees of the Aguila Company, one of whom happened to be a relative of Sir Henry Campbell-Bannerman, were killed in the rough, hot, violent country of the Isthmus. The British minister experienced the usual imperial outrage, but he could take no appropriate imperial action. The incident, he wrote, "call(s) attention to the deplorable extent to which the prestige of the white race has been allowed to sink in Mexico during the past few years." Events of this kind "would have been inconceivable in Mexico five years ago." Now, "the white man is the scorn and laughing stock of a vast number of Indians." Yet nothing could be done about it.[33] The Mexican government connived at anarchy; the United States government condoned it. Drawing on first-hand imperial experience, the Minister observed that in Africa such an event "would have raised a hue and cry throughout the Continent and resulted in a punitive expedition."

Plenty of Americans would have agreed. President Wilson did, of course, dispatch one punitive expedition, which did not prove very punitive. One of its officers, the young George Patton, excoriated the President for his pusillanimity, and for the pernickety restrictions that he placed on the expedition, limiting its operations and dooming it to failure. Wilson, Patton wrote to his father "has not the soul of a louse, nor the mind of a worm, nor the backbone of a jellyfish."[34] So there were frustrated red-blooded Americans, too. The important thing was that, even in 1919 when Senator Albert Fall's interventionist campaign coincided with the President's debilitating stroke, Wilson still set his face against armed intervention and refused to "solve" Mexico's "local crisis" by intervention, occupation, or a shift to formal empire. He would not go the way of Gladstone in Egypt or even McKinley in Cuba. For this, the pressure of the First World War was partly responsible. As Secretary of State Robert Lansing reasoned in 1915: "Germany desires to keep up the turmoil in Mexico until the United States is forced to intervene, therefore we must not intervene." No less important was the Wilsonian belief in democracy and self-determination, which predated the war and found its first major expression in his Mexican policy.[35]

Such a policy could not but shock British interests and officials, who deemed the revolutionaries to be wayward bandits, and the Mexicans to be

quite incapable of either representative government or social reform. British attitudes were strongly conditioned by imperial assumptions that Wilson, and many Americans, lacked.[36] Still we should note that there was a growing, though minority, opinion, exemplified by Theodore Roosevelt or Henry Cabot Lodge, which shared European imperial assumptions in general, and European disgust with Wilson's Mexican policy in particular. Of course, this Anglo-American divergence between, roughly, imperialism and self-determination continued. It resurfaced in Mexico in the 1930s, as I shall mention in conclusion; it was later evident in Churchill's misgivings about the terms of the Atlantic Charter and his feeling, shared by many Britons, that Franklin Roosevelt's ideas about India were sentimental and fatuous.[37]

If to Wilson the Mexican Revolution represented legitimate national strivings, to the British, businessmen and officials alike, it appeared a serious threat. The benign collaborative climate of the Porfiriato had given way to the squalls of social revolution, squalls which British observers, most of them admirers of empire and some of them veterans of empire-building, viewed through an imperial spyglass. Having served in St. Petersburg, Cairo, Tokyo, Addis Ababa and Constantinople (where he witnessed both the Armenian massacres and the Young Turk revolution) Hohler readily translated Mexico's confusing revolution into familiar categories. Mexican *peons*, he told President Wilson, were like Egyptian *fellahin*. Pancho Villa's career, he reported at one juncture, "is that of a dog in rabies, a mad Mullah, a Malay running amok."[38] And the revolutionary convention of Aguascalientes, a political gathering of central importance in the history of the Revolution, "resemble(d) nothing so much as the Parliament of monkeys described by Mr. Kipling in the Jungle Book."[39] Such imperial stereotypes were widely used by Europeans, less so by Americans, for obvious reasons. The British tended to see the old regime as one of congenial despotism, the new, if it was a regime at all, as one of banditry writ large. As such, it posed a major threat to foreigners and their property.

Here some interesting nuances are to be found. One aspect of the threat was physical. "To be a gringo in Mexico," as the American writer Ambrose Bierce put it, "ah, that was euthanasia."[40] Bloodcurdling stories of revolutionary massacre and mayhem were swapped in cafes, clubs, and consulates, especially in the great rumor-factory of Mexico City. As Zapata's insurgent *campesinos* extended their control over the neighboring state of Morelos, foreigners in the capital like foreigners in other major cities, witnessing the rising tide of rural insurrection, feared for their lives. The Zapatistas, wrote Rosa King, a British hotelier forced to evacuate her Cuernavaca hotel for the capital in 1914, were "savages [who] respect nothing and no person, man or woman." The Zapatistas, concluded a Foreign Office official who read Mrs. King's spine-chilling account, "act out of pure devilry."[41] Thomas Hohler, in conversation with Secretary of State Bryan,

raised the issue, "recount[ing] the various misdeeds and outrages of the bandits who infested the neighborhood" and painting a grim picture of what would happen if and when the bandit hordes poured into Mexico City. In such event, it was generally believed, Zapatista depredations would be enthusiastically seconded by "the criminal classes," another standard category of diplomatic analysis.[42]

Hohler was not alone. The diplomatic corps generally feared a repeat of the Peking siege. For the lugubrious Spanish Minister the fear was particularly acute since he had lived through the famous 55 days at Peking.[43] The British government specifically invoked the Peking precedent when it sanctioned sending arms to the British legation in Mexico City.[44] But Mexico City was not Peking, and the Zapatistas were not Boxers. Later in 1914, when Zapatista forces did enter the city, the population, Mexican and foreign, braced itself for the worst. Yet, Hohler observed, the Zapatistas seemed docile and even deferential, the "roughest of the rough" in appearance, but in practice "good-natured." No massacre ensued and the city remained tranquil under the "benevolent auspices of General Zapata."[45] Such rustic and popular rebels were perhaps not so bad after all. They lacked pretension, they knew their place, and they entertained no particular animosity towards foreigners, save the Spaniards. A similar transition affected Villa, the revolutionary scourge of the north. For years he had been pilloried as a bandit and menace. But with victory came familiarity and even acceptance. Villa, reported a surprised British consul, "is quite nice to talk to and takes a great interest in our war, expressing his desire for the Allies to win."[46] He was a man one could do business with.

This dawning realization had several causes. First, revolutionary mayhem had been greatly exaggerated, especially by city-based foreigners. Those in the rural hinterland, such as planters, miners, even some consuls, had a more realistic and less fearful attitude. Revolutionary xenophobia was, in fact, quite shallow and patchy. When it broke out it afflicted Spaniards, Mexicans, and Chinese far more than Britons or even Americans. In particular, popular peasant leaders like Villa and Zapata nursed few grievances against Anglo-American interests. Their aims tended to be parochial, political, and agrarian, rather than nationalist. In consequence, the brigands of yesterday became the potential *caudillos* of tomorow. Villa, in particular, suddenly became Porfirio Díaz *redivivus*, the man on horseback who could pacify war-torn Mexico, the *caudillo* risen from the rabble who, alone, could control the rabble.[47] To put it another way, British interests saw in Villa and Villismo a means to restore the shredded fabric of collaboration. That was quite plausible since Villa's treatment of foreign interests in his large northern domain was orderly and benign.

As it turned out, Villa and Zapata lost. They lost because they lost the crucial battles, not because foreign interests were aligned either with them or

against them.[48] But their defeat closed off one promising avenue of collaboration. Thus, from 1915 on, foreigners had to reckon with the victorious faction led by Carranza and Obregón. Again, an interesting turnabout took place. In earlier days the Carrancista leadership had seemed preferable to rowdy popular *caudillos* such as Villa and Zapata. Carranza, in particular, was a respectable, educated *político* of the old school. Obregón, if something of an upstart, was shrewd, literate, worldly and well-informed, a self-taught general. He won the crucial battles against Villa partly because he had absorbed the military lessons of the South African and First World Wars. Initially, therefore, these leaders seemed preferable. Once in power, however, they began to display an offensive nationalism. Unlike Villa or Zapata, Carranza, Obregón and their fellow-Carrancistas entertained a sort of blueprint for national reconstruction. While this did not call for the *expulsion* of foreign interests, it certainly involved their taxation and regulation, which were evident in the new nationalist provisions of the 1917 Constitution.

Foreign, including British, laments now changed key. It was not popular anarchy but nationalist reform that threatened British interests; not Boxer-like assaults on persons but "Bolshevist" attacks on property. The threat emanated, not from homespun peasant rebels, familiarity with whom had bred a certain paternalist contempt, but upstart revolutionary parvenus: petty lawyers, radical intellectuals, rabble-rousing revolutionary generals. These, one might say, were the *babus*[49] of the revolution: aspiring, "middle-class" reformers who dared challenge the "imperialist" interests on their own terms, with nationalist reforms and nation-building projects. A British consul compared two prominent politicians in Durango, 1918: one, Domingo Arrieta, was "an absolute *pelado* and yokel," an "unpretentious savage," illiterate and fond of "brutish pleasures," despite which, he was, said the consul, "an excellent friend," who "offers the great advantage of having no great ambition...gnawing at his vitals, nor socialistic craving to tear everything to pieces." Thus, he was "infinitely better than the demagogues, socialists, IWWs and Bolsheviki to whom, unfortunately, we are accustomed."[50] Typical of the latter was Gustavo Espinosa Mireles, a typical Mexican *babu*, "greatly proud of a certain amount of education in law, chiefly self-acquired," in appearance "not unlike a barber's assistant," but "swollen-headed," given to socialism, and sweet on the trade unions. (In fact, Espinosa went on to play a major part in the creation of Mexico's first big labor confederation, the CROM). Thus in Mexico, as in India or later in Africa, it was the urban nationalist, not the parochial peasant, who seemed most to threaten the status quo and, with it, the position of British interests.

The conflict which ensued between revolutionary *babus* and British interests was a long one, a war of gradual attrition rather than spectacular battles, which carries us beyond the initial period of armed revolution into

the second period of reconstruction. The oil industry was the chief issue since it was viewed by the new revolutionary regime as the outstanding foreign enclave: highly profitable, over-mighty, and defiant of Mexican sovereignty and well-being. The 1917 Constitution was devised in part to correct these abuses, by re-asserting Mexican control over Mexican resources. Through the 1920s and 1930s, government and oil companies sparred with each other, the government seeking to implement the nationalist provisions of the Constitution, the companies resisting what they termed expropriation. And while, in general, the Revolution and the First World War had served to increase United States economic preponderance in Mexico, the oil industry was a special case. New strikes in the 1930s favored the Aguila Company, Lord Cowdray's old enterprise, now a subsidiary of Royal Dutch Shell. The Aguila Company, aligned with the American companies, strenuously resisted the growth of the labor movement in the oil sector as well as the revolutionary government's recurrent attempts to regulate and tax the industry. Before mentioning the dramatic denouncement of 1938, it is worth remembering that the oil question, though it absorbed most British official attention, was only one manifestation of revolutionary policy. The British also reacted against revolutionary land distribution, labor legislation, educational reform, and anti-clericalism. As the first social revolution of the twentieth century, the Mexican Revolution confronted the major powers, Britain included, with a repertoire of reformist and nationalist policies that, by the 1940s and 1950s, would become standard features of Third World politics, with which the British and others had to reckon.[51]

The British reaction to the institutional revolution of the 1920s and 1930s displayed some clear continuities with prior reactions to the armed revolution. Old stereotypes survived, especially in Britain itself. When W. Osbaldeston Mitford left England in 1924 to join the British Legation in Mexico, he wrote that "the members of my Club...people...of considerable European travel, of a high standard of general education and tolerably well informed on world affairs" expressed their horror. "If you ever venture outside the capital," they warned him, "you will be made to occupy a cannibal's stewpot or be sacrificed on some pagan altar to an Indian god."[52] Britons *in* Mexico were better informed and usually more circumspect. Still, reformist policies were slighted and resisted. In 1923 the British Chargé was "33-ed" (expelled under the terms of article 33 of the Constitution) because of his intemperate criticism of the regime's agrarian reform. The British landowner Rosalie Evans embarked on a single-handed and quixotic crusade against "Bolshevik" agrarianism that led to her death in 1924.[53] In 1938 diplomatic relations were broken when Britain peremptorily protested the expropriation of the Aguila Company by Cárdenas. In a sense, the British Government could afford such rifts because Mexico now counted for less. British investment had shrunk, especially relative to that of the United States, and Britain's deference to

local American hegemony was even more marked. Moreover, there was no maverick like Carden to contest it. As a Mexican official put it in 1938: "as for England, it didn't have to be taken into account, it was clapped out, and everyone regarded it as a joke, seeing its old power in complete decline."[54]

Again, by contrast, enhanced United States hegemony did not necessarily make for greater intervention or overt control. During the First World War, the prime task of the United States ambassador was, in his own words, "to keep Mexico quiet" and to avoid entanglements, even if that meant tolerating Mexican snubs and excesses.[55] During the 1920s, revolutionary policies concerning land, oil, and the Church produced running diplomatic battles with the United States, but no armed intervention. Indeed, the United States sustained the regime in the critical days of 1923–24 and, through the agency of Ambassador Dwight Morrow, reached a cozy *modus vivendi* in the late 1920s. During the ideologically polarized 1930s, United States complaisance towards Mexico was, the British complained, even more marked. Faced with the most radical revolutionary administration to date, that of Cárdenas, the United States displayed an unusual tolerance, not only of sweeping agrarian reform, but even of the stunning oil expropriation of 1938. True, the United States stake in Mexican oil was now less than Britain's, and in material terms the United States surrendered less. But, more important, the United States was deeply concerned to maintain a stable and friendly regime south of the border at a time when the Axis threat was growing. The Roosevelt administration felt a certain kinship with the reformist regime of Cárdenas, a kinship that the Mexicans were at pains to emphasize.[56] While the British government responded to the importunities of the oil companies, Roosevelt spurned them.

Meanwhile, British officials and businessmen continued to display a certain imperial haughtiness. But with the revolutionary regime well established, and Britain's global position severely eroded since the 1900s, that haughtiness was less pronounced and pervasive. After the British Chargé had been "33-ed," his successor, Sir Esmond Ovey, adopted a more conciliatory approach, aligning himself, to the disgust of some British interests, with Dwight Morrow's policy of detente. During the 1930s, official British reports from Mexico occasionally expressed some comprehension of and even sympathy for Cárdenas' reformist policies. They appeared to work, they were not mere demagogy.[57] An Aguila Company manager sensibly suggested that his company should try to accommodate rather than to stonewall Mexican nationalist measures, for which he was berated by Sir Henri Deterding, Royal Dutch Shell's quasi-fascist boss, for being "half a Bolshevik." Deterding, the same manager explained, belonged to the old school, which "was incapable of conceiving of Mexico as anything but a Colonial government to which you simply dictated orders."[58] In general, therefore, British officials and businessmen in Mexico somewhat softened their strident anti-revolutionary

stance. They had to live with the Revolution, even if they disliked it. In contrast, Americans like Ambassador Josephus Daniels went out of their way to embrace it. In British eyes, Daniels protested expropriations of American property feebly; he accepted the legality of the oil seizure; worst of all, he enthusiastically attended President Cárdenas at teetotal and tuxedo-less diplomatic receptions and accompanied the president on his endless train journeys through the country. These journeys involved hot, hard, and, again, teetotal travel through the Mexican backlands that appalled foreign diplomats. Daniels and his wife were even seen to don Indian dress and to join in folkloric Indian dances.[59]

With the 1938 oil expropriation, British and United States perceptions diverged. Official minds differed; the old rift was again revealed. The British government, more concerned for Middle Eastern than for Mexican oil, took a strong line and lamented American feebleness. The British could risk a rupture, which is what they got. Mexico was sacrificed for the greater good of a declining empire. The United States, viewing Mexico as geopolitically crucial, was ready—and in the persons of Roosevelt, Daniels, and other New Dealers quite *keen*—to collaborate with the reformist but strenuously anti-fascist Cárdenas. The polarization of the 1910s was thus repeated (*mutatis mutandis*) twenty years later. Again, a liberal Democratic United States administration, sympathetic to reform and worried about German-Japanese ambitions, gave Mexico an easy ride and did not crack the whip over its wayward neighbor as the British had wanted. The rift that had fractured British and American attitudes towards revolutionary Mexico since 1910 thus remained, indicative of the contrasting "official minds" in Whitehall and Washington.

Things changed after 1938 as Mexican policy moderated and the Revolution ran out of steam. The British lost an empire, and, if they did not find a role, they acquired a greater understanding of Third World nationalism. Meanwhile, the United States emerged as a global superpower, its sympathy for reform, self-determination, and popular revolution blighted by the chills of the Cold War. Mexico's revolutionaries were fortunate that they waged their Revolution not only within the American rather than the British sphere of influence, but also during the era of Wilson and Roosevelt, before the American Republic became, in Raymond Aron's phrase, the Imperial Republic.

Fall Semester 1988

NOTES

1. J. Gallagher and R. Robinson, "The Imperialism of Free Trade," *Economic History Review*, 6, 1 (1953).

2. Ronald Robinson and John Gallagher with Alice Denny, *Africa and the Victorians* (London, 1961), ch. 5.

3. On British interests in Porfirian Mexico see Alfred P. Tischendorf, *Great Britain and Mexico in the Era of Porfirio Díaz* (Durham, N. C., 1961); and Lorenzo Meyer, *Su majestad británica contra la revolución mexicana, 1900-1950* (Mexico, 1991), ch. 2.

4. The degree and character of the nationalist challenge is open to debate. John Hart, *Revolutionary Mexico* (Berkeley, 1987), sees the Revolution a war of national liberation. Others would place less emphasis on this aspect.

5. Again, this is open to debate. Meyer, *Su majestad británica*, offers the best synthesis on British policy. Friedrich Katz, *The Secret War in Mexico* (Chicago, 1981), and P.A.R. Calvert, *The Mexican Revolution, 1910-14: The Diplomacy of Anglo-American Conflict*, locate British policy within an international context and provide abundant documentary evidence.

6. On the overburdening of Britain—Joseph Chamberlain's "weary Titan"—and the deference towards the United States that this encouraged, see Paul Kennedy, *The Realities Behind Diplomacy* (London, 1981), pp. 34-35, 107-08, 118-19; with regard to Mexico, see Esperanza Duran, *Guerra y revolución? Las grandes potencias y Mexico 1914-18* (Mexico, 1985), pp. 91-100.

7. Channing Arnold and Frederick J. Frost, *The American Egypt: a Record of Travels in Yucatán* (London, 1909). The British Minister in Mexico City, observing the "local crisis" as it peaked in late 1914, and lamenting United States inactivity, explicitly drew the parallel: "Mexico is frequently termed the Egypt of America, but it is on this point that the analogy entirely breaks down." Hohler, 11 Nov. 1914, FO 371/2032/79839.

8. "Cuba-izing" Mexico was one way of putting it: for example, U.S. Ambassador Walter Hines Page, London, to Col. Edward House, 27 April 1914, in Burton J. Hendrick, *The Life and Letters of Walter H. Page*, 3 vols. (London, 1924), vol. 1, p. 230.

9. The term derives from Robinson and Gallagher, *Africa and the Victorians*, pp. 19-21; cf. Kennedy, *The Realities Behind Diplomacy*, pp. 59-65.

10. Katz, *The Secret War*, conveys the atmosphere well. On British neglect of the northern revolutionaries, see Meyer, *Su majestad británica*, p. 129.

11. For example, the British oil companies complained about losing their German employees at the outbreak of war in 1914; more significantly, three years later Lord Cowdray along with other British economic interests favored recognizing the Carranza government in the interests of local stability while the Foreign Office demurred and had to be won round. Katz, *Secret War*, pp. 471-72; Jonathan C. Brown, *Oil and Revolution in Mexico* (Berkeley, 1993), pp. 146, 246.

12. Ronald Robinson, "Non-European Foundations of European Imperialism: Sketch for a Theory of Collaboration," in Roger Owen and Bob Sutcliffe (eds.), *Studies in the Theory of Imperialism* (London, 1972), pp. 120-23.

13. Alan Knight, *The Mexican Revolution*, 2 vols. (Cambridge, 1986), 1, p. 8.

14. Percy N. Furber, *I Took Chances From Windjammers to Jets* (Leicester, 1954), p. 109.

15. Reports of Consuls Miller, Tampico, 21 May 1914, and Bonney, San Luis Potosí, 30 Aug. 1915, National Archives, Record Group 39, State Department, Decimal File, 812.00/12346, 16135.

16. Knight, *Mexican Revolution*, 1, pp. 346-7.

17. That, at least, is in my opinion. Alan Knight, *US-Mexican Relations, 1910-40: An Interpretation* (UCSD, La Jolla, 1987), ch. 4.

18. Brown, *Oil and Revolution in Mexico*, pp. 47-70.

19. Memorandum of conversation between Cowdray and Walter Hines Page, 9 Jan. 1914, Cowdray Papers, Box A4.

20. Thomas Beaumont Hohler, *Diplomatic Petrel* (London, 1942), p. 173. Note also Brown, *Oil and Revolution*, p. 54.

21. Brown, *Oil and Revolution*, pp. 89-90, and David W. Walker, *Kinship, Business and Politics: The Martínez del Río Family in Mexico* (Austin, 1986), stress the politicized nature of the Mexican economy.

22. On Peláez, see Brown, *Oil and Revolution*, pp. 74, 252-306; and Knight, *Mexican Revolution*, 2, pp. 201-02, 383-89.

23. Memorandum of meeting between Hohler and Wilson, 11 Feb. 1914, FO 371/2025/8667. Cf. the comments of Reginald Tower, British Minister to Mexico, on the feeble mental endowments of Mexican Indians: Meyer, *Su majestad británica*, p. 71.

24. F. Goodchild to W. Hearn, 18 Dec. 1913, FO 371/2025/4058. See also Meyer, *Su majestad británica* , pp. 117, 130.

25. George Richardson of the Tlahualilo Cotton Estates lamented that, with the spread of the revolution in 1913-14, all the "better classes" had fled the Laguna region—"that is, all whom we were accustomed to know and do business with." Letter enclosed in Benson to Grey, 13 March 1914, FO 371/2025/11732. Grey concluded, on the basis of British reports, that "though many people in Mexico disliked Huerta, if they had to choose between Villa and Huerta as alternatives, they would prefer Huerta." Grey to Spring-Rice, 13 March 1914, FO 371/2025/12029.

26. For example, Kenneth J. Grieb, *The United States and Huerta* (Lincoln, Nebraska, 1969).

27. Hohler memorandum, Feb. 1914, FO 371/2025/8667; F. Goodchild to W. Hearn, 18 Dec. 1913, FO 371/2025/4058.

28. Spring-Rice to Grey, 23 Jan. 1914, FO 371/2025/5205, reports that the German military attaché had concluded that the United States government "had worked out a complete plan for the invasion and occupation of Mexico," its ostensibly moral diplomacy serving merely as a device to make intervention "a necessity and even a popular necessity." Spring-Rice's own (reasonable) opinion was that this was "to interpret American policy in terms of the German General Staff." See also Katz, *Secret War*, pp. 181-82.

29. Nicolson minute, 30 Jan. 1914, FO 371/2025/4117. On reluctant British deference to the United States over Mexico, see also Meyer, *Su majestad británica*, p. 143.

30. Calvert, *The Mexican Revolution*, pp. 220-21.

31. Katz, *Secret War*, pp. 171-72.

32. David Fieldhouse, *Economics and Empire, 1830-1914* (London, 1973), pp. 80-81.

33. Thurstan, Mexico City, 20 March 1917, FO 371/2966/88967.

34. George Patton to Papa, 28 Sept. 1916, Patton Papers, Library of Congress, Box 8.

35. Lansing Memorandum, 10 Oct. 1915, Lansing Papers, Confidential Notes and Memoranda, Library of Congress, vol. 1. There is a massive literature on Wilsonian diplomacy. The continuity of "liberal anti-imperialism" from Mexico to Versailles is stressed by N. Gordon Levin, *Woodrow Wilson and World Politics* (Oxford, 1962).

36. This is not to say that Wilson and most of the U.S. political establishment lacked racist assumptions: racism was not uniquely tied to imperialism, and racist critiques of imperialism

had a long pedigree. The argument that the United States could not afford to incorporate several million racially inferior Mexicans was deployed against intervention and annexation in both 1848 and 1914. Frederick Merk, *Manifest Destiny and Mission in American History* (New York, 1963), pp. 191-92, 247; Knight, *Mexican Revolution*, 2, pp. 154-55. Similarly, FDR's anti-imperialism was quite compatible with a dose of racism. Christopher Thorne, *Allies of a Kind* (Oxford, 1978), pp. 6-7.

37. Wm. Roger Louis, *Imperialism at Bay, 1941-1945* (Oxford, 1977), pp. 9, 121-22.

38. Hohler memorandum, 11 Feb. 1914, FO 371/2025/8667.

39. Hohler, Mexico City, 20 Oct. 1914, FO 371/2031/68897; 11 Jan. 1917, 371/2959/41521.

40. Ronald Atkin, *Revolution! Mexico, 1910-20* (London, 1969), p. 175.

41. Hohler, Mexico City, 2 Nov. 1914, FO 371/2031/76893.

42. In Spring-Rice to Grey, 7 Feb. 1914, FO 371/2025/7144.

43. Calvert, *Mexican Revolution*, p. 136. On the diplomats' "Pekin paranoia" see also Calvert, p. 125; Meyer, *Su majestad británica*, p. 152; Knight, *Mexican Revolution*, 2, pp. 40-41, 170.

44. Grey to Spring-Rice, 11 Feb. 1914, FO 371/2025/6537.

45. Hohler, Mexico City, 23 Nov., 8 Dec. 1914, FO 371/2032/85296/87594.

46. Caldwell, Zacatecas, 22 Oct. 1914, FO 371/2031/71957.

47. A similar recasting of roles had been evident in the case of the other great Chihuahuan revolutionary *caudillo*, Pascual Orozco, in 1911-12. Knight, *Mexican Revolution*, 1, pp. 290, 297-79.

48. That, at least, is my conclusion. For a different point of view, vigorously argued, see Hart, *Revolutionary Mexico*, ch. 9.

49. On the "*babu* explosion"—the growth of a Western-educated middle class, "fired with a new sense of identity and capacity to participate in the government of their country"—and the scornful British reaction, see Judith Brown, *Modern India* (Oxford, 1985), pp. 122-23.

50. Knight, *Mexican Revolution*, 2, pp. 484-85.

51. Robert Freeman Smith, *The United States and Revolutionary Nationalism in Mexico, 1916-32* (Chicago, 1972).

52. W. J. Osbaldeston-Mitford, *Dawn Breaks in Mexico* (London, 1945), pp. 5-6.

53. Rosalie Evans, *The Rosalie Evans Letters From Mexico*, ed. Daisy Caden Pettus (Indianapolis, 1926). Tim Henderson of the University of North Carolina, Chapel Hill, is completing a doctoral dissertation, which will unravel this interesting case.

54. "Ya que a Inglaterra no se le podía tomar en cuenta porque 'no soplaba' (palabras textuales) y todo el mundo se mofaba de ella, al ver su antiguo poderío en completo ocaso": quoted by Gobernación agent PS-12 (Jesús González Valencia), 24 March 1938, in Dirección General de Información Política y Social, Archivo General de la Nación, Mexico City, *caja* 4.

55. Smith, *United States and Revolutionary Nationalism*, p. 93.

56. Mexican government lobbying in Washington may have mushroomed in recent years, but it is not, of course, a new phenomenon. Luis Cabrera, during 1913-14, played an important role in moulding Woodrow Wilson's conception of the Revolution as a legitimate movement of social reform (Knight, *Mexican Revolution*, 2, pp. 139-40). In the wake of the 1938 oil expropriation Ramón Beteta proved an assiduous lobbyist for the Cárdenas government (see the presidential archive in the AGN, legajo 432.2/253-9, legajo 3).

57. See, for example, the report on the Laguna ejidos by vice-consul Dutton-Pegram, Torreón, 4 Jan. 1939, FO 723/172.

58. J. Murray, Mexico City, quoting Assheton of the Aguila Company, 17 Sept. 1935, FO 371/18708/8586.

59. E. David Cronon, *Josephus Daniels in Mexico* (Madison, 1960).

21

Welsh Nationalism

KENNETH O. MORGAN

The famous English detective, Sherlock Holmes, once solved a murder mystery by investigating "the dog that did not bark." In the historiography of Britain, one of the dogs that seldom barks—indeed, sometimes does not even wag its tail—is nationalism. Historians of France, Germany or Italy in my country are well aware of the enduring force of nationalism amongst those, perhaps more excitable, peoples. Even American nationalism is a theme that has captured increasing historical attention from the Spanish-American War of 1898 onwards. But nationalism in British history is infrequently accorded such central attention.

Yet it is beyond question that modern British history contains at least two broad categories of nationalism, two forces for integration and for diversity, often in conflict with each other. As a Welsh-speaking British citizen, I have been well aware of both throughout my own life. These forces are, on the one hand, the broad thrust of British nationalism focusing on the sovereignty of the Crown in Parliament, and on the other the countervailing national identities of Ireland, Scotland, and Wales. There is also the little-noticed historical phenomenon of *English* nationalism, which has tended to subsume the broader history of the United Kingdom of Great Britain and Ireland as it existed from 1800 onwards. At Oxford, as a university student in the fifties, I studied English history from the bulky volumes of the Oxford History of England (with a few glancing examinations of fringe territories such as Wales, Scotland, the Isle of Man and the Channel Islands). I was prescribed reading material from *The English Historical Review*. (The *Welsh History Review*, which I have myself edited since 1965, did not exist when I was a student, but I doubt very much if Oxford would have deigned to notice it if it had). The terms 'English' and 'British' were used interchangeably. This tradition had, after all, a long antiquity, since it went back at least to the Venerable Bede's distinctly nationalistic history of the English Church, completed in A.D. 731. When it emerged that I intended to write my doctoral

thesis on recent Welsh socio-political history, this was regarded as an endearing eccentricity.

Over the past thirty years or so, however, there has been a considerable change of perspective amongst British historians. It amounts to the virtual rediscovery of Britain, with the Celtic nations of Ireland, Scotland and Wales given due prominence for the first time. Historians in Britain have now become aware of what scholars like Oscar Handlin taught the American reading public almost two generations back: that British history, our island story, is in fact a story of continuous invasion and absorption, of ethnic and cultural pluralism.

There are, as I have suggested, two major conflicting themes in all this. There is first the emergence of the idea of British nationalism. From the time of its invasion by William the Conqueror in 1066, England has always been an unusually centralized country, directed from Westminster and then Whitehall. This is very apparent in current debates in Britain over the virtues or otherwise of a federal Europe, with continental Europeans seeing federalism as something that diffuses power and reinforces pluralism and subsidiarity, and the English tending to see the federal ideal rather as a form of national surrender, an external threat taking power away from their own governmental and legal system. This centralist outlook has been reinforced by the Act of Union with Wales under King Henry VIII in 1536, and later by the Acts of Union with Scotland in 1707 and, finally, with Ireland in 1800.

During the course of the eighteenth century, this centralized, insular view of the British Isles transformed itself into more specific theory of British nationalism. This was the product, variously, of the threat of foreign invasion fortified by the Jacobite incursions of 1715 and 1745, and by the constant rivalry presented by the French; of the defense of native Protestantism after the successful expulsion of the Catholic "tyrant" James II in the Glorious Revolution of 1688; and of Britain's world-wide trading and maritime role, which kept it distinct and apart from the territorial and dynastic rivalries of continental Europe, or so it was believed. Especially was this British nationalism reinforced by the long years of warfare with the French during the Revolutionary and Napoleonic Wars, and of course by the successful military and naval outcomes that resulted. In the nineteenth century, this broadened out into the cult of imperialism, in due time focusing on the somewhat improbable symbol of the "widow at Windsor," Queen Victoria, and reaching its heady climax at the time of her Golden and Diamond Jubilees at the end of the century.

But there was also another force in the making. From at least the end of the eighteenth century, there existed the simultaneous awareness of the distinct Irish, Scottish and Welsh components of this rising British nationalism. In economic expansion, in military achievement, in missionary activity overseas, the Irish, Scottish and Welsh elements of this British identity were also

increasingly recognized by writers, by popular publicists and by politicians. At the end of the nineteenth century, the cities of Belfast, Glasgow and Cardiff enjoyed a dual eminence. They were great imperial ports, centers of international trade, finance and industrial growth. And they were also the proud metropolitan centers of their own national and regional heartlands in Ulster, Clydeside and South Wales.

The national awareness of the Irish and Scots on the one hand, and the Welsh on the other, were different in character. Ireland and Scotland had been, after all, separate countries. They had known political unity of a kind even if that of Ireland had been complicated by English (or Anglo-Norman) penetration since the time of Strongbow. The Irish Act of Union dated from as recently as 1800. In any case, the formal union of the Irish with the British system of government was accompanied by an increasingly powerful, and ever more separatist nationalist movement there, from the time of Wolfe Tone in the 1790s and Daniel O'Connell in the 1820s onwards. The Irish Nationalist Party emerged as a powerful force in the 1870s, headed by Charles Stewart Parnell. By the 1880s, fortified by the emergence of a kind of sub-nationalism in Protestant Ulster, the question of Irish Home Rule produced an immense crisis of empire that went to the very heart of relations between the Irish people (more particularly, the overwhelmingly Catholic population in the 26 counties away from the north-east of the island) and the United Kingdom as a whole.

Scotland, too, had an acknowledged national status. Even after the Act of Union in 1707, even after the suppression of the final Jacobite uprising on the battlefield of Culloden in 1746, it retained important badges of national identity. The Presbyterian Church, not the Anglican, was the established religious institution. Scotland's legal system and professional structure remained quite separate from England's. So, too, did its educational system, from its thriving and relatively democratic school system to its universities, several of which vied with Oxford and Cambridge for antiquity. Scottish banks issued their own legal tender. It was not altogether surprising that, after pressure from Lord Rosebery and others, a Scottish Secretaryship of State was created in 1885 as a post in the British Cabinet. More generally, in a subtle admixture of Tory realism and romanticized legend, the writings of Sir Walter Scott kept the distinct national identity, culture and history of Scotland in the forefront of the awareness of the literary and intellectual world.

Wales, however, was always different, always a poor relation. It suffered from a kind of inbred inferiority complex. It had no Parnell or Walter Scott to terrify or beguile its English neighbor. It had never known political unity. Its fragmented princedoms were conquered by Edward I as long ago as 1282; his crumbling castles, from Conway in the north to Caerphilly in the south, remained as ancient symbols of occupation and suppression. In 1536 and

1543 Wales was formally incorporated by Henry VIII into the governmental system of England. Since the Tudors were a Welsh (or "British") dynasty, most of the Welsh seem to have accepted this absorption without demur. Indeed it was a Welshman, John Dee, operating in the reign of Elizabeth I, who cheerfully coined the term "The British Empire." And yet, throughout the centuries, the Welsh kept their identity alive, above all through their native language and through a powerful vernacular literature, secular and religious. The translation of the Bible into Welsh in 1588 was an immensely powerful force. With the spread of Puritanism and later Methodism, this meant that the chapels were able to keep the Welsh language alive in forms of popular worship, in marked contrast to the experience of Catholic Ireland or (beyond the more distant areas of the Highlands) Presbyterian Scotland. It was the people's language.

In the nineteenth century, that age of nationhood, Welsh national identity was given two powerful new forms of impetus. The first was the dramatic expansion of industrialism, initially in the ironworks on the rim of the valleys around Merthyr Tydfil, then in the massive growth of the mining communities to the south, and later the great coastal entrepôts of Swansea, Barry, Newport and especially Cardiff. This created new towns, new wealth, new bases for the social, cultural and religious life of Wales, new sources of employment. The surplus population of the poorer countryside in the hinterland of north, central and west Wales could find economic opportunity within their own land, instead of being forced into impoverishment or overseas emigration as was the case with the rural Irish peasantry. The second factor was religious nonconformity, the Methodists (both Calvinist and Wesleyan), the Congregationalists and the Baptists, who formed almost a unified popular religion which spread like wildfire into the industrial valleys, and took root in the more settled rural communities. By the time of the religious census of 1851, of those Welsh people at places of worship on census Sunday, some 80 per cent were at nonconformist chapels, and barely 20 per cent at the churches of the established Church of England in Wales. Nonconformity in Wales in the nineteenth century thus became a uniquely powerful force for cultural expression, educational advance, political challenge and social protest. Every major new development in Welsh history between 1850 and 1914 stemmed, directly or indirectly, from the power of the nonconformist chapels. They were, at least for a time, a unique voice of Welsh national identity.

Welsh national awareness, then, is *sui generis*. It never enjoyed the unique institutional focus and historic prestige of Scottish nationality. Nor did it experience the enduring, and increasingly violent, conflicts of modern Irish history, including especially the sectarian confrontations within the north of Ireland. The Welsh got off to a humbler start than the Scots; they have been invariably more peaceable (other than on the rugby field) than their Irish neighbors. But, to an increasing degree in the last 200 years, ever since the

eccentric *litterateur* and patriot, Iolo Morgannwg, invented the rites and runes of the Welsh national *eisteddfod* in response to the Jacobite passions kindled during the Revolutionary Wars with France, Wales has been as fiercely aware of national identity as any part of the United Kingdom. Their distinct history is an important part of the history of modern Britain, modern Europe, and the modern world, and of the self-consciousness of Welsh people like myself who have lived through its recent apotheosis.

II

The movement for Welsh national awareness has, historically, undergone three separate periods of development—the years from the mid-nineteenth century to the First World War, a great and creative era of national achievement; the years from the 1920s to the 1960s, a time of integration and unionism; and the period since the mid-1960s, years of a revived, if modest, nationalist outlook. Each of these three periods needs to be clearly identified and understood.

The first, as I have noted, was that from about 1860 to the end of the First World War in 1918. Until then, claims for Welsh national identity had been regarded with derision. Symbolically, the *Encyclopedia Britannica* carried the famous entry, "For Wales—see England." A Welsh Bishop dismissed Wales as merely "a geographic expression," much as Metternich had done for Italy prior to its unification in 1861.

The national upsurge that followed was, basically, a product of democracy. The huge expansion of the franchise (to men, at least) in 1867 and 1884 made Wales a political democracy and a stronghold of British radicalism, which it remains to the present time. Its demands for equality, religious, social and national, were spearheaded by middle-class, mainly professional Liberals, who straddled the principality from Anglesey in the far north to Cardiff on the Bristol Channel. Much of it was rooted in rural, Welsh-speaking Wales in a way that evokes the language and ethos of the rural Populism of the US Mid-West and South at the same period. I sometimes think I would like to have heard William Jennings Bryan's "Cross of Gold" speech at the Democratic Convention of 1896 translated into Welsh!

Wales from the 1870s onwards, therefore, was galvanized by a new national program. It was headed, significantly enough, by the demand for the disestablishment and disendowment of the Church of England in Wales; by pressure for a popular system of primary, secondary and higher education; by demands for land reform to grant security of tenure to nonconformist tenant farmers at the mercy of their Anglican landlords; and by Sabbatarian and temperance legislation. Welsh radicals denounced "the unholy Trinity"

of "the Bishop, the brewer and the squire." There sprang up dynamic young national leaders, an élite generation of nationally-minded Liberals, including Tom Ellis, the son of a Merioneth tenant farmer, D. A. Thomas, later a powerful coal tycoon, and the most famous of them all, David Lloyd George, brought up in a shoemaker's cottage and eventually to serve for almost six years as Great Britain's Prime Minister and a great world statesman. The politicians of the time, Gladstone foremost among them, were forced to listen to them, and they achieved several notable triumphs. Foremost among them was the creation of the distinct non-sectarian Welsh secondary education system in 1889, followed closely in 1893 by the establishment of a federal University of Wales, a unique symbol of Welsh identity of which I have the honor to be the Vice-Chancellor at the present time. Education has always provided an avenue of opportunity for the Welsh: Lloyd George and Dylan Thomas, different in every other respect, were the sons of schoolmasters. Richard Burton was another beneficiary.

These public achievements coincided with a powerful literary and cultural upsurge in Wales, typical of many developments amongst what Marx called the "unhistoric nations" of south-eastern and central Europe at that time, or western European "regions" like Provence or Catalonia. The music of Smetana and Dvorak struck up many a chord amongst the Welsh, as did the liberationist message of European leaders like Kossuth, Garibaldi and (especially) Giuseppe Mazzini. The end of the nineteenth century also saw a new scholarly concern with the structure and grammar of the Welsh language, focused on the work of John Morris-Jones, a professor at Bangor. There followed a new serious interest in Welsh history, significantly concentrating on the history of a purportedly independent Wales before the English conquest in 1282, as in the writings of Sir John E. Lloyd. Another feature of the period was the revived interest in the popular annual folk festival, the national *eisteddfod*, partly through an upsurge in choral music, partly through the fine Welsh-language strict-metre and lyrical poetry of men like Thomas Gwynn Jones and later Thomas Parry-Williams. The great-uncle of Dylan Marlais Thomas, a poet known as Gwilym Marlais, was a noted *eisteddfodic* bard. In the 1900s, Welsh poetry enjoyed a glorious high noon, without equal in the previous thousand years.

Welsh culture now had its physical landmarks as well—the National Museum at Cardiff; the National Library in Aberystwyth; and, of course, the federal University of Wales, comprehending colleges at Bangor, Aberystwyth and Cardiff, and shortly Swansea. At a more popular level, the Welsh rugby football team became a unique symbol of national achievement, while its international matches were preceded by fervent singing of the national anthem, *Hen Wlad fy Nhadau* (Land of my Fathers), one of the more successful such refrains of the period. The new vitality of Wales in politics and in the industrial expansion of the late-nineteenth century was thus

reinforced by the increased vigor of the native language and its literary culture in poetry and (to a lesser degree) prose. Ironically, this new life for the language came at a time when the linguistic censuses of 1891 and 1901 showed clearly what many had long suspected, namely that the coming of industry and the advent of mass immigration from England and elsewhere, were beginning to dominate the speaking of Welsh. At the dawn of the twentieth century, less than a half of the Welsh people spoke Welsh with any regularity, even if it was better and richer Welsh than ever before.

At the end of the nineteenth century and the years to 1914, Wales showed all the signs of a national awakening. Its youthful, patriotic spokesmen referred to themselves as *Cymru Fydd*, Young Wales, on the lines of the Young Irish or Young Italians. The press in both languages was suffused with a kind of patriotism capable of being harmonized with a wider British nationalism or imperialism. The process appeared to reach a climax during the First World War when David Lloyd George, the most celebrated of the new breed of Welsh politicians, succeeded Asquith as Prime Minister in December 1916 and stayed in power for nearly six years to become (in the view of the partisan Welsh press) "the man who won the war." In 10 Downing Street, he was surrounded by a veritable Welsh Mafia, advisers like Thomas Jones, J. T. Davies and John Rowlands of his private entourage in the Cabinet Secretariat and in his own prime minister's secretariat, the so-called "garden suburb." It was noticeable in 1914–16 that there was an unusually high rate of recruitment in the army amongst the Welsh population, despite the anti-war or socialist sentiment powerful amongst the Welsh miners. Dissenters or conscientious objectors received unsympathetic treatment. Indeed, in some ways, Lloyd George seemed to be directing a war fought for Welsh values in defense of what he called at the Queen's Hall in September 1914—"the little five-foot-five nations." He and his countrymen extolled "gallant little Belgium" and no less gallant little Serbia and Montenegro. It did not take an enormous flight of the imagination to see the cause embracing "gallant little Wales," as the nation and the Empire were led by what the Welsh press called "the greatest Welshman yet born."

Yet it was the First World War that marked the end of this first phase of Welsh national awareness. After all, in Wales and unlike Ireland, movements for national self-assertiveness seldom took the form of separatism. There was a half-hearted movement for modified Welsh home rule in the 1894–96 period, spearheaded by the youthful Lloyd George himself. In fact, it collapsed, essentially through the gulf between Welsh-speaking rural Wales and anglicized industrial and urban south Wales, perhaps also between localized Welsh sentiment and a broad commitment to British Liberalism. In January 1896 the movement for Welsh home Rule, *Cymru Fydd* or "the Wales that is to be," broke up. Nothing like it was to emerge again for almost another 100 years. Swansea, the location of Dylan Thomas's "two-tongued

sea," was a powerful stronghold of antagonism to separatism. So too were the great ports of Barry, Cardiff and Newport, and most of the growing and economically thriving parts of the land. Welsh home rule, unlike Irish, was never much of a cause: it never achieved the nationwide support for the disestablishment of the Church. What the Welsh wanted was not national exclusion, but national equality, a place in the sun, its own distinct status within the broader polity of Great Britain and its world-wide empire. Ambitious politicians like Lloyd George sought fame at Westminster, not the local security of the parish pump. By 1914, most of the historic objectives of Welsh Liberalism were close to being attained. The First World War, with its powerful integrative consequences, therefore, saw the effective end of the first great phase of Welsh national awareness. Lloyd George himself became marginalized as the voice of pre-1914 Liberal Wales. When the Welsh Church was indeed disestablished in 1920, just after the war, it was greeted almost with boredom. The concerns of Welsh people had moved on, and their first national movement had run its course.

The second phase in this process lasted from the end of the war down to the mid-1960s. This was a period of unionism and almost total absorption in the British political culture. Lloyd George was now a declining force. He lived with his mistress in middle-class Surrey; in any case his interests had moved on far beyond the national themes of the Wales of his youth. The granting of independence to the Irish Free State in early 1922 attracted comparatively little fellow-felling amongst the Welsh. Welsh life now was dominated largely by the clash between capital and labor. This is the era immortalized by Richard Llewellyn's *How Green Was My Valley*, and a generation of novelists from Jack Jones to Gwyn Thomas. Its politics and social aspirations were shaped by the trade unions (the Miners' Federation above all) and by the Labour Party in local and in parliamentary elections, especially in the industrial valleys of the south. Its religion was socialism, not populist nonconformity. Young men like Aneurin Bevan of Tredegar or James Griffiths of Ammanford represented a new political élite, products of the Labour Party, the mining union and the Marxist Central Labour College, whose objectives were far more cosmic that were those of pre-war middle-class Liberalism.

In the pre-war years, the early Labour Party, and especially the socialist Independent Labour Party, had been relatively sympathetic to Welsh and Scottish national claims and to ideas of local devolution and accountability. They acted as a counter to the centralizing ethos of the London-based Fabians such as Sidney and Beatrice Webb. Keir Hardie, first chairman of the parliamentary Labour Party and member of parliament for Merthyr Tydfil from 1900 to 1915, had favored uniting "the Red Dragon and the Red Flag." The First World War, with its encouragement to small national units throughout Europe, including such hybrids as Yugoslavia and

Czechoslovakia, took this process further. In the world of industrial unionism, pressures for local control of the mines and factories rather than for state nationalization directed from London, were powerful amongst the syndicalists of the Plebs League and the Unofficial Reform Committee in the Rhondda valley, as they were amongst the Scots of Clydeside.

But by the end of the First World War, the Welsh working class was absorbed by the class struggle of capital versus labor. Episodes like the miners' strikes of 1921 and 1926 and the General Strike of 1926 reinforced this mood of class solidarity. Hatred of the coal owners, disgust at the strike-breaking methods of the police and the armed forces, made Welsh miners and steelworkers comrades of their fellow workers elsewhere in Britain. The "sit-down" strikes of Detroit car workers or miners in the Asturias were an inspiration too. This mood was strengthened by the pressures of mass unemployment and industrial depression, more powerful in Wales than in any other area of Britain in the twenties and the thirties. This cohesive force continued until well after the end of the Second World War. There was an emphasis on class rather than community, on socialism rather than nationalism, on the imperatives of national planning rather than local separatism. The mood was colorfully expressed by the M.P. for Ebbw Vale, Aneurin Bevan, in the "Welsh day" debate in the House of Commons in 1944 when he derided the idea of having such a debate at all. How, he asked ironically, did Welsh sheep differ from English sheep, after all?

Even in the inter-war years, at the height of the depression, awareness of things Welsh was still lively in some areas. There was the new phenomenon of the Anglo-Welsh school of writers (perhaps parodying the Anglo-Irish of the Yeats/Synge/Lady Gregory model), whose English-language writings purported to be inspired by Welsh themes and sentiment. However, the almost a-political outlook of Caradoc Evans and Dylan Thomas suggests that the nationalist implications of such a school were distinctly limited. Thomas criticized his friend and fellow-writer, Glyn Jones, for not sufficiently rejecting "Welsh nationalism and a kind of hill-farm morality." Amongst the Welsh-speaking minority, a notable development was the founding in 1925 of Plaid Cymru, a Welsh nationalist party devoted to gaining self-government within the Empire and Commonwealth. Its first president, Saunders Lewis, a distinguished writer who served from 1925 to 1939, was an ardent right-wing Catholic who sought to return Wales to the organic society of the Middle Ages. He also became highly controversial for his apparent sympathy for corporate fascism and for evidence of anti-semitism in the thirties. In 1936 he and two other intellectuals engaged in an arson raid on an R.A.F. base in Caernarfonshire and were eventually imprisoned, but the wider impact of their martyrdom beyond Welsh-speaking university circles was not immense at this period.

In the Second World War, the Welsh largely subscribed to the national and patriotic ideals of the time. There were some moves towards administrative and economic devolution, but little more. Pressure for a Welsh Secretaryship of State found little support either from the Conservatives or from Labour. Some Celts felt the war was largely being fought to protect south-eastern England, the white cliffs of Dover and the capital city of London, and that the needs of Wales and Scotland were somewhat remote. But, in general, the war played a major role in integrating still further the people of Wales with the concerns of the United Kingdom as a whole. So, too, did the election of the Labour government of 1945–51, which the Welsh in general strongly supported. It represented workers all over Britain. Welsh Labour men like Bevan, Griffiths and Ness Edwards were active in government at the highest level. The fifties and early sixties, the period in which I grew up, years of full employment, economic growth and rising living standards, seemed to remove any economic incentive to promote national causes. The gloom of the depression years, the "dole" and the means test seemed to be dispelled in the affluent society. Plaid Cymru, the nationalist party, gained much of its strength from Welsh-speaking intellectuals and educationalists. It had no mass following. In election after election from 1945 to 1966 the party lost every deposit. A self-governing Wales seemed the merest pipe-dream.

Then, quite unexpectedly, in the mid-1960s the Welsh national movement entered upon a quite distinct third phase. There was, even in modified form, a new upsurge of nationalism. The Labour government of Harold Wilson set up in 1964 a Welsh Secretaryship of State, to parallel that existing in Scotland. But the office raised expectations that were not to be fulfilled. There followed a dramatic by-election victory for Plaid Cymru's much-respected president, Gwynfor Evans, for the Carmarthen constituency in 1966. In the next two years, encouraged by similar progress by the Scottish Nationalists north of the border and perhaps by the civil rights movement in Northern Ireland, Plaid Cymru made remarkable inroads into the mass Labour vote in mining constituencies in the south. There were fears that Labour might collapse in its very heartland, with local unemployment and other economic difficulties encouraging widespread support for a new and non-Conservative progressive third force.

Simultaneously, there was a powerful Welsh-language movement directed against government offices, road signs and official procedures of all kinds that resisted the use of Welsh. The veteran Saunders Lewis, in a notable broadcast in 1962, gave his blessing to widespread civil disobedience. In the heady atmosphere of the sixties, fired by the anti-Vietnam movement, the US student demonstrations in Berkeley, Yale and elsewhere, and a wider mood of revolt by the younger generation against restraint and rooted intolerance, the Welsh language became a symbol of freedom. In particular, the movement for Welsh-language secondary schools, a demand voiced by many middle-

class Welsh speakers in the Cardiff suburbs, made considerable headway. At a time of deep anxiety as to the future of the Welsh language, spoken now by barely a quarter of the population, there were revived battles for its official status and legal validity, to enhance its role in education, government and the law. Youthful partisans climbed up television masts and defaced road signs. Sober citizens declined to pay English-language tax demands or television licenses. There were fears of incendiarism or mass violence on the Irish or Quebecois model. The very integrity of the United Kingdom seemed at stake.

The outcome was Harold Wilson's setting up of the Crowther (later Kilbrandon) Royal Commission on the constitution in 1968 to examine the constitutional relationships of Wales and Scotland to the United Kingdom in general. It ranged widely over most aspects of local and central government. Eventually in 1973 a somewhat confusing series of reports proposed a parliament for Scotland and a somewhat weaker elected assembly for Wales. For the first time in modern history, the governance of Wales and Scotland were central to the British national agenda. This coincided with the majority Labour Party having from 1976 onwards a sequence of leaders from Welsh constituencies, James Callaghan, Michael Foot and Neil Kinnock (even though the last-named was in fact hostile to devolution in the first instance).

Scottish and Welsh devolution, however, made only limited progress in fact. In Wales, significant elements within the Labour Party were opposed to it; some of them in the South feared domination by Welsh-speaking rural Wales much as their predecessors had done during the *Cymru Fydd* controversy associated with David Lloyd George in 1896. When in March 1979, there was a referendum on a Welsh elected assembly, the Welsh voted it down by almost four to one. Even in Welsh-speaking Gwynedd in the mountains of the north west, there was a clear majority against. Welsh devolution collapsed in 1979 and since then, at a time of Conservative government, has shown little sign of a resurrection. Plaid Cymru has managed to capture four parliamentary seats down to the 1992 general election; but they are all in the predominantly Welsh-speaking, thinly-populated constituencies of the remote north and west. In my own university base of Aberystwyth on the coast of Cardigan Bay, university students and tourism have generated waves of Anglicization—or perhaps Americanization. In the broad mass of English-speaking, industrial and urban Wales, the Nationalists have made no lasting impression and they are weak in local government. The contrast with Scottish nationalism, which has won much support in cities such as Edinburgh, Dundee and Aberdeen, and in parts of Clydeside, is marked indeed. In fact, Welsh political nationalism has proved hitherto to be much less vigorous than Scottish. In soccer terms, the Scots have been described as "ninety-minute patriots:" the same may be even truer of the rugby-playing Welsh. In the 1994 Euro-elections, the Scottish Nationalists

actually won two of the nine Scottish constituencies, in the highlands regions, whereas Plaid Cymru captured none and came far behind the dominant Labour Party everywhere.

The main activity in Welsh national awareness since 1979 has, in fact, been in non-political areas, especially the language movement. The Welsh schools, the University of Wales, the arts, above all television and radio have all responded to pressure for support for the language. The winning of a Welsh-language television channel, S4C or Sianel Pedwar (Channel Four), in 1982 was a notable achievement, won in part by a Gandhi-like threat by the veteran Gwynfor Evans to fast unto death. The 1991 census showed that almost 20 per cent of the population still spoke Welsh, and that indeed the proportion showed some advance amongst teenage children, due to the success of the Welsh schools movement. The language had a strong bastion in professional areas of local government, higher education and the broadcasting media, while a Welsh Language Act in 1993, even if disappointing to some, afforded stronger legislative backing. By contrast, Welsh nationalism was an unofficial, alternative kind of movement. The investiture of the Prince of Wales at Caernarfon in 1969 was deliberately contrived as an antidote to it by the Labour government of the day. The investiture was designed to neutralize nationalist euphoria in the late sixties. As such it achieved some success. The existence of Charles as Prince of Wales is in no way a beacon of national identity. The official presence of the Prince (who seldom visits Wales) rather indicates the relative political impotence of his people. A friendly critic like Kingsley Amis in *The Old Devils* sees Welsh consciousness in the industrial valleys as little more than stagey posturing by saloon-bar revolutionaries, fighting the last class war but one.

III

For all that, Welsh nationality, and sometimes nationalism, has played a notable part in the history of modern Britain, to a degree that historians are still only just beginning to recognize. In many ways Wales significantly influenced the intellectual and cultural development of later twentieth century Britain. It has had a growing impact on historical writing, in shaping the awareness of British historians of the *mentalité* of popular culture, somewhat on the lines of the French historians of the *Annales* school. There are now significant debates between Welsh historians on such themes as consensus or conflict in Welsh history—itself a sign of maturity in Welsh historiography. Welsh self-awareness has also had its impact on British music, visual art, the theater (Anthony Hopkins, for instance) and, particularly perhaps, on the cinema, where Welsh-language media opportunities have helped generate new

creative genres. A Welsh-language film on Hedd Wyn, a young shepherd who received the *eisteddfodic* chair in 1917 just after being killed in battle in Flanders, was widely acclaimed at the 1994 Cannes film festival. There remain distinguished Welsh poets operating in both languages, the most notable being R. S. Thomas, himself a passionate nationalist, and a fiery symbol of revolt.

In political terms, the Welsh have many solid achievements to their credit over the past 100 years and more. Furthermore, they have been gained through constitutional political argument rather than through the direct action route of violence. From Lloyd George to Aneurin Bevan, they have been eloquent artists in the uses of political power. There was the disestablishment of the Church in Wales in 1919–20; separate Welsh legislation on Sunday Closing; administrative recognition in agriculture, energy, health and housing; the growing role of the Welsh Office in initiating policy in most aspects of Welsh life. The national educational system crowned by the University of Wales and funded at the higher levels by a separate Welsh Funding Council, is still a prized achievement. Prior to the First World War, the main instrument of change was the Liberal Party, linked closely with the nonconformist chapels. Since the 1920s, and especially since 1945, the major force has been the Labour party, with a particular commitment to local or regional policies to promote socio-economic development.

Apart from internal British party politics, there are now many other important forces for change. Europe is one. The growing emphasis on a "Europe of regions" (or nations) has attracted much interest in Wales. The effect of the European Community may thus be to promote local or regional forms of self-government. Within the EC, the Welsh sense of identity has been advanced by the so-called Motor scheme, linking up development programs in Baden-Württemburg, Catalonia, Rhones-Alpes, Lombardy— and Wales. The University of Wales has been a major factor in promoting this kind of linkage in higher education, both in student and staff exchange and in framing major research programs. As Vice-Chancellor, I have found it is an advantage for a university to represent a territory rather than a mere city. Nearer home, the continuing force of nationalist pressure in Scotland will continue to give encouragement to nationalist forces in Wales, and the European elections will only serve to reinforce this historic tendency.

Something wider is also in evidence—a tangible sense of disenchantment with British institutions as the century draws to its close. The governance of the realm no longer inspires the almost automatic respect and confidence that it once did. I cannot say that I myself have anything like the Fabian confidence in our governmental system that I had twenty-five years back. Blackstone, Bagehot, Anson and Dicey belong to an almost primordial past. There is, simply, much less unquestioning faith in the image of Big Ben, chiming out for liberty as it did in 1940, or in the tradition of "the mother of Parliaments," maintained so vigorously by Churchill and Attlee alike in the

past. Parliament, the legal system, the civil service, certainly the monarchy, no longer enjoy the awed deference they did down to the Second World War. No cows are sacred any longer. Years of post-imperial decline, economic weakness and cultural disillusion have seen to that. Current debates, passionate in Conservative ranks, about Britain's relationship to Europe, fears about the threat posed to national sovereignty by Brussels and Strasbourg have their important implications for Wales and Scotland, too. One result of this wider disenchantment is the growth of pressure for constitutional reform, from Charter 88 and other groups in modern Britain. This agenda takes in a possible bill of rights for individual freedoms, the reform of the second chamber, possible changes in the voting system and local devolution, for the various regions of England as well as for Scotland and Wales (here, as elsewhere, Northern Ireland is a problem all its own). There is a manifest current of feeling against the tradition of centralism that has dominated British attitudes for 900 years. For many British intellectuals and political commentators, it has become a symptom of inertia, civic sclerosis and wholesale long-term national decline.

It is improbable that the Welsh will ever vote for self-government, in the sense of detachment from England. For most of my countrymen, as for me personally, the sense of Britishness is far too strong. But there is every likelihood that they will play their lively part in the rediscovery of the sense of local community, and the redefinition of local and individual rights. The Welsh are truly what Marx called an "unhistoric" nation—but so too are the Baltic and Slav republics, and other peoples liberated by the end of the cold war and the collapse of the Soviet empire. For "gallant little Serbia" in 1914 read "gallant little Lithuania" today. The Welsh provide important insights into post-imperial, post-modernist Britain as does the South in the history of post-Civil War America. In 1994 Wales forms part of the politics of the British future, no less than of the past.

Fall Semester 1994

SUGGESTED FURTHER READING

John Breuilly, *Nationalism and the State* (London, 1982)

Linda Colley, *Britons: Forging the Nation, 1707–1837* (Yale, 1992)

John Davies, *A History of Wales* (London, 1993)

R. R. Davies et al. (eds.), *Welsh Society and Nationhood* (Cardiff, 1984)

Ernest Gellner, *Nations and Nationalism* (London, 1983)

Christopher Harvie, *Scotland and Nationalism* (London, new edn., 1984)

Eric Hobsbawm, *Nations and Nationalism since 1870* (London, 1990)

Philip Jenkins, *A History of Modern Wales, 1536–1990* (London, 1992)

Kenneth O. Morgan, *Wales in British Politics, 1868–1922* (Cardiff, new edn., 1992)

Kenneth O. Morgan, *Rebirth of a Nation: Wales 1880–1980* (Oxford and Cardiff, new edn., 1982)

Kenneth O. Morgan, *Modern Wales: Politics, Places and People* (Cardiff, forthcoming, 1995)

Keith Robbins, *Integration and Diversity* (Oxford, 1988)

David Williams, *A History of Wales* (London, 1950)

Glanmor Williams, *Religion, Language and Nationality in Wales* (Cardiff, 1979)

Glanmor Williams (ed.), *Merthyr Politics: the Making of a Working-Class Tradition* (Cardiff, 1966)

Gwyn A. Williams, *When was Wales?* (London, 1985)

British Studies at
The University of Texas 1975–1995

Fall Semester 1975

Paul Scott (Novelist, London), 'The Raj Quartet'

Ian Donaldson (Director, Humanities Research Centre, Australian National University), 'Humanistic Studies in Australia'

Fritz Fellner (Professor of History, Salzburg University), 'Britain and the Origins of the First World War'

Roger Louis (Professor of History and Curator of Historical Collections, Humanities Research Center), 'Churchill, Roosevelt and the Future of Dependent Peoples during the Second World War'

Michael Holroyd (Biographer, Dublin), 'Two Biographies: Lytton Strachey and Augustus John'

Max Beloff (former Gladstone Professor of Government, Oxford University, present Principal of Buckingham College), 'Imperial Sunset'

Robin Winks (Professor of History, Yale University), 'British Empire-Commonwealth Studies'

Warren Roberts (Director, Humanities Research Center), and David Farmer (Assistant Director, Humanities Research Center), 'The D. H. Lawrence Editorial Project'

Harvey C. Webster (Professor of English, University of Louisville), 'C.P. Snow as Novelist and Philosopher'

Anthony Kirk-Greene (Fellow of St. Antony's College, Oxford), 'The Origins and Aftermath of the Nigerian Civil War'

Spring Semester 1976

Joseph Jones (Professor of English), 'World English'

William S. Livingston (Professor of Government), 'The British Legacy in Contemporary Indian Politics'

John Higley (Associate Professor of Sociology), 'The Recent Political Crisis in Australia'

Elspeth Rostow (Dean of General and Comparative Studies), Standish Meacham (Professor of History), and Alain Blayac (Professor of English, University of Paris), 'Reassessments of Evelyn Waugh'

Jo Grimond (former Leader of the Liberal Party), 'Liberal Democracy in Britain'

Gaines Post (Associate Professor of History), Malcolm Macdonald (Professor of Government), and Roger Louis, 'The Impact of Hitler on British Politics'

Robert Hardgrave (Professor of Government), Gail Minault (Assistant Professor of History), and Chihiro Hosoya (Professor of History, University of Tokyo), 'Kipling and India'

Kenneth Kirkwood (Rhodes Professor of Race Relations, Oxford University), 'The Future of Southern Africa'

Lord [C. P.] Snow, 'Elite Education in England'

Hans-Peter Schwarz (Director of the Political Science Institute, Cologne University, and Visiting Fellow, Woodrow Wilson International Center for Scholars), 'The Impact of Britain on German Politics and Society since the Second World War'

B. K. Nehru (Indian High Commissioner, London, and former Ambassador to the United States), 'The Political Crisis in India'

Robert A. Divine (Professor of History), Harry J. Middleton (Director, Lyndon Baines Johnson Library), and Roger Louis, 'Declassification of Secret Documents: the British and American Experiences Compared'

Fall Semester 1976

John Farrell (Associate Professor of English), 'Revolution and Tragedy in Victorian England'

Anthony Honoré (Regius Professor of Civil Law, Oxford University), 'British Attitudes toward Legal Regulation of Sex'

Alan Hill (Professor of English), 'Wordsworth and America'

Ian Nish (Professor of Japanese History, London School of Economics), 'Anglo-American Naval Rivalry and the End of the Anglo-Japanese Alliance'

Norman Sherry (Professor of English, University of Lancaster), 'Joseph Conrad and the British Empire'

Peter Edwards (Lecturer, Australian National University), 'Australia through American Eyes: the Second World War and the Rise of Australia as a Regional Power'

David Edwards (Professor of Government), Steven Baker (Assistant Professor of Government), Malcolm Macdonald, Bill Livingston, and Roger Louis, 'Britain and the Future of Europe'

Michael Hurst (Fellow of St. John's College, Oxford), 'The British Empire in Historical Perspective: the Case of Joseph Chamberlain'

Ronald Grierson (English Banker and former Public Official), 'The Evolution of the British Economy since 1945'

Marian Kent (Lecturer in History, University of New South Wales), 'British Oil Policy between the World Wars'

Constance Babington-Smith (Fellow of Churchill College, Cambridge), 'The World of Rose Macaulay'

William Todd (Kerr Professor of English History and Culture), Walt Rostow (Professor of History and Economics), and James McKie (Dean of Social and Behavioral Sciences), 'Adam Smith after 200 Years'

Spring Semester 1977

Carin Green (Novelist) and Elspeth Rostow, 'The Achievement of Virginia Woolf'

Samuel H. Beer (Professor of Government, Harvard University), 'Reflections on British Politics'

David Fieldhouse (Fellow of Nuffield College, Oxford), 'Decolonization and the Multinational Corporations'

Gordon Craig (Wallace Professor of Humanities, Stanford University), 'England and Europe on the Eve of the Second World War'

John Lehmann (British Publisher and Writer), 'Publishing under the Bombs– The Hogarth Press during World War II'

Philip Jones (Director, University of Texas Press), William S. Livingston (Christian Professor of British Studies), Michael Mewshaw (Assistant Professor of English), David Farmer, Roger Louis, and William Todd, 'The Author, his Editor and Publisher'

Dick Taverne (former Member of Parliament), 'The Mood of Britain: Misplaced Gloom or Blind Complacency?'

James B. Crowley (Professor of History, Yale University), Lloyd C. Gardner (Professor of History, Rutgers University), Akira Iriye (Professor of History, University of Chicago), and Roger Louis, 'The Origins of World War II in the Pacific'

Rosemary Murray (Vice-Chancellor of Cambridge University), 'Higher Education in England'

Burke Judd (Professor of Zoology) and Robert Wagner (Professor of Zoology), 'Sir Cyril Burt and the Controversy over the Heritability of I.Q.'

Sandy Lippucci (Government), Roger Louis (History), Bill Livingston (Government), Walt Rostow (Economics), 'The Wartime Reputations of Churchill and Roosevelt: Overrated or Underrated?'

Fall Semester 1977

Donald L. Weismann (University Professor in the Arts), 'British Art in the Nineteenth Century: Turner and Constable—Precursors of French Impressionism'

Standish Meacham, 'Social Reform in England'

Joseph Jones, 'Recent Commonwealth Literature'

Lewis Hoffacker (former United States Ambassador), 'The Katanga Crisis: British and Other Connections'

James M. Treece (Professor of Law), Roger Louis, Warren Roberts, and Bill Todd, 'The Copyright Law of 1976'

Charles Heimsath (Visiting Professor of Indian History), Bob Hardgrave, Thomasson Jannuzi (Director, Center for Asian Studies), C. P. Andrade (Professor of Comparative Studies), and Bill Livingston, 'Freedom at Midnight: a Reassessment of Britain and the Partition of India Thirty Years After'

Lord Fraser of Kilmorack (Chairman of the Conservative Party Organization), 'The Tory Tradition of British Politics'

Bernth Lindfors (Professor of English), 'Charles Dickens and the Hottentots and Zulus'

Albert Hourani (Director, Middle East Centre, Oxford University), 'The Myth of T. E. Lawrence'

Mark Kinkead-Weekes (Professor of English, University of Kent) and Mara Kalnins (British Writer), 'D. H. Lawrence: Censorship and the Expression of Ideas'

J. D. B. Miller (Professor of International Relations, Australian National University), 'The Collapse of the British Empire'

Peter Green (Professor of Classics), Robert King (Dean of Social and Behavioral Sciences), Bill Livingston, Bob Hardgrave, Roger Louis, and Warren Roberts, 'The Best and Worst Books of 1977'

Spring Semester 1978

Peter Green, Malcolm Macdonald, and Robert Crunden (Professor of American Studies), 'British Decadence in the Interwar Years'

Terry Quist (U. T. Undergraduate), Steve Baker, and Roger Louis, 'R. Emmet Tyrrell's *Social Democracy's Failure in Britain*'

Stephen Koss (Professor of History, Columbia University), 'The British Press: Press Lords, Politicians, and Principles'

John House (Professor of Geography, Oxford University), 'The Rhodesian Crisis'

T. S. Dorsch (Professor of English, Durham University), 'Oxford in the 1930s'

Stephen Spender (English Poet and Writer), 'Britain and the Spanish Civil War'

Okot p'Bitek (Ugandan Poet), 'Idi Amin's Uganda'

David C. Goss (Australian Consul-General), 'Wombats and Wivveroos'

Leon Epstein (Professor of Political Science, University of Wisconsin), 'Britain and the Suez Crisis of 1956'

David Schoonover (School of Library Science), 'British and American Expatriates in Paris in the 1920s'

Peter Stansky (Professor of History, Stanford University), 'George Orwell and the Spanish Civil War'

Alexander Parker (Professor of Spanish), 'Reflections on the Spanish Civil War'

Norman Sherry (Professor of English, Lancaster University), 'Graham Greene and Latin America'

Martin Blumenson (Office of the Chief of Military History, Department of the Army), 'The Ultra Secret'

Fall Semester 1978

W. H. Morris-Jones (Director, Institute of Commonwealth Studies, University of London), 'Power and Inequality in Southeast Asia'

Hartley Grattan (Professor of History), Gilbert Chase (Professor of American Studies), Bob Crunden, and Roger Louis, 'The British and the Shaping of the American Critical Mind: a Discussion of *Edmund Wilson's Letters on Literature and Politics*'

James Roach (Professor of Government), 'The Indian Emergency and its Aftermath'

Bill Todd, 'The Lives of Samuel Johnson'

Lord Hatch (British Labour Politician), 'The Labour Party and Africa'

John Kirkpatrick (HRC Bibliographer), 'Max Beerbohm'

Brian Levack (Associate Professor of History), 'Witchcraft in England and Scotland'

M. R. Masani (Indian Writer), 'Gandhi and Gandhism'

A. W. Coates (Visiting Professor of Economics), 'The Professionalization of the British Civil Service'

John Clive (Professor of History and Literature, Harvard University), 'Great Historians of the Nineteenth Century'

Geoffrey Best (University of Sussex), 'Flightpath to Dresden: British Strategic Bombing in the Second World War'

Kurth Sprague (Instructor of English), 'T. H. White's *Once and Future King*'

Gilbert Chase, 'The British Musical Invasion of America'

Spring Semester 1979

Peter Green (Professor of Classics), Sandy Lippucci (Instructor in Government), and Elspeth Rostow (Dean of the LBJ School of Public Affairs), 'P.N. Furbanks's biography of E.M. Forster'

Roger Louis, Bob Hardgrave, Gail Minault (History), Peter Gran (History), and Bob King, 'E.M. Forster and India'

Paul M. Kennedy (East Anglia University, Visiting Professor of History, Institute of Advanced Study, Princeton), 'The Contradiction between British Strategic Policy and Economic Policy in the Twentieth Century'

Richard Rive (Visiting Fulbright Research Fellow from South Africa), 'Olive Schreiner and the South African Nation'

Charles P. Kindleberger (Professor of Economics, Massachusetts Institute of Technology), 'Lord Zuckerman and the Second World War'

John Press (English Poet), 'English Poets and Postwar Society'

Richard Ellmann (Goldsmiths' Professor of English Literature, Oxford University), 'Writing a Biography of Joyce'

Michael Finlayson (Scottish Dramatist), 'Contemporary British Theater'

Lawrence Stone (Professor of History, Institute of Advanced Study, Princeton), 'Family, Sex, and Marriage in England'

C. P. Snow, 'Reflections on the Two Cultures'

Theodore Zeldin (Oxford University), 'Are the British More or Less European than the French?'

David Edwards (Professor of Government), 'How United the Kingdom: Greater or Lesser Britain?'

Michael Holroyd (British Biographer), 'George Bernard Shaw'

John Wickman (Director, Eisenhower Library), 'Eisenhower and the British'

Fall Semester 1979

Robert Palter (Professor of Philosophy), 'Reflections on British Philosophers: Locke, Hume, and the Utilitarians.'

Alfred Gollin (Professor of History, University of California at Santa Barbara), 'Political Biography as Political History: Garvin, Milner, and Balfour'

Edward Steinhart (Assistant Professor of History), 'The Consequences of British Rule in Uganda'

Paul Sturges (Loughborough University), and Dolores Donnelly (Toronto University), 'History of the National Library of Canada'

Sir Michael Tippett (British Composer), 'Moving into Aquarius'

Steven Baker (Assistant Professor of Government), 'Britain and United Nations Emergency Operations'

Maria Okila Dias (Professor of History, University of Sao Paulo), 'Intellectual Roots of Informal Imperialism: Britain and Brazil'

Alexander Parker (Professor of Spanish), 'Reflections on *Brideshead Revisited*'

Barry C. Higman (Professor of History, University of the West Indies), 'West Indian Emigrés and the British Empire'

Gaines Post (Associate Professor of History), 'Britain and the Outbreak of the Second World War'

Karen Gould (Lecturer in Art) 'Medieval Manuscript Fragments and English 17th Century Collections: New Perspectives from *Fragmenta Manuscripta*'

John Farrell (English), Eric Poole (HRC) and James Bieri (English): Round Table Discussion of Jeanne MacKenzie's new biography, *Dickens: A Life*

Joseph O. Baylen, (Regents Professor of History, Georgia State University), 'British Journalism in the Late Victorian and Edwardian Eras'

Peter T. Flawn (President of UT), 'An Appreciation of Charles Dickens'

Spring Semester 1980

Annette Weiner (Assistant Professor of Anthropology), 'Anthropologists in New Guinea: British Interpretations and Cultural Relativism'

Bernard Richards (Lecturer in English, Oxford University), 'Conservation in the Nineteenth Century'

Thomas McGann (Professor of History), 'Britain and Argentina: An Informal Dominion?'

Mohammad Ali Jazayery (Director, Center for Middle Eastern Studies), 'The Persian Words in English'

C. Hartley Grattan (Professor of History) 'Twentieth-Century British Novels and the American Critical Mind'

Katherine Whitehorn (London *Observer*), 'An Insider's View of the *Observer*'

Guy Lytle (Assistant Professor of History), 'The Oxford University Press' *History of Oxford*'

C. P. Snow, 'Reflections on *The Masters*'

Harvey Webster, '*The Masters* and the Two Cultures'

Brian Blakeley (Associate Professor of History, Texas Tech University), 'Women and the British Empire'

Stephen Koss (Professor of History, Columbia University), 'Asquith, Balfour, Milner, and the First World War'

Tony Smith (Associate Professor of Political Science, Tufts University), 'The Expansion of England: New Ideas on Controversial Themes in British Imperialism'

Stanley Ross (Professor of History), 'Britain and the Mexican Revolution'

Rowland Smith (Chairman, Department of English, Dalhousie University), 'The British Intellectual Left and the War 1939–1945'

Richard Ellmann (Goldsmiths' Professor of English, Oxford University), 'Oscar Wilde: a Reconsideration and Problems of the Literary Biographer'

James Bill (Professor of Government), 'The United States, Britain, and the Iranian Crisis of 1953'

Fall Semester 1980

Decherd Turner (Director, Harry Ransom Humanities Research Center), 'The First 1000 Days'

Roger Louis, 'Britain and Egypt after the Second World War'

Alistair Horne (Visiting Fellow, Woodrow Wilson Center, Washington, D.C.), 'Britain and the Fall of France'

Edward Rhodes (Associate Professor of History), Peter Green, William Todd, and Roger Louis, 'Literary Fraud: H. R. Trevor-Roper and the Hermit of Peking'

Mark Kinkead-Weekes (Professor of English, Kent University), 'D. H. Lawrence's *Rainbow*: Its Sense of History'

Sir John Crawford (Vice-Chancellor, Australian National University), 'Hartley Grattan: In Memoriam'

John Stubbs (Assistant Professor of History, University of Waterloo), 'The Tory View of Politics and Journalism in the Interwar Years'

Donald L. Weismann (University Professor in the Arts), 'British Art in the Nineteenth Century'

Fran Hill (Assistant Professor of Government), 'The Legacy of British Colonialism in Tanzania'

R. W. B. Lewis (Professor of English, Yale University), 'What's Wrong with the Teaching of English?'

Charlene Gerry (British Publisher), 'The Revival of Fine Printing in Britain'

Peter Gran (Assistant Professor of History), 'The Islamic Response to British Capitalism'

Tina Poole (Humanities Research Center) 'Gilbert and Sullivan's Christmas'

Spring Semester 1981

Bernard N. Darbyshire (Visiting Professor of Government and Economics), 'North Sea Oil and the British Future'

Christopher Hill (Master of Balliol College, Oxford), 'The English Civil War'

Elizabeth Heine (Assistant Professor of English, University of Texas at San Antonio), and Roger Louis, 'A Reassessment of Leonard Woolf'

Bernard Richards (Brasenose College, Oxford), 'D. H. Lawrence and Painting'

Miguel Gonzalez-Gerth (Professor of Spanish), 'Poetry Once Removed: the Resonance of English as a Second Language'

John Putnam Chalmers (Librarian, Harry Ransom Humanities Research Center), 'English Bookbinding from Caedmon to Le Carré'

Peter Coltman (Professor of Architecture), 'The Cultural Landscapes of Britain: 2,000 Years of Blood, Sweat, Toil & Tears to Wrest a Living from this Bloody Mud'

Thomas H. Law (former Regent, University of Texas), 'The Gold Coins of the English Sovereigns'

Sidney Weintraub (Rusk Professor of International Affairs, LBJ School), James W. McKie (Professor of Economics), and Mary Williams (Canadian Consulate, Dallas), 'Canadian-American Economic Relations'

Amedée Turner (Conservative Member of the European Parliament), 'Integrating Britain into the European Community'
Muriel C. Bradbrook (Fellow of Girton College, Cambridge), 'Two Poets: Kathleen Raine and Seamus Heaney'
Ronald Sampson (Chief of the Industrial Development Department, Aberdeen), 'Scotland—Somewhat of a British Texas?'

Fall Semester 1981

Jerome Bump (Professor of English), 'From Texas to England: the Ancestry of our Victorian Architecture'
Lord Fraser of Kilmorack, 'Leadership Styles of Tory Prime Ministers since the Second World War'
William Carr (Professor of History, University of Sheffield), 'A British Interpretation of American, German, and Japanese Foreign Policy 1936–1941'
Iqbal Narain, (Professor of Political Science and former Vice-Chancellor, Rajasthan University, Jaipur), 'The Ups and Downs of Indian Academic Life'
Don Etherington (Assistant Director, Humanities Research Center), 'The Florence Flood, 1966: the British Effort—or: Up to our Necks in Mud and Books'
E. V. K. Fitzgerald (Visiting Professor of Economics), 'The British University: Crisis, Confusion, and Stagnation'
Robert Crunden (Professor of American Studies), 'A Joshua for Historians: Mordecai Richter and Canadian Cultural Identity'
Bernth Lindfors (Professor of English), 'The Hottentot Venus and Other African Attractions in Nineteenth-Century England'
Chris Brookeman (Professor of American Studies, London Polytechnic), 'The British Arts and Society'
Nicholas Pickwoad (Free-lance Book Conservator), 'The Libraries of the National Trust'
Kurth Sprague, 'John Steinbeck, Chase Horton, and the Matter of Britain'
Martin J. Wiener (Professor of History, Rice University), 'Cultural Values and Socio-Economic Behavior in Britain'
Werner Habicht (Professor of English, University of Würzburg), 'Shakespeare in Nineteenth-Century Germany'

Spring Semester 1982

Stevie Bezencenet (Lecturer in Photography, London College of Printing), 'Contemporary Photography in Britain'

Jane Marcus (Assistant Professor of English), 'Shakespeare's Sister, Beethoven's Brother: Dame Ethel Smyth and Virginia Woolf'

Wilson Harris (Professor of English) and Raja Rao (Professor of Philosophy), 'The Quest for Form: Britain and Commonwealth Perspectives'

Al Crosby (Professor of American Studies), 'The British Empire as a Product of Continental Drift'

Lord St. Brides (Visiting Scholar, University of Texas), 'The White House and Whitehall: Washington and Westminster'

Elizabeth Fernea (Senior Lecturer in English and President of the Middle East Studies Association), 'British Colonial Literature of the Middle East'

Maurice Evans (Actor and Producer), 'My Early Years in the Theater'

Joan Bassin (Kansas City Art Institute) 'Art and Industry in Nineteenth-Century England'

Eugene N. Borza (Professor of Ancient History, Pennsylvania State University), 'Sentimental British Philhellenism: Images of Greece'

Ralph Willett (American Studies Department, University of Hull), 'The Style and Structure of British Television News'

Roger Louis, 'Britain and the Creation of the State of Israel'

Peter Russell (Professor of Spanish, Oxford University), 'A British Historian Looks at Portuguese Historiography of the Fifteenth Century'

Rory Coker (Physics), 'Frauds, Hoaxes and Blunders in Science—a British Tradition?'

Ellen DuBois (Professor of History, SUNY Buffalo), 'Anglo-American Perspectives on the Suffragette Movement'

Donald G. Davis, Jr. (Professor of Library Science), 'Great Expectations—and a Few Illusions: Reflections on an Exchange Teaching Year in England'

Anthony Rota (Managing Director, Bertram Rota Ltd.), 'The Changing World of the Bookdealer'

Eisig Silberschlag (former President, Hebrew College, Visiting Gale Professor of Judaic Studies), 'The Bible as the Most Popular Book in English'

Fall Semester 1982

Woodruff Smith (Professor of History, University of Texas at San Antonio), 'British Overseas Expansion'

The Rt. Hon. George Thomas (Speaker of the House of Commons), 'Parliamentary Democracy'

Nigel Nicolson (English Historian and Biographer), 'The English Country House as an Historical Document'

Lord St. Brides, 'A Late Leaf of Laurel for Evelyn Waugh'

Lt. Col. Jack McNamara, USMC (Ret.), 'The Libel of Evelyn Waugh by the *Daily Express*'

James Wimsatt (Professor of English), 'Chaucer and Medieval French Manuscripts'

Christopher Whelan (Visiting Professor, UT Law School), 'Recent Developments in British Labor Law'

Brian Wearing (Senior Lecturer in American Studies, Christchurch, New Zealand), 'New Zealand: In the Pacific, but of it?'

Robert Hardgrave (Professor of Government), 'The United States and India'

James McBath (Professor of Communications, University of Southern California), 'The Evolution of *Hansard*'

Paul Fromm (Professor of Economics, University of Toronto), 'Canadian-United States Relations: Two Solitudes'

John Velz (Professor of English), 'When in Disgrace: Ganzel's Attempt to Exculpate John Payne Collier'

Roger Louis, 'British Origins of the Iranian Revolution'

Spring Semester 1983

Sir Ellis Waterhouse (Slade Professor of Fine Arts, Oxford University), 'A Comparison of British and French Painting in the late Eighteenth Century'

E. J. L. Ride (Australian Consul-General), 'Australia's Place in the World and her Relationship with the United States'

Edward Bell (Director of the Royal Botanic Gardens, Kew), 'Kew Gardens in World History'

The Very Rev. Oliver Fiennes (Dean of Lincoln), 'The Care and Feeding of the Magna Carta'

C.V. Narasimhan (former Under-Secretary of the United Nations), 'Last Days of the British Raj: a Civil Servant's View'

Warren G. Osmond, 'Sir Frederic Eggleston and the Development of Pacific Consciousness'

Richard Ellmann (Goldsmiths' Professor, Oxford University), 'Henry James among the Aesthetes'

Janet Caulkins (Professor of French, University of Wisconsin at Madison), 'The Poor Reputation of Cornish Knights in Medieval Literature'

Werner Habicht (Professor of English, University of Würzburg), 'Shakespeare and the Third Reich'

Gillian Peele (Fellow of Lady Margaret Hall, Oxford), 'The Changing British Party System'

John Farrell (Professor of English), 'Scarlet Ribbons: Memories of Youth and Childhood in Victorian Authors'

Peter Russell (Professor of Spanish, Oxford University), 'A Not So Bashful Stranger: *Don Quixote* in England, 1612–1781'

Sir Zelman Cowen (Provost of Oriel College, Oxford), 'Contemporary Problems in Medicine, Law, and Ethics'

Dennis V. Lindley (Visiting Professor of Mathematics), 'Scientific Thinking in an Unscientific World'

Martin Blumenson (Office of the Chief of Military History, Department of the Army), 'General Mark Clark and the British in the Italian Campaign of World War II'

Fall Semester 1983

Anthony King (Professor of Politics, University of Essex), 'Margaret Thatcher and the Future of British Politics'

Alistair Gillespie (Canadian Minister of Energy, Mines, and Resources), 'Canadian-British Relations: Best and Worst'

Charles A. Owen, Jr. (Professor of English, University of Connecticut), 'The Pre-1400 Manuscripts of the *Canterbury Tales*'

Major-General (Ret.) Richard Clutterbuck (Reader in Political Conflict, University of Exeter), 'Terrorism in Malaya'

Wayne A. Wiegand (Associate Professor of English, University of Kentucky), 'British Propaganda in American Public Libraries during World War I'

Stuart Macintyre (Australian National University, Canberra), 'Australian Trade Unionism between the Wars'

Ram Joshi (Visiting Professor of History, former Vice-Chancellor, University of Bombay), 'Is Gandhi Relevant Today?'

Sir Denis Wright (former British Ambassador in Iran), 'Britain and the Iranian Revolution'

Andrew Horn (Head of the English Department, University of Lesotho), 'Theater and Politics in South Africa'

Philip Davies (Professor of American Government, University of Manchester), 'British Reaction to American Politics: Overt Rejection, Covert Assimilation'

H. K. Singh (Political Secretary, Embassy of India), 'United States-Indian Relations'

Roger Louis, Ram Joshi, J. S. Mehta (LBJ School), 'Two Cheers for Mountbatten: A Reassessment of Lord and Lady Mountbatten and the Partition of India'

Spring Semester 1984

M. S. Venkataramani (Director of International Studies, Jawaharlal Nehru University), 'Winston Churchill and Indian Freedom'

Sir John Thompson (British Ambassador to the United Nations), 'The Falklands and Grenada in the United Nations'

Robert Farrell (Professor of English, Cornell University), 'Medieval Archaelogy'

Allon White (Lecturer in English, University of Sussex), 'The Fiction of Early Modernism'

Peter Green (Classics), Roger Louis (History), Miguel Gonzalez-Gerth (Spanish-Portuguese), Standish Meacham (History), and Sid Monas (Slavic): 'Orwell's *1984*'

Uriel Dann (Professor of English History, University of Tel Aviv), 'Hanover and Britain in the Time of George II'

José Ferrater-Mora (Fairbank Professor of Humanities, Bryn Mawr), 'A. M. Turing and his "Universal Turing Machine"'

Rüdiger Ahrens, (University of Würzburg), 'Teaching Shakespeare in German Universities'

Herbert Spiro (Professor of Political Science, Free University of Berlin), 'What Makes the British and Americans Different from Everybody Else: The Adversary Process of the Common Law'

Nigel Bowles (Lecturer in American Government and Politics, University of Edinburgh), 'Reflections on Recent Developments in British Politics'

Harold Perkin (Mellon Distinguished Visiting Professor, Rice University), 'The Evolution of Citizenship in Modern Britain'

Christopher Heywood (Senior Lecturer, Sheffield University), '*Jane Eyre* and *Wuthering Heights*'

Dave Powers (Curator, Kennedy Library), 'JFK's Trip to Ireland, 1963'

R. W. Coats (Visiting Professor of Economics), 'John Maynard Keynes: the Man and the Economist'

David Evans (Professor of Astronomy), 'Astronomy as a British Cultural Export'

Fall Semester 1984

John Henry Faulk, 'Reflections on My Sojourns in the British Middle East'

Lord Fraser of Kilmorack, 'The Thatcher Years—and Beyond'

Michael Phillips (Lecturer in English Literature, University of Edinburgh), 'William Blake and the Rise of the Hot Air Balloon'

Erik Stocker (Humanities Research Center), 'A Bibliographical Detective Story: Reconstructing James Joyce's Library'

Amedée Turner (Member of the European Parliament), 'Recent Developments in the European Parliament'

Michael Hurst (Fellow of St. John's College, Oxford), 'Scholars versus Journalists on the English Social Classes'

Charles Alan Wright (William B. Bates Professor of Law), 'Reflections on Cambridge'

J. M. Winter (Fellow of Pembroke College, Cambridge), 'Fear of Decline in Population in Britain after World War I'

Henk Wesseling (Director of the Centre for the History of European Expansion, University of Leiden), 'Dutch Colonialism and the Impact on British Imperialism'

Celia Morris Eckhardt (Biographer and author of *Fannie Wright*), 'Frances Wright and *England as the Civilizer*'

Sir Oliver Wright (British Ambassador to the United States), 'British Foreign Policy—1984'

Leonard Thompson (Professor of African History, Yale University), 'Political Mythology and the Racial Order in South Africa'

Flora Nwapa (Nigerian Novelist), 'Women in Civilian and Military Rule in Nigeria'

Richard Rose (Professor of Political Science, University of Strathclyde), 'The Capacity of the Presidency in Comparative Perspective'

Spring Semester 1985

Bernard Hickey (University of Venice), 'Australian Literary Culture: Short Stories, Novels, and "Literary Journalism"'

Kenneth Hafertepe (American Studies), 'The British Foundations of the Smithsonian Castle: the Gothic Revival in Britain and America'

Rajeev Dhavan (Visiting Professor, LBJ School and Center for Asian Studies), 'Race Relations in England: Trapped Minorities and their Future'

Sir John Thompson (British Ambassador to the United Nations), 'British Techniques of Statecraft'

Philip Bobbitt (Professor of Law), 'Britain, the United States, and Reduction in Strategic Arms'

David Bevington (Drama Critic and Theater Historian), 'Maimed Rites: Interrupted Ceremony in *Hamlet*'

Standish Meacham (History), 'The Impact of the New Left History on British and American Historiography'

Iris Murdoch (Novelist and Philospher) and John O. Bayley (Thomas Warton Professor of English, Oxford University), 'Themes in English Literature and Philosophy'

John P. Chalmers (Librarian, Humanities Research Center), 'Malory Illustrated'

Thomas Metcalf (Professor of History, University of California at Berkeley), 'The Architecture of Empire: the British Raj in India'

Robert H. Wilson (Emeritus Professor of English), 'Malory and His Readers'

Lord St. Brides, '*A Passage to India*: Better Film than Novel?'

Derek Pearsall (Medievalist at York University), 'Fire, Flood, and Slaughter: the Tribulations of the Medieval City of York'

E. S. Atieno Odhiambo (University of Nairobi, Visiting Professor, Johns Hopkins University), 'Britain and Kenya: the Mau Mau, the "Colonial State", and Dependency'

Francis Robinson (Reader in History, University of London), 'Indian Muslim Religious Leadership and Colonial Rule'

Charles B. MacDonald (Deputy Chief Historian, U.S. Army), 'The British in the Battle of the Bulge'

Brian Levack (Associate Professor of History), 'The Battle of Bosworth Field'

Kurth Sprague (Senior Lecturer in English), 'The Mirrors of Malory'

Fall Semester 1985

A. P. Thornton (Distinguished University Professor, University of Toronto), 'Whatever Happened to the British Commonwealth?'

Michael Garibaldi Hall (Professor of History) and Elizabeth Hall (LBJ School), 'Views of Pakistan'

Ronald Steel (Visiting Professor of History), 'Walter Lippmann and the British'

Douglas H. M. Branion (Canadian Consul General), 'Political Controversy and Economic Development in Canada'

Decherd Turner and Dave Oliphant (Harry Ransom Humanities Research Center), 'The History of the Publications of the Harry Ransom Humanities Research Center'

Robert Fernea (Professor of Anthropology), 'The Controversy Over Sex and Orientalism: Charles Doughty's *Arabia Deserta*'

Desley Deacon (Lecturer, Department of Government), 'Her Brilliant Career: The Context of Nineteenth-Century Australian Feminism'

John Lamphear (Associate Professor of History), 'The British Colonial "Pacification" of Kenya: A View from the Other Side'

Kingsley de Silva (Foundation Professor of Ceylon History at the University of Peradeniya, Sri Lanka), 'British Colonialism and Sri Lankan Independence'

Thomas Hatfield (Dean of Continuing Education), 'Colorado on the Cam 1986: from "Ultra" to Archaeology, from Mr. Micawber to Mrs. Thatcher'

Carol Hanbery MacKay (Assistant Professor of English), 'The Dickens Theater'

Ronald Brown, Jo Anne Christian, Roger Louis, Harry Middleton, and Ronald Steel—Panel Discussion: 'The Art of Biography: Philip Ziegler's *Mountbatten*'

Spring Semester 1986

B. J. Fernea (English and Middle Eastern Studies), Bernth Lindfors (English) and Roger Louis (History), '*Out of Africa*: the Book, the Biography, and the Movie'

Robert Litwak (Woodrow Wilson International Center for Scholars, Washington, D. C.), 'The Great Game: Russian, British, and American Strategies in Asia'

Gillian Adams Barnes (English) and Jane Manaster (Geography), 'Humphrey Carpenter's *Secret Gardens* and the Golden Age of Children's Literature'

Laurie Hergenhan (Professor of English, University of Queensland), 'A Yankee in Australia: the Literary and Historical Adventures of C. Hartley Grattan'

Brian Matthews (Flinders University of South Australia), 'Australian Utopianism of the 1880s'

Richard Langhorne (Fellow of St. John's College, Cambridge), 'Apostles and Spies: the Generation of Treason at Cambridge between the Wars'

Ronald Robinson (Beit Professor of the History of the British Empire, Oxford University), 'The Decline and Fall of the British Empire'

William Rodgers (Vice-President, Social Democratic Party), 'Britain's New Three-Party System: A Permanent or Passing Phenomenon?'

John Coetzee (Professor of Literature, University of Cape Town), 'The Farm
 Novel in South Africa'
Ayesha Jalal (Fellow, Trinity College, Cambridge), 'Jinnah and the Partition
 of India'
Andrew Blane (Professor of History, City College of New York), 'Amnesty
 International: from a British to an International Movement'
Anthony Rota (Antiquarian Bookdealer and Publisher), 'London Pride:
 1986'
Elspeth Rostow (Dean, LBJ School), 'The Withering Away of Whose State?
 Colonel Qaddafi's? Reflections on Nationalism at Home and
 Abroad, in Britain and in the Middle East'
Ray Daum (Curator, Humanities Research Center), 'Broadway—Piccadilly!'

Fall Semester 1986

Dean Robert King and Members of the '"Unrequired Reading List"
 Committee—The British Component': Round Table Discussion.
Paul Sturges (Loughborough University), 'Popular Libraries in Eighteenth-
 Century Britain'
Ian Bickerton (Professor of History, University of Missouri), 'Eisenhower's
 Middle East Policy and the End of the British Empire'
Marc Ferro (Visiting Professor of History), 'Churchill and Pétain'
David Fitzpatrick (Visiting Professor of History, Queen's University,
 Kingston, Ontario), 'Religion and Politics in Ireland'
Adam Watson (Center for Advanced Studies, University of Virginia, former
 British Ambassador to Castro's Cuba), 'Our Man in Havana—or:
 Britain, Cuba, and the Caribbean'
Norman Rose (Chaim Weizmann Professor of History, Hebrew University),
 'Chaim Weizmann, the British, and the Creation of the State of Israel'
Elaine Thompson (Senior Fulbright Scholar, American University),
 'Legislatures in Canberra and Washington'
Roger Louis (Kerr Professor of English History and Culture), 'Suez Thirty
 Years After'
Antonia Gransden (Reader in Medieval History, University of Nottingham),
 'The Writing of Chronicles in Medieval England'
Hilary Spurling (British Biographer and Critic), 'Paul Scott's *Raj Quartet*:
 The Novelist as Historian'
J. D. B. Miller (Professor of International Relations, Australian National
 University), 'A Special and Puzzling Relationship: Australia and
 the United States'
Janet Meisel (Associate Professor of History), 'The Domesday Book'

Spring Semester 1987

Miguel Gonzalez-Gerth (Liberal Arts), Robert Fernea (Anthropology), Joe Horn (Psychology), Bruce Hunt (History), and Delbert Thiessen (Psychology): 'Contemporary Perspectives on Evolution'

Alistair Campbell-Dick (Chief Executive Officer, Research and Development Strategic Technology), 'Scottish Nationalism'

Anthony Mockler (British Freelance Historian, and Biographer), 'Graham Greene: the Interweaving of His Life and Fiction'

Michael Crowder (Visiting Professor of African History, Amherst College), 'The Legacy of British Colonialism in Africa'

Carin Green (Lecturer in Classics), 'Lovers and Defectors: Autobiography and *The Perfect Spy*'

Lord St. Brides, 'The Modern British Monarchy'

Victor Szebehely (Richard B. Curran Professor of Engineering), 'Sir Isaac Newton'

Patrick McCaughey (Visiting Professor of Australian Studies, Harvard University; Director, National Gallery of Victoria, Melbourne), 'The Persistence of Landscape in Australian Art'

Adolf Wood (Deputy-Editor of *The Times Literary Supplement*), 'An Informal History of the *TLS*'

Nissan Oren (Visiting Professor of Political Science, Johns Hopkins University; Kaplan Professor, Hebrew University, Jerusalem), 'Churchill, Truman, and Stalin: The End of the Second World War'

Sir Michael Howard (Regius Professor of History, Oxford University), 'Britain and the First World War'

Sir John Graham (former British Ambassador to NATO), 'NATO: British Origins, American Security, and the Future Outlook'

Daniel Mosser (Virginia Polytechnic Institute and State University), 'The Chaucer Cardigan Manuscript'

Sir Raymond Carr (Warden of St. Antony's College, Oxford), 'British Intellectuals and the Spanish Civil War'

Michael Wilding (Reader in English, University of Sydney), 'The Fatal Shore? The Convict Period in Australian Literature'

Fall Semester 1987

Peter Green (Dougherty Professor of Classics), Winfred Lehmann (Temple Professor of the Humanities), Roger Louis (Kerr Professor of English History and Culture), and Paul Woodruff (Professor of Philosophy), 'Anthony Burgess: The Autobiography'

Robert Crunden (Professor of History and American Studies), 'Ezra Pound in London'

Carol MacKay (Associate Professor of English) and John Henry Faulk, 'J. Frank Dobie and Thackeray's Great-Granddaughter: Another Side of *A Texan in England*'

Sarvepalli Gopal (Professor of Contemporary History, Jawaharlal Nehru University, and Fellow of St. Antony's College, Oxford), 'Nehru and the British'

Robert D. King (Dean of Liberal Arts), 'T.S. Eliot'

Lord Blake (Visiting Cline Professor of English History and Literature, former Provost of Queen's College, Oxford), 'Disraeli: Problems of the Biographer'

Alain Blayac (Professor of Comparative Literature, University of Montpellier), 'Art as Revelation: Gerard Manley Hopkins's Poetry and James Joyce's *Portrait of the Artist*'

Mary Bull (Oxford University), 'Margery Perham and Africa'

R. J. Moore (Professor of History, Flinders University), 'Paul Scott: the Novelist as Historian, and *The Raj Quartet* as History'

Ian Willison (Head of the Rare Books Division of the British Library), 'New Trends in Humanities Research: the History of the Book in Britain Project'

The Duke of Norfolk, 'The Lion and the Unicorn: Ceremonial and the Crown'

Hans Mark (Chancellor, The University of Texas System), 'The Royal Society, the Royal Observatory, and the Development of Modern Research Laboratories'

Henry Dietz (Professor of Government), 'Sherlock Holmes: A Centennial Celebration'

Spring Semester 1988

Lord Jenkins (Chancellor of Oxford University), 'Changing Patterns of British Government from Asquith via Baldwin and Attlee to Mrs. Thatcher'

Lord Thomas (author of *The Spanish Civil War* and *Cuba, or the Pursuit of Freedom*), 'Britain, Spain, and Latin America'

Barbara Harlow (English), Bernth Lindfors (English), Wahneema Lubiano (English), and Robert Wren (University of Houston), 'Chinua Achebe: The Man and His Works'

Charles Townshend (Professor of History, Keele University), 'Britain, Ireland, and Palestine, 1918–1947'

Richard Morse (Program Secretary for Latin America, Woodrow Wilson Center), 'T.S. Eliot and Latin America'

Chinua Achebe (Nigerian Novelist), 'Anthills of the Savannah'

Tapan Raychaudhuri (Reader in Indian History, Oxford University), 'The English in Bengali Eyes in the Nineteenth Century'

Lord Chitnis (Chief Executive of the Rowntree Trust and Chairman of the British Refugee Council), 'British Perceptions of U.S. Policy in Central America'

Kurth Sprague (Senior Lecturer in English), 'Constance White: Sex, Womanhood, and Marriage in British India'

George McGhee (former U.S. Ambassador to Turkey and Germany), 'The Turning Point in the Cold War: Britain, the United States, and Turkey's Entry into NATO'

Robert Palter (Professor of the History of Science, Trinity College), 'New Light on Newton's Natural Philosophy'

J. Kenneth McDonald (Chief Historian, Central Intelligence Agency), 'The Decline of British Naval Power 1918–1922'

Yvonne Cripps (Visiting Professor of Law), '"Peter and the Boys Who Cry Wolf": *Spycatcher*'

Emmanuel Ngara (Professor of English, University of Zimbabwe), 'African Poetry: Nationalism and Cultural Domination'

Kate Frost (Assistant Professor of English), 'Frat Rats of the Invisible College: the Wizard Earl of Northumberland and his Pre-Rosicrucian Pals'

B. Ramesh Babu (Visiting Professor of Government), 'American Foreign Policy: An Indian Dissent'

Sir Antony Ackland (British Ambassador to the United States), 'From Dubai to Madrid: Adventures in the British Foreign Service'

In the Spring Semester 1988 British Studies helped to sponsor four lectures by Sir Brian Urquhart (former Under-Secretary of the United Nations) on 'World Order in the Era of Decolonization'

Fall Semester 1988

Round Table Discussion on Richard Ellmann's *Oscar Wilde*: Peter Green (Dougherty Professor of Classics); Diana Hobby (Rice University, Editor of the *Yeats Papers*); Roger Louis (Kerr Professor of English History and Culture); and Elspeth Rostow (Stiles Professor of American Studies)

Hugh Cecil (University of Leeds), 'The British First World War Novel of Experience'

Alan Knight (Worsham Professor of Mexican History), 'Britain and the Mexican Revolution'

Prosser Gifford (Former Deputy-Director, Woodrow Wilson Center, Washington, D.C.), and Robert Frykenberg (Professor of Indian History, University of Wisconsin at Madison), 'Stability in Post-Colonial British Africa: the Indian Perspective'

Joseph Dobrinski (Université Paul-Valéry), 'The Symbolism of the Artist Theme in *Lord Jim*'

Martin Stannard (University of Leicester), 'Evelyn Waugh and North America'

Lawrence Cranberg (Consulting Physicist and Fellow of the American Physical Society), 'The Engels-Marx Relationship and the Origins of Marxism'

N. G. L. Hammond (Professor of Greek, Bristol University), 'The British Military Mission to Greece, 1943–1944'

Barbara Harlow (Associate Professor of English), 'A Legacy of the British Era in Egypt: Women, Writing, and Political Detention'

Sidney Monas (Professor of Slavic Languages and History), 'Thanks for the Mummery: *Finnegans Wake*, Rabelais, Bakhtin, and Verbal Carnival'

Robert Bowie (Former Director, Harvard Center of International Affairs and Deputy-Director, Central Intelligence Agency), 'Britain's Decision to Join the European Community'

Shirley Williams (Co-Founder, Social Democratic Party), 'Labour Weakness and Tory Strength—or, The Strange Death of Labour England'

Bernard Richards (Fellow of Brasenose College, Oxford), 'Ruskin's View of Turner'

John R. Clarke (Professor of Art History), 'Australian Art of the 1960s'

Round Table Discussion on Paul Kennedy's *The Rise and Fall of the Great Powers*: Sandy Lipucci (Government), Roger Louis (History), Jagat Mehta (LBJ School), Sidney Monas (Slavic Languages and History), and Walt Rostow (Economics and History)

Spring Semester 1989

Brian Levack (Professor of History), 'The English Bill of Rights, 1689'

Hilary Spurling (Critic and Biographer), 'Paul Scott as Novelist: His Sense of History and the British Era in India'

Larry Carver (Director of the Humanities Program), 'Lord Rochester: the Profane Wit and the Restoration's Major Minor Poet'

Atieno Odhiambo (Professor of History, Rice University), 'Re-Interpreting Mau Mau'

Trevor Hartley (Reader in Law, London School of Economics, and Visiting Professor, UT Law School), 'The British Constitution and the European Community'

Archie Brown (Fellow of St. Antony's College, Oxford), 'Political Leadership in Britain, the Soviet Union, and the United States'

Lord Blake (Former Provost of Queen's College, Oxford, and Editor of the *Dictionary of National Biography*), 'Churchill as Historian'

Weirui Hou (Professor of English Literature, Shanghai University), 'British Literature in China'

Norman Daniel (British Council), 'Britain and the Iraqi Revolution of 1958'

Alistair Horne (Fellow of St. Antony's College, Oxford), 'The Writing of the Biography of Harold Macmillan'

M.R.D. Foot (former Professor of History, Manchester University, and Editor of the *Gladstone Diaries*), 'The Open and Secret War, 1939–1945'

Ian Willison (former Head of Rare Books Division of the British Library), 'Editorial Theory and Practice in The History of the Book'

Neville Meaney (Professor of History, University of Sydney), 'The "Yellow Peril": Invasion, Scare Novels, and Australian Political Culture'

Round Table Discussion on *The Satanic Verses*: Kurth Sprague (Associate Professor of American Studies); Peter Green (Dougherty Professor of Classics); Robert A. Fernea (Professor of Anthropology); Roger Louis (Kerr Professor of English History and Culture); and Gail Minault (Associate Professor of History and Asian Studies)

Kate Frost (Associate Professor of English), 'John Donne, Sunspots, and the British Empire'

Lee Patterson (Professor of English, Duke University), 'Chaucerian Commerce'

Edmund Weiner and John Simpson (Editors of the new *Oxford English Dictionary*), 'Return to the Web of Words'

Ray Daum (Curator, Humanities Research Center), 'Noel Coward and Cole Porter'

William B. Todd (Kerr Professor Emeritus in English History and Culture), 'Edmund Burke on the French Revolution'

Fall Semester 1989

D. Cameron Watt (Stevenson Professor of International History, London School of Economics), 'Britain and the Origins of the Second World War: Personalities and Politics of Appeasement'

Gary Freeman (Associate Professor of Government), 'On the Awfulness of the English: the View from Comparative Studies'

Hans Mark (Chancellor, U.T. System), 'British Naval Tactics in the Second World War: the Japanese Lessons'

T.B. Millar (Director, Menzies Centre for Australian Studies, London), 'Australia, Britain and the United States in Historical Perspective'

Dudley Fishburn (Member of Parliament and former Editor of *The Economist*), '*The Economist*'

Lord Franks (former Ambassador in Washington), 'The "Special Relationship"'

Herbert L. Jacobson (Drama Critic and friend of Orson Wells), 'Three Score Years of Transatlantic Acting and Staging of Shakespeare'

Roy Macleod (Professor of History, University of Sydney) 'The "Practical Man": Myth and Metaphor in Anglo-Australian Science'

David Murray (Professor of Government, the Open University), 'Hong Kong: the Historical Context for the Transfer of Power'

Susan Napier (Assistant Professor of Japanese Language and Literature), 'Japanese Intellectuals Discover the British'

Dr. Karan Singh (Ambassador of India to the United States), 'Four Decades of Indian Democracy'

Paul Woodruff (Professor of Philosophy), 'George Grote and the Radical Tradition in British Scholarship'

Herbert J. Spiro (Professor of Government), 'Britain, the United States, and the Future of Germany'

Robert Lowe (Wine Columnist for the *Austin American-Statesman*), '"God Rest you Merry, Gentlemen": the Curious British Cult of Sherry'

Spring Semester 1990

Thomas F. Staley (Director, Harry Ransom Humanities Research Center), 'Harry Ransom, the HRC, and the Development of Twentieth Century Literary Research Collections'

Thomas Cable (Blumberg Professor of English), 'The Rise and Decline of the English Language'

D. J. Wenden (Fellow of All Souls College, Oxford), 'Sir Alexander Korda and the British Film Industry'

Roger Owen (Fellow of St. Antony's College, Oxford, and Visiting Professor of Middle Eastern History), 'Reflections on the First Ten Years of Thatcherism'

Robert Hardgrave (Temple Centennial Professor of the Humanities), 'Celebrating Calcutta: The Solvyns Portraits'

Donatus Nwoga (Professor of English, University of Nigeria, Nsukka, and Fulbright Scholar-in-Residence, University of Kansas), 'The Intellectual Legacy of British Decolonization in Africa'

Francis Sitwell (Etonian, Seaman, and Literary Executor), 'Edith Sitwell: a Reappraisal'

Robert Vitalis (Assistant Professor of Government), 'The "New Deal" in Egypt: Britain, the United States, and the Egyptian Economy during World War II'

James Coote (Professor and Cass Gilbert Teaching Fellow, School of Architecture), 'Prince Charles and Architecture'

Harry Eckstein (Distinguished Professor of Political Science, University of California, Irvine), 'British Politics and the National Health Service'

Alfred David (Professor of English, Indiana University), 'Chaucer and King Arthur'

Ola Rotimi (African Playwright and Theater Director), 'African Literature and the British Tongue'

Derek Brewer (Professor of English and Master of Emmanuel College, Cambridge), 'An Anthropological Study of Literature'

Neil MacCormick (Regius Professor of Public Law and the Law of Nations, University of Edinburgh), 'Stands Scotland Where She Should?'

Janice Rossen (Senior Research Fellow, Harry Ransom Humanities Research Center), 'Toads and Melancholy: The Poetry of Philip Larkin'

Ronald Robinson (Beit Professor of the History of the British Commonwealth, Oxford, and Visiting Cline Professor, University of Texas), 'The Decolonization of British Imperialism'

Fall Semester 1990

'The Crisis in the Persian Gulf'—Round Table Discussion: Hafez Farmayan (Professor of History); Robert Fernea (Professor of Anthropology); Roger Louis (Kerr Chair in English History and Culture); Robert Stookey (United States Foreign Service Officer, Retired, now Research Associate, Center for Middle Eastern Studies)

John Velz (Professor of English), 'Shakespeare and Some Surrogates: An Account of the Anti-Stratfordian Heresy'

Michael H. Codd (Secretary, Department of the Prime Minister and Cabinet, Government of Australia), 'The Future of the Commonwealth: An Australian View'

John Dawick (Senior Lecturer in English, Massey University, New Zealand), 'The Perils of Paula: Young Women and Older Men in Pinero's Plays'

Gloria Fromm (Professor of English, University of Illinois in Chicago), 'New Windows on Modernism: The Letters of Dorothy Richardson'

David Braybrooke (Centennial Commission Professor in the Liberal Arts), 'The Canadian Constitutional Crisis'

Sidney Monas (Professor of History and Slavic Languages), 'Paul Fussell and World War II'

James Fishkin (Darrell Royal Regents Chair in Ethics and American Society), 'Thought Experiments in Recent Oxford Philosophy'

Joseph Hamburger (Pelatiah Perit Professor of Political and Social Science, Yale University), 'How Liberal Was John Stuart Mill?'

Richard W. Clement (Special Collections Librarian, Kenneth Spencer Research Library, University of Kansas), 'Thomas James and the Bodleian Library: the Foundations of Scholarship'

Michael Yeats (Former Chairman of the Irish Senate and only son of the Poet William Butler Yeats), 'Ireland and Europe'

'William H. McNeill's *Arnold J. Toynbee: A Life'*—Round Table Discussion: Standish Meacham (Dean of Liberal Arts); Peter Green (Dougherty Professor in Classics); Roger Louis (Kerr Chair in English History and Culture); Sidney Monas (Professor of History and Slavic Languages)

Jeffrey Meyers (Biographer and Professor of English, University of Colorado), 'Conrad and Jane Anderson'

Alan Frost (Professor of History, La Trobe University, Melbourne), 'The Explorations of Captain Cook'

Sarvepalli Gopal (Professor of History, Jawaharlal Nehru University, and Fellow of St. Antony's College, Oxford), 'The First Ten Years of Indian Independence'

'The Best and Worst Books of 1990'—Round Table Discussion: Alessandra Lippucci (Lecturer in Government); Roger Louis (Kerr Chair in English History and Culture); Tom Staley (Director, Harry Ransom Humanities Research Center); Steve Weinberg (Welch Foundation Chair in Science Theory); and Paul Woodruff (Thompson Professor in the Humanities)

Spring Semester 1991

David Hollway (Prime Minister's Office, Government of Australia), 'Australia and the Gulf Crisis'

Diane Kunz (Yale University), 'British Post-War Sterling Crises'

Miguel Gonzalez-Gerth (Spanish and Harry Ransom Humanities Research
 Center), 'T.E. Lawrence, Richard Aldington and the Death of
 Heroes'
Robert Twombly (Professor of English), 'Religious Encounters with the Flesh
 in English Literature'
Alan Ryan (Princeton University), 'Bertrand Russell's Politics'
Hugh Kenner (Andrew Mellon Professor of the Humanities, The Johns
 Hopkins University, and Visiting Harry Ransom Professor), 'The
 State of English Poetry'
Patricia Burnham (American Studies), 'Anglo-American Art and the Struggle
 for Artistic Independence'
'The Churchill Tradition'—Round Table Discussion: Lord Blake (former
 Provost of Queen's College, Oxford); Lord Jenkins (Chancellor,
 Oxford University); Field Marshal Lord Carver (former Chief of
 the Defence Staff); Sir Michael Howard (former Regius Professor,
 Oxford, present Lovett Professor of Military and Naval History, Yale
 University); with a concluding comment by Winston S. Churchill,
 M.P.
Woodruff Smith (Professor of History, UT San Antonio), 'Why Do the British
 Put Sugar in their Tea?'
Peter Firchow (Professor of English, University of Minnesota), 'Aldous
 Huxley: The Poet as Centaur'
Irene Gendzier (Professor of History and Political Science, Boston
 University), 'British and American Middle Eastern Policies in the
 1950s: Lebanon and Kuwait. Reflections on Past Experience and
 the Postwar Crisis in the Gulf'
John Train (Harvard Magazine and Wall Street Journal), 'Remarkable
 Catchwords in the City of London and on Wall Street'
Alan Sisman (Independent Writer, London), 'A. J. P. Taylor'
Roger Louis (Kerr Professor), 'The Young Winston'
Adrian Mitchell (Professor of English, Melbourne University, and Visiting
 Professor of English and Australian Studies), 'Claiming a Voice:
 Recent Non-Fictional Writing in Australia'
Bruce Hevly (Professor of History, University of Washington), 'Stretching
 Things Out versus Letting Them Slide: The Natural Philosophy of
 Ice in Edinburgh and Cambridge in the 19th Century'
Henry Dietz (Professor of Government), 'Foibles and Follies in Sherlock's
 Great Game: Some Excesses of Holmesian Research'

Summer 1991

Roger Louis (Kerr Professor) and Ronald Robinson (Beit Professor of the History of the British Commonwealth, Oxford University, and Visiting Cline Professor), 'Harold Macmillan and the Dissolution of the British Empire'

Robert Treu (Professor of English, University of Wisconsin, Lacrosse), 'D.H. Lawrence and Graham Greene in Mexico'

Thomas Pinney (Chairman, Department of English, Pomona College), 'Kipling, India, and Imperialism'

Ronald Heiferman (Professor of History, Quinnipiac College), 'The Odd Couple: Winston Churchill and Chiang Kai-shek'

John Harty (Professor of English, Alice Lloyd College, Kentucky), 'The Movie and the Book: J. G. Ballard's *Empire of the Sun*'

A.B. Assensoh (Ghanaian Journalist and Professor of History, Southern University, Baton Rouge), 'Nkrumah'

Victoria Carchidi (Professor of English, Emory and Henry College), 'Lawrence of Arabia on a Camel, Thank God!'

James Gump (Chairman, Department of History, University of California at San Diego), 'The Zulu and the Sioux: The British and American Comparative Experience with the "Noble Savage"'

Fall Semester 1991

Round Table Discussion on Noel Annan's *Our Age*: Peter Green (Dougherty Professor in Classics), Robert D. King (Dean ad interim and Rappoport Professor of Liberal Arts), Roger Louis (Kerr Professor of English History and Culture), and Thomas F. Staley (Director of the Harry Ransom Humanities Research Center)

Christopher Heywood (Okayama University, Japan), 'Slavery, Imagination, and the Brontës'

Harold L. Smith (University of Houston, Victoria), 'Winston Churchill and Women'

Krystyna Kujawinska-Courtney (University of Lodz), 'Shakespeare and Poland'

Ewell E. Murphy, Jr. (Baker & Botts, Houston), 'Cecil Rhodes and the Rhodes Scholarships'

I.N. Kimambo (University of Dar-es-Salaam), 'The District Officer in Tanganyika'

Hans Mark (Chancellor, U.T. System), 'The Pax Britannica and the Inevitable Comparison: Is There a Pax Americana? Conclusions from the Gulf War'

Richard Clutterbuck (Major-General, British Army, Ret.), 'British and American Hostages in the Middle East: Negotiating with Terrorists'

Elizabeth Hedrick (Assistant Professor of English), 'Samuel Johnson and Linguistic Propriety'

The Hon. Denis McLean (New Zealand Ambassador to the United States), 'Australia and New Zealand: The Nuisance of Nationalism'

Elizabeth Richmond (Assistant Professor of English), 'Submitting a Trifle for a Degree: Dramatic Productions at Oxford and Cambridge in the Age of Shakespeare'

Kenneth Warren, M.D. (Director for Science, Maxwell Macmillan), 'Tropical Medicine: A British Invention'

Adolf Wood (Deputy-Editor of *The Times Literary Supplement*), 'The Golden Age of *The Times Literary Supplement*'

Eugene Walter (Poet and Novelist), 'Unofficial Poetry: Literary London in the 1940s and 1950s'

Sidney Monas (Professor of Slavic Languages and History), 'Images of Britain in the Poetry of World War II'

The St. Stephen's Madrigal Choir, 'Celebrating an English Christmas'

Spring Semester 1992

Jeremy Treglown (Critic and Author), 'Wartime Censorship and the Novel'

Toyin Falola (Professor of History), 'Nigerian Independence 1960'

Donald S. Lamm (President, W.W. Norton and Company), 'Publishing English History in America'

Colin Franklin (Publisher and Historian of the Book), 'The Pleasures of 18th Century Shakespeare'

Thomas F. Staley (Director, Harry Ransom Humanities Research Center), '*Fin de Siècle* Joyce: a Perspective on One Hundred Years'

Sarvepalli Gopal (Jawaharlal Nehru University), '"Drinking Tea with Treason": Halifax and Gandhi'

Michael Winship (Associate Professor of English), 'The History of the Book: Britain's Foreign Trade in Books in the 19th Century'

Richard Lariviere (Professor of Sanskrit and Director of the Center for Asian Studies), 'British Law and Lawyers in India'

Round Table Discussion on A.S. Byatt's *Possession*: Janice Rossen (Visiting Scholar, Humanities Research Center), John P. Farrell (Professor of English), and Roger Louis

William H. McNeill (University of Chicago and former President of the American Historical Association), 'Arnold Toynbee's Vision of World History'

Derek Brewer (Master of Emmanuel College, Cambridge), 'The Interpretation of Fairy Tales: the Implications for English Literature, Anthropology, and History'

David Bradshaw (Fellow of Worcester College, Oxford), 'Aldous Huxley: Eugenics and the Rational State'

Steven Weinberg (Josey Regental Professor of Science), 'The British Style in Physics'

Sir David Williams (Vice-Chancellor, Cambridge University), 'Northern Ireland'

Summer 1992

R.A.C. Parker (Fellow of Queen's College, Oxford), 'Neville Chamberlain and Appeasement'

Adrian Wooldridge (Fellow of All Souls College, Oxford, and Staff Writer for *The Economist*), 'Reforming British Education: How It Happened and What America Can Learn'

Chris Wrigley (Professor of Modern British History, Nottingham University), 'A. J. P. Taylor: An English Radical and Modern Europe'

Fall Semester 1992

Round Table Discussion on E.M. Forster's *Howards End*: the Movie and the Book: Robert D. King (Liberal Arts), Roger Louis (History), Alessandra Lippucci (Government), Thomas F. Staley (Humanities Research Center)

Lord Skidelsky (Warwick University), 'Keynes and the Origins of the "Special Relationship"'

Sir Samuel Falle (former British Ambassador), 'Britain and the Middle East in the 1950s'

Ian MacKillop (University of Sheffield), 'We Were That Cambridge: F.R. Leavis and *Scrutiny*'

Walter Dean Burnham (Frank G. Erwin, Jr. Centennial Chair in Government), 'The 1992 British Elections: Four-or-Five-More Tory Years?'

Don Graham (Professor of English), 'Modern Australian Literature and the Image of America'

Richard Woolcott (former Secretary of the Australian Department of Foreign Affairs), 'Australia and the Question of Cooperation or Contention in the Pacific'

Ian Willison (1992 Wiggins Lecturer, American Antiquarian Society), 'The History of the Book in Twentieth-Century Britain and America'

Iain Sproat, (Member of Parliament), 'P.G. Wodehouse and the War'

Standish Meacham (Sheffield Professor of History), 'The Crystal Palace'

Field Marshal Lord Carver (former Chief of the British Defence Staff), 'Wavell: a Reassessment'

Lesley Hall (Wellcome Institute for the History of Medicine, London), 'For Fear of Frightening the Horses: Sexology in Britain since William Acton'

Michael Fry (Director of International Relations, University of Southern California), 'Britain, the United Nations, and the Lebanon Crisis of 1958'

Brian Holden Reid (King's College, London), 'J.F.C. Fuller and the Revolution in British Military Thought'

Neil Parsons (University of London), '"Clicko" or Franz Taaibosch: a Bushman Entertainer in Britain, Jamaica, and the United States *c.* 1919–40'

John Hargreaves (Burnett-Fletcher Professor of History, Aberdeen University), 'God's Advocate: Lewis Namier and the History of Modern Europe'

Round Table Discussion on Robert Harris's *Fatherland*: Henry Dietz (Government), Robert D. King (Liberal Arts), Roger Louis (History), and Walter Wetzels (Germanic Languages)

Kevin Tierney (University of California), 'Robert Graves: An Outsider Looking In, or An Insider Who Escaped?'

Spring Semester 1993

Round Table Discussion on 'The Trollope Mystique': Janice Rossen (author of *Philip Larkin* and *The University in Modern Fiction*), Louise Weinberg (Angus G. Wynne Professor of Civil Jurisprudence), and Paul Woodruff (Director of the Plan II Honors Program and Thompson Professor of Philosophy)

Bruce Hunt (Associate Professor of History), 'To Rule the Waves: Cable Telegraphy and British Physics in the 19th Century'

Martin Wiener (Jones Professor of History, Rice University), 'The Unloved
State: Contemporary Political Attitudes in the Writing of Modern
British History'

Elizabeth Dunn (Harry Ransom Humanities Research Center), 'Ralph Waldo
Emerson and Ireland'

Jason Thompson (Western Kentucky University), 'Edward William Lane's
"Description of Egypt"'

Sir Michael Howard (former Regius Professor of Modern History, Oxford
University, present Lovett Professor of Military and Naval History,
Yale University), 'Strategic Deception in the Second World War'

Gordon A. Craig (Sterling Professor of Humanities, Stanford University),
'Churchill'

Round Table Discussion on the Indian Mathematician Ramanujan: Robert
D. King (Rappoport Professor of Liberal Arts), James W. Vick (Vice-
President for Student Affairs and Professor of Mathematics), and
Steven Weinberg (Regental Professor and Josey Chair in Physics)

Martha Merritt (Lecturer in Government), 'From Commonwealth to
Commonwealth, and from Vauxhall to *Vokzal*: Russian Borrowing
from Britain'

Sidney Monas (Professor of Slavic Languages and History), 'James Joyce
and Russia'

Peter Marshall (Professor of History, King's College, London), 'Imperial
Britain and the Question of National Identity'

Michael Wheeler (Professor of English and Director of the Ruskin
Programme, Lancaster University), 'Ruskin and Gladstone'

Peter Marshall (Professor of History, King's College, London), 'Edmund
Burke and India'

Anthony Low (Smuts Professor of Commonwealth History and President of
Clare College, Cambridge University), 'Britain and India in the Early
1930s: the British, American, French, and Dutch Empires
Compared'

Summer 1993

Alexander Pettit (University of North Texas), 'Lord Bolingbroke's *Remarks
on the History of England*'

Rose Marie Burwell (Northern Illinois University), 'The British Novel and
Ernest Hemingway'

Richard Patteson (Mississippi State University), 'New Writing in the West
Indies'

Richard Greene (Memorial University Newfoundland), 'The Moral Authority
of Edith Sitwell'

Fall Semester 1993

Round Table Discussion on 'The British and the Shaping of the American
Critical Mind: Edmund Wilson, Part II', Roger Louis (History),
Elspeth Rostow (Stiles Professor in American Studies), Tom Staley
(Director, Harry Ransom Center), and Robert Crunden (Professor
of History and American Studies)

Roseanne Camacho (University of Rhode Island), 'Evelyn Scott: Towards
an Intellectual Biography'

Christopher Heywood (Okayama University), 'The Brontës and Slavery'

Peter Gay (Sterling Professor of History, Yale University), 'The Cultivation
of Hatred in England'

Linda Ferreira-Buckley, 'England's First English Department: Rhetoric and
More Rhetoric'

Janice Rossen (Senior Research Fellow, Humanities Research Center), 'British
University Novels'

Ian Hancock (O Yanko Le Redzosko) (Professor of Linguistics and English),
'The Gypsy Image in British Literature'

James Davies (University College of Swansea), 'Dylan Thomas'

Jeremy Lewis (London Writer and Editor), 'Who Cares about Cyril
Connolly?'

Sam Jamot Brown (British Studies) and Robert D. King (Linguistics), 'Scott
and the Antarctic'

Martin Trump (University of South Africa), 'Nadine Gordimer's Social and
Political Vision'

Richard Clogg (Professor of Balkan History, University of London), 'Britain
and the Origins of the Greek Civil War'

Herbert J. Spiro (United States Ambassador, Ret.), 'The Warburgs: Anglo-
American and German-Jewish Bankers'

Colin Franklin (Publisher and Antiquarian Bookseller), 'Lord Chesterfield:
Stylist, Connoisseur of Manners, and Specialist in Worldly Advice'

Jeffrey Segall (Charles University, Prague), 'The Making of James Joyce's
Reputation'

Rhodri Jeffreys-Jones (University of Edinburgh), 'The Myth of the Iron Lady:
Margaret Thatcher and World Stateswomen'

John Rumrich (Associate Professor of English), 'Milton and Science: Gravity
and the Fall'

J. D. Alsop (McMaster University), 'British Propaganda, Espionage, and
 Political Intrigue'
'The Best and the Worst Books of 1993': David Edwards (Government),
 Creekmore Fath (Liberal Arts Foundation), Betty Sue Flowers
 (English), and Sidney Monas (History and Slavic Languages)

Spring Semester 1994

Thomas F. Staley (Director, Harry Ransom Humanities Research Center),
 'John Rodker: Poet and Publisher of Modernism'
Martha Fehsenfeld and Lois More Overbeck (Emory University), 'The
 Correspondence of Samuel Beckett'
M. R. D. Foot (Historian and Editor), 'Lessons of War on War: the Influence
 of 1914–1918 on 1939–1945'
'Requiem for Canada?'—Round Table Discussion: David Braybrooke
 (Centennial Chair in Liberal Arts), Walter Dean Burnham (Frank
 Erwin Chair in Government), and Robert Crunden (Professor of
 American Studies)
Ross Terrill (Harvard University), 'Australia and Asia in Historical
 Perspective'
Sir Samuel Falle (British Ambassador and High Commissioner), 'The
 Morning after Independence: the Legacy of the British Empire'
Deborah Lavin (Principal of Trevelyan College, University of Durham),
 'Lionel Curtis: Prophet of the British Empire'
Robin W. Doughty (Professor of Geography), 'Eucalyptus: And Not a Koala
 in Sight'
Al Crosby (Professor of American Studies and History), 'Captain Cook and
 the Biological Impact on the Hawaiian Islands'
Gillian Adams (Editor, *Children's Literature Association Quarterly*), 'Beatrix
 Potter and Her Recent Critics'
Lord Amery, 'Churchill's Legacy'
Christa Jansohn (University of Bonn) and Peter Green (Dougherty Professor
 of Classics), *'Lady Chatterley's Lover'*
R. A. C. Parker (Fellow of Queen's College, Oxford), 'Neville Chamberlain
 and the Coming of the Second World War'
John Velz (Professor of English), 'King Lear in Iowa: Jane Smiley's *A
 Thousand Acres*'
Jan Schall (University of Florida), 'British Spirit Photography'
Daniel Woolf (Dalhousie University), 'The Revolution in Historical
 Consciousness in England'

Fall Semester 1994

Kenneth O. Morgan (Vice-Chancellor, University of Wales), 'Welsh Nationalism'

Round Table Discussion on Michael Shelden's *Graham Greene: The Man Within*—Peter Green (Dougherty Professor in Classics); Roger Louis (Kerr Chair in English History and Culture); and Thomas F. Staley (Director, Harry Ransom Humanities Research Center)

Robert D. King (Rappoport Regents Chair in Liberal Arts), 'The Secret War, 1939–1945'

Brian Boyd (Professor of English, University of Auckland), 'The Evolution of Shakespearean Dramatic Structure'

Lord Weatherill (former Speaker of the House of Commons), 'Thirty Years in Parliament'

Hans Mark (McKetta Chair in Engineering), 'Churchill's Scientists'

Steven Weinberg (Josey Regental Professor of Science), 'The Test of War: British Strengths and Weaknesses in World War II'

Dennis Welland (Professor of English Literature and American Studies, University of East Anglia), 'Wilfred Owen and the Poetry of War'

Alan Frost (Professor of History, La Trobe University), 'The Bounty Mutiny and the British Romantic Poets'

W. O. S. Sutherland (Professor of English), 'Sir Walter Scott'

Hazel Rowley (Lecturer in Literary Studies, Deakin University, Melbourne), 'Christina Stead's "Other Country"'

Herman Bakvis (Professor of Government, Dalhousie University), 'The Future of Democracy in Canada and Australia'

Peter Stansky (Field Professor of History, Stanford University), 'George Orwell and the Writing of 1984'

Henry Dietz (Associate Professor of Government), 'Sherlock Holmes and Jack the Ripper'

James Coote (Professor of Architecture), 'Techniques of Illusion in British Architecture: Robert Adam at Osterley Park House'

'The Best and Worst Books of 1994': Dean Burnham (Government), Alessandra Lippucci (Government), Roger Louis (History), Sidney Monas (Slavic Languages and History), and Janice Rossen (Humanities Research Center)

Spring Semester 1995

Elizabeth Butler Cullingford (Professor of English), 'Anti-Colonial Metaphors in Contemporary Irish Literature'

Thomas M. Hatfield (Dean of Continuing Education), 'British and American Deception of the Germans in Normandy'

Gary P. Freeman (Associate Professor of Government), 'The Politics of Race and Immigration in Britain'

Donald G. Davis, Jr. (Professor in the Graduate School of Library and Information Science),'The Printed Word in Sunday Schools in 19th Century England and the United States'

Brian Bremen (Assistant Professor of English), 'Healing Words: The Literature of Medicine and the Medicine of Literature'

Frances Karttunen (Linguistic Research Center) and Alfred W. Crosby (American Studies and History), 'British Imperialism and Creole Languages'

Paul Lovejoy (Professor of History, York University, Canada), 'British Rule in Africa: A Reassessment of Nineteenth-Century Colonialism'

Carol MacKay (Associate Professor of English), 'Creative Negativity in the Life and Work of Elizabeth Robins'

John Brokaw (Professor of Drama), 'The Changing Stage in London, 1790-1832'

Linda Colley (Richard M. Colgate Professor of History, Yale University), 'The Frontier in British History'

Iwan Morus (University of California at San Diego), 'Manufacturing Nature: Science, Technology, and Victorian Consumer Culture'

Brian Parker (Professor of English, University of Toronto), 'Jacobean Law: The Dueling Code and "A Faire Quarrel" (1617)'

Kate Gartner Frost (Professor of English), '"Jack Donne the Rake": Fooling around in the 1590s'

Mark Kinkead-Weekes (Professor of English, University of Kent), 'Beyond Gossip: D.H. Lawrence's Writing Life'